invaluable tool for those just starting out in the design business as well as seasoned veterans of the field. It provides standard procedures firms of all sizes can use to strengthen their business presence and build healthy practices for the future.

The sample business forms are available for downloading at www.creativebusiness.com/guide-book.html.

CAMERON S. FOOTE is the president of Creative Business, a Boston-based business-information resource for the design community. He has been involved in every aspect of commercial creativity for forty years: he has worked for large and small agencies, managed design functions, taught advertising, was creative director of a major corporation, and ran his own communications consulting business. In 1989, he founded the *Creative Business* newsletter, which he continues to edit. It is the only publication exclusively devoted to the design business. He is the author of *The Business Side of Creativity* (Norton).

THE

Creative Business Guide to Running A Graphic Design Business

Also by Cameron S. Foote
The Business Side of Creativity

THE

Creative Business Guide ⌒to Running A Graphic Design Business

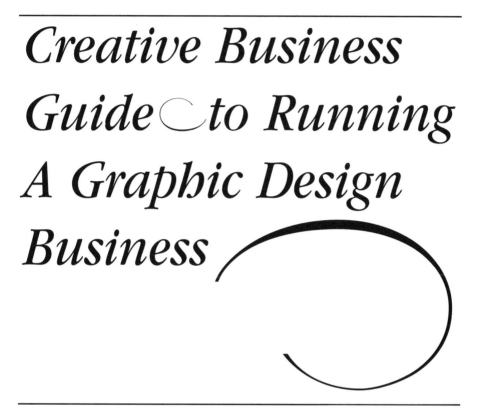

C A M E R O N S . F O O T E

W. W. Norton & Company
New York • London

Full-size copies of the sample forms shown throughout this book can be downloaded for personal use at www.creativebusiness.com/guidebook.html.

For information about permission to reproduce selections from this book, write to Permissions, W. W. Norton & Company, Inc., 500 Fifth Avenue, New York, NY 10110

The text of this book is composed in Palatino
With display set in Garamond
Manufacturing by Edwards Brothers
Book design and composition by Silvers Design
Production manager: Leeann Graham

Library of Congress Cataloging-in-Publication Data

Foote, Cameron S.
 The creative business guide to running a graphic design business / Cameron S. Foote.
 p. cm.
 Includes index.
 ISBN 0-393-73077-8
1. Commercial art—United States—Marketing. 2. Graphic arts—United States—Marketing. 3. Small business—United States—Management. I. Title.

NC998.5.A1 F663 2001 Bk
741.6′068′8—dc21 $29.70

 2001042556

 W. W. Norton & Company, Inc., 500 Fifth Avenue, New York, N.Y. 10110
 www.wwnorton.com

 W. W. Norton & Company Ltd., Castle House, 75/76 Wells Street, London W1T 3QT

 098765432

DEDICATED TO YOUNG
DESIGNERS EVERYWHERE,
THAT THEY MAY LEARN
FROM THOSE WHO HAVE
GONE BEFORE THEM.

Contents

PREFACE

Section
One
Organization

CHAPTER 1
A SOLID FOUNDATION . **17**
Two Personal Essentials... Legal Structure... Ownership Sharing... The
Need for Business Planning... Developing the Business Plan

CHAPTER 2
STRUCTURE AND FACILITIES . **35**
The Benefits of Structure... The Chain-of-Command Business Model...
The Coaching Business Model... The Associate Business Model...
Facilities Requirements and Budgeting... Lease Negotiation... Buying
Your Own Space

CHAPTER 3
OUTSIDE SUPPORT SERVICES . **51**
Accounting Services... Bookkeeping Services... Banking Services...
Insurance Services... Legal Services... Arbitration and Mediation
Services... Consulting Services

Section
Two
Personnel

CHAPTER 4
ORGANIZING . **77**
How Organized Are You?... The Case for Clearly Defined Policies... What
Employees Want to Know About... An Organization Chart... Employee
Handbooks... Publishing Employee Handbooks... Job Descriptions...
Noncompete Agreements... A Note to You

CHAPTER 5
HIRING ..**95**

Staffing Norms... How About a Virtual Staff?... Working with Outside Help... Using Interns... Finding Qualified Applicants... A Great Book is Not Enough... Interviewing Applicants... Evaluating Creativity... Salaries and Benefits... Informing Applicants

CHAPTER 6
MOTIVATING ..**115**

How We Are a Little Different... Intangible Motivators... Tangible Motivators... Evaluating Employees... Giving Raises

CHAPTER 7
CREATIVE DIRECTION**131**

Understanding the Need... Defining the Ground Rules... Adopting a Two-Step Process... The Time for Nondirection... Stimulating Creativity... Critiquing Constructively... The Preliminary Test... The Creative Review

CHAPTER 8
DISMISSING ..**143**

Downsizing Considerations... Dealing with Problem Employees... Trying to Change Bad Habits... How to Say Goodbye

Section
Three
Marketing

CHAPTER 9
POSITIONING ..**155**

Marketplace Trends... Is it Better to Specialize?... What About Broader Positioning than "Graphic Design"?... When is a Design Firm Something Else?... Mission Statements... Positioning for the Future

CHAPTER 10
PROMOTING ..**171**

The Many Benefits... Design Firm Fundamentals... Advertising... Web Promotion... Direct Mail... Reputation Building... Publicity... Networking... Volunteering and Pro Bono Work ... Creative Competitions

CHAPTER 11
SELLING ..**189**
Is the Web Changing Things?... How Much is Enough?... Hiring
Salespeople... What to Expect From a Salesperson... Qualifying Clients...
Talking the Talk and Walking the Walk... Pitching Revenue-Crucial
Projects... Pitching High-End Projects... Pitching Moderate-Visibility
Projects

Section
Four
Operations

CHAPTER 12
PRICING YOUR SERVICES ..**213**
Hourly Fees... Price by Value?... Markups... Commissions... Noncash
Compensation... Working on Retainer... Provide Volume Discounts?...
Give a Break to Not-for-Profits?... Raising Prices without Raising a Flap...
Determining Client Budgets

CHAPTER 13
WORKING WITH CLIENTS ..**241**
Give 'Em What They Need or What They Want?... Coping with Client
Incompetence... Conflicts of Interest... How Many Concepts?... Give Up
Computer Files?... Danger Signs... Surveying Client Happiness...
Outgrowing and Resigning

CHAPTER 14
GROW THE BUSINESS? ..**273**
How Big?... Size Control... What's the Right Business Mix?... The Three
Business Stages... Managing Growth... New Business from Old Clients...
Adjusting Work Flow... Electronic Help

CHAPTER 15
FINANCIAL ISSUES ..**299**
Funding Operations... Figuring Profitability... Improving Billable
Efficiency... Balance Sheets and Income Statements... Benchmarking
Trends... Avoiding Risks

CHAPTER 16
PERSONAL ISSUES ..**335**
The Perils of Perfectionism... The Entrepreneurial Disease... Avoiding
Burnout... Valuing the Business... Cashing Out

Section
Five
Appendices

APPENDIX I
TWENTY-FIVE MANAGEMENT STANDARDS**357**
Marketing Standards... Operating Standards... Financial Standards

APPENDIX II
SIX MANAGEMENT CASE STUDIES...**365**
Case Study 1: Self-destructive Management... **Case Study 2:** Dealing with the "Gorilla Client"... **Case Study 3**: Fast-Growth Danger Signals... **Case Study 4:** Not Making Tough Decisions... **Case Study 5:** Relying on Referrals... **Case Study 6:** Failing to Institutionalize the Company

APPENDIX III
A DESIGNER'S SHORT COURSE IN MARKETING**379**
A Marketing Orientation... What It Is and Isn't... Marketing Focus Versus Customer Focus... Marketing Structures... The Four *P*s of Marketing... Strategy and the Marketing Mix... Marketing Plans... Marketing Plan Formats... Marketing Plan Style

APPENDIX IV
SAMPLES AND FORMS ..**391**
Formal Business/Financial Plan... Estimating Worksheet... Letter of Agreement... Detailed Proposal... Employee Handbook... Agent Agreement... Work-for-Hire Form... Emergency Planning Form

Preface

VERY BUSINESS, every industry, is unique. But some have a special uniqueness. That is, they operate in ways that are outside standard business practices and experiences. Design is one of those businesses.

Our special uniqueness is partly due to the fact that design is a young industry. Although art has been produced commercially for a thousand years or more, it was not until about a hundred years ago that printed materials started to be professionally designed. Even the largest, most prestigious graphic design firms were formed only a few decades ago, and some are only a decade or so old. The standards and procedures learned by trial and error and passed along in most industries haven't had time to be institutionalized here.

Another reason for our uniqueness is the way most of our businesses are formed. Businesses in other industries tend to be launched by entrepreneurial types looking for an economic opportunity; the type of business is secondary to its financial potential. Not so with design businesses. They are almost always started by individuals who are designers first, business people second. Put another way, the design business selects us, we don't select it. Because of this, the emphasis in most firms is disproportionately high on the product offered, disproportionately low on running the business efficiently and profitability.

Third, who we are, how we work, and what we produce resists standardization. Every client, every assignment, is different. Volume fluctuates. Each project is priced individually. Creative individuals often don't respond to traditional management practices. And client review of what we do is always subjective.

However many ways you define the uniqueness of the graphic design business, it all leads to one conclusion: traditional business standards and

practices are often inappropriate. This is a business that responds best to its own, particular management style and operations agenda.

There is also a larger issue cloaked by the design business's uniqueness. Is there, as many would suggest, a basic incompatibility between the talent necessary for making good design and that required for running a successful business? Can right-brained individuals immersed in the subjectivity of aesthetics also deal effectively with analytical, left-brained business matters?

Let me answer this question before going any further: designers are not genetically business impaired. It is a myth, a convenient excuse perpetuated by one-dimensional individuals. Artistic and entrepreneurial talents can and do exist side by side. Many of the most talented people I know easily switch back and forth between both worlds every day. Whatever truth there is in our lack of business understanding, it comes not from an inherent lack of ability, but from lack of training. At a time when most designers end up being self-employed at one time or another during their careers, there continue to be virtually no business courses taught in the art schools where most designers study.

This lack of basic instruction has always been an expensive inconvenience to those with ambitions. It is now also of mainstream concern. Until a decade or so ago, design was primarily a cottage industry where a lack of business management techniques and skills did not have significant implications. Not so today. Graphic design is now a business involving ever larger and more complex companies, a business where all companies, smallest to largest, are required to make significant capital outlays in equipment, personnel, and facilities. To give short-shrift to managing these assets effectively not only risks a fair return on investments, but also threatens a company's very existence. While technique, craft, and professionalism have more or less kept pace with the industry's growth, one area—management—has fallen behind. What little most of us know, we've learned in the school of hard knocks, the most expensive means of education.

It is to address the aforementioned uniqueness of the design industry that this book is dedicated.

Some of the material in the chapters that follow comes from my experiences as the creative director in a Fortune 500 corporation. Others come from a decade of running my own business. Most of it, however, was developed after founding Creative Business in 1987. More than four thousand individuals have attended Creative Business workshops and roundtables across the country, and several thousand more have subscribed to the *Creative Business* newsletter, the only publication exclusively addressing the ongoing business needs of designers. Their feedback—what actually works and what doesn't in the real world—is the primary source of

the content of this book. Since much of the content has previously been published in the *Creative Business* newsletter, it has also been given the tests of relevance and accuracy through extensive peer review.

In its focus on the management of a multiperson firm this book complements the previously published *The Business Side of Creativity*. That volume addresses freelancing and the basics of pricing, selling, and running a small design or communications firm.

Finally, just like the industry itself, this book is a work-in-progress. Although it represents the best management thinking available at the time of publication, some things may have changed by the time you read it. Moreover, every principal and every shop has different considerations, so don't let anything published here overrule your own common sense. Use this book as a guide to learn to think creatively about business as well as client assignment issues; use it as your business model to build a viable design business in the twenty-first century.

SECTION ONE

Organization

Of the many aspects of running a design business, the least satisfying to most of us are structural issues: setting up the company, doing business planning, negotiating leases, finding insurance, and dealing with accountants and lawyers. As we'll see later in the following sections of this book, the other aspects of the business, even marketing, are all more creative; making even small modifications to them often results in noticeable changes.

The bad news is that addressing basic organizational and structural issues is more than just important: it is necessary to long-term success. The more potential your firm has to prosper and grow, the more crucial it is to set it up right in the beginning. Metaphorically speaking, this is the foundation upon which your business is built. So take the time to make sure it is solid.

The good news about dealing with organizational and structural issues is that they are really not that complicated or time-consuming. Moreover, once addressed the process is pretty much over forever unless you later want to make changes. And if you already run a firm and missed some of these steps when you first started out, it is never too late to go back and redo things.

Returning to our metaphor, it is a costly mistake to assume that you can build a strong company on a weak foundation.

"The first law ... is that everything is related to everything else."

Barry Commoner

1 A Solid Foundation

 OST READERS will have already gone through the process of establishing their companies. Chances are this was done more by the seat of the pants than by plan, but the opportunity to do everything right from the beginning is now past. So if you are among this majority, should you concern yourself now with the issues normally addressed when setting up a graphic design business? Yes. For several reasons.

Doing so will allow you to make changes in those areas where it is readily possible and the rewards quickly realized. Reviewing your procedures will also allow you to compensate in other areas for whatever organizational shortcomings you have to live with. It will provide you with the knowledge to make appropriate changes when opportunities present themselves. And, of course, there is always the chance that you might form another company sometime in the future.

❧ Two Personal Essentials ❧

Design businesses are relatively easy to start and run. Although it is not as easy today as it was just a decade or so ago, it is still possible to start a business today with little more than talent. But, being a *successful* design business—successful here defined as the ability to generate both long-term enjoyment and profits—requires a principal to possess two personal essentials. If you don't already have them you need to work at acquiring them.

A STRONG EGO. The nature of the design business—part art, part science, an unfamiliar process to clients—means that even the most talented and knowledgeable individuals have to deal with a skeptical world. Maintaining enthusiasm and perspective takes a well-developed sense of self-worth. The strongest, most innovative solution becomes a wasted effort if the client can't be persuaded to produce it, or insists on inappropriate modifications. So designers who wish to build a successful company must believe, passionately, that the creative solutions they recommend are the best ones possible given the time and budget constraints under which they have to work. They must be convincing when presenting them. Being passionate about what one believes in—defending it and fighting for it without appearing inflexible or arrogant—is an art. But it is a necessary one for any successful principal to develop.

A PRAGMATIC BRAIN. Perhaps more than anything else, the business world worships pragmatism, and the business world is where your design firm and its clients reside. Designers who are practical, those ultimately willing to adjust to business circumstances and client desires (albeit often after putting up the good, friendly fight), are the most sought after, the most successful. Designers successful in business belie the notion that it is impossible to be both creative and practical at the same time. In running their own businesses they know that a practical approach is nothing more than organizing around what works best, not necessarily what they might prefer. In dealing with their clients, they know that it takes looking at problems from the client's perspective, not just their own. They keep up-to-date and maintain high creative and ethical standards. They also know that their future will be determined not in the abstract or by an ideal, but rather by what proves to work best for themselves and their clients.

❋ Legal Structure ❋

With the minimal personal requirements for success covered, we can now look at the legal alternatives for structuring a design firm. In the United States there are currently six alternatives. (There are similar structures in most other countries.)

SOLE PROPRIETORSHIPS. If you are the only principal of your company and have not incorporated or set up a Limited Liability Company (LLC) or Limited Liability Partnership (LLP), by definition you run a sole proprietorship, whether you have no employees or hundreds. Registering with local authorities does not affect your business's legal structure.

The risk of sole proprietorship, which you are probably already aware of, is that your personal assets are indistinguishable from your business's

assets. This means, simply, that all financial obligations incurred by your company become your personal financial obligations. Because most businesses incur substantial financial obligations, Creative Business recommends against running a design business as a sole proprietor. The only exception would be if an accountant specifically recommends doing so for tax reasons, and you have had legal counsel regarding the extent of potential liability. In nearly all situations, however, there are better alternatives worth the slight extra cost and inconvenience.

PARTNERSHIPS. Whenever two or more sole proprietors conduct activity under a common name or identity, they are partners. The partners' names do not necessarily have to be part of the company name, nor does there have to be any type of written agreement or registration. As examples, a common telephone listing, letterhead, or business cards can legally establish a partnership. (In legal terms this is referred to as a "general partnership" to distinguish it from a "limited partnership," as described below.)

Anyone doing business with any of the partners can hold any one of the other partners equally responsible for his or her activities and obligations. There is no legal distinction or separation between the personal assets of the partners and their collective business assets. In essence, this makes a partnership with another individual twice as risky as a sole proprietorship; one with two other individuals three times as risky. Again, in the absence of specific accounting and legal advice to the contrary, Creative Business recommends against partnerships for graphic design businesses.

A partnership should not be confused with an arrangement in which two or more colleagues get together and incorporate an organization, or form a Limited Liability Company (LLC) or Limited Liability Partnership (LLP) in which each owns shares. We recommend one of these forms—corporation, LLC, or LLP—for sharing ownership.

LIMITED LIABILITY PARTNERSHIPS (LLPS). This is a recent and preferable option to a general partnership for sole proprietors and existing partnerships who wish to share ownership. LLPs are governed by state laws that vary, but some generalizations can be made. They are similar to general partnerships in that they provide flexibility in structuring and management. There are also specific tax advantages that usually make them preferable for estate planning purposes, especially when other family members are involved as partners. But most important is the limitation of liability they offer to all but one individual: the general partner. All others, the limited partners, have no financial liability beyond that of their investment, so sharing ownership poses no great financial risk for them. The general partner does incur all the business risks, but he or she has no liability for nonbusiness actions of the limited partners.

LLPs have to be formally registered and adhere to the specific laws of the state in which they are registered. This usually requires attorney and registration fees, and some additional ongoing reporting expenses. There may also be restrictions on operating procedures. For firms that are not incorporated or LLCs, and, for tax or other reasons, prefer not to become one, LLPs are the means of ownership sharing recommended by Creative Business.

JOINT VENTURES. These are relationships in which independent individuals or companies work together. (Jointly pitching clients is one example.) As long as each party involved maintains a separate, distinct identity, there's no implied partnership and, therefore, no partnership liability. This arrangement avoids the risks of a partnership, while still providing expense-sharing and income-generating benefits. Joint ventures can be for one project, or for a series of projects until those involved decide it is no longer in their best interests. Another type of joint venture, appropriate for very significant projects, is to team up with others under a new, separate business name. Although this is legally a partnership, an agreement can be drawn up by an attorney that will limit each partner's responsibilities to the single project and activity. Think of joint ventures this way: They are a means of sharing ownership of a particular project, rather than of a company.

CORPORATIONS. This is the traditional way of organizing a design business, and still the one of choice for most firms. Incorporating provides a company with a legal identity and obligations independent of its owners. Legal precedents are well established in every state. Each owner receives shares in the organization proportionate to his or her investment, and financial liability is limited to the investment. The only drawbacks are setup costs (typically $1,500 or so), and extra, ongoing bookkeeping, tax, and accounting costs (several hundred dollars yearly and up, depending on size). Creative Business recommends that most design firms incorporate. Which corporate form is preferable—"S" or "C"—depends on individual circumstances. The decision should be made, and periodically reviewed, with your accountant.

Subchapter S corporations. This is the form preferred by most smaller companies. The primary reason is that it allows taking out all of the corporation's profits each year without worrying about profit buildup or double taxation. There are, however, some limitations on corporate benefits—at this writing most significantly the deductibility of the principals' medical and life insurance premiums.

Subchapter C corporations. This form is especially preferred by growing companies because it offers additional tax advantages, as well as ways to

build financial equity within the corporation. There is also no limit to the number of shareowners, whereas S corporations are limited to thirty-five.

LIMITED LIABILITY COMPANIES (LLCS). This structure is becoming increasingly popular because it offers many of the advantages of an S corporation with fewer setup and ongoing costs. The major drawback is that it is a relatively new form of business structure and case law and legal precedents are not well established. There is probably no advantage to switching if your firm is already incorporated. If you are considering a way to limit personal liability for your firm's financial activities, it may or may not be appropriate as an alternative to incorporation, depending on your state of location and current business and future plans. Check with your accountant.

❀ Ownership Sharing ❀

The ideal business model for most entrepreneurs—graphic designers included—is 100 percent ownership and control. You get to make all the company decisions; you get to pocket all the profits; and you get 100 percent of any equity that develops. Everything else is a compromise. Right?

Well, not always. Sometimes making all the decisions leads to bad ones. Pocketing all the profits is great, but what if your company doesn't produce any? Likewise, holding 100 percent of your company's equity sounds good, but it's immaterial if there isn't any.

Sometimes an additional owner or two can contribute to prosperity. Decision making can be easier because two (or more) heads are better than one. Profits may increase if the other owners contribute a substantial amount of new income. Their involvement may also help to institutionalize a business, the single most important component of building equity. (Institutionalized businesses are those with a life of their own; those not dependent on an individual or specific circumstances.) Additionally, and especially relevant to design businesses because of their dependence on the quality of talent, having more than one owner increases the talent base—in both the creative and managerial areas.

The decision whether to share ownership is not a simple one. It depends on many factors: individual talent and business skills, market opportunities, capitalization needs, lifestyle preferences, business objectives, etc. Even when sharing ownership seems like a good idea, there are the additional issues of going about it the right way and making sure you choose the right person(s).

UP-FRONT CONSIDERATIONS. The primary reason why other types of companies opt for ownership sharing is the need for growth capital. It is

nearly impossible for many organizations, especially manufacturing ones, to grow without an infusion of outside capital, and growth is essential for survival. The amount that can be borrowed (non-equity funding) is often limited and the interest costs are high. In contrast, selling ownership shares (equity funding) allows money to be raised with little cost other than giving up some control.

The reasons for ownership sharing are different with design firms. Of course, adequate funding is crucial, but design firms' needs are relatively small and can usually be met out of profits or with short-term loans. Moreover, there is usually no grow-or-die imperative because design firms can be successful at any size. So most design firms have the option to avoid giving up equity or limit how much they do give up. At the same time, there are other, more complex reasons for considering ownership sharing.

Client perceptions. Many clients, especially larger ones, need reassurance that their suppliers have adequate resources for the tasks assigned. Although it is certainly possible to succeed with nothing but the name of the founder on the door, there's also no question that projecting a perception of shared ownership makes the job a little easier. Indeed, even if there are no plans to ever share ownership, it is probably wise to name an organization as if there were multiple owners—e.g., The Williams Organization, or The Elm Street Design Group, or Smith & Associates.

Competitiveness and growth. It is easy to obtain freelance help or to farm out work when necessary to meet occasional talent needs. When the need for a specific type of talent becomes ongoing, full-time staff can always be hired. But outsiders and employees seldom, if ever, provide the same degree of effort or dedication as someone who also has a financial stake in client satisfaction. When strength in a particular area is crucial to long-term success, ownership sharing is often the best way to accomplish it. Individuals with a piece of the action can also contribute additional input to business planning. The greater the variety of the talents, experiences, and insights of the principals, the better a company's strategic direction will be.

Everyday management. Running a small design firm requires wearing many hats. Some of us welcome the challenge. We acquire whatever new skills are required, learn how to allocate time, and delegate responsibility easily. But some of us find this need to be multidisciplined not only a burden, but also a costly distraction from what we do best: create. If you are the former, sharing ownership for any reason other than raising capital makes little sense; if you are the latter, you may wish to consider sharing ownership even if you have adequate capital. In addition to this, and independent of personal likes and dislikes, there is the quality of decision making. Too many decisions made in too little time by too few individuals often result in opportunities missed, or situations mishandled.

Lifestyle issues. A business that consumes too much of a principal's time, especially when there are family or other interests, soon ceases to be enjoyable. Yet enjoyment is a key element of entrepreneurial success. Even workaholics benefit from an occasional break. Ownership sharing provides the backstopping that allows for vacations and restorative time away from business pressures.

Business continuity and equity protection. The best way to provide for a business to outlive its current owners and allow them to cash in any equity they may have built up is to bring in additional, younger owners. If this is your desire, address when and how you will do this as soon as possible.

Tax and legal issues. Sharing ownership often involves changing the legal structure of a company, which, in turn, may change its tax and other obligations. These factors can have a major long-term impact on a business and should be considered when deciding whether to share ownership, and how to go about it.

TWO WRONG REASONS. Before going any further, it helps to be aware that many design firm principals go about ownership sharing for two common and misguided reasons:

You like them. Teaming up or sharing ownership simply because you like and want to work closely with another individual can be disastrous—for the friendship and for the business. The qualities of good friends and lovers are not the same qualities required of a business associate. The primary consideration in sharing ownership has to be whether it will increase business viability. Admiration and respect among owners are, of course, important, but close personal relationships are not. In fact, they often turn out more negative than positive. Principals must feel free to act in the best interests of the business without worrying about the effect on their friendships. Even routine business decisions and financial pressures can put a tremendous strain on personal relationships.

You want to reward an employee. There are many ways to show appreciation—pay raises, bonuses, profit sharing, promotions, etc. Sharing ownership is seldom one of them. (See chapter 6.)

THE RIGHT KIND OF PERSON. Avoiding the wrong reasons for sharing ownership is one thing, finding the right person(s) is quite another. Although there may be other, personal preference issues, anyone offered more than a token share should be able to measure up to at least the following three criteria:

Has complementary skills. As counterintuitive as it may seem at first, someone just like you and the other owners—same temperament, world view, experience, and skills—is probably not a good choice. A good choice is someone whose skills are complementary—what they have is exactly what

your organization lacks. From a business perspective, complementary skills strengthen a company by extending its talent, marketing, or management capabilities. They allow it to provide even better products to a wider client base. That's what you are paying for. So make sure you get your money's worth.

From a personal perspective, there are less likely to be the internal conflicts that inevitably occur when styles, skills, and interests overlap. When individual owners have distinct areas of expertise and responsibility, decision making happens more quickly, employees are kept better informed, and efficiency is increased. Think diversity; avoid similarity. Look for a compatible individual who will extend your capabilities.

Brings something of value to the table. Except in cases of token ownership, the individual should also contribute something of defined value. It may be tangible—cash or the immediate influx of new clients and business. Or it may be intangible—expertise that will allow entry into a previously inaccessible field, or talent that will make the firm more profitable. Whichever it is, a financial figure should be attached, and that figure should, in the present owners' minds, equal the value of the ownership share assigned.

Of course, any valuation will be subjective and imprecise, but going through the process is nonetheless important. It helps both parties recognize that there is an equal trade-off, a quid pro quo. The exchange, and the values attached to it, should be agreed to in writing, even when stock certificates are provided. This not only provides a legal basis for ownership assignment: it further reinforces the true worth of the exchange. (For help in determining business value, see chapter 16.)

Has management strength or potential. This is an important attribute of any individual with more than token ownership, and a crucial one if gradually transferring ownership is being considered as a way for present owners to phase out. The same attitude toward managing the financial aspects of the business is especially important.

A REALITY CHECK. Even when initiated for all the right reasons and the "partners" are complementary, sharing ownership successfully is still a longshot. The fact is that most partnerships end up dissolving acrimoniously. And most corporations, LLCs, and LLPs go through at least one wrenching change of ownership, and often several. Aside from the reasons already given, the usual cause is not considering the procedural changes required.

Management is different. New principals expect responsibility and authority commensurate with their ownership. Even token owners expect their status to be publicly acknowledged. Also, and as ideal as it may sound, having several equal decision makers seldom works. Different owners giving different directions at different times is a formula for disaster. Employees

and vendors need to know to whom to listen under which circumstances. The directions they get must be more or less predictable. All this necessitates looking at individual management strengths and agreeing to specific responsibilities before implementing an agreement. Not to have a solid understanding of who will have what responsibilities is to set up any new arrangement to fail.

It will affect the creative product. The products of a design company are influenced by the tastes of its owners. When they recognize the marketplace advantages of variety and are willing to subordinate their own tastes to it, sharing ownership can be rewarding. However, when owners hold strong and divergent opinions, it usually isn't. There should be no compromising on overall quality, but owners can't strongly disagree over taste or subjective issues. This will only confuse the staff, wreak havoc on shop efficiency, and compromise the quality of the product. What may be a large but healthy ego in a single-owner company could be the kiss of death in one with several owners.

SHARING OPTION #1—TAKING IN GENERAL PARTNERS. This option is restricted to sole proprietors and partnerships. The advantages are that it is simple, inexpensive, and very flexible. The individual partners have the freedom to divide up and change responsibilities, obligations, and profits as they see fit, with or without any formal agreements or legal costs.

Whatever agreements do exist between the partners—e.g., division of profits—can exist on nothing more than a handshake. Alternatively, partnerships can have written agreements that specifically define or limit individual rights and responsibilities. For example, a partner who has contributed one third of the capital may, with the approval of the other partners, receive two thirds of the profits, or vice versa. This flexibility, however, comes at a very real risk: being held personally liable for bad business decisions or financial obligations, even when created by a partner without your knowledge. (As covered in chapter 3, it is sometimes possible to buy insurance as protection against suits arising from the actions of other partners, but it is limited and expensive.) Moreover, all the other benefits of shared ownership—more capital, economies of scale, greater potential, improved cash flow, additional skills, companionship, etc.—can also be obtained through one of the other structures. Creative Business does not recommend a general partnership as a means of ownership sharing except in unusual situations and when recommended by an attorney.

SHARING OPTION #2—STOCK DISTRIBUTION. This is the way most design firms choose to share ownership. That's because it is the only practical way for small corporations to do so. (An equivalent procedure for LLCs is assigning a membership percentage.)

The basics. The number of shares (stock) issued by a corporation or LLC represent its total value. So if one hundred shares are issued, and an individual is given forty, he or she will then own 40 percent of the value of the organization's present and future assets and dividends. So far no problem.

But unlike the stock of organizations that are listed on stock exchanges (publicly traded), there's no established market for the stock of smaller (privately traded) ones. What this means is that the stock has no monetary value unless a future sale can be guaranteed at a price predetermined by some type of pricing formula. Thus, the first step in ownership sharing through stock distribution is to determine the current value of the organization, then to ensure that the same formula will be used to determine its value in the future. The next step is to provide for a guaranteed sale of stock based upon this predetermined valuation formula. This is accomplished by making it mandatory for the organization to buy back the stock, and it guarantees that the stock will not slip into the hands of outsiders. Without going through the valuation process and providing for a guaranteed sale, stock distribution is a legal minefield of future contention.

Stockholder issues. Since a share of stock represents a percentage of an organization's assets, its value is affected by the number that have been issued. If, for example, more are issued in the future, the value of each will drop. (This is called "share dilution," or "watering the stock.") Therefore, to retain value the number of shares of stock issued must not change, or if it does there must be a legal mechanism for equitably adjusting value. Likewise, the future value of a share of stock is affected by the organization's retained earnings and dividend payouts. How the board of directors allocates profits also has an effect.

CONTROL AND DECISION MAKING. To avoid deadlock, the ownership shares of corporations, LLCs, and LLPs with two owners should never be evenly split; there should always be a majority and a minority owner. When there are three or more owners, decisions are determined according to the wishes of the majority. (What constitutes a majority depends on the issue involved as well as state law.)

Having majority ownership or the agreement of a majority of owners does not, however, automatically bestow unchecked control. Minority owners often have specific rights determined by the state in which the corporation, LLC, or LLP is registered. Because the laws of every state differ, it is difficult to generalize. By and large, however, they provide a way to address mismanagement and shareowner dissatisfaction.

To give an example of how this could affect you, let's say you own 60 percent of a corporation and you have four employees who each own 10 percent. Three of the four become disgruntled over reduced profitability and the fact that because of it they have received no raises for over a year.

They bring suit as shareowners to force the company to reduce the pay of the president (that's you) and redistribute the savings to shareowners (that's them) in the form of dividends. (There are ways to minimize the potential loss of control—usually by establishing a separate class of non-voting shares—but they involve some legal footwork.)

The point is, control of an organization and its decision making can be compromised whenever there are multiple owners. The more owners and the larger their combined shares, the greater the potential for compromise. Morals: the fewer owners, the better; the more shares held by one party, the better; know what specific rights shareowners are entitled to under the laws of the state in which the corporation, LLC, or LLP is registered.

LEGAL PROTECTIONS. Division of ownership should be in writing, except when there is tangible evidence, such as stock certificates. In most cases this will require nothing more than a simple agreement signed by all parties. It is also crucial that the new owner sign a noncompete agreement prohibiting him or her from any business contact with the firm's clients for at least six months after departure. In addition, be sure to have an agreement providing a right of first refusal to other owners—i.e., in the event of departure, disability, death, or divorce, shares would have to be offered first to other owners at a price determined by a valuation formula. And "key individual insurance," policies paid for and payable to the company, should be provided for any owners who possess more than token shares. This will provide the company with the funds necessary to buy back the shares of a deceased or disabled owner. (See chapter 3 for more on insurance.) It is also prudent to set money aside to fund buying back the shares of departing or divorcing owners. (In the latter case, this avoids the diffusion of ownership.)

❧ The Need for Business Planning ❧

There's an old cliché that "the business that fails to plan, plans to fail." Of course, if that were strictly true very few design businesses would remain in business. For, the truth is, most don't do any planning. They just go along, month after month, more or less wherever fate takes them. Does this mean that the business of design is fundamentally different, that designers can safely forgo conventional business wisdom and practice? Hardly. They just suffer the consequences more—fail more often, and are less prosperous than they should be.

DEFYING REALITY. There are, of course, many factors that contribute to the inefficiency or ultimate failure of a design business, and not all of them are predictable or preventable. But certainly one factor that's both is lack of

planning. Planning doesn't guarantee success, but it surely lays the groundwork for it. Conversely, lack of planning doesn't guarantee being blindsided, but it surely contributes. To be successful in the design business, you have to want to *succeed in business,* not just do design that you get paid for.

As right-brained people, we often tend to think of the more analytical aspects of business, such as planning, as being left-brained, nonstimulating activities. Yet in truth, mapping our future and then working to make it happen can be among the more stimulating and creative aspects of working for ourselves. The better your business is run, the more satisfying the assignments will be, the less you'll have to work, and the more money you'll make. There is a direct correlation between how well a design business is run, and the creative satisfaction of its principals.

One of the significant advantages of a design business, as opposed to nearly any other type of small business, is that little planning is actually required. To avoid failure, most other businesses require their proprietors to master such arcane disciplines as finance, purchasing, manufacturing, and inventory turnover. Designers require very little of this, perhaps another reason why so few prepare plans: what is so simple often ends up simply ignored. Yet, when you consider just how little time is actually involved in planning and how easy it can be, there's little reason not to do it.

THE REASONS WHY. Developing a business plan ensures that the planning process is taken seriously, and it increases its overall effectiveness. It puts a much sharper focus on business efficiency and productivity, provides convincing detail for influential outsiders, and offers a much better means of regularly measuring progress over the months and years to come.

It can set long-term strategy. The most successful businesses, especially in a dynamic market like design, are those that are proactive and attempt to shape their markets, rather than reactive, allowing their markets to shape them. When the principals of an organization know where it is headed, the motivation and means to get there become easier to come by. As has often been said, "If you can describe it, you're already halfway to achieving it." A well-developed business plan sets down a blueprint and rationale for future decisions. And by establishing a clear direction, it also reduces the chances of wasting time chasing the wrong opportunities.

It can make daily operations more efficient. The second most important benefit of a business plan is its potential to affect day-to-day activities. Knowledge of the organization's long-term goals encourages job-to-job continuity, reduces the potential for arbitrary decision making, and enhances employee morale. In other words, a good business plan can provide a reference and rationale upon which both principals and employees can base difficult daily decisions. ("Is accepting this job at this price in our best interest, or not?")

It can develop critical analytical skills. The very process of detailed planning forces one to think analytically, not emotionally, about the future. It helps creative individuals develop the critical, left-brained analytical business skills needed to complement their right-brained talent skills.

It can document company potential. To outsiders evaluating a company's potential—bankers, possible partners, etc.—having a solid, realistic business plan is second in importance only to the company's tax returns and ledger sheets. The larger your business, the more important the outsider you are courting, the more important the plan becomes.

It can demonstrate progress. If the plan is regularly referred to and updated at least yearly, it will not only play a major role in helping your company dodge the errors and miscalculations that torpedo many small creative businesses, it will also show how effective you are at doing so. A good business plan is a living document, constantly modified and updated. A library of past business plans is a history of learning and progress.

FORMALIZING THE PROCESS. Whether we define it as such or not, most of us already do extensive planning. For example, it may happen in the shower when we're thinking about how to get better clients. It may happen while stuck in traffic and we're considering how to allocate work flow among employees. It may happen when we are paying bills and must decide which vendors to pay now, and which to put off until cash flow improves.

These are all valid forms of planning. They are typical of the mental activity everyone in every business has to constantly engage in. For, as much as we might like it to be otherwise, no business is ever static. Business constantly changes, and this requires us to constantly consider how we will cope with change. But while we are all occasionally engaged in planning, very few of us do it on a regular, formal basis—i.e., being organized and disciplined in our considerations, then committing them to paper. Without discipline, organization, and documentation, no plan is ever more than just an idea.

Rule Number One. There should be a planning process, time and effort devoted at least once a year to thinking about the future. This rule applies to all design shops regardless of size or location. The only difference between planning in large versus small operations is the extent of the effort and its formality.

Rule Number Two. A plan is only as good as what it says on paper. A plan must be written down in some detail to be effective. The discipline of writing assures that you will take the process and result seriously. In addition, it gives you benchmarks against which to constantly measure progress and refine your ideas as time passes. A mistake too often made by design firms is

that they only do a written business plan when it is required by the circumstances of asking for a loan or talking to a potential partner. Not only does this type of preparation pressure result in inefficiency and hasty planning, but the plan also does not benefit from a history of refinement.

GENERAL CONSIDERATIONS. The most important component of a business plan is the quality of thought that goes into it. Its effectiveness lies in how well it is able to match the particular attributes of a company to its potential markets and customers. Good plans are not something quickly cobbled together. They are the result of serious thought focused around getting facts, setting goals, and preparing strategies. This process does not have to take a long time, but it should be thorough. If you can't find uninterrupted thinking time in your workplace, devote some time to it offsite. Ask your key employees to join you in a brainstorming session.

Start with the facts. Jot down everything important you can think of about your business, present and future. For example: Where do most assignments come from? Who are your competitors, and what are their strengths and weaknesses? What is the realistic potential compared to present activity? Is the business acceptably profitable? What problems and opportunities can you predict for the future?

Identify goals. Now consider practical options and alternatives for growth and greater prosperity. As tentative goals for next year, write down up to ten business changes/options with the greatest potential. Try to think in specific, quantifiable terms. For example: Expand the business base from five to seven dependable clients. Reduce the work from a specific type of client or industry from 65 to 55 percent of revenue. Increase the number of a certain type of assignment from ten to twelve yearly. Grow profit by $10,000.

Rough-out strategies. Now take the goals you have set down and write thoughts next to them on what it would take to make them come true. Weed out those that are obviously not feasible, settling on six or fewer that have a good chance of success. (Don't try to accomplish more than six; doing so will dilute your efforts.) For example: To expand the business base, plan to make a presentation to at least one potentially new client each week. To reduce dependence on one type of client or industry, plan to do six promotional mailings showcasing your broader capabilities. To increase a specific type of business, plan to seek out competitors' dissatisfied clients. To grow profit by $15,000, plan to increase hourly labor rate by $20.

Specific considerations. Now modify the above general considerations with those things that define your firm's talent, style, experience, and client service—your firm's strengths. Example: In which type of work is your portfolio strongest? What underutilized talents do your employees possess? Where does your unique combination of talent, skill, and experience

best fit? If you find your uniqueness best fits your current mix of clients, planning should probably concentrate on getting more of the same type of assignments. If not, it should probably concentrate on exploring new clients and areas of business.

❧ Developing the Business Plan ❧

Assuming that some informal thought or planning has already taken place, it should be possible to prepare a well-documented, formal business plan in less than a dozen or so hours. If spread out—say, four hours a week for three weeks—chances are this time will never be missed. And once prepared, a business plan with a good structure can be revised and updated in even fewer hours.

In developing your plan it is best to follow the standard business plan format—an 8 1/2 x 11" spiral-bound booklet. Any other format, and probably any creativity in the plan's design and presentation, will most likely make it more difficult for a noncreative person (think banker) to comprehend. This is a place to rest your creativity, not exercise it.

When writing the plan always do so as though you were addressing an outside audience. This is important even when you have no immediate plans to show it to others. It will force you to think carefully about options, including information you might otherwise take for granted, and compel you to be more objective.

Because the markets and opportunities for every design business are different, no two business plans are ever exactly alike. Nonetheless, there is a consensus about which bases should be covered, and what is the best structure for doing so. The best plans usually consist of three sections: a one-to-two-page up-front summary and table of contents; a multi-page description of the business and its structure; and a short description of finances. Each major section is separated by a titled divider sheet (it is not usually appropriate to use tabbed separators). Style should be businesslike and tasteful, as well as somewhat formal.

SECTION I: SUMMARY AND STATEMENT OF PURPOSE. This is the first text page of the plan, immediately following the coversheet. The summary statement should be a concise two-to-three-paragraph overview of the company (often referred to as the "mission statement"), as well as the plan's purpose. The table of contents immediately follows. Nothing else is necessary. (For a sample mission statement, see chapter 9.)

SECTION II: BUSINESS AND STRUCTURE. This section of the plan should detail the business's organization, services, and markets. Think of it as a complete description of how the company is structured, what it does at

present, what it is capable of doing, and what the markets for its present and future services are. Another way to view this section is as the supporting and credibility-enhancing detail needed to back up the summary statement in section I.

The challenge, especially for one not used to writing, is to be complete, but also concise and to make the plan easy to read. Topics should be specific enough that they can be described in a single page or less. Occasionally, two pages are required, almost never more than two pages per subject. In addition, remember that you should write in a style that makes your company understandable to an outside audience that often has little or no knowledge of the design business. So don't be in a hurry. Outline the important points to be covered. Then write. And rewrite. The following ten topics should be covered:

1. *The business*—What your business consists of. Most outside readers won't know, and will form the wrong impressions unless you're specific.

2. *The principals*—Who they are, what their creative and management experience is, and what relevance it has to the potential success of this type of business in meeting its objectives.

3. *The organization, staff, and facilities*—What type of company (sole proprietorship, partnership, corporation, LLC, or LLP); how many employees, how they are structured, what their strengths are, and what type of productivity is achieved; what major physical resources the company has (computer systems, office facilities) and whether they are owned or leased.

4. *The services provided*—The more specific, the better. Include types of work (strategizing, developing concepts, print preparation, production supervision); types of assignments (Web sites, brochures, annual reports, packaging). Also name several typical clients and indicate job dollar ranges.

5. *The market*—The need, as you can best estimate it, for the types of services you provide within your market area (typically within a fifty-mile radius from your studio).

6. *The sales activity*—How you market your services: who does it, where you get leads, and what kind of success you have. If you know, be sure to include the cost of sales as a percentage of income.

7. *The competition*—How many other firms provide the same or similar services and their size and competitiveness. Be sure to indicate what competitive advantages you offer.

8. *The opportunity*—Why a combination of talent, organizational, and market factors points to a bright future for your organization.

9. *The yearly goals*—Your strategy for business improvement based upon an analysis of your strengths, the market, and your competition. This section should be detailed enough to provide an effective road map to follow for at least the next year. (When the plan is shown outside the company, this section can be condensed to provide only a summary of planned activities.)

10. *The projection*—How much bigger your business should be, and where the business will be in one and five years. Estimate as accurately as possible, but don't worry about how accurate your projection will be. Accuracy is not as important as the discipline of calculating and projecting.

SECTION III: FINANCES. This section is of crucial importance to company principals and to bankers, outside investors, and potential partners. It is separated from the rest of the plan to make financial data easily accessible and understandable, and omitted from plans circulated to those without a direct interest, such as employees. Depending upon the company's financial condition and purpose of the plan, two topics may be covered:

Financial need. A separate need page is included if the purpose of the plan is to encourage investment or apply for a loan or funding. State why the money is desired, for what specific purposes it will be used, and when it will be needed. If the purpose of the plan is to supplement a loan application, also indicate for how long the loan will be needed and what resources (business expansion, etc.) will allow it to be paid back. If the plan is to encourage investment, indicate what type of return (ROI) an investor can expect. (For more on how to figure return on investment, see chapter 15.)

Financial condition. Include spreadsheets for several different scenarios. Also have your accountant prepare a "statement of financial condition" for inclusion. Include last year's personal tax returns if you operate as a sole proprietor or in a partnership, and corporate tax returns if your company is incorporated.

ENSURING A PLAN'S EFFECTIVENESS. Once completed, keep your business plan where it can be referred to easily and often. Having it reside only in an obscure electronic file, or filed away at the back of a drawer, isn't enough. To be effective, a business plan must be easily accessible. Out of sight is out of effectiveness.

Refer to the plan at least once a quarter. Evaluate how well you are doing, and what changes need to be made if you are to meet your goals. Only stick with the original when it is still advisable. Otherwise, change, expand, or contract it appropriately. The best plans are those that are active documents, constantly modified. The time you spend revising it will

almost certainly be among the most productive you spend. Don't make the mistake of being too busy to regularly attend to business planning details. Otherwise, eventually there won't be any business details to look after.

After the first year, preparing each subsequent year's plan should be a simple matter of reviewing the one from the preceding year, including all its changes. Update it with new goals as appropriate. The ideal time to do this is at the year's end, when you can test your previous year's projections against the outcome.

Don't be concerned or discouraged if you fall far short of your objectives. The benefit of planning is in the process, not the accuracy of the results. You are far better off planning to reach the stars and only getting half way, than never planning at all. Finally, as you update and revise your plan from year to year, learning as you go along, you'll find that the planning process gets easier and more sophisticated. No doubt you will come to view it as an indispensable, creative, and pleasant procedure.

A sample business plan is in appendix IV. Several software programs are also available that can help make business planning easier. Keep in mind, though, that despite being excellent outliners and providing easy formatting, no program can substitute personal, customized preparation and styling. This process is, and will remain for the foreseeable future, the norm for most firms, especially larger ones.

CHAPTER 2 Structure and Facilities

IFFERENT CUSTOMERS, products, and processes require different business models and facilities. In addition, the design business is totally dependent on talent, so organizational structure and management style have great impact on employee initiative and productivity. What is the best organizational model? How much and what kind of office space is appropriate? What do you need to know when negotiating a lease? What are the advantages and disadvantages of buying your own building or office condominium, versus being a tenant?

⸙ The Benefits of Structure ⸙

Like all service organizations, design businesses are little more than a collection of people. Assets come in the door in the morning and go out the door in the evening. The significance of this is that personnel organization and management style become crucial to success. There is little else that can be modified—few facilities to improve, no manufacturing to run more efficiently, no distribution to change. Any betterment must happen at the organizational and management levels.

THE ORGANIZATIONAL PHOBIA. Despite the obvious, it is still a common belief among principals of design firms that less organization is better. Even when the need for it is acknowledged, it is often viewed as a compromise—a business necessity they worry will have a negative effect on their shops' creative products. Principals suffer from the fear that too

much structure will reduce the freedom that is a fundamental component of every creative's persona. Yet, the truth is, not only are organization and structure necessary for the business side of design, but they actually improve the product side as well. They do not reduce the freedom that defines our personalities, and that we so cherish.

THE STYLE DILEMMA. Most design principals want their firms to be collegial in style, and consider their employees as family. Many of them also have nonconfrontational personalities. And, of course, few have management training. It's a problematic mix.

What's best for business is not always in the best interests of individual employees. Principals must feel free to make tough decisions without undue concern about confrontation or employee feelings. This is difficult when the decisions involve friends. The best management style is to keep employee relations on a less than familial basis. Be informal, open, and friendly. Take a genuine interest in their lives and welfare. But stop short of personal relationships. It is possible to be nice, maintain a happy operation, and run a business efficiently. But doing so requires keeping an emotional distance from employees and their personal lives.

THE NEED FOR PREDICTABILITY. Consistent processes and results are key to business success. At the same time, lack of predictability is the essence of creativity. How to reconcile these? Or is it even possible when every project, every client, is different? Actually, this is not the dichotomy it seems to be. While the creative process itself can't be structured, the procedures that make it possible can and should be. This is because creativity is enhanced by a predictable working environment. The more organized and stable things are, the less individuals become distracted, the freer they are to concentrate, and the more their creativity will flourish. Creativity thrives within structure; it withers in chaos.

Despite common perceptions to the contrary, Creative Business surveys have consistently shown that most employees in most shops would be happier with more, not less, structure. The more predictable their working environment, the happier they become. Conversely, unpredictability—lack of procedures, confusion, and dealing with the unexpected—is high on the list of employee gripes. Principals' well-meaning attempts to keep policies and procedures to a minimum usually backfire. Most err on the side of too few, not too many.

Predictability is also essential from a productivity standpoint. Efficiency is enhanced when individuals have no doubts about a course of action, and when routine functions are handled in a routine manner. The alternative is redundancy, wasted time, and reduced profitability.

To make the case for predictability is not to argue for complexity and regimentation. An organizational model for design firms should be simple

enough to provide all the benefits of predictability, but not so complex as to be rigid or inflexible.

THE NEED FOR SCALABILITY. By most standards design organizations are volatile businesses. That is, activity is prone to rapid expansion or contraction, depending on client needs. Change always affects work flow, efficiency, and profitability, and sometimes it even necessitates hiring or laying off employees. Inherent volatility means that creative organizations must be able to accommodate business fluctuations without affecting efficiency. That is, they must work as well at one activity level, or one size, as another. The way to ensure this is to disburse as many tasks and functions throughout the organization as is practical. Doing this reduces the chances of problems—details missed or bottlenecks—when change occurs.

The less concentrated the decision making, the more flexible the organization, and the less chance it will breakdown under the pressures of change. Principals often delegate too little and not far enough down in their organizations. Sometimes this is out of a fear of consequences, sometimes it is because they are reluctant to share control. Whatever the reasons are, the benefits of greater delegation usually far outweigh any of the potential risks of doing so.

LAYING THE FOUNDATION. Just as types of businesses develop their own procedures, individual businesses develop their own cultures. In larger ones it is formed by a combination of history and management practices. In small ones it evolves mostly out of the idiosyncrasies of the principal(s). In short, your personal style becomes the style of your organization (in small firms), or heavily influences it (in medium-sized ones). This is important when considering organization and management issues because major changes can be disruptive. You have to be careful not to define your organization in a way that doesn't fit your personal preferences and skills. The appeal of each of the three operating models described and illustrated below—chain-of-command, coaching, and associate—largely depends on the size of the business, the personality of the principal(s), and the workplace culture.

The Chain-of-Command Business Model

A top-down, hierarchical model would most likely come to mind if we were asked to visualize an organizational structure. It is the familiar, traditional approach. Organization charts look like pyramids; it is the default of organizational structuring. Consciously or not, and for better or for worse, it is the way most of us run our businesses: we (the boss) make decisions; others (employees) carry them out.

WHERE IT WORKS. The larger the organization and the more specialized the functions of the employees, the better a chain-of-command organization works. And vice versa. The perfect example is a manufacturer's assembly line where each employee carries out one prescribed operation. This model can also be appropriate in larger design businesses where employees handle single-project functions—for instance, designers, copywriters, and art directors working within a creative department or an account structure.

Even in these situations, however, chain-of-command models need to reflect the times. In today's complex, information-driven economy employees also need to be encouraged to contribute outside their specific job function. Doing so—empowering employees—increases enthusiasm and morale, and provides a new source of ideas. For these reasons, many large design firms today operate with a modified model. They organize the business into many units, within each of which the structure is relatively flat. This allows for greater teamwork, while still preserving the business's overall chain-of-command.

WHERE IT DOESN'T WORK. Despite its widespread use, the chain-of-command model is seldom suitable for small- to medium-sized design organizations. It is too rigid and doesn't work well when employees handle entire projects. It is particularly ineffective when combined with informal, laissez-faire management. Combined, they produce the worst of both worlds—a minimum potential for employee initiative, maximum potential for confusion. It is a square-peg management style within a round-hole organization.

Where there are multiple owners, the situation can be even worse unless there are clear-cut and well-understood divisions of responsibility. Generally, the broader the functions of employees and the more subjec-

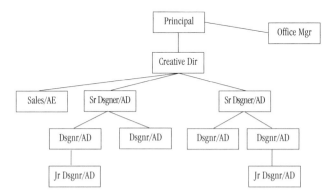

This is the traditional, chain-of-command organization structure. Advantage: It is what we are used to. Disadvantage: Often too rigid for maximum creativity and efficiency.

tively their work is evaluated, the more inefficient the chain-of-command model is. This is especially true in small creative organizations where employee teamwork is crucial. Such firms typically require maximum employee empowerment, top to bottom.

The Coaching Business Model

This model, also traditional, is a stylistic variation on the chain-of-command approach. It evolved out of organizations seeking efficient ways to work with independent-minded, creative employees—inventors, teachers, researchers, designers, and planners. The coaching model recognizes that true creativity can only be encouraged and directed; it can not be specified, ordered, or demanded. So, how do design firm principals encourage and direct their employees most efficiently? The answer lies in a sports analogy: the coach and the team.

In this model the coach (principal or supervisor) has overall responsibility for winning; the team (employees) has specific performance responsibility. There is no question about authority and who gets to set direction and strategy. But there is also recognition that the coach stays mostly on the sidelines and team members make most on-the-spot decisions. In the design business this model works best when there are no more than ten "players" (employees) to each "coach" (supervisor).

THE ROLE OF COACH. The role of the coach is to organize, strategize, direct, motivate, and mentor in whatever ways produce winning results. This usually requires: having experiences and talents similar to those of the team members; recognition that the talents of team members are often greater than those he or she possesses; and maintaining the respect of the team, because without it their performance will lag. Good coaching also requires: a willingness to delegate, to share knowledge and experience, and to make unpopular decisions. In short, the role of coach is to lead by inspiration, example, and respect, not to direct because of authority or rank.

PICKING THE TEAM. Good coaches pick team members exclusively on how much strength and depth they add to the team. They don't hire those who duplicate existing talents and experiences, or just because they favor them or their style. This is particularly important for design businesses because variety in experience, talent, and style is crucial in both problem-solving and attracting a mix of clients. Principals who suppress diversity by hiring employees whose styles and backgrounds closely match their own unknowingly strangle their businesses. The more diverse the employees, the greater the opportunity to take a greater variety of client challenges, and the less likely the firm will be adversely affected by fads and trends.

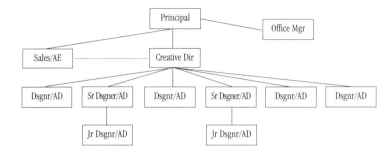

The coaching structure puts emphasis on individual initiative. Advantage: More similar to the way creatives work. Disadvantage: Requires a nontraditional style of management.

WORKING WITH THE TEAM. Teamwork requires that every team member be informed of, and perhaps participate in, most project (or account) stages—sales, strategy, budget, scheduling, etc. The greater their involvement, the more employees will feel a part of a team. The higher their satisfaction, the better the quality of their work, and the happier the client. Implementing a team environment may be as simple as providing more detail in staff meetings. Or it may call for employee participation in new functions and activities. Or it may require greater delegation. However implemented, the goal is the same: to get employees more interested in the big picture. It is to counteract the tendency among designers to focus on creative tasks to the exclusion of others; it is to shift focus in a way that keeps projects on track and employees' feet firmly planted in reality.

FULFILLING THE PROMISE. Creative Business recommends most principals of small to medium-sized firms (up to twenty-five employees) follow the coaching model when running their businesses. It combines the familiarity of traditional structuring with the flexibility required to stimulate creatively talented employees. The distinction between the coaching and chain-of-command models is mostly a matter of style. Policies, standards, job descriptions, and employee evaluations needn't change. But principals' attitudes, actions, and behavior should.

❧ The Associate Business Model ❧

The associate model for organizing and running a design business goes beyond style. It involves both a different way of thinking about the business and a radical restructuring of its operations. In some ways it is a modern version of the guilds that were the first commercial creative establishments.

THE BACKGROUND. The traditional employer/employee system assumes different levels of ability (management and labor), value added through experience, and more or less predictable market demand. It is a system designed around traditional product manufacturing and sales environments. In contrast, design businesses comprise individuals with more or less comparable skills whose talents do not become appreciably more valuable with experience. In addition, in traditional project-based markets such as design there is also highly fluctuating demand. For these reasons, a traditional management/labor structure, in which you reward employees based on seniority and pay them the same in times of high or low activity, may not be appropriate. Even more of a concern is having to pay employees a regular salary when they are not busy, and pay them overtime or farm work out to freelancers in times of extreme activity.

A possible solution is to adopt a system in keeping with that used by other professional service organizations, such as consultants, lawyers, and accountants. It is the associate model, and it is based on employee profit-sharing. For principals, it avoids many issues that accompany having employees. For employees, it is a way to enjoy many of the benefits of self-employment without some of its risks.

THE BASICS. In the associate model some senior employees are given the chance to become associates of the firm and work not for a salary but for a percentage (commission) on each project they are given responsibility for. In effect, they become project managers with a financial stake in individual projects. To clients, this arrangement is transparent: they deal with the firm no differently than they would deal with any other.

The associate model is based on three components: 1) the firm, which is the owner and his or her facilities; 2) the sales associates, who find new clients, handle account service and oversee all jobs (they may also be principals in firms without professional sales help); and 3) the creative associ-

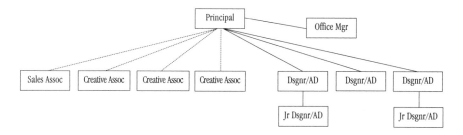

The associate structure provides project profit-sharing for key employees. Advantage: Greater employee initiative and less turnover. Disadvantage: Less short-term profit.

ates, employees who are assigned responsibility for a project, including getting it done on time, on budget, and to the firm's quality and client's specifications. The firm's legal structure (e.g., corporation) is not affected. The owner has full management responsibility, including hiring, firing, and quality control. Associate employees are partners in individual projects, but not in the firm. For tax and benefit purposes, they are treated no differently than other employees.

INCOME DISTRIBUTION. Billable income for each project handled by associate employees is divided three ways. Fifteen percent goes to the sales associate. This is "salary." The sales associate also gets the same percentage on any markup of outside services. Forty-five percent goes to the creative associate. This is "salary." The creative associate also gets the same percentage on any markup of outside services. Forty percent goes to the firm to cover overhead and profit. The firm also gets the same percentage on any markup of outside services. These percentages are recommended as starting points based on the need to attract and hold good individuals, and provide a fair return on a firm's investment in facilities and support. They can be modified as appropriate.

OBTAINING AND ESTIMATING PROJECTS. Working from an associate model requires a strong commitment to ongoing sales and marketing. Creative associates depend on sales associates (or a principal) to provide a steady stream of work, which is distributed according to talent and busyness. Because both the sales and creative associates have a stake in completing each project profitably, pricing and deciding what will or will not be provided is a joint exercise. A proposal is written and a commitment is made to the client only when both agree.

THE ATTRACTIONS TO EMPLOYEES. For designers, the associate model combines the major benefits of self-employment—freedom and opportunity—without all the downsides of establishing their own businesses. For salespeople, it removes the earning cap.

Money. Employees have the potential of earning what they are worth, despite seniority or experience. Those who are ambitious and talented can earn more than they would in any other employment system, possibly more than they would in their own businesses.

Association. Size, reputation, and experience are important in the eyes of many clients, and the associate structure is transparent to them. An employee working as an independent associate within a well-known firm can work on projects that might be impossible to land as a freelancer.

Facilities. Office, computer, software, etc. are all provided, just as they would be for any regular employee, so there's never a concern about keeping up with technology or paying the rent.

Support. Having full-time sales representation eliminates the biggest headache of freelancing—the constant need to find new clients and projects. It becomes possible to concentrate on creating, not having to worry about where the work will come from. Likewise, clerical support eliminates paperwork concerns.

Lifestyle. Because compensation is directly tied to their output, associates are largely free to make their own working arrangements. This freedom within a structure is a particularly strong attraction for working parents and anyone seeking independence without the isolation of working alone.

THE ATTRACTIONS TO THE FIRM. The associate model eliminates many financial and management concerns that accompany design firm growth.

Less cash flow worry. Associate employees are paid their percentage of a project's billings only after the client pays. Therefore, the only regular payroll expenses are draws against future commissions and support staff and employees not working as associates. The cash-flow crunch that plagues many firms with a hefty professional payroll is minimized. The need to carry a substantial bank balance or line of credit is also reduced.

Less management worry. Associates are self-managed. They require no supervision, performance reviews, raises, or bonus calculations. They also assume management responsibility for each project they work on. Everyday management is required only for support staff and employees not working as associates. Thus, it frees up principals to devote more time to significant management and strategic issues.

Reduced turnover. Associates are not only well rewarded, but they play the major role in deciding what work to take, how to approach it creatively, and how much to charge. This participation eliminates nearly all the reasons to move to another firm (few pay better, or offer more stimulation), as well as most of the reasons for considering going out on their own (many more risks with only marginally more opportunity).

Accumulation of equity. A design firm's cash value (owner's equity) is largely dependent on how little of its activity would be lost with new owners. The more intimately involved the principal is in the business, the less value it has. Even in small firms, the principal(s) of those using an associate model need not be involved with every project or client. So it is less likely that many clients or projects will be lost with a change of ownership.

THE DOWNSIDE. The associate model does not offer the immediate profit potential of the chain-of-command or coaching models. This is not the model for a principal who wishes to maximize profit, especially in the short-term. Indeed, it is possible that in some years principals may actually make less money than some of their associate employees. Nonetheless, annual net margins up to 10 percent of sales are possible from the firm's

business activities. Moreover, if the principals also work on some projects as associates (sales or creative) they can supplement what they take out of the firm in profit with their project commissions.

THE SUMMARY. The associate model is not focused exclusively on business profitability. Rather, it is a balanced business model that combines the opportunity to combine reasonable short-term profits, a more collegial working environment, lower-stress management, and the potential for equity build up.

❧ Facilities Requirements and Budgeting ❧

More than most other types of employees, designers can't be happy and productive shoe-horned into a corner, or rattling around in a barnlike auditorium. Designers are also much more sensitive than other types of employees to their environment. So, what's appropriate?

HOW MUCH TO HAVE. This is affected by employee's personal preferences; the type of work the firm does (e. g., packaging design requires more space than Web design); layout (open space or individual cubicles?); rank (senior individuals often expect more space); wiring (where networked equipment must be located); and building amenities (location of natural light, etc.).

It helps to think about space for a design firm with what is often referred to as the "3 Cs formula" of space planning. First, work space must always be *cozy*, providing a feeling of home-away-from-home for employees. Second, it must be *creative* in the sense of offering a stimulating environment. And third, the space must be *comfortable* in a way that enhances productivity. Consideration of volume comes only after these three factors.

Keeping the 3 Cs formula in mind, the minimum two-person office (not shared with another firm) is usually about 250 square feet; the best size is around 400 square feet; maximum size is about 600 square feet. Predicting space requirements for larger firms is more difficult. For example, as support staff and equipment (printers, copiers, etc.) are added, layout and placement become crucial. If the space is undivided, less is required per individual, but it must be more carefully configured or productivity suffers. And the need for common areas always grows geometrically with staff. As a rule, our experience is that three-to-five person shops require from 600 to 1,250 square feet; six-to-ten person shops 1,200 to 2,500 square feet. A good starting point for larger firms is to multiply the number of employees by 200 to 250, depending on office rental pricing, the space configuration of a specific location, and future plans.

As for facilities, there should be one up-to-date computer workstation per employee, networked and with Internet connection. Peripherals vary

according to the firm's type of work. Firms smaller than a dozen employees usually average about one telephone line per employee, although not personally assigned (some are for talk, some for data transmittal). Firms of one to two dozen employees average about one telephone line for every 1 1/2 employees (again, a combination of voice and data lines); firms larger than two dozen employees somewhat fewer.

HOW MUCH TO SPEND. The urge to spend lavishly on trendy, highly designed, and impressive facilities is common among design firm principals. The urge is also encouraged by employees who, quite naturally, want to come to a "cool" place to work. Yet spending too much raises rent to an unsustainable level, and the attendant furnishing costs are a significant drain on capital.

If you are one who is tempted by a desire for stylishly distinctive and expensive facilities, it is wise to first consider that the location and decoration of your firm's office is likely to be more important to you and your employees than to most clients. Moreover, the monthly "nut"—the fixed cost of rent, utilities, and upkeep—is a constant, while income isn't. Suppressing the urge and pressure to design something worthy of *Architectural Digest* magazine can be a battle, but it is one that's much too important to lose. Better to make money in a barn than to lose it in a palace.

Creative Business recommends that design businesses spend approximately six percent of predictable Agency Gross Income (AGI) on facility costs. (Agency Gross Income is income that "sticks," or is not passed through, and is primarily composed of fees, commissions, and markups.) Facility costs consist of a combination of space (rent/mortgage/taxes), utilities (heat and electricity), and upkeep (cleaning). In smaller cities it should be less; slightly more in larger cities with more expensive rentals. Spending more may be a way to satisfy your sense of style or scratch an interior design itch, but it can seldom be justified by a corresponding increase in profitability. (A possible exception are firms doing a significant amount of advertising or PR work. These type of agencies, which are often expected by clients to be in first-class buildings in central business districts, typically spend a couple percentage points more than design firms in any given market.)

When considering a move to newer or larger quarters, not only keep the recommended percentage in mind, but stay away from any space that won't allow you to recoup relocation expenses within a year, either through new business or greater efficiency. The additional cost of yearly rent must be covered by at least an equal increase in yearly billing. Indeed, some firms believe that a two-to-one payback is more appropriate. When figuring payback, be careful to include all the expected one-time and ongoing costs of the move—redecorating, new furniture and equipment, utility relocation and fees, moving expenses, changes in parking and commuting costs, additional insurance, and changes in cleaning and mainte-

nance services. If your payback ratio is lower, the move can only be considered as a speculative investment in the future. As with any investment, time will determine whether it was good or not, but try to protect yourself by taking a short-term lease, constantly monitoring your income, and being prepared to move back to less costly quarters.

Even if your pre-move analysis shows that the new location you have selected is appropriate, don't forget that it is based on a projection of future activity, and business volume can drop as easily as it can increase. In other words, be conservative. Don't base your move to new, expensive quarters on a highly speculative projection of future income; it is risky enough to base a move upon what appears to be steady business. Economic downturns have produced thousands of studios and agencies that went belly up by overextending their fixed costs based on overly optimistic revenue projections.

⚜ Lease Negotiation ⚜

Negotiating a lease is a somewhat arcane activity, comfortable mostly to those who do it every day, like a landlord who sits on the other side of the negotiating table. Typical commercial leases run from three to ten years, although shorter terms can sometimes be negotiated. Obviously, the longer the term, the lower the price, the greater the inflation protection, and the more stable your address. The price for all these benefits is financial commitment and some cash-flow risk. And speaking of risk, don't take lease obligations lightly. A lease is a legally binding contract usually backed up by more lawyers than you can afford to fight.

Follow two basic rules when negotiating any lease. The first, which you're probably already aware of, is that everything is negotiable. In practice this means that prices or terms, no matter how "firm," are always open for discussion. Every landlord must balance the financial drain of vacant space against the speed and ease with which the property can be rented. Most will readily give up something for an immediate commitment.

The second rule is to never take anything for granted, especially if you've driven a hard bargain, or come to a quick agreement. A lease is the most significant legal contract most businesses sign. Not understanding all the terms or accepting ambiguous language can be costly mistakes that can haunt you for months or even years to come.

COMPARE ALL THE COSTS. To make a valid comparison between commercial properties, make sure it's really an "apples to apples" evaluation. Although things can get complicated with big-space, long-term leases, for most design firms there are only a few things that are truly significant.

How much room are you getting for your money? Start with the rent, usually expressed as the annual cost of a square foot of space (e.g., $25 a square foot means $25,000 a year for 1,000 square feet). Now take the space layout (floor plan) and plan working areas, furniture and equipment fit, and work-flow patterns to determine how much space is usable. There are at least a couple of inexpensive software programs that can help. Subtract any square footage (odd corners, etc.) that you can't use.

Next, find out how much of the square footage you'll be paying for has been apportioned to public areas—lobbies, bathrooms, and mechanical space. Called the "loss factor" by real estate people, it can be 15 percent or more, depending on the formula used to calculate it. Subtract this figure.

Now that you know how much usable work space you'll get, consider the services provided. Most office properties operate on what is called a "gross lease," an agreement that holds the landlord responsible for all building expenses, including taxes, insurance, maintenance, and repairs. Heating, ventilation, and air conditioning (HVAC) costs are usually included as well. But not always, and sometimes there's a surcharge for usage over a specific level. Even more important to consider is that commercial space seldom has twenty-four-hour, seven-day-a-week HVAC service. So if you occasionally need to work nights and weekends to make deadlines, make sure that such service is possible, and that the lease specifies how much extra you will be billed.

Can the rent go up? Look for what is usually referred to as an "escalation clause." It's a way landlords cover themselves against rising expenses. Some clauses are based on inflation (the Consumer Price Index), others are prorated on increases in taxes, heating, maintenance, and other costs.

Who pays for improvements? This is the area in which landlords are usually most flexible. Which also means it is where lease negotiation is most productive, the land of hard bargaining. Obviously, the longer the lease, the more willing the landlord will be to chip in. If you're thinking about a loft or converted warehouse space, improvements will probably be on you. By definition, older buildings are more costly to renovate, and the landlord seldom has onsite maintenance staff available to do any work.

On the other hand, space in most modern office buildings is relatively easy to reconfigure and redecorate, and there's usually onsite staff available to handle it. Most of these leases come with a renovation or "build-out" allowance. How much varies and is negotiable. Regardless of the age or condition of the building, you should press for the improvements you desire. When doing so, remember that you're much more likely to get the landlord to pick up the tab for something beyond a cosmetic coat of paint if it will enhance the space beyond your tenancy. A wiring upgrade for phone lines or computer networking may be agreed to in a flash. On the

other hand, things you desire to help make a creative statement—unusual partitioning, designer colors, and decorator lighting, to name just three— probably won't be covered. They don't increase the value of the landlord's property. Moreover, they may even have to be removed or changed at some expense when you leave.

This brings up another point: any agreements about major renovations—yours or the landlord's—should be put in writing, preferably with detailed plans and sketches attached. Sometimes referred to as a "workletter," the document should specify who owns the improvements. As illogical as it may sound, everything a tenant (you) attaches—light fixtures, work counters, bookshelves, cabinets, even window air conditioners—is usually considered property of the landlord. So make sure you specify in the lease which of your improvements you'll later be able to take with you and which you won't.

CHECK THE TERMS. Is the space available the way you want it, today? If so, there's probably no problem. But what if there's remodeling to be done, or the current tenant has to move out and there's a delay? Don't take a chance on finding out the hard way. Make sure the lease clearly spells out what happens when the space is not available on the move-in date. This should take the form of a significant financial penalty or a reduction in the rent for several months. Be particularly wary of an arrangement to provide "equivalent space" unless it is contiguous. Otherwise, you'll suffer from double moving costs and dislocation disruption.

Will you be able to renew? Now, not later, is the time to make sure that you'll have first rights to the space when your lease expires. Also, agree on a renewal pricing formula, typically a percentage change that's tied to an inflationary or business cost index. If you don't have this protection, you may have to move at lease end. Even if allowed to stay, chances are you'll end up paying higher rates. While you are negotiating this clause, also check on how and when you must give your intent to renew. In some leases, a tenant must provide notification of intent to stay in writing several months in advance or the lease automatically expires.

Who are your neighbors? Check to see what types of firms are allowed in the building. Zoning laws usually protect against totally incompatible neighbors, but not always. And what about the current occupants of contiguous space. Will their activities bother you, or vice versa? How long does their lease run?

Can you sublet? It is an understatement to say that ours is a volatile business. What if halfway through your lease you have to find a new location because you've run out of room? Worse, what if business takes a downturn and you need to move to less expensive quarters? What about easing the

rent burden by sharing the space with another firm? It could be a problem unless there is a clear definition of what the landlord will and will not allow. The best you will probably be able to negotiate is having the right to sublease to new tenants that meet the same standards as others in the building. Keep in mind that the more freedom you have to sublet, the more your neighbors have as well.

How are you protected? Office buildings usually have one or more insurance policies that cover common areas against liability (e.g., one of your clients being injured in the lobby). In addition, most will insist on their tenants carrying commercial general liability (CGL) insurance to protect them against an accident in your office, or damage to other parts of the building (e.g., starting a fire). Your insurance agent should review the landlord's policies to assess your risk, then provide protection that plugs any gaps. Don't rely on a standard CGL policy alone. Disaster stories abound of businesses that were caught up in conflicting insurance claims after a major fire, flood, or earthquake. (For more on insurance, see chapter 3.) Equally significant, what happens if the landlord goes bankrupt and the mortgage holder forecloses on the property? Your lease may suddenly be declared invalid. Don't take a chance on the goodwill of the new landlord to honor it. You can protect yourself by insisting that the lease contain a standard "recognition" or nondisturbance clause.

⚙ Buying Your Own Space ⚙

If you have the resources, purchasing your own office space, either a whole building or an office condominium, is an option worth looking into. It solves the periodic lease negotiation dilemma, it may be a sound investment, and it may also have tax sheltering implications. Although historically this has been an option mostly exercised by larger design organizations acquiring distinctive, stand-alone buildings, it needn't be any longer. Today, office condominiums of varying sizes, locations, and prices, some organized around common facilities and amenities (similar to the executive-suite concept) are available.

It should go without saying that purchasing any real estate is a long-term investment not to be taken lightly. As many investors have discovered, property prices can fall as well as rise. Further, commercial real estate has a dynamic of its own, related but not tied to other economic indicators, such as housing prices. In addition, it is seldom a wise investment for a firm whose growth hasn't stabilized to make, and seldom a good investment unless a commercial area is undervalued and has definite upscale potential. If your idea is to make a design statement by finding and remod-

eling an older building, remember that doing so may also limit its future value and resale potential. The more unusual the remodeling, the less attractive it will probably be to anyone else. As an investment, any remodeling has to be consistent with what real estate people refer to as the property's "highest economic use."

When it comes to finding a mortgage, most banks want at least 20 percent down for a commercial property investment, and the federal loan guarantees that often make residential properties affordable will probably not be available. Banks also want to see a healthy bank account, a well-prepared business plan, and a history of strong business growth. Finally, it is most likely that you personally, not just your business, will be liable for the note. So everything you own will be put on the line.

If you're willing to take the risk, have the down payment, and can persuade a banker to lend you (personally) the rest, purchasing rather than renting can provide your firm with substantial benefits: a stable address and rent (mortgage payments), elimination of periodic lease-negotiation hassles, and great latitude in selecting location, architecture, and decoration.

Perhaps equally important as a benefit is the potential effect on your personal income. You personally own commercial real estate that you can rent to any company or individual. But rather than looking for a tenant, you lease it to your firm for going market rates, ideally at or near the same amount as your mortgage payments. When you do this, rent payments are fully tax-deductible for your firm, just as if made to another landlord. The rental income you personally receive is taxable, but all expenses—mortgage payments, utilities, maintenance, taxes—are deductible because it is investment property.

If planned right, the immediate result can be a wash—no change in company taxes, and your additional personal income will be offset by additional personal investment expenses. In the process, however, you are actually purchasing the real estate and paying down the mortgage with before-tax company funds. You also get an immediate tax break through depreciating the property, although much of this will probably have to be paid back through capital-gains taxes when you sell.

In the long run, you will personally benefit from any appreciation in the value of the property over the years. Since it is difficult to build transferrable equity in a design business, many principals have discovered that a personal investment in real estate for their firm ultimately becomes a major portion of their future retirement package. (For more on building business equity, see chapter 16.)

3 Outside Support Services

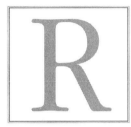

REGARDLESS OF type or size, all businesses require outside support services. They provide expertise that would be unrealistic to acquire full-time, as well as specialized knowledge that can save time and broaden opportunities. Not needing to acquire equipment or staff for occasional needs also saves money. And, of course, designers are legally prohibited from undertaking certain activities themselves anyway.

Outside support falls into two broad categories: the services we need to meet the needs of our clients—copywriters, programmers, photographers, printers, etc.—and those services we need to keep our businesses running smoothly—accountants, bookkeepers, insurance persons, lawyers, bankers, consultants, etc. The latter are not only of vital importance, but services we are not ordinarily trained to interact with, which we call upon only when we have problems. A successful design business requires more. It requires building a relationship with a team of carefully selected outside professionals.

❧ Accounting Services ❧

The greatest similarity between design firms is not their artistic training, stylistic appreciation, or activities. Rather, it is that they are all businesses, and the lifeblood of business is money. Keeping track of your business's money is the job description of an accountant.

Every business needs an outside, objective analyst to help it follow standard financial operating procedures and make important financial decisions. In addition, the tax obligations of the simplest enterprise today are much too complex for even interested and knowledgeable principals to handle themselves. Rules change quickly, often without public notice, and the price for not following them to the letter can be steep.

The best accountant for most design firms is either a self-employed individual or a small, two-to-four person (plus support staff) practice. The accountant should be an individual or part of a firm specializing in small businesses, ideally one with other design, advertising, or PR clients. The more your accountant knows about your type of business, the more valuable the advice and counsel will be. In addition, your accountant should be a CPA (Certified Public Accountant). This is a state-granted designation available only to individuals who have taken a comprehensive series of financial courses and passed a rigorous exam. CPAs are licensed to perform audits and are required to subscribe to a set of high ethical standards. There is no reason for you to accept less than a CPA as your accountant.

Unless you have already established a good relationship, your accountant should not be a moonlighter who works for a large corporation or the "friend of a friend" who works for a prestigious partnership. Such persons may be experts in dealing with the problems of larger businesses, but chances are they have inadequate experience with small business issues. Likewise, it is unlikely that your company requires the specialized services of one of the "big six" accounting firms. Finally, tax-preparation services—e.g., H. & R. Block—are not a substitute for an accountant.

LOOKING FOR AN ACCOUNTANT. A lack of good accounting services can be hazardous to your firm's health. If you are not happy with the service you have been getting, look for someone new. The best way is to ask your creative colleagues. (Accountants can work for competing firms without a conflict of interest.) If you come up dry, call local creative clubs for possible recommendations and look for ads in local creative publications. If you have a relationship with a local bank (see below), ask for several names. As a last resort there is the Yellow Pages.

In addition to an understanding of and interest in your business, when interviewing also look for a personality fit. Don't be negatively influenced by an accountant's lack of style or creativity. Remember, you are looking for someone who is fundamentally different than you, someone who is much more detail- and process-oriented. It is important, however, that you personally like him or her. A good relationship requires personal rapport, someone you can respect and trust, and someone you can talk to on a first-name, peer basis. After all, an accountant knows everything there is to know about one of the most intimate aspects of your life—your money.

It is also crucially important that you understand your accountant's advice and reasoning. Just as you occasionally have to explain to an unsophisticated client why you do what you do, your accountant must be able to give the rationale for his or her recommendations in understandable, jargon-free English. This is important because other than in cases of gross negligence, the government will hold you—not your accountant—responsible for any tax or accounting mistakes. You need someone you can freely question until you are comfortable, as well as someone who is also cognizant of your aspirations, risk tolerances, and financial limitations.

WORKING WITH AN ACCOUNTANT. The more knowledgeable your accountant is about your day-to-day operations, the more specific and helpful his or her advice will be. Expect any getting-up-to-speed process to take six months to a year. If after this time you have made a good effort to communicate and are still constantly baffled by what your accountant does, it is probably time to seek a new one. Before you do so, however, make sure first that the problem is not your own unrealistic expectations.

You should see your accountant at least twice a year—once at tax preparation time and once in midyear for a business review update. (Larger firms may require a meeting monthly, or even more often.) At the business reviews you should go over any changes that might affect taxes and financial planning. In addition, ask what else the accountant sees that could be helpful to your business, and what any trade-offs might be. In doing so, it is important to note that the accountant can't be expected to make strategy decisions for you. In nearly all cases you must provide the information or the germ of an idea; the accountant will point out the feasibility and the financial ramifications. In other words, you have to provide the "what if" scenario.

Your accountant's approach to taxation should not to be so aggressive as to risk repeated audits, or the later disallowance of deductions that will result in the payment of penalty and interest fees. A good accountant is not one who pushes hard, betting you won't get audited. An audit is not only very expensive (at the very least, the cost of the accountant's time to represent you); it may also mark you for special attention in the future. What you should expect, even demand, is an aggressive pursuit of all legal avenues to minimize taxes. You should also expect your accountant to be current on appropriate tax rulings and to give you—not the IRS—the benefit of the doubt in key areas. What you can't expect the accountant to do is advise you on anything illegal or dishonest, such as cheating on your taxes. It is, however, perfectly fair to ask "what if" questions regarding legal risk and penalties.

You should feel free to ask your accountant to assist you in any business or personal financial matter. Here are some of the most common services—

other than tax preparation—performed by accountants for design firms and their principals:

- Recordkeeping—setting up the books and financial procedures
- Retirement planning and funding—for yourself and employees
- Structuring—e.g., changing from an "S" to a "C" corporation
- Tax reduction strategies—ways to legitimately reduce your tax bite
- Negotiating a loan—nothing provides more credibility to a banker than a financial statement prepared by a CPA
- Bookkeeping—finding a competent bookkeeper (see below)
- Professional counsel—when you need a competent insurance person, sympathetic banker, or aggressive lawyer, call for a recommendation
- Valuation—putting a dollar figure on your enterprise
- Succession planning—ways of structuring to make it feasible

BOOKKEEPING AND ACCOUNTING ARE SEPARATE FUNCTIONS. While an accountant must work with a firm's bookkeeper, and many accounting firms offer bookkeeping services, having them also handle bookkeeping is seldom cost-effective. Having an independent bookkeeper also provides an additional source of financial knowledge. And an independent bookkeeper can act as a go-between for you and your accountant, translating "accountant-speak" into English if necessary. (See "Bookkeeping Services" below.)

WHAT ARE REASONABLE COSTS? Accountants working for small businesses typically charge from $100 to $200 per hour. Total fees vary, naturally, depending on how much work is done. A one- to three-person shop should expect to pay from $2,500 to $4,000 yearly; a shop of a dozen employees from $5,000 to $9,000. These fees include tax preparation, planning sessions, and answering a reasonable number of information or "what if" calls. You should also expect your accountant to contact you when tax laws affecting you change, or when new options for deferring income or taxes become available.

❋ Bookkeeping Services ❋

Creative Business recommends that most design firms with a staff of two to five use an outside bookkeeping service. A possible exception is when principals have both the time and inclination to handle the function well. But don't underestimate its importance and the effort and skill required. Bookkeeping firms (often a freelance person) service several as needed. Two-person shops may require one day of bookkeeping a week; three- to

four-person shops may need eight to twelve days a month. The best way to find such a service is through your accountant. He or she is in the best position to evaluate two important characteristics needed in a bookkeeper: quality of work and an ability to interact with whatever system has been set up by your accountant. Charges typically run in the range of $40 per hour.

Your firm probably needs an in-house bookkeeper when it grows to more than five employees or has gross revenues exceeding $600,000. Hiring one should be done even more carefully than hiring creative staff. Not only do you most likely know less about this function, but the risk of making a mistake is also greater (he or she will be handling your money!). Involve your accountant in reviewing résumés and making the final decision. The few hundred dollars it costs will be well worth it. And before making a hire, be sure you check at least three references. Bookkeeper fraud is much more common than you think. (For information on guarding against fraud, see chapter 15.)

The salary range for experienced, full-time in-house bookkeepers is $30,000 to $50,000 annually. For a part-time individual, prorate the pay accordingly. In some cases, a bookkeeper can also double as a receptionist. Although this appears very cost-effective, be cautious: the two jobs are quite different. If you do decide to combine functions, hire the individual for her or his bookkeeping, not receptionist, qualifications. The high end of the pay scale is for metropolitan markets and where there are more duties; the low end is for rural areas and fewer duties.

❂ Banking Services ❂

While we are on the subject of money, let's talk about banks. Every design firm needs a business relationship with one for possible lines of credit, payroll deposits, 401K plans, linked savings and checking accounts, etc. The more the business grows, the more these types of services are required, and the more complex needs become. A good banking relationship is crucial to ongoing financial efficiency. Ask yourself whether your present banking arrangement is adequate for your current business and future plans. Is your bank an approachable, helpful resource? Does the staff know you and the needs of your business? Do you actually have a relationship, or just an account? If the bank doesn't meet these basic criteria, it's time to change things before you have a financial need it can't, or won't, respond to.

SELECTING A BANK. For most design business, the type of bank and its current products and fees are irrelevant. Since most banks can service all our

needs, and their products and fees fluctuate, select one primarily for convenience, friendliness, and size. Small, local, and helpful is ideal. You don't need what large commercial banks do best—syndicate loans, handle complicated financing, arrange international trade, etc. But you do need what they often don't do well—maintain personal and flexible relationships with small businesses. If you currently use two or more banks, it is probably wise to consolidate most of your activity in one. The more financial activity you can generate—personal and company—the stronger your position will be if and when you need to negotiate for services such as a loan or line of credit. You may also want a bank that is either a Small Business Administration (SBA) Certified or Preferred Lender, especially if yours is a minority or woman-owned business. (Certified and Preferred Lenders can shorten the SBA loan application process.)

To establish a banking relationship, call a local branch of the bank you are considering and ask the name of the branch manager. Call back later and ask for that person. When connected, explain who you are, what you do, and that you are thinking about moving your business and personal accounts to a new bank. Ask for an appointment to discuss the bank's "products and services." Indicate that your business is growing and it is time to have a closer banking relationship. If you wish to establish a better relationship with your existing bank, do the same thing, but say you would like to discuss the additional products and services you will need as your business grows.

Why the branch manager? Because it is how you get taken seriously. It is a reasonable request providing you have picked your bank right. In fact, if you can't see the branch manager, you've probably picked the wrong bank.

MAKING AN IMPRESSION. Many bankers are unfamiliar with what most of us do. Even those who aren't view it as mysterious, even a little suspicious. Their world is one of "normal" small businesses—retail stores, builders, and manufacturers. To them, chances are graphic design will sound like interior decorating. Saying you do "print communications," "advertising," or "Internet sites" may help. Also keep in mind that bankers who are informed about graphic design may consider artistic people to be poor money managers. Convince them otherwise.

Thus, the objective of the initial meeting is to educate the banker about what you do, and that you have the same financial concerns, needs, and opportunities as other business people. In this regard, describe your business and your future plans as quantitatively and analytically as possible. Bring a business plan for the banker's file, along with a financial statement prepared by your accountant. Finally, open accounts and arrange for transfers as necessary. Remember, when it comes to future loans and services,

bankers treat most favorably those whom they know best. (Information on a related subject, funding operations, can be found in chapter 15.)

✦ Insurance Services ✦

Chances are, sooner or later, a little rain will fall on your business's financial life. For protection you will need the right size insurance umbrella— big enough to cover the essentials; small enough to be affordable. Without the right coverage, the cost of a major business loss could devastate even the most prosperous design business.

SELECTING AN AGENT. Creative Business strongly recommends channeling most of the business's and principals' personal insurance through a single independent agent. Having one agent responsible will help you keep track of things and will guard against over- or under-insuring. More business will also lead to better agent service. Independent agents (versus company agents who represent firms like State Farm and Allstate) handle many insurance companies and types of coverage so they can better provide custom-tailored packages. If you ever have a claim, you'll probably also want to have an independent agent going to bat for you.

If you don't already have an independent agent, or are unhappy with the service you have been receiving, ask your creative peers whom they use. The more experience any agent has in writing policies for creative businesses, the more attuned he or she will be to your needs. Otherwise, ask your accountant. Most work closely with several agents and have a good feel for insurance needs. You can also get the names of independent agents by looking in the Yellow Pages. Seek those advertising all four insurance categories—"business," "home," "life and health," and "auto."

When calling for an appointment explain your business and say you are in the process of selecting someone to review and consolidate your personal and business insurance coverage. Bring to the appointment information on all your present policies—types, coverage, premiums, etc. Be prepared to describe your business in more detail, what coverage you think you need (see below), and where you believe your business is headed. Inquire about the agent's business mix, experience in handling creative businesses of your size, and his or her background and certification. The most prestigious letters following any name are CPCU, Chartered Property Casualty Underwriter. Other important designations are CIC, Certified Insurance Counselor, and ARM, Associate in Risk Management. All require a high level of test-certified insurance knowledge.

Indicate that you will expect an initial, written recommendation and yearly written reviews of your account. Also ask what, if any, costs are

involved. (There should be none.) You should also note how many and what type of questions the agent asks you. Good agents are not only interested in their clients' businesses, they need enough information to recommend the right policies and coverage.

It may be necessary to interview several agents before finding the one with the right combination of experience, price, and service.

REVIEWING YOUR NEEDS. Regardless of the size of your firm, your needs probably include: health, life, disability, auto, homeowner's/renter's, office liability, equipment, general business, and specialty insurances. All these should be reviewed initially with a new agent and at least yearly thereafter. If you have a significant other in your life, also make sure his or her insurance coverage is taken into account. (It may have a substantial impact on what you need, especially in medical coverage.) Likewise, if you share office space the other party's coverage will probably affect your rates.

Finally, inform the agent of your company's organizational status and any changes. Whether you operate as a sole proprietorship, partnership, LLC, or corporation will likely affect the way some policies are written, how the premiums are paid, and the claim procedure and tax status for payouts. If your organizational status raises concerns, check with your accountant.

HEALTH (MEDICAL) INSURANCE. Although you may not think of it this way, this is your most important business insurance decision. A design business is totally dependent upon the well-being of its staff. And health care is a major expense/benefit.

Health Maintenance and Preferred Provider Organizations (HMOs and PPOs). These provide health insurance plans to groups. Since the larger the group the lower the rates, businesses of ten or fewer employees are usually best advised to join a group sponsored by a trade association or local business group. Even if you have only one employee you can probably enroll as a group. But to prove your business's legitimacy you will need a federal tax identification number and to provide tax returns. (Rates may be prohibitive, however.) Your insurance agent can help you set up a group and shop for the best group rates.

HMOs require you to use their salaried physicians and facilities; PPOs allow you to choose from among designated physicians and facilities. Group insurance through HMOs is usually a little less expensive; PPOs usually provide greater flexibility and choice.

Cost: Rates vary throughout the country, but the following example is typical. For coverage procured through a local business group an individual with no dependents can expect to pay from $200 to $300 monthly; family coverage will probably cost $600 to $750 monthly.

Private carrier insurance. This is coverage offered by national insurance companies through their local ("captive") agents, or by independent agents. These policies are also sometimes called "indemnity plans." You choose the extent of your coverage and can obtain treatment by nearly any physician or facility. This makes these plans the most flexible. They may also be the least expensive if you opt for "catastrophic" (high deductible), not "every illness" coverage. Private carrier health insurance is sometimes difficult to obtain. Rates and coverage are also affected by an individual's age and physical condition. There's a nuisance factor, too—you'll likely have to pay first, then get reimbursed by obtaining the physician's signature on a form submitted to the insurance company. There is little or no regulation or control over future cost increases.

Cost: Because the options offered by national insurance companies are so varied, it is difficult to be specific about pricing. As a guideline, premiums will be somewhat higher than similar HMO/PPO coverage. (Medical Savings Accounts, a tax-advantaged way of self-insuring against catastrophic illnesses, are also available on a trial basis in some states.)

Dental insurance. It is affordable only as part of a group health insurance plan and often requires 100 percent group participation. There is often a one-year wait before anything other than preventive benefits (teeth cleaning, etc.) take effect, and orthodontics are not covered.

Cost: Group premiums average $30 to $35 a month for individual coverage; $60 to $70 a month for family coverage. (Dental injury caused by accidents is normally covered by health insurance policies.)

Tax deductibility. Health and dental insurance premiums paid by employers are fully tax-deductible for C corporations, even for an employee owner. For S corporations employee premiums are fully deductible, but not those of owners. At this writing 60 percent of premiums are deductible for S corporation owners, sole proprietors, and LLC partners.

DISABILITY INSURANCE. This is the second most important type of business insurance. It is your (and your employees') guarantee of an income in the event an illness or disability makes working impossible. Think of it as protecting your company's principal asset—its income-producing abilities. Unlike the lack of health insurance, which would be noticed with every illness, lack of disability insurance doesn't become important until it's too late—incapacitation. Therefore, put mildly, an individual without disability insurance is playing a game of Russian roulette with the future. The only exception are individuals who have adequate financial resources to cover loss of income.

Disability insurance should not be confused with worker's compensation (sometimes called State Disability Insurance). As covered later, disability insurance is an employer requirement and its benefits apply only to on-the-job injuries.

Employer-sponsored group plans. Policies are available for both short- and long-term disablement. Short-term policies typically cover disablement from one day (accidents) or eight days (sickness) up to thirteen or twenty-six weeks. Long-term policies cover from thirteen or twenty-six weeks up to age sixty-five or seventy. Either or both can be offered as an employee benefit. The amount of coverage (percentage of salary replaced) can vary but must be the same for everyone enrolled. This lack of customization keeps costs down and eliminates the possibility of any favoritism or discrimination. Definition of benefits is also somewhat rigid. Coverage is automatically cancelled when an employee leaves the employment of the plan sponsor.

Cost: Group rates depend on average employee age. A short-term policy that replaces 60 percent of an individual's salary to thirteen weeks will typically have an individual premium of $.40 to $.70 per month per $10 of monthly benefit. Premiums for long-term policies are based on company payroll. Typical premiums run $.45 to $1.25 per month per $100 of payroll covered.

Individual policies. Anyone desiring broader coverage than available with employer-sponsored policies should get what is referred to as a "secured" or "non-cancelable" disability policy. As the name implies, these non-group policies can remain in effect despite the employment status of the insured. They also offer the opportunity to define terms of disablement and to custom tailor benefits.

Determining benefits. The first thing to consider in selecting disability insurance is how soon after disablement income will be required. The longer the deductible or elimination period, the cheaper the policy will be. A ninety-day wait for benefits (the deductible) is most common. As for long-term need, keep in mind that payouts could be tax-free (see "Payment of premiums" below), you could do away with most work-related expenses, and you could scrimp on personal pleasures. As a guideline, insurance companies figure that 50 to 60 percent of present income will be necessary. You may come up with a lower figure, but be realistic.

Determining disablement. The policy should provide for at least partial disablement if one cannot perform all normal work functions, including calling on clients, even if creative faculties or management activities are unimpaired. Set your own definitions of disablement and ask your insurance agent to shop around to find a policy that matches them as closely as possible. Remember, what might not be disabling to a normal white-collar worker could be to a creative person (e.g., a hand tremor could put an illustrator out of work, but have no impact on a typist).

Also check to confirm that the policy has the following: a residual benefits provision (partial benefits without total disability); coverage for both accident and illness disability; a cost of living (inflation) rider; is "guaran-

teed renewable" (can't be canceled, but premiums can rise) rather than being "non-cancelable" (no changes possible); and if available, an "own occupation" provision rather than "reasonable occupation."

Cost: A typical disability insurance policy providing $3,000 a month and starting ninety days after declared disability will run a 35-year-old male about $100 a month ($1,200 yearly). Half this coverage equals half the premium—$1,500 for about $55 a month. Premiums on policies for females are often 25 to 30 percent more.

Payment of premiums. When disability premiums are paid by the organization (before taxes), any disability payouts will be taxable. If paid for by private funds (after taxes), payouts will not be taxable. For this reason, some employers provide the money to pay nongroup (only) premiums to employees as salary, letting them make their own payments. (Downside: if they forget to pay, their coverage will be canceled.)

Tax deductibility: The same rules apply as for health and dental insurance.

LIFE INSURANCE. We often think of it only in a personal context, but adequate life insurance is also a business issue. It can help provide protection to your dependents, as well as ensure the orderly transition of your business interests. Some policies can also provide tax-deferred retirement money.

Employer-sponsored group plans. These reduce the cost of life insurance as well as providing an employee benefit.

Cost: Group rates depend on average employee age. They range from $.08 to $.45 per month for $1,000 of coverage.

Individual life insurance. How much money your beneficiaries will need, how much if any retirement funding is desired, and how big a monthly premium is affordable are all personal issues. As one guideline, the insurance industry recommends a policy that pays a lump sum of five to eight times the annual income for family wage earners with average indebtedness. You may need more or less.

Cost: Individual life insurance rates are based on an individual's age, sex, and health, so cost-estimating is difficult. As an example, however, a thirty-five-year-old, nonsmoking female can usually purchase straight term (no cash value) life insurance for about $1 per year per $1,000 of death benefits plus an additional $25 to $75 policy fee. In other words, a $100,000 policy will have an annual cost of $125 to $175.

The same individual purchasing whole-life insurance (insurance with cash value) will pay from $2.50 to $7.00 per $1,000 (depending on the cash buildup) plus the policy fee, or from $250 to $700 yearly for a $100,000 policy. As for how much cash will build up, a rule of thumb is that the total premiums should at least equal the cash value of the policy in ten years or less.

Tax deductibility: Only company-paid group life insurance is normally tax deductible.

KEY-PERSON/BUY-SELL INSURANCE. This insurance makes it possible for remaining owners to come up with the cash to buy out a deceased or disabled owner. It can also be used to fund the buyout of a departing owner, or the death or disablement of a valued employee. An optional addition to key-person life insurance can provide protection from suits arising from the actions of partners. Key-person policies should be written in conjunction with a buy-sell agreement controlling distribution of business assets. This protection is crucial for any firm with more than one principal, or vital employees. Without it, chances are the firm will be either financially crippled, or the principals will find themselves in a legal wrangle over future management and the distribution of assets.

When there are only two principals, each usually takes out a life insurance policy on the other, is responsible for its premiums, and is its beneficiary. When there are more than two principals, policy premiums are usually paid by the company, which is the beneficiary.

Term insurance is the least expensive option, although premiums do become increasingly expensive as insureds grow older. There is also no buildup of cash value. Variable universal life insurance is more expensive, but premiums do not increase with age, and policies offer a buildup of cash value, which might be used to fund a buyout. It may be the appropriate choice in some cases. In addition, it is wise for every principal and crucial employees to be covered by a similar disability policy. This policy, funded like life insurance, is in addition to a disability policy that an insured may carry on him or herself to ensure income.

Cost: The same as life and disability policies written for traditional purposes.

Tax deductibility: Depends on who pays and who benefits.

INSURANCE AS AN EMPLOYEE BENEFIT. The tighter the job market and the older the employee, the more important insurance benefits become.

Health insurance. This is the essential employee benefit, reflected in the fact that Creative Business surveys show that most design firms provide one or more health insurance plans for which they pay all or a portion of the premiums. The most common employer contribution is 75 percent of the employee's premium. Some larger and a few smaller firms pay 100 percent, but the percentage is dropping each year as health insurance costs continue to rise. About 30 percent pay the same percentage for dependents as employees.

Creative Business recommends that where possible firms pay 80 percent of employee premiums, but none of dependent premiums. This takes most of the bite out of the cost for employees while still ensuring their participation

and interest. We do not feel that offering dependent coverage is crucial in light of the fact that dependents are often employed by other firms with their own, often better, insurance plans. Offering dependent coverage may, however, be important in firms with mature employees or in tight labor markets.

Worker's compensation insurance. This is not a discretionary employee benefit. It is a required, state-administered insurance that covers employees against disabling, on-the-job (not off-the-job) injuries. Worker's comp is usually purchased by the employer from a private insurance company. What's required and how much it will cost is state- and occupation-based. Typically, it runs $2 to $3 per year per $1,000 of total payroll for a creative business located in a major industrial state.

Although the requirements of every state vary, chances are that even short-term temporary employees (in-house freelancers) must be covered. This is often picked up to the owner's surprise and added expense when the actual yearly payroll is compared by the insurance company at year end to the firm's beginning-of-the-year estimate. To avoid this, ask your insurance agent for an "if any" worker's comp policy as well as information on your state's specific requirements.

Disability insurance. As described earlier, this is insurance for off-the-job accidents. About 50 percent of design firms offer short-term plans; only about 25 percent offer long-term coverage. Premiums are covered by most firms offering group disability plans. (The employer must pay at least 25 percent of premiums for most group plans.) Typical short-term coverage is 60 percent of an employee's salary after eight days and up to thirteen weeks; typical long-term coverage is 60 percent of salary after thirteen weeks until age sixty-five.

Life insurance. Most design firms of more than twelve employees provide it; about half of those in the six-to-twelve-employees range do; it is seldom provided by smaller firms. Typical coverage is one year's salary.

GENERAL BUSINESS COVERAGE. The most economical insurance coverage for businesses renting commercial space almost always comes from a multifaceted business owner's policy (BOP). This might also be true if you have an extensive home office where employees work.

BOPs typically include the three common needs of small businesses described below—general contents, commercial general liability, and business interruption insurance. Most BOPs have a minimum premium of $300 to $500 yearly. If your needs are modest, ask your agent if it's possible to add coverage without raising the premium.

Cost: From $350 up, depending on the size of the business covered.

General contents coverage. It can be specified as "all risk," which includes everything not specifically excluded, or "named peril," which covers only things specifically identified. All-risk coverage with no exclusions might be difficult or expensive to obtain, depending upon the location of your

business. Coverage that excludes specific damage, such as that by floods or earthquakes, might be all that is possible. In some situations named peril coverage that specifies a dozen or so coverages, no more, will be all that is obtainable.

Commercial general liability (CGL) insurance. It covers bodily injury to others (e.g., an accident in your office) and damage to someone else's property (e.g., causing a fire that damages other offices in the building). Many landlords will insist on "in-force CGL insurance" before renting space.

Business interruption (business income) insurance. It provides compensation based on your financial history for twelve months if your business is unable to function as a result of circumstances (not personal or medical) beyond your control.

SPECIFIC BUSINESS COVERAGE. In addition to a Business Owner's Policy most design firms also have a need for one or more additional polices to cover risks excluded or limited in a BOP.

Computer insurance. Most BOP policies will cover all the equipment of a small design firm. Registered software is also covered by most policies up to 20 percent of hardware value. Be sure to check with your agent to determine the extent of coverage, particularly if your business is electronic-intensive. Also note that work-in-progress is never covered by commercial policies. The best (sometimes only) protection is to back up files and store them offsite. Adequate computer coverage for mid- to large-sized firms often requires a separate Business Electronic Equipment policy. These policies can be written to cover work-in-progress. However, they might require keeping an up-to-date inventory of equipment and software.

Cost: Typically $550 to $750 for $30,000 of equipment and $100,000 of "extra expense" or reconstruction (work-in-progress) coverage.

Errors and omissions insurance. This coverage protects your firm against liability arising from mistakes. It remains expensive, but costs have come down somewhat recently. Because of the expense, most shops rely on the protection afforded by client sign-offs and, ultimately, by incorporation. If necessary to have it for a particular, high-risk project, try to get "one shot" coverage and bill the premium to the client as a job expense.

Cost: Typically $1,200 to $1,500 annually for $100,000 of coverage. The exact type of coverage also must be carefully specified.

Umbrella liability coverage. It protects your business from the high awards often assessed by juries for accidents because of negligence.

Cost: From $250 to $500 annually for $2 million coverage.

Bailee's coverage. It covers the value of client or supplier items in your possession that may be lost, stolen, or damaged, such as stock photos.

Cost: From $50 to $75 annually per $10,000 of coverage.

Valuable papers coverage. It covers artwork stolen, damaged, or destroyed (except in transit).

Cost: From $20 to $40 per year per $10,000 of coverage when added to a BOP. The same coverage would cost about $150 if purchased independently.

Transit coverage. Maximum liability for most express delivery services is $500. Additional coverage can usually be purchased. Be sure, however, to identify the insured material as "commercial" instead of "fine" art. If you do a lot of shipping, investigate a blanket transit coverage policy.

Cost: Varies.

Flood, earthquake, and natural disaster insurance. It extends coverage to these otherwise uninsured risks. It can also cover such miscellaneous problems as malicious damage caused by disgruntled employees.

Cost: It is based on probability, so premiums vary widely depending on business location.

Contents of employees. This insurance protects the personal items of employees while at work (e.g., a thief entering and stealing a pocketbook). It can be obtained by a rider to standard BOP policy.

Cost: From $50 to $75 for $5,000 of coverage.

Bonding. Providers of pension plans (e.g., 401Ks) require those with administrative responsibility be bonded against fraud.

Cost: Several hundred dollars yearly depending on coverage.

Employer benefits liability. This insurance protects the employer from the costs of defending a suit led by an employee who believes his or her benefits were mishandled.

Cost: From $100 to $150 for $1 million of coverage.

Employer practices liability. This insurance protects the employer from the costs of defending a suit filed by an employee for sexual harassment, age or race discrimination, improper dismissal, etc. It does, however, require employees to submit personal information that might raise invasion of privacy issues.

Cost: From $750 to $1,500 for $1 million coverage.

Automobile insurance. You may not be aware that your present auto insurance could be insufficient when you're engaged in commercial activity. Make sure your auto policy covers any business use of your vehicle. In addition, when employees use their vehicles on company business, employers may be liable for any damage or injuries they cause. To protect your company against damages, ask your agent to provide a "non-owned/hired" auto policy.

Cost: Most insurance agents recommend liability coverage (bodily injury to others) of at least $250,000 per person, or $500,000 per accident

for autos regularly engaged in commercial activity. Such coverage will cost $100 to $200 yearly, depending on state, location, and driving history. It is also important to have underinsured and uninsured motorist coverage to cover you and employees hit by others with little or no insurance. The former costs about $30 to $50 extra yearly; the latter $100 to $150. A "non-owned/hired" policy covering several employees will run from $50 to $100 annually.

INSURANCE SUMMARY. Insurance is only one aspect of emergency planning. You should keep an up-to-date inventory of insured items. You should also have a plan for coping with the other disruptive aspects of an emergency—who should be notified, what needs immediate attention and what doesn't, and who is responsible for what actions. For help with this, see the Emergency Planning Form in appendix IV.

Finally, as business conditions change, so should your coverage. Insurance coverage should never be static. It should be evaluated and adjusted at least yearly—the reason why you should have an independent agent/consultant to advise you.

❀ Legal Services ❀

Sooner or later most design businesses require legal counsel. It would be unwise in the extreme not to have legal representation when buying into or selling out of a firm, making important commitments, or being sued. It is risky not to have counsel when structuring or restructuring, getting married or divorced, and registering intellectual property. And, of course, we all know that it helps to have a lawyer in your corner if you want to collect a substantial unpaid invoice. (See "Arbitration and Mediation Services" later in this chapter for an alternative.)

FINDING A GOOD LAWYER. For most of the situations design firms find themselves in, personal compatibility is at least as important as legal talent or specialty. When the need arises, you need someone to whom you can easily talk, who understands your business, and who can clearly explain the consequences of specific actions. The reason personal compatibility is so important is that legal situations usually involve making tough choices: Sue, or settle? Maintain the status quo, or opt for change? Accept terms, or hold out for better ones? There's seldom a right answer, only a judgment call, which *you* have to make. A lawyer's job is to explain the law, present your options, explain the possible consequences of each choice, and provide a recommendation. But in the end, you have to decide what to do.

The best way to find a lawyer who has the right combination of compatibility, ability, and experience is usually to ask your creative peers. You

may also want to contact a local creative club (GAG, AIGA, ad club, PRSA, IABC) for recommendations. Other referral sources are your accountant and banker. If you find no one to your liking, visit the Martindale-Hubbell Lawyer Locator at their Web site: www.martindalehubbell.com. It lists 900,000 lawyers and law firms. Searches can be done by location or speciality (e.g., intellectual property, contracts, divorce, etc.). It also provides biographical information on individual lawyers and firms as well as links to the Web pages of many of those listed. Other helpful law sites are: www.advertisinglaw.com, www.nolo.com, and www.courttv.com/legal-help/business.html. You can also call your local or state bar association office and ask for a listing of local lawyers who have experience working with ad agencies, PR firms, and design shops. In addition to this referral service, many bar association offices also provide general information on dealing with legal matters.

MAKING THE SELECTION. Once you have the names of several lawyers or law offices, call to determine whether they are appropriate to, and interested in, your business. If the issue is more or less routine, a phone conversation may be all that's necessary. Or you can arrange for a personal interview, which may or may not be chargeable, depending on what is involved. If chargeable, it may be at a nominal rate, or it may be at the full rate, again depending on what is involved.

At an interview meeting ask specific questions: How many similar clients do they have? Do they have experience handling your type of problem? Will the lawyer you interview be working on your business, or will an associate or clerk do most of the work? Don't expect or ask for any legal advice at an interview, although it is appropriate to request a timetable of what will happen, and when. Establishing a timetable is important to ensure that the lawyer or law firm will be responsive to your needs. Be sure to also ask about charges and billing procedures. It is perfectly appropriate to ask for an estimate based on your needs. But remember, as in the design business an estimate is only as good as the information upon which it is based.

WORKING WITH A LAWYER. Always insist on a written contract detailing the services that will be provided and their cost. Always. In fact, most states now require a contract, especially if the fees are contingent. Lawyer contracts often take the form of what is called a "retainer agreement." They provide for an up-front payment against which future billing is deducted. There is no set amount for the up-front payment. (Don't confuse this type of "retainer" with those often used by design firms and described in chapter 12.) Here is what to look for: Will you be charged strictly on an hourly basis, or are some services (e. g., routine contracts and other standardized services) billed by fixed fee? Which expenses are covered and

which are separately billable? Will you be billed a minimal monthly fee if no services are required? Can the fee basis be raised?

Once you have signed the contract, you are a client, the opposite of your own business relationships. Having been on the other side of the table in a service business is a very valuable experience. It should make you acutely aware of the many ways you can make a client/vendor relationship more productive and cost-effective. For example, as when your clients meet with you, thorough preparation results in better quality work, produced at less cost. Before the appointment, go over in your mind all the events that are relevant your meeting with the attorney, and their history.

Organize and bring along any and all relevant documents—proposals, letters of agreement, contracts, correspondence, copies of creative work, and the names, addresses, and phone numbers of the individuals involved. A good paper trail is often essential to the satisfactory resolution of many legal matters. Be prepared to detail as precisely as possible your needs, both immediate and future. For example, if you are there because of a contract dispute, you not only need to resolve the current situation, but also figure out a way to avoid similar situations in the future.

Keep in mind during your meetings that lawyers spend years in law school learning to be as analytical as humanly possible. By contrast, chances are that by both inclination and training you're the opposite— you're probably a right-brained individual and he or she is probably a left-brained individual. Thus, a successful relationship requires you to make an extra effort in being organized and precise.

HOW LAWYERS CHARGE. Perhaps the most common problem clients have with attorneys is lack of communication over billing procedures. (Sound familiar?) Attorneys charge for their services in several ways. These commonly include: hourly fees, contingent fees, statutory fees, flat fees, and expenses.

Because every situation is different and lawyers, like you, have only their time and talent to sell, hourly fees are the way most legal work is billed. Lawyers dealing with small-business matters normally charge in the range of $150 to $300 per hour. Time is usually counted in tenths of an hour (six minutes). This means that if you talk on the phone for twelve minutes to a lawyer charging $200 per hour, you will probably be billed $40. Attorneys specializing in intellectual property work—copyright violations and trademark registrations—typically charge $200 per hour and up. Legal specialists also charge more than $200 per hour.

In a contingency fee arrangement, the attorney is paid no money unless there is monetary recovery. If there is recovery, the attorney gets a percentage, agreed upon in advance, based on the difficulty of the case. The percentage normally ranges from a low of 15 percent to a high of 40 percent.

Statutory fees are set by the law (statute), although the law sometimes gives a judge discretion within a prescribed range. Statutory fees are usually awarded in cases of bankruptcy, trademark or copyright infringement, or unfair or deceptive trade practices.

Flat fees are charged when your attorney agrees to perform specified services for an agreed upon price. This might, for example, include certain corporate filings, the review of a legal contract, sending a payment demand letter, or drawing up a will. They are usually inappropriate for customized work or when counsel is needed.

Finally, lawyers add most out-of-pocket expenses—copies, phone calls, parking, etc.—to the bill without markup. The cost of time that secretaries, paralegals, and clerks spend working on a specific case is usually billed as a separate line item.

GETTING A LEGAL AUDIT. Although most of us think of contacting a lawyer only when we have a problem, another valuable service they provide is a legal audit. A legal audit is a top-to-bottom review of a business's practices from a legal perspective. The purpose is to identify weaknesses or deficiencies that could result in unnecessary exposure to liability or financial risk. Think of it as a way to get a preventive inoculation against future legal illnesses. (Caveat: Because doing a good audit requires understanding a company's business, one should only be undertaken by an attorney who has had experience with other firms in the creative services industry.)

A legal audit usually begins with a meeting in which the attorney asks for a general overview of the company's activities and plans. The attorney then discusses general risk-management procedures, and specifically areas where the firm may be vulnerable. Finally, he or she asks for copies of all relevant documents, policies, and procedures, which will be scrutinized later to ensure that the company is in compliance with all applicable laws and regulations. This involves not only assessing what might be missing, but also the completeness of what is extant. The goal is to ensure complete protection.

After a careful review of the business, the attorney will make specific recommendations for changes that should be made, the cost of making them, and the risk (ultimate cost) of not making them. In addition, he or she will usually identify other areas of vulnerability where action may or may not be immediately warranted, depending on the principal's wishes. A comprehensive report is normally provided that details the attorney's recommendations.

As a guideline, legal audits typically start at around a few thousand dollars. Obviously, the larger the firm, the more legal work involved, the higher the cost.

⚜ Arbitration and Mediation Services ⚜

The traditional way to resolve serious conflicts is litigation in the civil court system. But it is expensive, and a case can take months or years before being heard and resolved. Both parties often end up unhappy. Using mediation or arbitration, collectively called "alternative dispute resolution" (ADR), offers a recourse to the big fees, clogged courts, and disgruntled participants that mark the civil court system. Although it is probably not the answer when you've clearly been "stiffed" or wronged, ADR may be right for honest disagreements. An example would be a client refusing to pay because they believe they have been overcharged for project alterations. Essentially, ADR is a process in which both parties agree to sit down before a "neutral" (industry term) and try to settle their differences.

MEDIATION. This is a nonlegal procedure and the first and sometimes only step necessary. It can be proposed by either party at the time of a dispute (i.e., without prior agreement) and the results are not binding. Nonetheless, it can be effective because a third party can often suggest compromises that allow the antagonists to save face and keep from duking it out in the courtroom. Indeed, the effectiveness of mediation is such that some judges now require it before agreeing to hear civil suits. Mediation works best when both parties believe the dispute is an honest disagreement and also recognize the high cost of involvement in a winner-take-all legal suit. The more each is willing to concede that things might not be one-sided, the better the chances are that mediation will work.

ARBITRATION. This is a legal process that takes place outside the courts. It requires that both parties consent in writing to submit the dispute to arbitration and abide by the neutral's (arbitrator's) decision. If so, the decision is as enforceable as any court judgment. Lawyers may represent the parties at arbitration hearings, but they are not crucial. Hearings are not as adversarial as court sessions, and the laws of evidence do not apply. Because of the consent needed from both parties, arbitration is usually only effective when it is agreed upon before there is a problem. For creative work this means a clause included in a project's signed estimate, proposal, or letter of agreement (see "How It Works" below). Otherwise, you can ask the client to agree to submit to arbitration, but it's a long shot, especially if there is animosity between you.

TRADE-OFF #1. Attaining agreement may be difficult. Clients, especially larger ones, may not agree to an arbitration clause, preferring instead to put any legal problems into the hands of their attorneys. Employees and others may not consent to mediation because they distrust the process, particularly when the party they are having the dispute with suggests it.

BENEFIT #1. Your legal costs will likely be reduced. Business disputes should be avoided for no other reason than the fact that settling them can be costly, win or lose. ADR is just less so. The total cost can be half that of hiring a lawyer and going to court. For instance, using a private ADR firm will cost $100 to $200 and there will be the mediator's or arbitrator's time at hourly rates of $150 to $300 per hour. Also, the cost of arbitration is generally shared by the parties.

TRADE-OFF #2. You'll probably have to settle for less. ADR often involves compromise. If you have a strong emotional stake in the issue or want vindication, ADR may leave you feeling frustrated. Don't consider ADR unless you are willing to accept a practical rather than the "right" solution to the problem.

BENEFIT #2. You'll probably save time. This may be the most significant benefit, depending on how disruptive to normal business the dispute becomes. ADR hearings can be set up in days and a decision handed down in anywhere from several days to a couple of months. By contrast it could take anywhere from six months to several years, depending on local case load, to get resolution in the civil court system.

HOW IT WORKS. The first step in ADR is to arrange for a neutral, or arbiter or mediator, in your area. You can find organizations that provide this service in most metropolitan area Yellow Pages under "Arbitration Services." The larger ones are: American Arbitration Association (212-484-4000, www.adr.org); Jams (800-352-5267, www.jamsadr.com); National Arbitration and Mediation (800-358-2550, www.nationaladr.com); Resolute Systems (800-776-6060, www.resolutesystems.com); and U.S. Arbitration & Mediation (800-318-2700, www.usam.com). Most ADR organizations are private and provide help setting up the process. There is usually no initial fee; they make their money on an administrative charge when their services are required, and from a portion of the fees from the arbitrators or mediators contacted through them. The American Arbitration Association, on the other hand, is a not-for-profit that acts only as a source of names of qualified arbitrators and mediators. It does not provide assistance in individual cases, but its services are free.

Because they also handle the arrangements, private ADR organizations recommend using their language in contracts. It typically reads something like this:

> Any controversy or claim arising out of or relating to this (contract, proposal, letter of agreement, etc.) or the breach thereof, shall be settled by arbitration in accordance with the applicable rules of (name of ADR organization). The arbitrator's decision shall be final, and legally binding, and judgment may be entered in any court having jurisdiction thereof.

Each party shall be responsible for its share of the arbitration fees in accordance with the applicable rules of arbitration. In the event a party fails to proceed with arbitration, unsuccessfully challenges the arbitrator's award, or fails to comply with the arbitrator's award, the other party is entitled to costs of suit, including a reasonable attorney's fee for having to compel arbitration or defend or enforce the reward.

PRACTICAL APPLICATION FOR A DESIGN FIRM. The application of ADR is as varied as the types of legal problems design firms face. Some typical ones follow.

When you're really small and they're really big. In theory the law is impartial; size doesn't matter. In reality it very much matters. The larger an organization, the more access it has to legal resources. It is easy for a small firm to be legally stonewalled and "out-lawyered" when challenging a large client. An arbitration agreement levels the playing field. It denies the advantages of size to the other party by ensuring that the disagreement will stay out of lawyer territory—the courts. Instead, the agreement is made in an environment where there is little opportunity for playing the legal game.

When a client won't pay. Normally, solvent and reputable clients don't simply refuse to pay for work that is completed. There is usually a reason—inferior quality, mistakes made, not delivering what they expected, delays in delivery, etc. An arbitration agreement would bring the problem to the fore and get the issue resolved in a fraction of the time it takes to hire a lawyer and go through the courts.

When a client doesn't want to pay the full amount. Here's an example: The client said they had to have the job on a certain date, but were late with input and approvals. So meeting their deadline meant working many night and weekend hours. Perhaps you should have kept them better informed on the escalating costs, but your priority was getting the job done. With an arbitration agreement, you'd have two choices. For a client you'd like to continue a relationship with, suggest mediation. It offers a route to compromise without the downside of showing weakness. And if it doesn't work, you can still rely on arbitration later. If, on the other hand, you think the client's demands for an invoice reduction are unreasonable, and they aren't someone you'd want to work with again, you can refer it to arbitration immediately.

When an employee threatens or brings suit. Improper dismissal, discrimination, harassment, whether real or imagined, are all grounds for employee suits. They must be addressed whatever their apparent merit. If the storm is still brewing and attempts to diffuse it have failed thus far, suggest mediation. Agree to abide by whatever the mediator recommends. The employee may not go along with this, but making a good faith effort to

resolve the problem will be to your benefit if the dispute escalates into a lawsuit. If you need to respond to a suit that has already been filed, ask your lawyer to contact the employee's lawyer about withdrawing it and agreeing to settle by arbitration instead. It could save both parties substantial amounts of time and money.

❖ Consulting Services ❖

Hiring a consultant to tell you what is right and not so right about your business is a fairly recent practice in the design industry. It is also an acknowledgment of how complex the business has become. There used to be little call for consultants. Muddling through, learning by trial and error, or simply picking the brains of mentors was enough. Today, though, design firms often look to paid consultants in an effort to set things right. The opinion of Creative Business is that a good consultant can be extremely valuable. But one that it is not so good is a waste of time and money. Some selection guidelines follow.

BACKGROUND. Design companies are different than other businesses; they combine art and commerce. This unusual nature makes many standard business procedures inapplicable. Fully understanding your business and its opportunities requires someone intimately familiar with the industry, maybe even your particular niche of it. Chances are the more design/advertising/PR/interactive firms a consultant has worked with, the more valuable he or she will be. Be wary of anyone without solid experience specific to your needs. General business consultants are only valuable if you have very general business problems.

REFERENCES. Consulting should be viewed from a bottom-line perspective. A consultant's services should save or make more money for his or her clients. When this is the case, these clients are enthusiastic. So ask for a list of recent clients and call several at random. Don't be a future client unless past ones are ardent in their endorsements.

INVOLVEMENT. A good consultant will require—not merely request—that you not only provide complete facts and figures, but also share your goals and aspirations. He or she may also want to interview your employees, and maybe your clients. Look for thoroughness of approach. And don't sign on unless you are prepared to devote the time and effort necessary to getting your money's worth.

REPORT. Ask what kind of report you will get. The more detailed, the better. Particularly useful are industry benchmarks, and how your firm stacks up next to them. The report also should provide specific recommendations

for improvements, a timeline for actualizing them, and what results you can reasonably expect.

MONEY. Good consultants usually command a couple thousand or so dollars a day. This means that one day data gathering and interviewing, another writing a report, and a few follow-up hours will result in a bill of at least $5,000. This can be money well spent for a firm of several employees, either for the new knowledge imparted, or as a certification that most things are being done right. If you feel you need consulting help but can't justify this type of expense, contact the Service Corps of Retired Executives (SCORE). As the name implies, this is an organization of retired executives who volunteer their time to help fledgling businesses. The help you receive may, or may not be significant, but it is free. Contact them through their Web site: www.score.org.

IMPLEMENTATION. Working with a consultant is exploring change. Don't be too busy to implement recommendations or take advantage of any follow-up services. You don't have to agree with everything, but not seriously considering the recommendations makes the whole exercise pointless.

SECTION TWO

Personnel

To say that design is a personnel-intensive business is to state the obvious. As important as other business concerns are, a design firm's staff, its people, is still first and foremost. It is, after all, human talent, not hardware or software, that creates a great portfolio. It is the ability to convince clients you can address their needs, not low price, that lands most good projects. It is the ability to work closely with clients, not merely to meet their specifications and deadlines, that creates long-term relationships. And it is the way individuals interact, not job descriptions and procedures, that create a happy, productive workplace.

Around 70 percent of most design firm expenses go to meeting payroll and benefits. So bad personnel decisions are costly in the extreme. Internal problems faced by most design firms are nearly always personnel related—office politics, salaries, working conditions, time off, etc.

Design businesses have few if any assets, no tangible products, and no inventory. All they have is the skill of the principals and the talent of those who do the work.

"Always hire people who are better
than you are."
David Ogilvy

CHAPTER 4 Organizing

T HERE'S A POPULAR THEORY among social scientists that is often referred to as the "broken windows effect." When societies ignore small, seemingly insignificant quality-of-life concerns such as broken windows and dirty streets, a larger social malaise often escalates and crime increases. Moreover, proactive intervention (repairing windows) is much less costly than reactive intervention (fighting crime).

There's an analogy in the design business, what could be called the "chaos effect." Lack of structure and disorganized procedures usually lead to inefficiency and reduced profitability. Similarly, when this need is addressed before it causes problems, efficiency rises and profits increase, and everyone is happier.

Most designers do their best work in a stable, predictable, well-organized environment. Workplace intensity can occasionally increase short-term creativity (the so-called pressure effect), but it nearly always does so at the expense of long-term productivity.

⊛ How Organized Are You? ⊛

Before attempting to organize personnel policies, it helps to look first at your personal work style. When you work alone (freelance), your organizational deficiencies are yours alone. But when you supervise others, your work style sets the organization's style or company culture. Regardless of what may be contained in any official policies and procedures, employees

usually take their lead from the boss. Helter-skelter managers usually run helter-skelter organizations, and vice versa. In short, a principal's personal habits are among the most important aspects of a business's organization. This is true whether you have just one or dozens of employees. Even the best organizational efforts will fall short if they belie the actions and beliefs of the firm's principal(s).

Here's a short test of your organizational skills. Circle 3, 2, 1, or 0 on each of the following questions. If you answer "always," circle 3; if you answer "usually," circle 2; if you answer "sometimes," circle 1; and if you answer "never" or "rarely," circle 0.

1. Do you spend a few minutes planning each day or activity?

 3 2 1 0

2. Do you keep regular, predictable hours?

 3 2 1 0

3. Do you usually get your work done within your regular work day?

 3 2 1 0

4. Do you list tasks by priority and concentrate on the top?

 3 2 1 0

5. Do you prioritize messages and mail?

 3 2 1 0

6. Do you assign mundane tasks as high a priority as interesting ones?

 3 2 1 0

7. Do you maintain an ongoing "to do" list of future tasks?

 3 2 1 0

8. Do you try to handle important tasks when you feel most alert?

 3 2 1 0

9. Do you group similar tasks together?

 3 2 1 0

10. Do you break large projects down into small chunks?

 3 2 1 0

11. Do you have a system for easily filing/retrieving work?

 3 2 1 0

12. Can you find things easily?

 3 2 1 0

13. Do you have a way of saving or recording thoughts?

 3 2 1 0

14. Are you early or on time for most meetings?

 3 2 1 0

15. Do you have a clear agenda for meetings?

$$3 \quad 2 \quad 1 \quad 0$$

16. Does sloppiness and disorganization in others bother you?

$$3 \quad 2 \quad 1 \quad 0$$

17. Are you impatient when others waste time?

$$3 \quad 2 \quad 1 \quad 0$$

18. Would you describe your creative style as "classic" or "clean"?

$$3 \quad 2 \quad 1 \quad 0$$

19. Are you always looking for ways to be more efficient?

$$3 \quad 2 \quad 1 \quad 0$$

20. Do you keep track of your (and employees') efficiency?

$$3 \quad 2 \quad 1 \quad 0$$

Total points _____

If your score comes out between 50 and 60, you are well organized. If it's between 35 and 49, you need a few modest improvements to become more efficient. If it's between 20 and 34, you need to think a lot more about organization. And if your score is below 20, you have a lack of organizational skills that is truly business threatening—make changes now before it's too late.

With this understanding of your personal organizational strengths and weaknesses we can now move on to describing one of the most important ways a design business can organize for maximum staff efficiency—developing formal policies.

❂ The Case for Clearly Defined Policies ❂

Working in the design business is not like working as a flight controller—confusion can't be fatal. Nonetheless, ours is still a detail-intensive business. A wrong word or misplaced comma can change the meaning of copy dramatically. Transposing a picture or dropping a caption can result in rerunning an expensive brochure. Send the wrong ad to the wrong place at the wrong time and you'll lose a client. Render features inaccurately and days of work may end up worthless. Workplace confusion also contributes to the poor financial health and premature death of design firms. It may be a cliché, but when most of what you have to sell is time, wasting it wastes money. Good policies that result in a lack of workplace confusion keep from wasting it.

Although often considered otherwise, policies are not just for large firms. Granted, the larger the firm, the more costly the lack of them can be. But lack of well-understood, day-in, day-out procedures in small firms can also be a significant problem. As a rule, firms of fewer than four employees can usually get by without written policies providing the principals are well organized, take care to explain how they expect things to be done, and the employees aren't prone to take advantage of workplace informality. All larger firms, or smaller firms that can't meet these criteria, should have published policies and procedures as well as an organization chart for employees to refer to.

But, you ask, doesn't this promote organizational bureaucracy? Doesn't it make an informal, friendly, and creative shop—a cool place to work—into one that's stiff and bureaucratic? Surely it does if taken to an extreme. Not, however, if handled properly. A well-organized firm is nearly always preferred by employees to one that is "loosey goosey."

THEY WON'T DISCOURAGE CREATIVITY. The common belief that policies and creativity are like oil and water is a myth. Standards that ensure everyone is treated fairly and that minimize confusion in everyday work-life nearly always increase, almost never decrease, overall creativity. The more stable and predictable a work environment is, the fewer distractions there are from producing consistently good work. The only employees who complain about reasonable rules and standards are prima donnas. It may (or may not) be true that pure artistry thrives on confusion and chaos, but commercial creativity never does.

THEY'RE NEEDED BECAUSE OF OUR TYPE OF WORK. Doing creative work is by definition less routine than, say, making widgets, where customer specifications can be precise and manufacturing machinery programmed. Because the very nature of our work is nonstandard—that is, every assignment is different—we have to gain our business efficiencies through staff procedures. And efficient staff procedures require some measure of structuring. If not, we may be doing great design but at the expense of short-term profitability and long-term business viability.

THEY AREN'T DIFFICULT, TIME CONSUMING, OR COSTLY. There's no need to reinvent the wheel. Most of what you'll need to consider is below. Samples to use as templates are in appendix IV. Use them as is or modify them to fit your needs. Keep in mind that you can't cover every possible situation. Policies are ways to supplement management prerogatives, not replace them. The purpose is to ensure that all employees understand and adhere to common procedures. Every design business will eventually develop its own procedures. Those firms that have not taken the trouble to formally

define them will find that they develop and evolve around personal idiosyncrasies and individual convenience, rather than around overall efficiency. Good management requires that procedures be defined by the business's best interests, not by mere chance.

THEY INCREASE PRODUCTIVITY. The less time employees spend thinking about what is routine, the more productive they become. Further, employee productivity is the single most important profit factor in a service business. Standardizing everyday working procedures—making them well understood and routine—is of particular relevance to design firms where creative activities can never be reduced to what's routine. Put another way, when there is so much that can never be made routine, everything that can be must be.

THEY ENHANCE QUALITY. Studios that run efficiently with few disruptions and surprises are pleasant places to work in. This is not only important for its own sake (you work there, too), but high employee satisfaction also produces higher quality work, reduces turnover, and makes hiring new employees easier.

THEY MINIMIZE MISUNDERSTANDINGS. The potential for disruptive errors and misunderstandings grows rapidly as staff increases, new situations arise, and management becomes less accessible. The best way to keep these inevitable problems from escalating is to anticipate them and provide guidelines that everyone can follow. The more employees function alike as a smoothly running team, the more the firm's overall efficiency will multiply.

THEY DISCOURAGE MICROMANAGEMENT. The responsibility of planning, decision making, stimulating employees, and ensuring the quality of the work is a full-time job. When a principal has to be involved in minor, everyday issues—micromanaging—time spent on what's truly important is reduced. Micromanagement also encourages a lack of employee initiative and responsibility that has the long-term effect of sapping productivity.

THEY REDUCE OVERREACTION. By developing a set of interrelated policies now there will be less tendency to institute them hastily in reaction to a specific situation or employee misconduct in the future.

THEY INSTITUTIONALIZE A BUSINESS. Design firms are seldom stable until they are run like businesses, not mere extensions of the founders' whims and idiosyncrasies. Objectivity and consistency are important in maintaining business relationships, keeping clients happy, and attracting good

help. Developing standard operating procedures on all levels—"institutionalizing" the business—is essential to long-term viability.

What Employees Want to Know About

Before formalizing your firm's policies, it helps to consider what employees are most concerned about. Creative Business surveys of employees over the years indicate the following. The order of importance varies by age group, with working environment more important to younger designers, career path more important to more experienced designers, and salaries and benefits more important to mature designers.

WORKING ENVIRONMENT. The smaller the organization, the more important the environment of the workplace and your creative philosophy as an employee benefit. These can be a big assist in leveling the playing field when competing for talent against the greater prestige and salaries of larger firms. They reassure new employees by indicating that small in size does not necessarily mean small in sophistication or potential.

WHERE THEY FIT. How important is my job? What's the pecking order here? Who listens to whom? How qualified are my peers? Whether stated or not, these and similar questions are on the mind of every employee.

EVERYDAY PROCEDURES. What are normal working hours? How are jobs tracked? Who will review my work? How often do I pass in my time sheets? Can I freelance after hours? Knowing in advance what is normal procedure and what is not reduces an employee's chances of making embarrassing mistakes.

SALARIES AND BENEFITS. How many sick days can I take? What about overtime? How often do I qualify for a raise? A perception of fairness and consistency in salary and benefit administration is usually at least as important as the money and perks employees actually receive.

CAREER PATH. Where am I headed? Is this a résumé-building job? Is working here an upward step on my career ladder, a lateral move, or a dead end? The more ambitious an employee is, the more important answers to these questions become.

An Organization Chart

Yes, we all hate the thought. And organization charts do, indeed, symbolize the very bureaucracy many of us started our own firms to escape. But

as formal and off-putting as they may at first appear, they do serve the purpose of providing vital information at a quick glance. (Isn't that the very essence of good design?) They show employees where they fit in an organization. Also, by showing the delegation of authority and responsibility, they minimize employee confusion and encourage better work flow. The bigger the firm, the more important this becomes. Although it is not absolutely necessary for you to prepare and publish an organization chart for your company, if you desire efficiency it is necessary that employees know how the firm is structured and where they fit in its hierarchy. Organization charts are a tried-and-true way to do that for any firm larger than half a dozen employees. For this reason, Creative Business recommends that all firms of more than six employees have one.

The organization chart for a typical six-person design shop would look something like this:

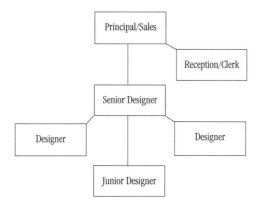

The organization chart for a typical twelve-person design shop would look something like this:

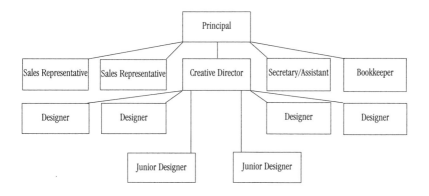

Note that the organizational structures shown in these illustrations are relatively flat—i.e., there are several employees to each supervisor. For a talent-driven service organization, the ratio of employees to supervisors should normally be less than ten to one. For more on organizational options, see chapter 2.

☙ Employee Handbooks ❧

The employee handbook personifies a firm's structure to employees and makes its procedures understandable and rational. Although often called the "policies and procedures manual," it is better to stay away from this nomenclature because it conveys the impression of being a list of what employees cannot do. Employee Handbook (or Employee Information if "handbook" seems inappropriate because of size) is more user-friendly and effective.

The best employee handbooks are short, informal, and written in everyday language. Lengthy, formal, and legalistic ones are seldom read or understood. More importantly, particularly in creative organizations, they can be off-putting to right-brained individuals. They also don't necessarily provide a greater degree

A page from a typical employee handbook. See appendix IV for a complete model.

of information or protection against individual misbehavior or mistakes. Firms of up to a dozen employees can usually get by with a handbook of a dozen or so pages. Larger firms will probably require a handbook with

more pages, but care should be taken not to make the descriptions of policies and procedures overly detailed. The handbook's tone is as important as its message.

WHAT'S REQUIRED. Although state and local labor laws vary, there are few requirements covering what you must communicate to employees. Moreover, in nearly all situations the employee/employer relationship is one of mutual consent, which either party may terminate at any time. In other words, employee handbooks are for information only. Within reason, nothing stated there will overrule your everyday management prerogatives, including the right to change your mind. Given the wide variance in local labor laws, however, you should have a copy of your employee handbook reviewed by a lawyer before distributing it. (Here are just two of the reasons why: some states require certain companies to publish or post antidiscrimination and sexual harassment policies; and "improper termination" suits may result unless certain procedures are described and followed prior to dismissing an employee.)

WHAT SHOULD BE COVERED. The objective is to answer basic questions and provide guidelines within which responsible staff members have freedom to exercise their own judgment. Don't try to cover every possible situation. A simple explanation of basic shop organization and procedures is all that is necessary.

Teamwork and philosophy. A personal message from the principal(s) sets the tone. It should emphasize the importance of individuals to the organization's success, and why following a few simple polices and procedures benefits everyone. It helps to state here the three needs that every business must address (customers, investors, and employees) and the company's operating philosophy (the "mission statement").

Organization and personnel. Acknowledged or not, hierarchies exist in every organization with a staff of more than three. To pretend otherwise leaves employees in the dark about the position they occupy. Organization charts are a simple, graphic way to shed light, especially when job positions are used rather than individual names. In organizations of less than a dozen persons, it also helps to include a profile of each employee. This provides useful information (e.g., home phone numbers) and makes individual employees feel they are important players on a major-league team. (Firms larger than a dozen employees can accomplish the same purpose without encumbering the employee handbook by publishing profiles separately.)

Working policies and procedures. The goal here is to help ensure that all employees work in a fashion that enhances productivity and reinforces the company culture. At minimum, this usually requires defining the following:

- Working hours—starting and quitting times, work breaks, etc.
- Attendance—the importance of promptness and how much flexibility is allowed
- Working relationships—resolving disputes, reporting sexual harassment, etc.
- Dress code—what's appropriate
- Quality standards—the creative review process
- Preparation standards—how work is prepared for client review
- Staff meetings—schedule and format.
- Time accounting—job sheets, etc.
- Security and safety issues—working after hours, etc.
- Noncompete agreements—limitations upon leaving the company (see the section later in this chapter)
- Idea and concept ownership—what employees are free to take and show when they leave

Dealing with the outside. As a service business, the way in which employees deal with clients and vendors directly impacts the company's reputation and future opportunities. Specifying how to handle the following situations will ensure that all employees present a uniform face to the public:

- Telephone greetings—what's appropriate
- Correspondence—style and formats
- Welcoming visitors—office hospitality procedures
- Vendors and suppliers—free choice, or are some preferred?
- Purchase orders—when and for what required
- Presentation standards—how work should be shown ("sold") to clients
- Cabs and delivery services—when to/not to use
- Freelancing—is it allowed, and under what conditions?
- Creative competitions—does the company encourage and pay entry fees?

Salaries and benefits. This is the area with the most potential misunderstandings, which also makes it the section of the employee manual read most thoroughly:

- Payroll schedule—how often is payday?
- Performance evaluations and salary reviews—how often?
- Holidays—which ones are observed?
- Sick and personal days—how many?
- Vacation time—how is it accrued?

- Overtime—when is it paid?
- Expenses—what's reimbursable?
- Meetings and dues—does the company pay for?
- Jury duty—the company policy
- Parental leave—the company policy
- Leaves of absence—does the company permit them?
- Bonuses—are there any, and who gets them?
- Healthcare benefits—what plans are offered, and who pays how much?
- Insurance—does the company offer any coverage?
- Retirement (pension) plans—does the company offer any, and if so, does it contribute?
- Employee stock ownership (ESOP)—is there a plan, and who qualifies?

Job descriptions. Including them in the employee handbook is important because they provide the basis for performance reviews. In addition, letting employees know the requirements for all positions in the company and their interrelationship shows the paths and requirements for advancement. The following summarizes what each should include. (More on preparation is under "Job Descriptions" below):

- Education—what is required and preferred
- Experience—what is required and preferred
- Important attributes—what an ideal candidate will possess
- Primary responsibilities—the most important functions of the job
- Secondary responsibilities—the less important functions of the job
- Promotion path—steps to advancement
- Salary grades—the compensation range of the job
- Labor status—whether the job is exempt from federal and state labor laws
- Supervisory responsibilities—positions overseen
- Reports to—who supervises the position

❧ Publishing Employee Handbooks ❧

You know best how to make your company's employee handbook impressive and befitting your company's style. You may need reminding, however, that it shouldn't be just published and forgotten; effectiveness requires occasional updating as new needs and procedures arise. One rea-

son employees often fail to take handbooks seriously is that they are not regularly updated.

In years past, most firms opted for a loose-leaf binder format with occasional single-sheet updates. The trouble with this approach is that it relies on recipients to do the updating, which they seldom do. A far more efficient approach today is to store the handbook as an electronic document and use print-on-demand technology to produce new handbooks as required. Larger firms can also make it available on their intranet, with changes announced by e-mail.

FOR CURRENT EMPLOYEES. If you are preparing your first employee handbook, or are revising a previous effort, first ask for employee input. What do they think should be included? Asking the question gives employees a sense of participation and will help blunt any criticism about the company becoming too structured.

When employees question the need, reassure them that it is simply a way of ensuring that working conditions won't be negatively affected by future growth or changes. It also reflects the reality that the company is engaged in an increasingly competitive business, not just art. Emphasize that if everyone follows the same procedures work life will be easier, efficiency increased, and there will be greater profitability, which leads to more opportunities for salary growth. Pose this question to any doubters: "Have you ever heard of a successful business that didn't have a way to ensure consistent and dependable products and services over the long run?"

Depending on initial employee reaction, it may also be wise to show your first draft for comments at a staff meeting. If so, be careful to indicate that you are seeking only ideas and style comments, not a rethinking of established policies.

When it is completed, provide each employee with a copy of the handbook at a special, dedicated staff meeting. Read over the content item-by-item, explaining the intent, filling in details that may have been omitted, and asking if there are any questions about application. This will ensure that all employees are equally well informed. Be sure to stress that the handbook provides only workplace guidelines and that policies are subject to change. Whenever an employee has doubts about a policy or procedure, you or their supervisor should be contacted for clarification.

FOR NEW EMPLOYEES. A handbook should be given to every new employee as part of his or her orientation. Here, too, read over the content item by item, explaining the intent, filling in details, and asking if there are any questions about application. This not only provides a good introduction to the company, but ensures that all new employees are as well informed as existing ones.

No matter how much time and effort you put into an employee handbook, it will only be as good as its implementation. This means that the policies and procedures should be followed by *all* employees—yourself included.

Job Descriptions

As summarized previously, job descriptions are an important component of employee handbooks. But even more important is the role they play in hiring, supervising, and rewarding employees. The most crucial resource any creative firm has is its talent, and job descriptions help organize it in a way that produces maximum benefits.

Just in case you may still think otherwise, "talent and organization" is not the oxymoron it may seem to be. It is true, of course, that talent needs freedom to bloom. But in commercial creativity it is also true that freedom has already been constrained by objectives, time, and budgets. Organization is simply a way of ensuring that talent resources are applied productively within the work environment. Good management of creative talent requires just enough, but not too much, control of employees; enough to enhance efficiency, but not so much as to dampen creativity. Employee job descriptions—along with hiring practices, policies and procedures, and periodic performance reviews—are one of the four cornerstones of good talent management. (For more on the benefits of structure, see chapter 2.)

WHY THEY ARE IMPORTANT. Every design firm with employees should have job descriptions, even when there are just one or two employees who work under the direct supervision of the principal(s). Here's why.

Hiring. Hiring the wrong individuals is among the most common and costly mistakes design firms make. Sometimes this happens because of busyness: "We're swamped. Let's get someone—anyone!—in here right away." Other times it is caused by not considering all facets of a job: "His book is just fantastic. So what if he's a little hard to get along with?" Still other times it is an unrealistic view of an employee's potential: "She is asking for a lot of money. But we'll find a way to cover it." In these and other typical employment situations, having a written summary of job requirements and duties can be an invaluable aid to describing, interviewing, and hiring the right individual. It will help keep you and the prospective employee from failing to recognize a latent situation that may cause big problems later on.

Productivity. Even the most creative individuals and organizations respond positively to some degree of structure. The bigger the organization, the more employees need reassurance about their position: How important is

it? Where do they stand in the pecking order? What is expected of them? How much future potential is there? The less concern employees have about such issues, the more their morale and productivity improve.

Evaluating. Every employee's performance should be periodically evaluated. Relating it to previously agreed upon job requirements adds a measure of objectivity to the process. The more objective the evaluation is, the easier it will be for you to conduct and the employee to accept. Indeed, it is both unfair and counterproductive to criticize an employee for any responsibility that hasn't been clearly explained. Although daily interaction is the primary means for this, it should build upon what is laid out in the written job description. (Don't be concerned about the possibility of job descriptions killing initiative—"I didn't do that because it isn't in my job description." Individual initiative is always implied and should be expected.)

Reward. Jobs that are clearly described, ranked in order of importance, and assigned a corresponding salary range are the best means of ensuring fair employee compensation. They also provide the incentive of an employee "advancement ladder." Without relating salary increases (raises) to both performance and an individual's position within a given salary grade, there's a strong likelihood of over- or undercompensation. For instance, an employee doing excellent work near the top of a job's salary range should get a smaller increase than one performing at the same level who is near the bottom. When an employee reaches the top of a job's salary range, he or she shouldn't get more increases unless qualifying for a promotion to a more senior job with a higher salary range. (For more on how to give raises see chapter 6.)

Protection. The opposite of rewarding and promoting employees is punishing or dismissing them. It is an essential component of good management, but can be risky in today's contentious and litigious world—unless it is based on objective criteria known to the employee. Performance appraisals based on previously agreed upon job descriptions provide the objective criteria. (There is more on this subject in chapter 8.)

Growth. Sales success and the growth that accompanies it can be a great thing for a company. Or it can be a disaster. Much depends on whether procedures to handle growth are in place. Defining a set of jobs and the relationships between them, including salary progression, assures a certain degree of orderliness in personnel growth. Remember, personnel are the most important component of a design firm.

JOB DESCRIPTION CONSIDERATIONS. Keep the following points in mind when preparing job descriptions for your firm.

There should be several. Even if you only have one employee, you should detail at least two job positions—the one the employee occupies, and one

Typical job description.
See appendix IV for a complete set.

for advancement. The minimum for most multiperson firms is three creative positions (e.g., Junior Designer, Designer, and Senior Designer) and one or more noncreative positions (e.g., Receptionist/Clerk). It is best is to have half a dozen clearly defined positions.

Salaries/grades. The compensation range of a position should be specified in salary grades, not dollars. This keeps salaries more private and allows changing the salaries within grades without redoing the job descriptions. Most positions should have a range of two grades to provide for salary growth. Also, some grades are appropriate to more than one position. When assigning salaries to grades, a range of around 20 percent (e.g., $30,000 to $36,000) is appropriate. Salaries within grades should also overlap by about 10 percent—i.e., the top salary of the next lower grade should overlap the lowest salary of the next higher grade. When assigning grades to job descriptions, bear in mind that the work time of individuals occupying the position must be billable at three or more times their salary. If this is not possible, the grade or person in it has been misclassified.

Language. Job descriptions should be simple and concise enough to clearly convey tasks and responsibilities. In addition, they should also make the employee feel that he or she is a valuable member of a team. The language used must be free of sexism, ageism, etc. Positions and responsibilities cannot be described in terms of race, age, sex, or fitness unless there is a compelling reason.

Titles. The label you assign to a particular position should not, within reason, limit your use of titles. For example you may prefer to give the per-

son occupying the position of senior marketing representative the outside title of Vice President of Marketing. Or give the occupant of a senior designer position, the title of Senior Designer and Co-creative Director. Use discretion, however. Titles may imply a responsibility not in keeping with the job description. They often affect the perception of other employees, too. And while they can be an important psychological reward to valuable employees, they can also go to the head of some employees. Further, check with a lawyer before giving any employee the title of Vice President, either officially or unofficially. It may convey fiduciary or other legal responsibilities, making you liable for some employee actions.

Labor laws. Whether or not an individual is exempt from labor laws depends upon his or her responsibilities. The labor status of an individual occupying a position should be stated in the job description, as well as personally explained. (The requirements one has to meet to be exempt are covered by state law but can't be less than those in the Federal Fair Labor Standards Act. Designers, salespeople, and other professional staff are nearly always exempt; clerical workers and nonprofessional staff nearly always nonexempt.)

Noncompete Agreements

Can or should you prohibit an employee from taking clients with them when they leave? The answer is a somewhat qualified "yes." Creative Business recommends that a firm's policy require all employees to sign noncompete agreements.

WHAT NONCOMPETE AGREEMENTS CAN AND CAN'T BE. First, it is important to recognize that if the agreement is reasonable, detailed, and limited in scope it will probably be enforceable. If it is none of these it probably won't be. As an example, an agreement prohibiting an employee from "doing graphic design for clients within the banking industry for six months after termination" would probably not be enforceable because it could deprive an individual of his or her right to earn a living. But a contract that prohibits an employee from "working for three months for any firm that has been a client of (company) within the past six months" is probably specific enough to be enforceable.

THE LIMITS OF EFFECTIVENESS. It is important to be realistic. Enforcing a noncompete agreement can be disruptive to business and expensive. The outcome can be anything from a simple "cease and desist" court injunction, to monetary damages, to a countersuit by the employee. In addition,

it is also possible that enforcement action will anger the very clients one is trying to save; a little like shooting off your foot while drawing your gun. Attempts at enforcement also often send a negative, "sour grapes" signal to other clients. If a client and one of your employees really want to work together in another arrangement, you'll probably lose the client anyway. So what's the benefit of prohibiting it? Spite?

THE REAL BENEFIT. What noncompete agreements are very effective at doing is making employees (and vendors when appropriate) aware that you take your business seriously and will fight to keep it. The confrontations you win are the ones you don't actually have.

BETTER TO ADDRESS THE PROBLEM THAN THE SYMPTOMS. Equally important in protecting business is for principals and sales representatives to constantly demonstrate to clients that meeting their needs takes a combination of strategy, creativity, service, and experience. In other words, your firm offers much, much more than the creativity and skills of a single individual, no matter how talented he or she may be. In the same vein, providing responsibility and incentives (profit sharing) will eliminate much of an employee's desire to leave. Our experience is that the solution to most potential problems lies in addressing the underlying causes—typically employee discontent or the principals and sales reps not taking an active enough role in servicing the business.

A COMPROMISE? The combination of noncompete agreements, employee satisfaction, and principals' involvement should eliminate most of the risk of employees walking away with good clients. In situations where a confrontation seems inevitable, however, a compromise is often preferable. A commission of 10 to 15 percent on assignments that a contested client provides to a former employee during the period of contractual obligation is worth considering as a release from the obligation. It can help both parties avoid a confrontation that benefits no one.

A sample noncompete agreement is on the following page. Rewrite it as appropriate. Then run your draft by a lawyer for reaction and fine-tuning.

⊛ A Note to You ⊛

Few things discourage employees faster than individuals or situations that appear to be above the rules that everyone else follows. If you find it necessary to make exceptions to placate invaluable talent (creative "stars"), they should be kept as invisible as possible.

Most important, if you don't take company policies seriously you may as well not go through the trouble of developing them. This isn't to sug-

gest that you not enjoy the privileges of rank, only that you not flaunt them. Employees will follow the lead of the principals who set the company's culture and style by their actions. A good manager not only enforces the rules, but also must be diligent about his or her observance of them.

It is also important to consider that written policies are just one of many management tools. To be effective they must be accompanied by other tools such as business plans, job folders, time sheets, efficiency tracking, and performance evaluations, to name a few.

And finally, there is no substitute for managing directly. Policies only supplement, never replace, the need for hands-on management. In design businesses

(print on letterhead)

Dear (name of new employee):

We are pleased to offer you a position of (job title) at (name of company).

Before entering our employment (as a condition for continued employment), (name of company) requires employees to understand and agree to the following provisions:

1. During my employment with (name of company) I will not independently accept, nor work on (graphic design/writing/illustration) assignments for payment, except as may be approved by (principal's name) or his (her) designee.

2. During my employment with (name of company) or thereafter at any time I will not disclose to others or use for my own benefit any trade secrets or confidential information pertaining to any of the business activities of (name of company), or its clients.

3. Upon termination of employment for any cause whatsoever, I will not continue to work on assignments that I began at (name of company), except as may be approved by (principal's name) or his (her) designee.

4. Within 180 days (six months) of termination of employment for any cause whatsoever, I will not solicit nor accept work from any individual or firm that has been a client of (name of company) within the past year, except as may be approved by (principal's name) or his (her) designee.

5. Upon termination of my employment for any cause whatsoever, I will surrender to (name of company) in good condition any and all records in my possession regarding the company's business, suppliers, prospects, and clients. Further, I will not make nor retain copies of these records.

If signed, this becomes a legally binding agreement. If you do not understand it, seek competent advice.

Sincerely,

(name)
Principal

I fully understand and agree to the above mentioned employment requirements.

_____ Date:_____

Typical noncompete agreement.

more than in most others, it is important for employees to receive regular feedback on the quality of their work and daily performance. This is the type of management that can never be codified and depersonalized. The role of policies is to free up time for hands-on, personal management by automating simple and routine procedures. Nothing more, nothing less.

A sample employee handbook and set of job descriptions can be found in appendix IV.

CHAPTER 5 Hiring

OW MANY PEOPLE does it take to run a successful graphic design firm? No more than it takes to run an unsuccessful one. There's little or no correlation between staff size and success. Small-firm principals can be as creatively and financially prosperous as principals of the largest firms. (More on the economics of size and growth for design firms is in chapter 14.)

But there is a very definite correlation between a design firm's income, its size, and its success. Even more important is the correlation between the quality of staff and success because employee quality largely determines product (creative) quality.

Knowing when, whom, and how to hire is at the very heart of the personnel issues facing a design firm of any size.

⊛ Staffing Norms ⊛

The relationship of income to staff is the first staffing consideration because it indicates how many people—principals and employees—are actually affordable. Pure design firms, those that neither place advertising nor purchase printing, traditionally have had about ten staff members for every $1 million in sales. By contrast, large ad agencies traditionally have about one staff member for every $1 million in media billings. Smaller combination shops, those whose work is a more or less equal mix of collateral and ads, often have five or so staff members for every $1 million in media billings and sales.

The problem in looking at these traditional ratios is that today most firms have their own unique mix of income-producing activities, including that newcomer—interactive or Web projects. This not only reflects some clients wanting more services under one roof, but also a desire of the firm to tap into every possible profit potential in order to remain competitive. Therefore, a more universal indicator of staff size to income is called for. Creative Business recommends using AGI (Agency Gross Income) instead of sales volume. AGI is defined as what's left after outside costs of goods resold—usually printing, media, and outside labor—are subtracted. It is the money that "sticks," primarily composed of hourly fees, commissions, and markup profit.

Using AGI as a measure, and irrespective of their specialties or size (see "The markup/commission effect" below), most design businesses should have an average AGI of $9,000 per month, per employee, or better. The higher the figure, the more profitable the operation. To determine it, simply divide your firm's average monthly AGI by the total number of employees—creative and noncreative, including principals. As an example, an average of $55,000 for a six-person firm would give a figure of $9,166 per person. (For part-time employees use appropriate fractions.)

FINANCIAL FACTORS. AGI will give a good overall indication of staff affordability because it takes into account both income-producing (creative and production) and non-income-producing (sales and administrative) staff. If your employee/AGI ratio is too high, chances are you are over staffed; if too low, you could probably afford more staff. But before making any decisions, be sure also to look at it in terms of the following, all of which are summarized in chapter 15.

The payroll effect. To achieve the AGI goal of $9,000 or higher per employee, the billed time of billable employees will probably have to be at least three times their salary—i.e., an employee making $3,000 a month should average billable time of *at least* $9,000 monthly. If this is not the case, the employee is either overpaid, underworked, or the billing rate is too low.

The billable efficiency effect. Most design firms that have been successful over the long run average from 50 to 75 percent billable efficiency (the average percentage of a firm's time that's billed out). Staying within this range is crucial. Billable efficiencies outside the range are sometimes the result of faulty reporting. If accurate, however, they indicate serious problems—less than 50 percent a marketing or time-management problem; more than 75 percent a neglect of crucial administrative and long-term planning functions. Either way, they are unsustainable.

The markup/commission effect. For most design firms any markup (printing) or commission (ad) income that accounts for more than about 20 percent of a firm's AGI should be excluded in determining the employee/AGI

ratio. If this is not done, it will give a false indication of appropriate staffing. Equally important, by taking the focus away from staff efficiency and putting it on commissionable sales, business emphasis is shifted from unique services to hard-to-differentiate commodities—not a good strategy for most design firms. Markup and commission income should normally be considered additional profit, not the firm's raison d'être. (This would not be true for large, commission-driven ad agencies. They operate with a different business model and would include all commissions in determining staffing levels.)

The productivity effect. Finally, keep in mind that the employee/AGI ratio is not a static figure. When salaries rise as fast or faster than productivity, as is the case at this writing, the figure will go up. (Creative Business's recommendation a few years ago was $8,500.) If, on the other hand, productivity should outstrip salary increases, the figure will go down.

Salaries-to-other-expenses. Payroll and benefit expenses for most service organizations generally run in the range of 60 to 70 percent. (All nonpayroll expenses 30 to 40 percent.) Most design firms should also fall within this range when AGI rather than total income is used for the calculation. While accurate for firms of all types and sizes, these numbers can be misleading for project-based organizations such as design studios or smaller marketing communications firms. For, unlike agencies whose ongoing contracts make new business costs comparatively tiny, project-oriented firms face significant marketing costs. When the personnel cost of marketing (salaries) is lumped together with all other salaries, it results in a distorted view of the actual costs of procuring business.

For this reason, Creative Business recommends that for staffing determination purposes the salaries of marketing personnel be considered as a cost of marketing, not a general payroll cost. When considered this way, our recommended distribution of AGI is 45 percent payroll/benefits (excluding sales' salaries), 20 percent marketing (including sales' salaries), and 35 percent for all other costs.

Profit margin. As counterintuitive as it may seem, profit is usually not a reliable indicator of staff affordability for most design firms. The reason is that the traditional definition—what remains after all expenses—assumes that salaries, the major expense category, are independently determined by marketplace forces. This is not true, however, of closely held firms whose principals set their own salaries.

Those firms where principals give themselves generous paychecks end up with lower profits than those with comparable income whose principals are more conservative. Moreover, the smaller the firm, the more effect principals' salaries have on profitability because they are a higher percentage of expenses. In fact, most design firms show no profit, the princi-

pals taking out all their firm's earnings as salary. (It is often a prerequisite that a business show something in the profit column before it can obtain significant financing.)

For the above reason, Creative Business recommends that closely held firms use principals' salaries, not profit, as a rough guide for staffing affordability. Before additional staff is added, principals should be paying themselves as much as they could make if employed elsewhere, or as much as an investor would pay someone else to run the company. This is a realistic indication of whether their business is profitable enough to afford more help. Larger design firms, those who do have profit margins to look at, must be able ultimately to maintain or better their profitability after staff additions. Any temporary reduction should be considered as an investment of the firm's profits into a buildup of personnel resources. Expect a return on this investment—previous profitability or higher—within six months or so. (For more on defining profitability, see chapter 15.)

THE 60/6 RULE. This is a particularly helpful guide for smaller organizations: Principals or affected employees should be working around sixty hours each week for six months or longer before additional staff is considered. Until then, work hard, pay overtime, or hire freelance or temp help. Don't hire more permanent staff until the pain of not having enough becomes both unbearable and demonstrably long-term. Observing this rule will reduce the very common mistake of hiring too soon; of making a long-term commitment for what is actually a short-term need. Keep these two points in mind: 1) Every new employee comes with the need for a regular paycheck in the future, whether or not the work will be there to cover it; and 2) dismissing an employee is always much, much harder than hiring one.

THE TALENT MIX. Until recently there were loose guidelines design firms could follow regarding what types of talent were needed as they grew. Most are no longer applicable. One reason is that today there's a greater variety of work being done for more types of clients than ever before. There is also an across-the-board increase in the level of competition, which requires more marketing and customer service for some firms. And there is the "productivity revolution," a sea change in the way work is handled and by whom—employees may be doing traditional print design today, interactive design with a little programming thrown in tomorrow, and presenting to a potential new client the day after.

For these reasons traditional staffing ratios are seldom applicable anymore. It may, however, help to know what they were. Awareness of the staffing mix many firms used in the past might help you make better decisions about how many of which kinds of talent are needed for your firm's particular business mix. Below are two traditional models often used as a firm grew to half a dozen individuals. Beyond this point all staffing is par-

ticular to the firm's requirements, although some ratios are more or less ongoing.

Traditional design firm staffing. First person—design/sales; second person— design; third person—design; fourth person—clerical; fifth person—sales (or design if 1st person is devoted 100 percent to sales); sixth person—traffic/production; seventh person—bookkeeping.

Traditional advertising agency staffing. First person—creative/AE; second person—creative (talent complementary to 1st); third person— creative/production; fourth person—production/reception/clerical/bookkeeping; fifth person—traffic/media; sixth person— creative; seventh person—creative/AE.

How About a Virtual Staff?

It sounds attractive: building a design firm around a stable of freelancers or temps who can get the work done, but don't require an employment commitment or employee benefits. Unfortunately, what sounds great seldom is. There are three reasons why.

The first reason for opting for permanent staff over outsiders is that chances are you'll have to offer your clients dependable, consistent talent if you want to grow your business successfully. Employees give you more control over quality and scheduling, allowing you to obtain the size that often leads to better clients, workload consistency, and creative variety. The temp or freelancer you need may not be always available.

The second reason is economics. It is hard to find consistent, dependable outside talent that is not more expensive in the long run than salaried personnel. Good, independent freelancers have to charge more than comparable staff salaries for comparable levels of talent. If they don't, they won't be in business long. If you rely on temp agencies, you pay for the individual plus the agency commission. (Temp agencies usually mark up the fees of their talent by sixty percent.) In other words, it's tough for you to consistently mark up good outside labor enough to make an acceptable profit.

The third reason for not relying on freelancers is to stay out of trouble with the authorities. Anyone working consistently on your work, especially if working in your premises with your equipment, must be treated for tax and legal reasons as an employee. To treat them as contract labor is to run the risk of significant fines and penalties. Even if challenged and you win, it will be costly. The risk just isn't worth it. Before providing a lot of work to a single source of outside contract labor, be sure to check with your accountant. (Note: Temps hired through agencies are not a problem, as they are actually employees of the agency.)

Temporary employees, whether hired on your own, through an agency, or by posting jobs on freelance/job-connection Web sites, are great back-ups. But that's it.

❧ Working with Outside Help ❧

Design firms should be staffed for "normal" levels of activity. Freelancers and temps should only be called on as necessary to handle rush work, get over a crunch in times of high activity, or to fill in for absent staff. This is the traditional "crisis-driven" use of outsiders. It is still valid and always will be.

What's changed in today's business environment are the definitions of "normal" activity and staffing. As most experienced shop principals will attest, the situation now is dramatically different than it was just two decades ago, in the pre-computer era. Computers have raised overhead costs significantly, leaving most firms much less financial breathing room. By consolidating many functions in one place handled by a well-paid individual, they have also raised the cost of some functions. The result is that today's design company must be much leaner and more efficient to remain competitive. But how to also maintain the same level of creativity—a firm's "product"— while doing so? This is where the new emphasis on the use of freelancers and temps in a profit-driven (versus crisis-driven) role comes in.

Some firms have learned to operate around a core group of a few talented and experienced individuals. These individuals are senior talent and project directors who put together teams of freelancers and temps to augment, as necessary, their own talents and availability. Firms adopting this modular fashion of operation have the freedom to expand or contract their personnel resources as business opportunities dictate. When properly structured and utilized, such an arrangement can, overnight, make a small firm into a much larger one, supplement otherwise limited experience, and provide specific talents for specific assignment opportunities. It is the practical application of the "virtual staff" idea.

Even for everyday, run-of-the-mill work, this structure has the potential of increasing profitability. Given the cost of benefits and downtime it is often possible to pay a short-term freelancer or temp substantially more per hour than some employees receive and still produce more job profit. If his or her pay can simply be marked up and passed along in the invoice, additional profit is possible.

THE POTENTIAL PROBLEMS. If the above is the opportunity, then what are the problems? One is that it is next to impossible for any principal to know of all the varieties of talent available in most metropolitan markets. And even if it were, a great portfolio is still no guarantee that an individual has

good work habits. If you've hired freelance talent recently, you know only too well of the difficulty finding individuals who are reliable, talented, and businesslike.

There is also the concern about whether a freelancer might be classified by taxing authorities as an employee. To them, an employee is anyone who meets certain workplace criteria, regardless of what anyone else, including you and the individual in question says. How a worker is classified makes a difference because, among other things, if he or she is an independent contractor you don't have to worry about withholding employee taxes or paying the employer portion of Social Security, worker's compensation, or unemployment insurance. On the other hand, if the freelancer is an employee of yours (or could be classified as one), you do. As you can see, it is an expensive distinction. That's why the IRS and state authorities are always looking for firms saving money, often innocently, with employees they have misclassified. After hiring a freelancer, if you are not careful about his or her working conditions, the amount of control you exercise over the freelancer's work, and payment procedures, it can cost you dearly in the future. If discovered, you will not only be subject to paying what you owe, but interest will be added, and you may be required to pay a penalty.

USING A TEMP AGENCY AS A RESOURCE. The problems mentioned above can be addressed by a temporary personnel agency specializing in creative individuals. They can take on the rough-cut interviewing, leaving you to make a decision from among just a few qualified individuals. And by becoming the selected freelancer's employer of record, they eliminate all your tax, regulatory, and administrative costs and concerns.

Individuals of all talent and experience levels and prices are usually available for both long-term in-house assignments and short-term out-of-house projects. You set your own criteria and terms. As for value, chances are good that you will be able to get higher-quality individuals for only slightly more than if you hired them without temp firm involvement. This is due primarily to the large number of creatives you have to choose from. Most savings, however, come from much reduced interviewing, bookkeeping, and administration costs. An additional benefit is the possibility of using the temp firm to place temps with you on a trial basis, with permanent employment in mind.

WHEN WORKING WITH A TEMP AGENCY, CONSIDER THESE FIVE POINTS:

1. Define your specific need and find the firm(s) who recruit and place individuals with the skills you require. Some firms specialize in certain industry areas (e.g., publishing), while others tend to be generalists.

2. Ask about how the firm(s) you select recruit and screen individuals, including how candidates are prequalified regarding appropriate expe-

rience levels and how they are reference-checked. How are an applicant's credentials and reference information made available to you?

3. Make sure the candidates are available for interviewing by you before you make the hiring commitment.

4. For tax-reporting purposes, be sure the individuals are appropriately classified as employees of the temporary services firm. This ensures that they, not you, are responsible for insurance and taxes and for withholding and reporting. This helps protect you from a wide variety of potential job-related claims.

5. Make sure there is a policy regarding what happens if you are unhappy with the person selected, and that replacement candidates are available. Check the depth and breadth of the temp firm's talent pool. Ideally, you'll want to have more than one candidate from which to choose, as well as access to backups if the workload increases beyond what was initially anticipated.

TO GET YOUR MONEY'S WORTH, BE SURE TO:

1. Define your project and personnel needs first. If you are not sure, ask the temp firm for help.

2. Define the job as precisely as possible: What do you expect? By when? What flexibility do you have about the approach ("Just do what I say," versus "I'd like your input").

3. Assemble required resources (e.g., printed material, access to others within and outside your organization).

4. Advise those individuals within and outside your organization who might have contact with him or her that a temporary employee will be working with you.

5. Determine in advance which information should be shared with the temp, and which shouldn't be.

6. Identify mileposts, and expect the temp to adhere to the same high standards you apply to your permanent employees.

7. In case of a problem, deal with it early. If you don't want to deal with it directly, call the temp firm for assistance.

⊛ Using Interns ⊛

Interns are not the way to address a shortage of labor. In many cases they take up more time than they contribute. This is not to discourage their employment, but do it for the right reasons: helping a young person learn the practical side of the business, tackling tasks that otherwise never get

done, and possibly trying out a student as a potential future employee. Principals who take on an intern primarily as a way of quickly obtaining cheap help are almost always disappointed. Also, and not insignificantly, it creates resentment in the intern, one of the young people who represent the future of our industry, our best and brightest. Don't consider taking on an intern without first thinking about the following.

SELECT CAREFULLY. It may not be as important as for a permanent employee, but choosing an intern still requires interviewing several individuals and selecting the one with the combination of experience, talent, and personality that best fits your firm's style and culture. Selection is especially important if the internship is a trial that may eventually lead to a permanent position.

DEFINE RESPONSIBILITIES. The intern must know exactly what will be expected and be comfortable with it, even if it is nothing more than being a gofer. Set regular working hours and provide a dedicated workstation.

INVOLVE YOUR EMPLOYEES. They are the ones who will have to work side-by-side with the intern. So solicit their input. One employee should also be designated as a mentor to answer questions and determine priorities.

PROVIDE COMPENSATION. It is the only way to ensure productivity. It helps both you and the intern take the assigned responsibilities seriously. Compensation does not necessarily mean cash, however. It may also mean course credit, or it may be a combination. The experience of most *Creative Business* newsletter subscribers is that interns who work totally free are worth less than what they are paid, since they cost heavily in terms of work-flow disruption.

Finding Qualified Applicants

The labor market for graphic designers waxes and wanes—sometimes it's tight, sometimes not. There is one constant, though: all principals comment on the difficulty of finding qualified applicants. When trying to fill a junior-level position the problem is usually locating a well-rounded talent who is not overly enamored with gimmicks and technology, and who appreciates the commercial side of the business. With more senior positions the problems are the higher costs driven by competition from corporate salaries and benefits. Although we can offer no easy solutions to these universal complaints, we can pass along some thoughts about the available options.

Before that, however, a word of caution: While you need to be as specific as possible when trying to attract talent to your firm, you also need to

be careful not to give the appearance of discrimination. For example, never advertise for a "young" person, or for applicants by sex. Even though small businesses are exempted from many state and federal antidiscrimination laws, some do apply.

NETWORKING. The oldest way to find creative talent is probably still the best way. If you're lucky it may be all that's necessary, especially if there is enough time, the job market is not too tight, and your firm has a reputation as a stimulating place to work. It is your least expensive option; it reduces the number of unqualified individuals to interview, the input that often accompanies referrals makes selection easier; and most potential applicants will be from the local area. So the first thing to do when looking for qualified individuals is to put the word out. Everywhere—creative club meetings, local colleges, paper reps, service bureaus, printers, and competitors (yes, competitors, for the following reason). Broadly publicizing your need not only increases your chances of finding the right person, but it also usually reinforces the perception that your firm is prosperous and growing.

WEB POSTINGS. Listing your opening on the Web and checking the résumés of designers looking for work should probably be your second choice. Second only because the individuals you find this way probably won't be as well-qualified as those who come through networking, and most listings are national, rather than local. There are sites devoted to this activity, as well as several industry organizations and publications that provide job bank and résumé listings on their sites. Some are free, some ask a nominal charge.

PRINT ADVERTISING. This traditional route of publicizing an opening and attracting candidates has been somewhat usurped by the Web, but ads in magazines still have great impact. They are delivered right into the hands of potential applicants; there is greater opportunity to design an ad for impact, and it is possible to target the audience more precisely. Cost is a drawback, but many of the most effective publications, such as creative club newsletters, are inexpensive. Even classified ads in local editions of advertising publications and general circulation design magazines are relatively inexpensive, especially when compared to employment agency fees.

TEMP AGENCIES. Most temp agencies can also be a source for full-time employees. It is usually possible to select an appropriate individual and arrange "trial" employment through them. It may even be possible to try out several candidates this way. The obvious benefit is that even the most rigorous pre-employment screening is never as good as the day-in, day-out opportunity to observe someone for an extended time under actual

working conditions. In taking this route it is always best to let the agency know at the outset so they can select the most appropriate individuals. Temp agencies are most valuable in finding permanent help from the local area and when the job description calls for individuals with skills and talents already represented in their existing database. The major drawback is cost. There are the normal fees during the trial period, and the placement fee can be 30 percent or more of the employee's first year salary, although it is often discounted based on the time already billed through them. Further discounts may be available if you have called upon the agency for several temps in the past.

EMPLOYMENT AGENCIES. Traditional employment agencies ("headhunters") are most valuable when a specific type of individual or talent is sought, or when the employee search is extended to areas where the principals have few contacts. There is usually no fee for enrolling. (An exception, applicable only to the largest firms in the business, is an "executive search" in which a fee is paid regardless of the outcome.) The industry consensus on the use of employment agencies is mixed, depending on the client's (your) needs, sophistication, and budget. They probably have more dissatisfied clients than happy ones if large agencies and corporate clients, the bulk of their business, are excluded. But some small creative firms are enthusiastic. Here are some things to consider.

Pros: It saves on running ads, sifting through résumés, and conducting numerous interviews. Outsider involvement and the possibility of paying a fee forces needs to be defined more carefully, and provides a measure of objectivity that can result in hiring better individuals. Agencies have industry sources that can produce candidates who could not be found in any other way, an important consideration when looking for specific talents and experience. And, finally, there may be no cost to you unless you actually hire a candidate who stays. (Most employment agencies use a sliding scale of fees for hires who end up leaving the employer within a few months.)

Cons: The cost is 30 percent or more of the new hire's first year's salary. Moreover, because the greater the new hire's salary the more the agency's commission, there's a tendency to encourage candidates to overprice themselves. Some agencies also don't do a good job of prescreening, especially for the possibility of subjective, "cultural" mismatches. To maximize the potential of success, make sure you have a detailed, up-to-date description of the position for the agency to work from. Also, be very specific about your personal idiosyncrasies, likes, and dislikes. If you consider individuals from outside your immediate area (the situation in which they are most effective), the employee may expect you to pay relocation expenses, usually $10,000 and up.

However you come by applicants, remember that you are hiring a living, breathing individual, not just a portfolio. As great as an individual's book may look, there is much more at stake. In reviewing the reasons why new hires don't work out, Creative Business surveys show that it is most often because the person was hired based only on his or her talent. Eventually, the important issues of personality, working habits, experience, judgment, client compatibility, and over- or underpayment surface. In addition, it is hard to determine when looking at a portfolio just how much of it is the actual work of the presenter.

Sample application form.

ESCHEW CLONES AND FRIENDS. As tempting as it might be to hire those with similar creative styles and experence, resist the temptation. You want a staff that can be a source of different creative and business perspectives. It is also better not to employ friends and sometimes family. Running a business requires making decisions that affect the lives of others (e. g., who should receive salary increases). Making these decisions is tough enough without the additional worry about affecting friendships.

REQUIRE RÉSUMÉS. Ask for one, even from an individual whom you know has a great book, and will occupy a minor role in your organization. Why? Because it is both a summary of skills and experience, and a fileable listing of important personnel data should the applicant later be hired. For two- or three-person creative businesses a résumé can also serve double duty as a job application. When requesting résumés you should also ask for a stylesheet, tearsheet, or sample. To save the time and expense of looking at and returning portfolios, it is better not to request them. Quickly reviewing résumés and a creative sample is a time-saving filter that can limit your interviewing/portfolio reviews to fewer than a dozen of the most promising candidates.

If you get a large number of résumés from an ad or public inquiry, you'll probably want to separate them into three groups: 1) the best—the half dozen or so that warrant an interview/portfolio review; 2) the "maybes"—a half dozen or so others that are worth seeing only if you can't get an employee from the first group; and 3) those that don't make the cut for the first two groups.

USE A JOB APPLICATION FORM. The reason to use a form is that it will provide standard information on each candidate. Résumés not only have different styles, but they may omit vital information. Having a standard job application makes comparing qualifications easier, and it forces each candidate to go on record about his or her background. In addition, it will become part of an employee's personnel file. A sample job application form is shown opposite. (In shops with just two or three individuals an application may be overkill, providing the interviewing process is thorough.)

❧ Interviewing Applicants ❧

A good interview will probably take an hour, some may take longer, and some others (mostly for higher-level positions) may take place several times and involve a lunch or two. Good interviews cover two areas—an objective review of the applicant's history and experience, and a subjective evaluation of his or her qualifications and potential. The key to uncovering the real individual behind the candidate facade is to let him or her do most of the talking and for you to do most of the listening.

Applicants should be interviewed first by the person to whom they will report. Strong applicants should also be interviewed by the firm principal(s) if he or she is not the same individual. The final decision, however, must be in the hands of the person who will be the applicant's supervisor. (Each employee should report to a single individual, even in firms with

Since you don't interview employment candidates every day of the week, here are tips from those who do—personnel managers.

• Study the candidate's résumé and application beforehand. The less often you refer to them during the interview the more comfortable you will both be.

• Take notes. You'll need them to recollect specifics later on. But don't bury yourself in your notepad, either. This is an interview, not an inquisition.

• Encourage the candidate to ask about the job and your organization. Remember, he or she should be interviewing you as well.

• Try to keep questioning open-ended. Avoid questions with obvious "right" answers. Those beginning with "how," "why," or "when" usually produce much more revealing answers.

• Be particularly careful to avoid questions that don't effect performance, especially marital status, race, age, ethnic background, etc.

• Listen for hints of job-related problems: poor attendance, "prima donnaism," difficulty being a team player, trouble with client relationships, etc. Probe these areas in the interview, and later when checking references.

• Watch the candidate's body language. It can reveal a lot about interpersonal skills.

• Keep in mind that past problems don't necessarily disqualify a candidate. It's what he or she learned from them that counts.

• Be noncommittal. Don't make or imply any promises. They could come back to haunt you later.

• Do not ask anything that might imply discrimination. Examples: Who takes care of your children? (Possible sex discrimination.) Is there anything that might affect your work that we should know about? (A code for finding out about handicaps.) What does your spouse do for a living? (A way to indicate sexual preference.)

multiple principals.) Leading candidates should be introduced to other staff members, allowing them the opportunity to chat casually for a few minutes. Soliciting employee impressions before making a hiring decision will not only provide additional input, but help them feel they are part of a team effort. Some things to look for when interviewing follow.

PERSONAL CHEMISTRY. The smaller the company, the more stressful the working conditions, the more important it is to hire someone whom you and other employees can easily get along with. Remember this: Talent and style should be different, personality and worldview similar.

ATTENTION TO DETAIL. Unless the job is specifically for a "concept person," you'll want an individual who is executional and detail-oriented, one who is as much a craftsperson as an artist.

GROWTH POTENTIAL. Find the very best talent you can afford, then train and help him or her grow. Don't worry about whether or when the employee might leave. In most cases your business will benefit far more from a real talent who leaves to go on to bigger and better things than from a lesser light who sticks around, thankful for any job.

BUSINESS SENSE. A good candidate appreciates that your com-

pany—and continued employment—will depend not only on producing good work, but also producing a predictable profit.

A TEAM PLAYER. The success of every design firm requires teamwork. In smaller firms, everyone occasionally has to pitch in on a variety of chores. In larger firms, creative teaming is usually required.

ADAPTABILITY. The job an employee is hired for quickly changes in most organizations, especially in small ones or in high-level positions. Circumstances are constantly changing, and every individual brings to a position a unique style and ambitions. The more flexibile, versatile, and easygoing the candidate is, the greater the chances he or she will perform satisfactorily in a changing environment.

COMPLEMENTARY SKILLS. The path to growth, stability, and profitability lies in the ability to offer clients a variety of styles, techniques, and solutions to problems. This means hiring new employees who complement and enhance the company's capabilities not duplicate them. It cannot be overemphasized that ideal candidates are similar in personality, but different in creative style and experience.

SELF-CONFIDENCE. Ideal applicants also interview you. They recognize that they need to be as

QUESTIONS TO ASK

In addition to specific inquiries into a candidate's background and experiences, you should also ask questions designed to provide insight into personality and ambitions. Here are a few examples (and what you should look for).

• Who are your creative idols, and what is it you particularly like about their style? (Do you like the applicant's choices?)

• What adjectives would you use to describe your work? (Do they match your impressions?)

• What adjectives would you use to describe your personality? (Do they match your impressions?)

• What is the most difficult design challenge you've had in the last two years, and how did you handle it? (Look for good problem-solving skills.)

• What do you consider your most significant personal accomplishment? (Are you impressed?)

• Can you give me two examples that demonstrate your initiative? (Do they show a self-starter?)

• Describe the two most important strengths you'll bring to our organization. (Look for an ability to "sell" his or her talents.)

• What are your creative and working weaknesses? (Look for honesty without self-effacement.)

• Without using names, describe two of the most difficult people you've ever worked with, and how you managed? (Does the answer demonstrate creative and working flexibility?)

• What would you like to be doing career-wise in five and ten years? (Look for ambition and a desire to learn and grow.)

• Why should we hire you and not another candidate for this job? (This is a test for self-confidence.)

comfortable with your procedures and opportunities as you are with their background and style.

ENTHUSIASTIC REFERENCES. Call and personally talk not only to each reference provided, but also any appropriate employers and clients. (Caution: Do this only with the applicant's permission, as it may alert the world to the fact that he or she is looking for another job.) Given the reluctance of many references to say anything that might adversely affect an individual's employment possibilities, look for unqualified recommendations. This is your protection, albeit imperfect, against hiring somebody else's problem.

❧ Evaluating Creativity ❧

Looking at the applicant's work is the other subjective part of the interview. Only you can determine if it meets your quality standards. But there are also several other issues to consider, not the least of which is determining just how much of what you see is the result of the candidate's own thought and execution.

PROBLEM SOLVING. Solving clients' communications problems is the very essence of a design business. The more the applicant talks about objectives and strategy and how his or work addresses them, the better. Regardless of samples, beware of applicants (especially younger ones) who demonstrate excessive concern about style and "integrity." They may be talented, but have trouble adapting to the compromises of the real world.

VARIETY. Simply, the more the better. Look for demonstrable accomplishments (major clients, demanding assignments, prestigious awards, etc.) that complement your subjective impressions.

ORIGINALITY. Good commercial design, the type that pleases clients, requires coming up with original solutions. Adapting something already done in another situation is not only artistic ennui, but it is usually inappropriate.

EXECUTION. Unless your firm also has junior-level staff to flesh things out, great concepts are only as good as the ability to produce them.

POTENTIAL. A portfolio is simply an (imperfect) indication of what the individual has accomplished, not necessarily what he or she is capable of doing. Does the applicant show promise? It is usually cheaper and better to hire someone with lots of promise and enthusiasm than someone with good samples, less initiative, and limited growth potential. At the same time, however, don't fantasize about making someone more talented,

because you can't. Employees can grow in experience and styles can evolve, but talent is innate. They either have it or they don't.

A TEST. Even the best portfolio and interview can't tell you for sure how much creative direction the candidate requires, or how efficiently he or she works. The best way to find out how much talent a person actually has is to give a test, a standard procedure for some large design firms. The test you give doesn't have to be elaborate. Simply devise a creative problem, then sit the applicant down with paper, pencil, and a creative brief in a nondistractive area. Allow an hour to come up with a couple of solutions. If you compare the results from two or three different candidates, usually the best of the group will be apparent.

ASK TO SEE REJECTED WORK. This is another way to assess how good an applicant may be on their own. It not only indicates their unmodified style and taste, but will be free from any commercial considerations and modifications made by the client. It is also sometimes the only way to see how good young designers really are.

⊕ Salaries and Benefits ⊕

The larger the design organization and the more mature the applicant, the more important compensation (salary and benefits) becomes. The smaller the organization and the younger the applicant, the more salary and benefits take a back seat to such considerations as a relaxed working environment and the opportunity to work on stimulating projects. Whatever your size, the *combination* of what you offer a potential employee—salary, benefits, working environment, and creative stimulation—should be at or above the norm for your area, and especially those of your competitors. It is the only way to attract and hold good employees. And a stable of good employees is the key to long-term success.

SALARIES. The pay you should offer an applicant is a function of what you can afford, local market conditions, and the person's talent and experience. The first of these is covered earlier in this chapter (see "Staffing Norms"). The next, local market conditions or what others are paying, can usually be determined by networking at local creative club meetings or simply asking around. Your accountant, who probably sees the books of several other small businesses, can also give you a good read on what others pay employees with comparable skills.

Salary surveys, such as those published by the American Institute of Graphic Arts (AIGA) and design publications, including the *Creative Bus-*

iness newsletter, can also be helpful, as can Web sites devoted to salary research. Finally, there's always a certain amount of winging it—discovering what an applicant is willing to accept and what he or she isn't.

Keep in mind that the salary offered to an applicant should fall within the range for that position as determined by the job description (see chapter 4). The appropriate salary for applicants whose talents and experience only minimally qualify them should fall in the lower third of the range; the salary for an applicant with average qualifications should fall in the middle; and the salary for a very well-qualified applicant should fall in the top third. This is important because the higher an employee is within the salary range for the job, the more difficult it is to get future raises.

BENEFITS. Ethical and legal considerations require that most benefits be the same for all employees—ethical because it is only fair, legal because the tax deductibility of most requires that they be offered equally to employees. Therefore, they are not normally a subject for negotiation when hiring an individual, although their extent can often have a major influence on whether an employee will accept an offer. This is especially true among more mature employees with families and responsibilities. Following is a summary of industry norms and what Creative Business considers necessary at the time of writing.

Health/dental insurance. This is the most important employee benefit, and all but the smallest firms offer plans. Average employee premium covered is 75 percent; average dependent premium 10 percent. For all firms we recommend 80 percent coverage for employees, none for dependents—enough to be a real benefit, but not so much as to eliminate an individual's sense of personal responsibility.

Life insurance. Nearly all large and most small firms have company-sponsored plans, and most contribute to them. We recommend that every firm have one, that coverage be for 50 percent of one's yearly salary, and that 100 percent of premiums be covered.

Parental leave. Keeping an employee's job open for several months may be required by law. About 25 percent of firms, nearly all of them larger shops, provide full pay for up to three months. For most, we recommend an unpaid leave of absence for up to three months.

Disability insurance. Despite its importance, only about half of firms provide a plan, although most that do pay premiums. We recommend that firms provide it, and offer to reimburse (not pay) 50 percent of premiums for a policy that covers 75 percent of current salary until age sixty-five. (By having the employee pay the premium and providing reimbursement as additional salary, any benefits will be tax-free.)

Overtime pay. It is not required for exempt (mostly creative and sales) staff. It is for nonexempt (mostly clerical) staff. (Nonexempt personnel are individuals covered by state labor laws, which dictate certain working conditions.) Nonetheless, 10 percent of firms we've surveyed grant it to exempt staff after eight hours; 25 percent after ten daily hours, or fifty weekly hours. Most others provide informal and arbitrary comp time. We recommend a formal comp time policy (no overtime pay)—1 1/2 hours for every hour worked over ten in one day, or fifty in one week, preferably taken during slow times. (Note: exempt employees should be expected to put in something more than a forty-hour week without additional compensation. It's part of the definition of being a professional.)

Vacations, holidays, and sick days. Industry averages are difficult to calculate because of the effect of employee longevity, and because firms often distinguish between vacation days and sick days. Our recommendation is to eliminate the distinctions and provide all employees with 1 vacation/sick day off for every month or fraction worked for the first four years (twelve days yearly used any way desired); 1 1/2 days per month for five or more years. We also recommend that principals exercise discretion in whether or not to count occasional, legitimate sick time. As for holidays, ten per year is the average and our recommendation.

Retirement plans. About half of all creative firms, and nearly all larger ones, offer some type of plan. About 25 percent also contribute to them. The most popular is a 401k, which arguably has the best combination of affordability and flexibility. (401k plans are stock investment plans provided by an employer.) Given individual situations and constantly changing options, we can't make a blanket recommendation. We do, however, recommend that all firms have some type of company-sponsored plan, and distribute a portion of any profit sharing through it. We also recommend that the plan have long-term vesting (usually seven years), which means that employees only receive a portion of any company contributions if they leave before being fully vested. (They will, of course, receive all they have personally contributed to it.)

❧ Informing Applicants ❧

It is seldom appropriate to hire anyone on the spot. End every interview by informing the candidate when you will make a decision, giving yourself as much time as possible (a week or two is normal). If you are seriously interested in the candidate, say he or she is on the "short list" (no more) and that you would appreciate a call before another offer is accept-

ed. If you are unable to make a decision within the time you've indicated, contact each serious candidate and say that you have decided to continue your search. Give a new date on which you expect to reach a decision.

Candidates who don't make the cut should be informed as soon as possible. This should be done by letter. Say that as impressive as their résumé and portfolio are, their experience and capabilities do not, in your opinion, match the requirements for the job. As much as you may be tempted, it is risky to be much more specific. A pleasant, timely letter informing them of your decision, phrased more or less in this way, and wishing them well in their search for a new career opportunity, is not only the proper thing to do, it is also your best defense against any later charge of hiring impropriety.

CHAPTER 6 Motivating

MUCH OF THE HEALTH of any design business can be attributed to personal motivation—yours and that of your employees. Organizations that can maintain motivation through the pressures of growth, clients, finances, and personalities nearly always remain healthy. Those that can't are very likely to end up as over-the-hill, Stage Three businesses. (For more about business stages, see chapter 14.)

There are two major aspects of motivation that affect all creative service firms. The first are the intrinsic issues that are especially important to creative individuals—aesthetic concerns, pride of accomplishment, acknowledgment, having fun, etc. These intangible motivators are largely indirect, somewhat unique to us, and subjectively determined. The second aspect of motivation regards extrinsic issues. These are the tangible things that motivate everyone, everywhere—salaries, bonuses, benefits, security, working conditions, titles, advancement, etc. These are more direct and objective.

❀ How We are a Little Different ❀

There is an the old saying among creative firms that "Our inventory comes in the door every morning and goes out the door every evening." As in every business, keeping the inventory fresh is a crucial element in keeping customers happy.

THE INTERNAL CHALLENGE. By temperament and training designers are usually most comfortable working individually—doing their own thing.

Yet most commercial creativity takes place in an environment that values collective action. Providing design services is essentially a business of teaming. (Albeit somewhat less so now that so much can be done at one computer workstation.) Whether you operate with small or large staff, every project requires working with others in a productive manner. At minimum there is client interaction, and more typically there is also involvement with other creatives, programmers, service bureaus, and printers. So the motivational challenge is to inspire individuals in a way that also promotes teamwork. For it is the teamwork among staff, clients, and suppliers that ultimately produces a healthy, profitable organization. Focusing only on motivating individuals is to miss the forest for the trees.

THE EXTERNAL CHALLENGE. Although motivation must be largely internally focused—within one's self or an organization—external factors do have an important effect on design firms. The most significant are client relationships. (Others are supplier relationships.) It used to be that even the very best clients didn't require much from a designer beyond talent and availability. Not any more. Now even clients with modest budgets look for design firms they feel they can work with in a collaborative way—i.e., being a member of a team.

Being considered a member of a client's team makes it easier to get your work (and prices) accepted. This, in turn, strengthens firm morale and stimulates even greater efforts and creativity. Nothing motivates quite as well as an enthusiastic client. In short, internal motivation is strongly affected by the clients with whom you work. If you don't have enough motivating clients, increase your marketing efforts until you do. It is a critical and often overlooked component of motivation and morale. (See chapter 13 for more on working with clients.)

Intangible Motivators

Individuals working in most other fields come to a career choice largely by happenstance. An accident of fate is the reason they've ended up in a certain industry. Not so with most designers. Our choice is usually predetermined. The need to exercise our talent more or less dictates that we'll wind up in an artistic occupation. Due to our orientation, it is also likely that we view our work as more than just a means of getting a paycheck. Usually equally important is a sense of creative accomplishment. Recognition of accomplishment is a crucial component of creative individuals' motivation.

Below are seven motivational factors to consider. The first—outlook (attitude)—affects us all, freelancer or principal. The other six—working together, delegating responsibility, criticizing effectively, acknowledging regularly, evaluating properly, and sharing information—are management skills requiring constant practice.

A POSITIVE OUTLOOK (WORLDVIEW). Individuals who possess positive attitudes toward business are more highly motivated than those who do not. It is easy to see how a freelancer's attitude can directly affect his or her business. Not as apparent, yet equally crucial, is the attitude of the principal. He or she determines the firm's culture. Principals who are basically unhappy nearly always run poorly motivated operations. The psychological aspects of a negative attitude are well beyond the scope of this book. There are, however, two factors we can comment on.

1. *Too many hours on the job over too many years usually leads to some degree of burnout.* It also sets a bad example for employees (time worked is more important than efficiency or quality). Long hours and a frenetic pace may occasionally be necessary, but they should be the exception, not the norm. They ultimately kill motivation instead of enhancing it.

2. *Trying too hard to achieve perfection can reduce motivation because it can lead to frustration.* Perfection is difficult to achieve within most clients' budgets, and they aren't always willing to pay extra for it. Knowing how much effort is enough, and when it is overkill, is crucial to sustaining motivation. (See chapter 16.)

WORKING TOGETHER. Motivating a creative organization requires a different management model than that used by most other organizations. The traditional model—a boss directing employees in what to do and when to do it—fails our particular motivational needs. Creative organizations must sustain an environment that encourages individuals to come up with their own novel solutions to problems. For more on organizational models appropriate for design firms, see chapter 2.

DELEGATING RESPONSIBILITY. The more good employees are challenged, the more motivated they become. Challenges come in many forms, not the least of which is having real responsibility—as much as any individual can handle. Providing responsibility (and the authority that goes with it) takes a willingness to delegate. Good indicators of the need to delegate more are principals who are continuously snowed under and employees who are constantly asking for guidance. How much to delegate, and to whom, depends upon the quality of employees. But most principals delegate far

too little—sometimes out of fear that others will screw up, sometimes from a reluctance to give up control.

Keep in mind that the cost of an employee occasionally dropping the ball is more than offset by the overall productivity gains that result from giving him or her more responsibility. Likewise, loss of control is seldom a problem if adequate systems and procedures are in place. Here's the ultimate delegation test: If you worked for yourself, would you be highly motivated?

CRITICIZING EFFECTIVELY. Design is highly personal, and designers tend to be more introspective and sensitive than the general population. For these reasons, criticizing is a motivational minefield. Indeed, the individuals who need stroking the most are those who are most likely to take offense.

Be a good listener. Ask individuals to describe, or sell you on, their ideas. It forces them to evaluate their validity. Listening carefully also has the motivation-building effect that designers get when their ideas are carefully considered.

Do it privately. Constructive criticism seldom happens in public in a supervisor/employee relationship. Constructive criticism usually happens in private.

Don't be quick to judge. "Gut reactions" are usually inappropriate, particularly for ideas or concepts that have been well developed. If positive, the offhand way they are given makes the critiques less meaningful; if negative, they demean an honest attempt.

Be businesslike. There are few absolute rights and wrongs in creativity, only expressions of taste. Commenting that you don't like something is never valid. Valid criticisms relate to how the work meets client objectives and the firm's standards.

Present alternatives. The absence of an alternative makes a comment critical rather than constructive. If you can't think of an alternative on the spot, give yourself some thinking time, or withdraw the criticism. Also, when presenting an alternative, never do so by saying, "I think you should. . . ." Be positive and subtle: "What would happen if you tried . . . ?"

ACKNOWLEDGING REGULARLY. Motivating creative employees comes more from style than it does from procedures. The right style can be summarized this way: a genuine interest in employee welfare. Perhaps the most common and effective way is the "walk around" —occasionally touring the shop and chatting. This is not done to check up, but rather to be an

accessible mentor. It is particularly effective in large firms where there are management layers between employees and principals.

Ways of acknowledging individuals are as varied as one's imagination. Among the more common are sharing the spotlight when making portfolio showings or filling out award show applications, recognizing accomplishments at staff meetings, and celebrating birthdays, employment anniversaries, and similar events.

SHARING INFORMATION. Think in terms of "keeping them in the light. " Motivated employees are those who know what's going on and how it will affect their jobs—sales, opportunities/problems, profitability, company plans, etc. A once-a-week, business-review staff meeting is probably all that's necessary to keep them informed. On the other hand, sharing of detailed financial information—open-book management—is seldom a good idea. It isn't the norm, so there's no motivational imperative. Even if you have no reluctance to share, it requires employees to possess business sophistication and financial expertise. Without it, looking at financial data can often be misleading and more harmful to morale than beneficial.

❀ Tangible Motivators ❀

As important as the intrinsic (qualitative) issues of teamwork and relationships are, they are only half the motivation equation. The other half are direct, tangible (quantitative) rewards. They are such things as salaries, benefits, titles, security, bonuses, and the workplace environment. They affect employee and principal alike. As crucial as creativity may be to defining our interests and personas, at the end of the day we all still need to make a living. Many of us also have to provide for others. And to some extent we all gauge our successes by tangible expressions of our worth.

PERSONAL CONSIDERATIONS. Self-employment requires personal discipline and management skills. It also comes with financial and psychological risks. As in every other aspect of life, risk should be compensated by reward.

To maintain personal motivation over the long run, Creative Business surveys indicate that the tangible rewards of running a multiperson shop should at least equal what they would be if you worked for someone else. (For freelancers, the figure should be at least 80 percent. It is lower because lower risk leads to earlier satisfaction.) If your direct compensation—salary and benefits—does not meet this simple criterion, it is likely your motivation will ultimately suffer. However, if you are not already

at or above the appropriate number, it should be attainable. If not, question whether you should be investing your future running your own business.

The intangible rewards—being one's own boss, the satisfaction of building a business, more freedom, etc.—should be considered incremental bonuses. Most individuals who focus on intangible rewards sooner or later experience a sense of underappreciation that leads to a diminishment of motivation.

SHOP STANDARDS. The tangible rewards an employee receives are nearly always less important than the belief that they are fair. An employee who believes he or she is not rewarded fairly is an unmotivated employee, whether or not the belief is based on fact. Of course, there is no hundred-percent remedy for individual beliefs, but procedures everyone follows—shop standards—reduce the potential for problems. They enhance both morale and creativity by minimizing uncertainties. Creative Business's experience is that low morale is often the result of arbitrary evaluations and procedures. A side benefit is that standards provide employees with a reassuring sense of professionalism and sophistication, something especially important in smaller firms. When the handling of routine activities is not prescribed, procedures inevitably develop around individual idiosyncrasies rather than ease and efficiency.

CAREER PATH. Even single-employee firms should have a set of job descriptions, a career ladder that outlines responsibilities corresponding to various titles and salary grades. They outline the opportunities for growth as an individual's talents and skills increase. (See chapter 4, and appendix IV for examples.)

EDUCATION, TRAINING, AND AWARDS. These incentives have a dual benefit: employee motivation and a more productive staff. Creative Business recommends budgeting between $1,000 and $2,000 per professional employee per year to cover training (e.g., Photoshop techniques) and conferences and conventions (e.g., AIGA events). Tap the fund as appropriate to reward selected individuals with a convention trip and expenses, or to attend a training session. Budget for a company (multiple-individual) membership in one or two creative organizations, but let employees cover their own meeting expenses. Create a policy and separate budget for award shows, as described in chapter 10.

SALARIES AND BENEFITS. As employees become older and take on more responsibilities, salaries (and benefits) play an increasingly important role in motivation. Yet while higher ones increase motivation and productivity, they

also decrease profitability. The right balance is achieved when they are slightly above the norm for the area, enough so that good employees won't easily find a better deal, but not so much that profitability is unnecessarily affected.

As important as a starting salary is, most employees recognize that it is largely determined by talent, experience, contribution, and local employment conditions (supply and demand). Not so with salary increases. They are viewed as totally discretionary. How a supervisor handles performance reviews and salary adjustments has a significant impact on whether an employee comes away feeling motivated. Doing salary reviews in a way that motivates all employees, not just those who receive anticipated raises, requires an objective and uniform approach. (See "Employee Evaluations" below.)

BONUSES AND PROFIT SHARING. Creative Business surveys show that about 35 percent of design firms give employee bonuses. They average a few thousand dollars; some are five figures. Most are arbitrarily determined and given out as year-end gifts. Few firms have a formal profit-sharing plan, and those that do tend to be large and well established.

The industry practice of giving year-end bonuses is admirable, but not particularly effective for motivational purposes. Bonuses don't motivate unless they are closely related to a specific event. In fact, year-end bonuses can become unmotivating if they are skipped or are smaller than expected. Our recommendation is to avoid arbitrary year-end bonuses in favor of a formal profit-sharing program. It should be based on distributing an amount of money in excess of a comfortable, predetermined bank balance. The following guidelines help determine what is affordable and when.

Management criteria. A bonus should not be considered until all normal management procedures are in place and functioning smoothly. These include personnel policies, job descriptions, noncompete agreements, a retirement plan, and regular performance evaluations. All employee salaries should have been reviewed within the past year and appropriate adjustments made.

Performance criteria. Unless the company meets the following criteria, it is probably not healthy enough to afford bonuses or profit sharing: total salaries and benefits (including bonuses and principals' compensation) should not exceed 70 percent of AGI; billable time (all creative employees) should average above 60 percent; quick ratio (short-term assets ÷ short-term liabilities) should be higher than 1.50; debt-to-asset ratio (what's owed ÷ what's owned) should be less than .40.

Eligibility criteria. Bonuses and profit sharing can be awarded to all employees or only selected ones (e.g., company vice presidents). If they

are to function as a profit-sharing "perk" for loyalty, only current employees who work more than half-time (20 hours a week) should qualify.

Figuring "profit." Because net earnings are the same as profit for principals of sole proprietorships, partnerships, S corporations, LLCs, and LLPs, there is no separate profit figure upon which to base bonuses. The profit of a C corporation is largely determined by how much or little the principals take out in salary. Thus, for the purposes of calculating bonus affordability, we have arbitrarily defined profit as "excess" earnings. (See chapter 15 for more about figuring profitability.) Earnings are not excess until the following conditions have been met: total principals' salaries are at least: $90,000 for sales of $250—$650 thousand; $100,000 for sales of $650 thousand—$1 million; $150,000 for sales of $1 million—$2.5 million; $200,000 for sales of $2.5 million—$4 million; employee salaries have been paid to date; current tax obligations are covered; accounts payable are under 60 days; there are no anticipated and unbudgeted near-term expenses.

Calculating the bonus. Keeping in mind the above profit definition, distribute as bonuses any excess money up to 2 percent of the firm's AGI. Distribution should be proportional to the salaries of eligible employees (e.g., if an employee's salary is one-third of your eligible payroll, that person should get one-third of the bonus money). Principals should also be considered employees, as should commissioned sales reps. Normal payroll procedures must be followed when making bonus payments. Funds remaining after the bonus payment can be retained (C corporations only), distributed to principals as dividends, or invested in principals' qualified retirement plans.

Direct investment. Rather than paying out cash, you may opt to deposit bonuses in each employee's name directly in a company-sponsored qualified retirement plan. Doing so can provide substantial tax benefits. This is a way to encourage employee loyalty, as well as reduce the ultimate cost of bonuses. Only employees who meet the vesting criteria (it can be several years) will ultimately get the money. (See your accountant for details and current vesting limitations.)

A bonus alternative. Bonus plans are the most common form of profit sharing that doesn't involve surrendering some ownership and control. There is, however, an alternative you may want to consider. It is structuring key employees as "associates" in your firm. Rather than salaries and bonuses, selected employees—associates of the firm—receive a percentage of the billing of each project they work on. (See chapter 2.)

PROMOTIONS AND OWNERSHIP. Most individuals are motivated by the potential to move up the ladder—gain more responsibility, a better title, perhaps even score a piece of the action. As previously described, a series

of job descriptions with graduated responsibilities and salary ranges (a career ladder) is the key. It sets out a clear path for getting ahead and by establishing criteria for doing so, helps prevent salary and promotion escalation without corresponding increases in skill.

Raises. Handing out increases in salary without corresponding increases in skill is a common management error. It is a misguided motivational attempt that works only in the short-term and carries a costly long-term price tag. Seniority, your personal likes and dislikes, even an individual's personal needs should rarely be a reason for a salary increase. Unless every employee earns what he or she gets, others will be unmotivated. Profits will also suffer, which reduces the amount available to disburse to other employees.

Promotions. These should be given only when an individual meets the criteria for a higher job level and the higher salaries that accompany it. All promotions should be publicly announced and celebrated. (Advancement within a job grade and the raises that result are always private.)

Titles. They're too important to be casually or arbitrarily assigned; they accompany a specific job description. Occasionally, however, it may be appropriate to use a title as a motivator if done selectively. For example, giving an individual the title of Acting Creative Director or Vice President of Marketing without changing his or her job description. (Caution: Get legal advice before awarding a vice presidential title. It may imply certain rights and responsibilities.)

Ownership. This may or may not be the ultimate motivator, depending on the individual. There are several options, including employee stock ownership plans (ESOPs), partnerships (both limited and fully participatory), and right-of-first-refusal buy-sell agreements. Specific arrangements and the benefits are covered in chapter 1.

There is, however, another component to ownership sharing—whether it is really necessary. Giving up equity should be a last resort, proposed only to the most valued employees and only when it is the only way to adequately reward and motivate them. If management participation is involved, the individual should have demonstrated talents in these areas—rewarding is not enough. In any event, be sure to obtain competent accounting and legal and advice before discussing it. There is nothing worse for morale than holding out a possibility that isn't serious and never kept. (An ownership alternative is the associate arrangement detailed in chapter 2.)

WORKING ENVIRONMENT. As an industry driven by both innovation and style, an individual's working environment is a powerful motivator.

Facilities. Whatever appeal stylish, sometimes funky office space may or may not have to clients, there's no doubt about its attraction to creatives, principals included. The danger here is usually not too little attention to the need, but going overboard and ending up with space that isn't functional and is a budget drain. We recommend the most stylish facilities and functional workstations possible without spending more than 5 to 7 percent of AGI on rent or mortgage, utilities, etc. We do not recommend upgrading computers or software for motivational (versus functional) reasons. (See chapter 2.)

Flextime. The solitary nature of many creative-firm tasks lends itself to nontraditional working arrangements. Letting valued employees work odd hours can be strongly motivating to those with unusual situations. But, before offering flextime arrangements, take a look at the trade-offs. The individual may be needed for input, client meetings, teaming, and production conferences at hours he or she won't be available. The arrangement may be resented by other employees, and it requires a high degree of trust (see below). In other words, the net result should be motivating to the individual, but at least neutral to the rest of the shop.

Telecommuting. Some employees will consider this the ultimate motivator because it gives the greatest freedom and implies the greatest trust. But it can backfire. Working alone productively, even if only one or two days a week, requires the self-discipline many individuals lack. It also reduces the motivational and symbiotic effects that come about when employees work together. Telecommuting has an even higher degree of the potential problems already mentioned under flextime. In addition, it requires more flexibility in judging employee performance. It may require the need for compatible computer systems, network connections, additional software licenses, and conference hookups. And it may raise insurance and liability issues.

Our recommendation is to limit telecommuting to very valuable, senior employees with needs that would cause them to otherwise leave the company or severely limit their productivity. The employee should be willing to work even harder than normal in return for the accommodation. The arrangement should be cancelable at any time, and the employee should have regular off-site work hours or a regular production schedule to follow.

❂ **Evaluating Employees** ❂

Official performance reviews are how employees find out how they stand relative to their expectations and peers. Also, they usually are and should be the means by which pay is increased or not. Sometimes they present a

rare opportunity to get the boss alone and focused on the employee's personal concerns. It is the time when employees can get to know principals better, get things off their chest, determine their creative and financial potential, even butter up the boss. Because of all this, and everyone's inherent need for recognition, most employees consider the few hours each year spent reviewing their performance to be among the most important they spend. There is, in short, little that will have more effect on an employee's motivation than a performance review.

WHEN TO DO IT. Performance reviews should be conducted at or around the six-month anniversary for every new employee, six months later, and at least yearly thereafter, preferably around the anniversary date. No exceptions. A "Keep up the good work" comment and other praise, while important, are not the same. Few things will drag down shop morale and individual motivation faster than a boss who doesn't conduct formal reviews, does them infrequently, or doesn't treat them with sufficient gravity. To a principal, an employee's review might only be one of many, but it is the only one the employee has, and some of the most important aspects of his or her life will be discussed—livelihood, career, and paycheck. Avoid canceling or postponing a review session unless there is a bona fide emergency. Also be sure to take time to reflect on the employee's past performance, prepare specific suggestions for improvement, and consider the appropriateness of his or her salary. Do your homework.

UP-FRONT CONSIDERATIONS. An employee's performance should always be related as objectively as possible to the requirements of the position he or she occupies. It should not be related to the principal's personal whims, idiosyncrasies, likes, or dislikes. Likewise, any salary adjustments that follow from a performance review should always be based on the salary range for the position and the individual's place within it. For these reasons it is next to impossible to conduct an effective performance review without having the objective base of a formal job description to refer to. (See chapter 4.)

One of the major criticisms employees have of performance evaluations is that they feel they're being evaluated on arbitrary criteria. Although subjective judgments are an important component of any boss's evaluation, they should not be arbitrary, but related to specific requirements as defined in the job description. Another major criticism is that evaluations often focus on what the employee is doing wrong, not on ways to grow and improve. Good performance reviews help employees grow, which is a good thing even if it means that eventually the employee will leave for a better opportunity. The cost of occasionally losing an employee is small compared to the extra efforts put in by motivated ones.

ORGANIZING YOUR THOUGHTS. The best way to do this is to use an evaluation form similar to the one reproduced opposite. A form like this ensures that there will be consistency from year to year and also from employee to employee. Not only does this make the job easier, especially if you do several reviews a year, but it also helps protect you from any later charges of arbitrary decision making or favoritism.

Before meeting with the employee, sit down and consider his or her performance using the evaluation form as a guide. First, consider how well he or she meets the specific criteria established for the position. Next, evaluate how he or she stacks up by more general criteria—personality, attendance, initiative, organization, self-control, and ability to communicate. Then, add your subjective comments. Finally, set goals you would like to see the employee meet before the next review. To help you stay focused during the upcoming review session, you may want to jot down a few notes on what you want to cover.

It is usually a good idea to give employees blank evaluation forms a week before the review session and ask them to rate themselves. (You'll probably be surprised at how honest they are.) This will not only give you a good idea of what the employee thinks, but will demonstrate how fair you are trying to be. You may even want to provide a copy of your evaluations the night before the review as a way of keeping the next day's discussion on track.

WHERE TO DO IT. The best environment for a review is where there will be no interruptions, where both parties can be relaxed, and where you won't be observed or heard by other employees. This usually argues against doing it on the premises, especially behind the ominous "closed door."

The location that usually works best is a good restaurant over lunch. Choose a place where you can talk candidly without being overheard. The better the restaurant is, the more important the employee will feel. In picking locations, be careful to treat all employees equally. If you don't always go to the same place, select restaurants of comparable quality.

CONDUCTING THE REVIEW. It is best to refrain from starting a review session by jumping right in. Devote the first ten minutes or so to making the employee comfortable by discussing topics of interest outside the workplace. The less you know the employee, the more important it is to humanize the occasion and develop a comfort level that will allow productive discussion later. If you have a generally positive evaluation to discuss, segue into it by indicating what a pleasure it is to get away to share good news. If the evaluation is not generally positive, indicate that you wanted to get away so you could talk one-on-one about their future without being distracted or interrupted.

Employee Performance Evaluation

Employee: _____
Review period: _____

Position: _____
Requirements/attributes: _____

1) Evaluate performance by circling the appropriate response:
 1 = substandard, needs constant supervision
 2 = below average, needs improvement
 3 = average, satisfactorily meets criteria
 4 = above average, exceeds criteria
 5 = exemplary, deserving of unusual recognition
2) Enter comments as necessary.
3) Set goals for the next review period.
4) Complete the back side (supervisor only).

Primary responsibilities: _____

Secondary responsibilities: _____

Career path: _____

General Criteria

Personality/demeanor:
Flexible and easy to get along with, an adaptable team player.
 1 2 3 4 5

Communication skills:
Listens, understands and expresses him/herself well.
 1 2 3 4 5

Attendance and promptness:
Observes assigned working hours, is conscientious.
 1 2 3 4 5

Initiative:
Works without close supervision, initiates independent action.
 1 2 3 4 5

Organization and time-awareness:
Sets and observes own priorities for the best use of his/her time.
 1 2 3 4 5

Self-control:
Maintains composure and performs well under pressure.
 1 2 3 4 5

Position-Specific Criteria

Proficiency:
Understands craft, systems and processes.
 1 2 3 4 5

Project management:
Organizes tasks and assignments.
 1 2 3 4 5

Attention to detail:
Attentive to all aspects of assignments/workflow
 1 2 3 4 5

Client interaction:
Relates to client needs, both spoken and unspoken.
 1 2 3 4 5

Creativity:
Seeks innovative solutions.
 1 2 3 4 5

Business skills:
Understands and works to increase profitability
 1 2 3 4 5

Comments

Employee's major strength: _____

Area needing most improvement: _____

Other comments: _____

Goals

I have been shown this evaluation. My signature below does not necessarily imply agreement:

(Employee's signature/date.)

Scheduled date of next evaluation: _____

(Supervisor's signature/date.)

Employee performance evaluation form.

Minimize personality. You do not have to like someone for them to be a good employee. An individual's personality and lifestyle preferences are only important to the extent that they affect his or her work or the ability to relate to clients and other employees. The only valid review criteria are those that affect job performance.

Be positive. Think of a review session as a way to help an employee advance and improve your company's profitability. This approach requires you to zero in on ways of doing things better, applying only enough criticism to demonstrate why change is beneficial.

Never reprimand. This is not the time or place. Reprimands must be specific to individual events and dealt with as close as possible to the time they occur.

Solicit input. Although you should direct the conversation, the review should be a discussion, not a lecture. To present employees from becoming defensive, go over their evaluations of themselves, and ask for their input on your observations. Keep the emphasis on ways you can work together to improve what is not yet quite perfect.

Be specific. Vague comments, criticisms, suggestions, and objectives are subject to misinterpretation. What you've observed and what you recommend must be clearly understood, which is one reason for using numeri-

cal ratings on the evaluation form. Never criticize actions or behavior patterns without being prepared to say exactly how you would prefer things to be handled.

Set goals. End the performance review by mutually agreeing on specific ways in which job performance (and employee career growth) can be enhanced. Note these goals on the evaluation form so they get special notice at the next review. If you are dealing with a problem employee, set immediate goals for improvement and plans to monitor progress. (See chapter 8.) If the employee's performance is so bad it puts his or her job in jeopardy, say so. Then get a commitment to correct the situation by a specific date and schedule a follow-up review.

Keep a file. Make notes of any significant points brought up during the review. Attach them to your copy of the evaluation form, along with the employee's self-evaluation. Keep everything in the employee's file folder.

⊕ Giving Raises ⊕

Most employees are quick to discuss creative and other issues on an as-they-occur basis. So they see a performance review as a way to discuss bigger issues. Whatever else this may include, it nearly always includes money. Specifically, "When am I going to get my next raise?"

At the beginning of each year, before doing any performance reviews, you should decide what you can afford in salary increases. This decision should be based on the stability of your business, past profitability, your capital (cushion), and prospects for the coming year. The result should be one of three possibilities: 1) No money, so no raises to anyone; 2) very little money, so inflation-only adjustments for qualifying employees; 3) profitability that can support rewarding employees, so inflation-plus-performance raises for qualifying employees. (Measuring the financial strength of your company is covered in chapter 15.)

If your company has a bonus or profit-sharing program, it should not normally be part of the salary review process. Unless employee compensation is directly tied to performance (e.g., commission based), profit-sharing decisions should be based on extraordinary profitability and made independently of salary decisions.

If you've determined that you cannot afford raises this year, be candid about it with employees at their reviews. Indicate that this unfortunate condition affects everyone, yourself included, and that just as soon as conditions change, you will reevaluate all salaries.

If you've decided you can afford raises, here's how to determine who gets how much. Use these figures unless you have extraordinary circum-

stances (e.g., a grossly underpaid employee): For outstanding performance, give the current rate of inflation, plus a 2 to 6 percent performance increase (for example, if inflation is running 3 percent, a total minimum 5 percent, a total maximum 9 percent). (An employee who deserves more should receive a promotion and the salary increase that goes with it, not merely a raise.) For good-to-average performance, give the rate of inflation or one point under (-1 percent) plus a 0 to 3 percent performance increase (using the above example, a total minimum 2 percent, total maximum 6 percent). For substandard, but improvable, performance give from 0 percent to the current rate of inflation. For poor performance, give nothing—especially important if you later end up terminating the employee.

No matter how prosperous your company is, do not succumb to the temptation or pressure to give raises based on personal problems, seniority, or keeping up with inflation. Salary growth should be a function of perfor-mance growth, nothing else.

Also, never make the mistake of giving some employees an increase while telling others that there's no money for raises. This changes the employment ground rules from individual to individual, and is discriminatory and illegal. You can (indeed, should!) amply reward some employees while giving others little or nothing, but it must always be done on the

Salary adjustment compilation form.

basis of fairness.

Finally, recognize that as great a working atmosphere as your firm provides, it will be difficult to keep good employees without giving them an occasional salary adjustment. Creative Business's experience is that two years is the limit of a talented employee's patience unless times are really tough, or they have reached the top of what they can earn in the marketplace. Not only do even the most dedicated, loyal, and patient employees need to provide for rising material needs and costs, but they also occasionally need a monetary vote of appreciation.

7 Creative Direction

CREATIVE DIRECTION is the most significant difference between pure art, following one's own muse, and applied art, being in the design business. The better the direction, the greater the workplace productivity, company profitability, creative impact, and personal satisfaction.

Yet, it doesn't come naturally. Efficiently directing ourselves requires putting aside our personal preferences and focusing our skills on what will work best within the constraints of client schedules and budgets. Efficiently directing employees requires not only this, but also skill in motivating others. And most of us occasionally have to direct the work of creative outsiders—photographers, illustrators, printers, programmers, etc.

❉ Understanding the Need ❉

By definition, design involves taking innovative and unusual approaches to problem solving. It is a process that is the antithesis of direction and control. The more control, the less creativity, and vice versa. So even the phrase "creative direction" itself is something of an oxymoron. Little wonder then that creative individuals resist the idea of direction. Too much input, client oversight, production constraints, and in-house review are sure-fire ways to dampen one's enthusiasm to innovate. They can easily become a formula for mediocre, safe, "white bread" solutions.

On the other hand, without direction it is easily possible to wind up with a world-class effort directed at the wrong target. Or something with tremendous impact but impracticably expensive to implement. Given the unpredictable nature of creative thought, some direction is required to

131

keep any effort on the right track. Equally important, good direction nearly always improves design. It provides the peer input, objectivity, and refinement that elevate work to a higher level. Anyone who does not recognize this potential is a dilettante, not a professional.

Thus, the art of creative direction is learning the right balance between too much and not enough. Enough direction is necessary to ensure that an effort is practical, correctly aimed, and properly refined but not so much as to inhibit one's ability to explore, challenge, and produce unusually powerful solutions. The more highly creative an individual is, the more difficult it is to obtain the right balance. A few individuals, like agency "stars," have earned the right to operate with only minimal direction. But most others have to adapt to a less ideal world, a world where constraints are put on their creative impulses.

Defining the Ground Rules

Two parties are involved in most design. One is the specifier—clients, bosses, creative directors, etc. The other is the doer—writer, designer, photographer, printer, etc. Both share the same goal—producing great work. Their roles in making it happen are complementary, but different nonetheless.

FOR SPECIFIERS: Up front they have to set the assignment parameters (budget, schedule, etc.), creative preferences (what's acceptable and what's not), and objectives (desired result). During the job they have to provide clear direction on changes and what is and isn't appropriate, but not instructions on how to accomplish them.

FOR DOERS: Up front they have to help define what's acceptable and willingly accept any limitations. During the assignment they have to direct their efforts to furthering the objectives of the job, not satisfying their own creative impulses.

Developing internal recognition of this division of responsibility is simply a matter of practicing good creative management. External recognition comes as a natural outgrowth of client confidence. (The test: Clients have to feel comfortable when you say, "Just give me the facts, then relax. I'll handle the rest.") When both parties recognize the benefits of dividing job responsibility, most of the problems of how much creative direction is enough, and how much is too much, will disappear.

Adopting a Two-Step Process

Here's a safe generalization when starting an assignment: Clients will be concerned about whether you will be able to give them what they really

want. Here's another: You will be concerned about whether the clients will let you give them what they really need. There's obviously no way to guarantee that both concerns will be met. But adopting a two-step creative process—defining creative and positioning basics followed by a creative review—will make it a lot more likely. Consider making it an essential part of defining new jobs, along with physical specifications, schedules, budgets, and estimates.

ASSIGNMENT BASICS. This is the first step, a process that involves getting client input on creative and positioning parameters. It is also a process that culminates in a written description of the elements that will ultimately affect its development. It requires, as soon as possible after receiving the assignment, gathering the basic facts regarding the client's company, product/service, and competition/market.

This should normally take only a single, well-organized meeting. For complex assignments (an annual report, a Web site) plan on up to two hours; for smaller assignments (small brochure or print ad) plan on up to an hour. Later meetings will, of course, usually be necessary to flesh out the details. But the basic parameters, the core around which the job will be built, should be defined first.

All, or at least the lead creative(s) on the job should be present, along with account or sales personnel. The client side should be represented by all individuals who will have conceptual input, as well as most of those who will be part of the approval process. The reason: only by starting out with a broad consensus on what is and isn't crucial is it possible to produce a creative result that will give the maximum impact for the client's money. The more decision makers included, the easier later approvals become, and the happier everyone will be with the work.

To focus the meeting and its input, use a form such as the Assignment Questionnaire shown on page 134, or develop your own. Such forms, widely used by ad agency account executives, ensure that relevant information is gathered, and that there is consistent input from job to job. They supplement job specifications and are the primary source material from which to conduct a creative review later. In addition, the process of filling one out gives clients confidence. The process is often as important as the information gathered.

CREATIVE REVIEW. This is the second step, a checklist to ensure that concepts measure up to both shop standards and client needs. Some larger firms often precede or replace this with a "creative brief." Although it can help keep a project on track in shops with multiple management layers, Creative Business does not recommend it for most design firms and small-to mid-sized agencies. A brief can unnecessarily inhibit creative initiative unless it is handled properly.

We believe a better approach is to involve the creative team up front in helping to define the assignment, then giving them the freedom to develop what they believe is appropriate, tempered by the knowledge that it will have to pass an in-house review before being presented to the client. Evaluating a concept with a creative review checklist (shown at the end of this chapter) provides the objective assessment usually missing from the development process. It helps you to step back and see

Assignment questionnaire.

both little mistakes and total misdirection. Plus, it only takes a few minutes.

Knowing that a concept has passed an in-house review provides assurance to clients and enhances a presenter's confidence. ("Before I came over this afternoon, I ran this through our firm's creative review checklist to make sure it not only met all your objectives, but also was up to our creative standards. What I'm going to show you is not only exciting, but also right on target strategically.")

A creative review works equally well for individual freelancers double-checking their own work, or a firm principal/creative director reviewing staff efforts. It strikes the proper balance between inhibited and unbridled creativity, and guards equally well against lightweight solutions or brilliant ones that are strategically unsound.

⊛ The Time for Nondirection ⊛

So the first step in creative direction is ensuring that there's adequate positioning and strategic information. After that, the second step is ensur-

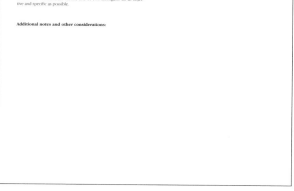

Assignment questionnaire instructions.

ing there's a final check to determine whether both client needs and shop standards have been adhered to. Equally important, however, is what happens between now and the presentation. This is the informal part of creative direction, the part that should not be prescribed. Whoever has responsibility for a project's creative development should be free to develop it in his or her own style and manner.

When this is not the case, when there is an attempt to direct creativity at this level, several unfortunate things can happen—a firm's work begins to look all the same, to have a formulaic style that reduces its competitiveness; the varied experiences and talents of creative staff (what principals pay high salaries for) are inadequately utilized; employees don't have the opportunity to grow creatively and become more valuable; and the enthusiasm, pride, and morale of the creative staff suffer.

Once the creative and positioning parameters have been established (the assignment basics referred to previously), the project should be turned over to the persons assigned creative responsibility. No direction. No interference. If providing this degree of responsibility makes the principal or creative director nervous, the wrong person has been selected. If there's no one competent to handle the project, the principal or creative director should assume responsibility. Only where there is a major problem should they interject themselves into the process later on.

Learning to delegate creative responsibility is difficult for many principals because it bears directly on the quality of a firm's output. Also, it will likely produce work that is different in style and approach from their own.

And sometimes there's the fear that it will train an employee who will later leave to become a competitor. Nonetheless, delegation is a necessary component of developing the product variety and staff strength that institutionalizes a firm and gives it long-term viability. Giving talented employees their creative head, including allowing them to learn from trial and error, is expensive and risky. But it is nearly always a good long-term investment, even when employees screw up and talented ones later leave to strike out on their own.

❧ Stimulating Creativity ❧

Creativity is not something that's easily taught. And even if it were, doing so wouldn't be cost-effective in a business environment. It is, however, possible to develop a business culture that stimulates creativity.

PEOPLE. Good creativity can only come out of talented individuals, so the raw material you have to work with is the most important component of creative stimulation. When considering outsiders, any extra it takes to find the right combination of talent, personality, and style will be more than made up for by getting things right. An individual's problem-solving abilities, a good sense of what is practical, the capacity to operate both independently and on a team, and attention to detail are all equally important.

If you are dealing with internal staff, what you have to work with is the result of past hiring decisions. It may be too late to make staff changes that will affect a current assignment, but keep in mind the following points when making future hiring decisions: The way to build your firm's creative muscle is to hire people better than you; team players usually contribute more in profit than those with undisciplined talent; an individual's growth potential is usually more important than his or her experience. (See chapter 5.)

REWARD. Praise, peer recognition, awards, perks, and promotion are all ways of stimulating future creativity. Not least of all is that it usually takes above-average pay and benefits to stimulate above-average talent.

DELEGATION. As already mentioned, giving up creative responsibility is among the hardest things any designer can do. There is, after all, nothing more defining than one's personal style, approach, and preferences. Entrusting that responsibility to others is risky. But sooner or later it becomes a necessity for principals of growing firms. At some point (usually sooner than realized) it becomes impossible to handle creative direction and management equally well. There aren't enough hours in the day,

so a choice has to be made: more managing and less creating, or vice versa. Assuming one has sufficient talent in both areas, the better choice is often creative delegation.

One reason for this is variety—offering clients greater choice of styles and approaches—expands a creative company's product line. In turn, this allows the company to compete for a wider range of assignments and clients. Put another way, creative delegation is simply a way for a creative organization to maximize its talent.

A second reason is profit. As in any business, the way to make more money is to get others to do your work at a profit. As a general rule, the more you do yourself, the less money you will take home.

TEAMING. Although it is standard in developing ads, creative teaming isn't the norm for most print and multimedia work. It probably should be. There is nothing wrong with creative individuals working alone, but teaming up to bat around ideas nearly always results in stronger, more original results. Two individuals working on the same problem from two different perspectives can produce more than two individuals working alone. The process also helps refine ideas.

The best results are obtained when two individuals with complementary talents are involved, typically a writer and art director/designer. Each brings to the table his or her unique viewpoint and creative training. Yet, because of a common world view, their individual approaches clash only in productive ways. Good teammates also complement each other's idiosyncrasies, style, and experiences: relaxed versus aggressive; emotional versus analytical; conceptual versus precise; speedy versus deliberative. These differences help ensure that many approaches are considered, and they promote a sense of friendly tension.

BRAINSTORMING. Exciting, yet strategically sound creativity seldom comes in a flash of inspiration. Nor does it usually come from staring at a blank sheet of paper or a computer screen. More often than not it comes out of brainstorming. Although by its very nature brainstorming is an uninhibited process, productive sessions seldom just happen. They are encouraged, planned, and follow a few simple rules:

- Think beforehand—it helps to get things moving quicker
- Set aside enough time—two to four hours a session is best
- Make sure there will be no interruptions—with no exceptions
- Have everything needed—information, samples, swipe files, etc., close at hand
- Begin with the basics—the creative and positioning data gathered on a form such as the Assignment Questionnaire on page 134

- Consider everything—nothing off limits as long as it fulfills the creative and positioning requirements
- Send out for food when timely—it often rejuvenates the process
- Try several approaches—even after you fall in love with one

TIME LIMITS. Without them there's a tendency for designers to refine and polish ad infinitum. Working against the clock focuses thought. Whatever the task, require it to be accomplished within the time budgeted, which was set by the job estimate. Adherence to budgets and schedules slays procrastination, accelerates thinking, and produces better work. And not incidentally, without time constraints profit usually flies out the window. Cost control is as important to the company's future as its creative product.

THE SPOTLIGHT. The individual responsible for the project's creative development should present it to the client. Not the firm principal, not a sales representative, although they may be present and lend support. Knowing in advance that he or she will have to stand before the client and justify why things were done the way they were forces an individual to consider every approach taken, as well as those rejected. It also provides a psychological reward, and makes any firm appear larger to the client.

The ability to sell a concept is as important for every designer as the ability to conceive one. Anyone uncomfortable in this role probably shouldn't be given creative responsibility. Or, if an employee doesn't have this skill but shows promise, he or she should be coached on concept presentation.

COACHING. Speaking of coaching, allowing others the freedom to follow their creative instincts does not mean there should be little or no supervision. It does, however, mean adopting a style more akin to coaching than managing: players are free to play the game their own way with only occasional suggestions from the bench.

There is great variety among designers, but they tend to share some common characteristics. Perhaps most common is a need for feedback. Given the highly personal and psychologically risky nature of much of their work, even veterans occasionally need it. Designers also are often more introspective and sensitive than others. This means that the very individuals who need feedback the most are the ones least likely to ask for it.

Critiquing Constructively

After addressing all the other ways of stimulating creativity, the final trick of creative direction is being able to offer encouragement, answer questions, provide wisdom, share experiences, make suggestions, and monitor

progress—all without appearing judgmental. Commenting on another's creative efforts is a potential minefield. Learning to navigate it can pay big returns in raising employee morale, stimulating creativity, and increasing productivity. Here are a few basic tips to make sure your comments and critiques are always viewed constructively.

DON'T BE QUICK TO JUDGE. Gut reactions are fine when discussing options, approaches, or brainstorming but they are nearly always inappropriate for criticizing developed, thought-through ideas or concepts.

TAKE YOUR TIME. A hastily given critique will make it less meaningful if it is positive. If it's negative, it will demean an honest effort and probably demoralize the creator.

BE A GOOD LISTENER. A willingness to listen to another's point of view is crucial to effective criticism. When you don't give another person the opportunity to defend what he or she has done, you create resentment or rejection of your opinion. You might also miss a compelling reason to change your mind. Simply asking the creator to elaborate on an approach will force him or her to reexamine reasons for choosing it.

ACKNOWLEDGE DIFFERENCES IN TASTE AND STYLE. There are few, if any, absolute creative rights or wrongs, only endless expressions of taste. So only commenting that you don't like something isn't valid. The only valid criticisms are those that examine how the creativity meets the objectives of the client or assignment, and the firm's standards. If you are faced with something you don't like and have no other criticism, be big enough to say something like: "Actually it doesn't reflect my personal taste, but that's unimportant. What is important is that it meets all the objectives the client laid out for it."

DO IT PRIVATELY. When two individuals work one-on-one in a team situation, there's little need to be concerned about tact and diplomacy. But when three or more people are together, the situation changes, especially when a boss-employee relationship exists. Constructive criticism is almost impossible in such situations. Never criticize an employee's work in public. (But do praise it in public whenever possible.)

SUGGEST AN ALTERNATIVE. A criticism without an alternative is never constructive; it is just a critical comment. So don't be critical unless you can also suggest another approach that will work better.

WHAT THEY ASK FOR MAY NOT BE WHAT THEY REALLY WANT. Be particularly sensitive in situations when someone asks for your opinion, especially an employee. Truth is, anyone asking for comments or a critique may only be seeking affirmation. When your response is not required, it is best to

diplomatically dodge the request: "I'm afraid that my comments wouldn't be much help. I don't have the benefit of the background you had in developing this, and my tastes are different from those of the intended audience."

⊕ The Preliminary Test ⊕

Another aspect of creative direction is to try to build time into the production schedule for a cooling-off period. The idea is to put a concept aside for a while and go on to something else. Then bring it out later and look again with fresh eyes and new objectivity. This also functions as a preliminary test for those responsible before they show the concept to others. Does it still work? If so, it can be presented for the creative review with confidence. If not, it can be refined beforehand.

It is seldom a good idea at this point to make major revisions or start over. Aside from the obvious cost and loss of time, too much revision can refine any concept to death. There is also a tendency in retrospect to scrap or water down a strong concept for something more conservative, something safer. It also helps to preview the concept to a few select peers who can judge it on its communications ability without knowledge of the constraints under which it was developed (never, however, to the person who will later do the creative review).

Do they like it? Do they have any minor suggestions for improvements, or do they all require changes that are either improbable or impossible, such as a larger budget?

If a preview is limited to a few knowledgeable persons, it can be a helpful means of pointing out obvious problems that often go unnoticed by someone closer to the project.

Testing and previewing concepts can not only result in improving them, but also build confidence in those who will have to present them for the final step—the creative review.

⊕ The Creative Review ⊕

This is the end of the creative process, or at least the end of this phase. (Changes and implementation will, of course, follow.) It involves running ideas, concepts, or presentations through a creative review before they are shown to a client. It is a quality-control step for firm principals and creative directors.

The review should not be a critique. Rather, it should simply be a check to make sure everything measures up to both client objectives and firm standards before presentation. It shouldn't take much time. An hour or

Creative Review Checklist

Date: _____
Client: _____
Project: _____
Job #: _____
Creative Team: _____

Product/Service

☐ Is central to creative concept.
☐ Is correctly shown/explained.
☐ Its benefits/features (uniqueness) are properly emphasized.
☐ The way it is shown reinforces established positioning and customer perceptions.
☐ Logos/trademarks/names/intellectual property are treated correctly.
☐ Other products/services could not be easily substituted within this creative concept.

Creative Approach

☐ Is unique/unusual to the product/service.
☐ Is attention getting.
☐ Fits tone/style of the product/service.
☐ Fits tone/style of the client organization.
☐ Complements other media efforts.
☐ Addresses primary interests of readers/viewers.
☐ Has inherent interest or story appeal; is not merely decorative or explanatory.
☐ Directs readers/viewers attention to what's most important about the product/service.
☐ Is memorable.
☐ Is believable.
☐ Is persuasive.
☐ Appears stylish and contemporary.
☐ Encourages further action by readers/viewers.
☐ Provides means for contacting/next step.
☐ Has staying power (is not quickly outdated).

Shop Standards

☐ Can be produced within time and budget constraints.
☐ Presentation materials are organized and professional.
☐ Presentation has been gone over/rehearsed.

Client Objectives

Primary objective: _____
Is addressed by: _____

Secondary objective: _____
Is addressed by: _____

Other Considerations

Evaluation

☐ Okay as is.
☐ Needs further refinement.

Comments: _____

Creative review checklist.

less is all that's necessary. Think of it as something akin to proofing. When considered this way, it should be possible to fit it into the schedule of even the busiest firms. Anything more—a critique—would be time-consuming over-direction that would likely result in inhibiting future creativity, reducing morale, and delaying the project. Any need for more direction and control indicates that those responsible should not have been given creative independence in the first place.

Good designers shouldn't object to a final review. The process will sharpen their thinking and is, after all, nothing more than a creative director or principal exercising responsibility for quality control. Designers who can't accept this are usually not worth the effort it takes to keep them happy.

The illustration above shows a creative review checklist that we feel is appropriate in most situations. The form can be used as is, or as a model for one more specific to the needs of a particular firm, or as an idea starter for a different approach. It is designed to be quick to use and focus attention on the issues that nearly every project has to address. In addition, there's space to write in client objectives and how they have been covered to help ensure that the requirements for a specific project have been met. It also serves as a summary of key points that should be covered when presenting the work to the client, and provides the space to record other considerations.

In cases where multiple concepts are developed for one project, we suggest using one form for each. It takes only a few more minutes, and it will

help the decision-making process by pointing out which concepts are stronger and which are weaker.

All creative review forms should become part of each project's permanent record. Copies can be made and put in employee records for future performance evaluations where warranted. Although intended primarily for internal use, creative review forms can also be shown to clients as a confirmation of thoroughness when presenting work.

CHAPTER 8 Dismissing

ESIGN FIRMS are personnel-intensive businesses. The ability to relate to clients' needs and interests is affected by the way employees relate to them. Product quality—the creativity of what is produced—depends on individual talent, and most profit depends directly on labor efficiency.

All this presents a paradox. On the one hand, too many employees doing too little work will quickly slay any profitability. On the other hand, good talent is hard to find and reducing staff too quickly will simply result in rehiring in the future and increased labor costs. There is also the dilemma of problem and low-talent employees: When is it better to tolerate them, when to get rid of them? Making this decision is among the hardest any principal faces.

⊛ Downsizing Considerations ⊛

When looked at objectively, many of the conditions affecting the need for staff downsizing are simply the opposite of the conditions for staffing up, covered in chapter 5. But, of course, it is difficult to look at it objectively because individuals are involved, and losing a job is a lot more significant than getting one. As an employer you have an ethical responsibility not to capriciously eliminate someone's means of making a living. Those affected may be friends, too. There's also the effect on those remaining—the morale factor.

For these reasons and more, downsizing—the euphemism for laying off—is a painful decision. It is agonized over and delayed, always for what seem valid reasons—the business climate will pick up, a new client will show up, or a good client will call up. If there is a tendency among design firms to staff up too quickly before there's a real need, there's an even greater tendency to staff down too slowly after there's a real need.

PREVENTION IS BETTER. The subject of downsizing shouldn't be looked at without first recognizing that many, perhaps up to half of all design firm reductions, aren't necessary at all. Too often they are the direct result of bad practices that are unnecessarily expensive to the firm and disruptive to employee lives. Here are the three most common ways to avoid the downsizing problem in the first place.

Don't have too much work tied up with too few clients. The loss of work that comes from losing a big client is the single biggest cause of layoffs. It can be minimized by ensuring that no one client accounts for more than a third of your income (25 percent is better); no two more than half. The more clients you have, the more insulated you will be from the arbitrary actions of any one or two.

Don't ignore the need for constant marketing. Inconsistent workflow—the financial pressure to reduce staff when the pipeline dries out—is the next most significant cause of layoffs. The only way to combat this is with constant marketing. Waiting for the phone to ring, or waiting until things quiet down before going out to rustle up new business, is almost a guarantee of boom-or-bust activity and the problems that come with it. (Marketing is covered in detail in section 3.)

Don't make hasty hiring decisions. Hiring based on little more than gut feel is the third most common cause of layoffs. New employees should be brought on only after the need has been ongoing for several months and can be projected to continue, and only after an in-depth evaluation of their talent, qualifications, and personal compatibility. Speedy hiring decisions often result in ignoring hiring safeguards. Better to turn work down than to get stuck later choosing between inflated payroll costs or a painful layoff. (See chapter 5.)

ASSUAGING THE GUILT. If you have been guilty of these sins, resolve to change your procedures. But don't put off a need at hand. In the simplest terms, a business requires only a certain number of people to operate efficiently. When there are too many, everyone else is subsidized out of a reduction in profits. In most cases, this means your own pocket. As nice as you are, it is probably not your intention to be in business to give away your own money. From a standpoint of rational self-interest then, every minute delaying a downsizing decision extends your financial pain.

Alleviating your pain doesn't necessarily transfer it to the laid-off employees either. Most will quickly land new positions. Since freelancing—full- or part-time—is always a possibility, most have this option to turn to if they desire. Keeping unneeded employees on the payroll also hurts other employees. In the short run it reduces the money available for raises, promotions, and bonuses. More important, in the long run not reducing staff when called for jeopardizes the health of your business. If your business becomes too unhealthy, even more pink slips will follow. Therefore, never treat a staff reduction casually, but don't agonize excessively over it either.

WHEN TO CONSIDER IT. Two easily considered guidelines give a good indication of when a design firm is overstaffed.

The first, total payroll divided by total fee-based income (AGI), indicates an appropriate staffing level for all employees. In most well-run design firms, salaries and benefits range from 60 to 70 percent of fee-based income. Consider reducing staff when total payroll expenses rise to more than 75 percent of fee-based income for more than a month and a half.

The second, fee-based income as a multiplier of the creative payroll, indicates an appropriate staffing level for billable employees. For most well-run design firms, fee-based income is three or more times creative payroll. Consider reducing creative staff when fee-based income drops to two and a half times creative payroll for more than a month and a half.

Both these indicators assume that your firm maintains an appropriate salary reserve—three months of payroll in liquid form, line of credit, etc. If lower, you should probably take action sooner; if higher, you have a little cushion.

PREPARING EMPLOYEES. Despite a common belief to the contrary, employers are not generally required to provide advance notice of termination. In the absence of a specific contract, employment is normally held to be "at will." This means employees can be dismissed at any time for any legal, nondiscriminatory reason. Nonetheless, it is unethical suddenly to remove the security of an individual's regular paycheck. Plus, from a self-interest standpoint, the speculation that precedes a layoff nearly always has a negative effect on overall morale and productivity. Employees who are kept in the dark and sense through reduced work flow that their jobs may be in jeopardy are always less motivated and productive than informed employees. The rumors about what might happen are usually much worse than the reality of what actually does happen.

SETTING THE STAGE. If you have regular staff meetings or involve your employees in account management they will already have a good sense of the extent of and reasons for the business slowdown. They should also have

a feeling for the future prospects with current clients. If you don't practice this type of management, it's time to start. What employees never know—what you must candidly provide—is a best guess of what other potentials you see, how long you can sustain the present level of reduced activity without reducing staff, and if worse comes to worse, who will be let go.

WHICH EMPLOYEE(S)? "At will" employment notwithstanding, it can be risky to follow anything other than a "last in, first out" (LIFO) layoff policy. To keep a more productive short-term employee on while letting a less productive longer-term one go, may be misconstrued by the laid-off employee as discrimination. ("Why me, and not him?") It may also raise the suspicions of the state unemployment insurance office and your insurance carrier. (Benefits for individuals laid off are usually greater than for those fired or "terminated with cause.") Because of the expense of defending your actions in court, even if you are completely exonerated, we suggest discussing the situation with a lawyer before laying off anyone who was not the most recently hired.

HOW MUCH NOTICE. It should be possible to give layoff candidates several weeks' warning before the fact. Tell them that you hope it won't be necessary, but that it's only fair that you inform them of the possibility as far in advance as possible. Stress that your decision is forced by economics, not the quality of their work. Set an end-of-the-week date for termination that will be reviewed two weeks before. If the work flow doesn't pick up, this date will have to be their last.

Offer to let laid-off employees take company time, within reason, to go on interviews. Provide job-hunting suggestions, contacts, and references. Be magnanimous; you bear at least some responsibility for the situation. Also be sure to go over any noncompete agreements they have signed so there are no future misunderstandings. Depending on the individual and circumstances, you may want to offer the possibility of reemployment or freelance assignments. But be careful not to make promises. Laid-off employees should not automatically get reemployment preference.

SEVERANCE PAY AND BENEFITS. There is no requirement beyond payment for unused vacation time. However, industry norms and Creative Business recommends two weeks severance pay for junior employees; one week for every year employed for senior employees up to a maximum of four weeks. Company benefits are normally paid up through the end of the last month in which the employee works. Laid-off employees may also be eligible to continue purchasing health insurance at your group rates (COBRA benefits). Check your obligations with your accountant.

CLIENT PERCEPTIONS. Most clients will never know, but some may be used to working with one or more of the affected individuals. In these cases,

inform them that, "We've realigned some of our functions to serve our clients even better, and (name) has left to pursue other interests. (Name) is now handling her responsibilities." Handle any inquiry about how to get in touch with laid-off individuals on a case-by-case basis, depending on the caller. The safest response is: "I'm sorry, but I'm afraid that is personal information I'm not at liberty to divulge."

UNEMPLOYMENT INSURANCE PREMIUMS. They are partially based on the number of benefit claims made by recent employees. The more claims made, the more your rate goes up. An occasional layoff of an individual or two probably won't affect your premium. Multiple layoffs affecting multiple individuals could add several hundred dollars yearly.

REMAINING STAFF. Finally, don't ignore the concerns of employees who remain. You can be sure they'll have ongoing worries about whether there will be a next time, and if so, whether they will be among the unlucky. Explain the layoff in terms that appeal to their self-interest—more money for raises, promotions, and bonuses. Then discuss future opportunities in an optimistic but not unrealistic manner. The goal is to reassure them that they are among the chosen who remain, and that, at least for now, their jobs are secure.

⚙ Dealing with Problem Employees ⚙

That every individual is unique makes life interesting and enjoyable. Fortunately, each of us is a one-of-a-kind original, a complex combination of different abilities, experiences, habits, and aspirations. But what makes life interesting in the aggregate also brings challenges in the specific—as in managing people. Individual idiosyncrasies can easily end up as personality clashes or conflict with business objectives in employment situations.

Creative employees pose a special challenge because the nature of creative work requires freedom to explore and experiment. Too much enforcement of too many rules can easily backfire by destroying employee enthusiasm and initiative. Yet, if employees don't adhere to some rules and procedures, a business will cease to be one very quickly. (See chapter 4.)

GOOD INTENTIONS AREN'T ENOUGH. It's rare for principals of design firms to have personnel management training, although most do come to their positions with experience as employees and lots of enthusiasm about doing things right now that they're in charge. The problem is that one needs more than good intentions when it comes to the complex world of managing people effectively. Large organizations address their managers' lack of personnel experience with training backed up by human resources

departments. Principals and supervisors in small organizations are pretty much left to sink or swim.

Personnel-management mistakes are seldom fatal, but trial and error is an expensive way to learn, psychologically as well as financially. Saying or doing the wrong thing at the wrong time could also put you in legal hot water. Of course, the larger your firm grows, the more employees you hire, the more you and your business are at risk. Learning to handle potentially disruptive employee issues is a crucial step in running an efficient, happy, and profitable firm. Any firm of more than a single individual will eventually have some type of employee problem. That much is inevitable. How serious and disruptive the situations become, however, depends in large measure upon what preventative actions have been taken.

HIRE CAREFULLY. Employee problems often have a very simple cause: the wrong person was hired. It is an easy mistake for a small company to make because there is little or none of the oversight or procedures common in large organizations. This situation is exacerbated in design businesses by the tendency of principals and managers to focus on an applicant's talent and give inadequate consideration to other factors. Often equally important are personality, compatibility, flexibility, and work habits. These factors can't be discerned by merely looking at an applicant's portfolio. (See chapter 5.)

BE A FAULT-TOLERANT BOSS. Here's another management-induced problem in small firms: expecting too much from employees. There is a fundamental difference between the interests of most employees and those of the principal(s). Principals have a major stake in the prosperity of a company, employees have a minor stake. It is unrealistic to expect from them the same degree of dedication and hard work that you expect from yourself.

It is also counterproductive to expect employees to do everything your way. Diversity within broad guidelines makes firms stronger, more competitive, and happier places. The best employees—those whom you want to attract and hold—are often those with the strongest personalities and opinions. Don't encourage problems by being unreceptive to new approaches, and don't let personal likes and dislikes unduly influence staffing. Compatibility is important, but even more important is the strengths an employee brings to the business. A good employee is not necessarily someone you personally like.

CONSIDER A TRIAL. Offering a three-month temporary job with the understanding that it may become permanent is a way for both applicant and employer to check each other out. It's an arrangement particularly appropriate for prestigious firms interviewing young candidates, less so for

older candidates who have financial obligations, and when the labor market is tight.

HAVE AN EMPLOYEE HANDBOOK. Policies and procedures are too often left unstated, expectations too often assumed. Whatever form it may take—a small company's informal list of practices and job requirements, or a large company's comprehensive manual—every firm with employees should have a reference that lays out basic expectations and procedures. (See chapter 4 and appendix IV.)

BE CONSISTENT. Many of the situations employees face can't be predicted. Their only guide to an appropriate response is what they believe their supervisor would expect. Supervisors whose style is consistent and predictable, not arbitrary, help employees keep from making bad decisions.

KEEP EYES AND EARS OPEN. Good supervisors use an early warning system to nip problems in the bud. They stay in touch through "walk arounds," staff meetings, and creative reviews. They also earn the trust of employees by keeping confidences private and practicing discretion when dealing with personal issues.

DO REGULAR PERFORMANCE REVIEWS. They provide the primary means to identify, discuss, and correct latent or early-stage problems. Do them at six months for all new employees, and at least yearly for others. (See chapter 6.)

⊛ Trying to Change Bad Habits ⊛

Unless a problem employee is insubordinate or incompetent, it is far better to try to change his or her attitude and work habits than to consider termination. The cost in lost productivity, disruption, hiring, and training someone new is typically in the range of 25 percent of the salary for the position, often more.

There are also other considerations. From an ethical standpoint, termination should be a last resort because it removes a person's livelihood and is damaging to self-esteem. You may also be partly at fault through a bad hiring decision or sloppy management practices. Moreover, firing is one of the most unpleasant tasks facing any manager.

When concern becomes significant enough in your mind to ultimately threaten an employee's job, schedule an immediate performance review with them. Don't wait for the next regularly scheduled one.

Explain what is troubling you and ask the employee what he or she thinks the underlying cause of the problem may be. Ask if there is anything you can do to help. For example, habitual lateness may be caused by

a day care schedule that can be accommodated by adjusting work hours. If it is a personality conflict with other employees, changing workstations or shifting assignments may reduce tensions. Be as accommodating as possible without setting precedents you may later regret.

Your offer of concern and help, backed by the implied threat of bad future evaluations and little or no salary increases, may be all that's necessary to get an errant employee back on track. If so, other than the next regularly scheduled performance review a follow-up may not be necessary.

On the other hand, if there's no easy resolution, try to get the employee to make a commitment to improve by a specified date. Make a note of it and put it in the employee's folder. Then schedule a future follow-up session to evaluate progress. You've now started the process—still reversible at this point—of terminating the employee.

❧ How to Say Goodbye ❧

Other than in rare documented cases of stealing, intoxication, or physical abuse, when to terminate an employee is a tough call. Think of it as a "business toothache." Would you rather keep enduring some pain, or get rid of the pain entirely knowing that doing so will require short-term agony?

Only you can decide. But keep in mind that when an individual doesn't pull his or her weight in a small organization, everyone suffers. An overall decline in productivity means less money in your pocket, and fewer raises for other employees. Firm morale also invariably suffers ("How can he get away with that when I can't?"). Serious employee problems usually get worse. The only solution is management intervention and the threat of termination.

MAKING THE HARD DECISION. There are three things that are important when considering terminating employees: 1) protecting yourself against any possible charges of employer misconduct; 2) making it easy for yourself; and 3) making it easy for them.

The legal issue. Most U. S. states (and many foreign jurisdictions) define employment as being "at will"—i.e., employers have the right to hire and fire whomever they wish, whenever they wish. Despite this, a disgruntled former employee can still be a legal bombshell. It is relatively easy for him or her to claim termination was actually for reasons prohibited by law— for example, sex or age discrimination. Furthermore, "improper dismissal" suits are expensive to defend against since many are taken by lawyers working on a contingency-fee basis. Your only protection against suddenly finding yourself as a defendant is to have the reasons for termi-

nation so well documented that any lawsuit would be quickly dismissed. (Insurance protection against employee lawsuits is relatively inexpensive. See chapter 3.)

The importance of written performance reviews. You should not fire employees without first giving at least one, and preferably several, uncomplimentary written performance reviews. They constitute a paper record that the employee did not perform up to standards even after ample notification. The last review should state clearly that unless improvement is made by a certain date, termination is an option. Be careful in setting this date to make it at the end of a week, and not around the employee's birthday or right before a national or religious holiday. Make sure the employee signs this review and put a copy in his or her file.

The only common exception to the above rule of ample written notification is when you have recently hired an employee and it is obvious that you've made a mistake. It is probably better to rectify this situation as quickly as possible. You should probably also seek legal advice if the new employee made long-term commitments, or actual or implicit promises were made during the hiring process.

Lowering the ax. If you've provided ample warning, including a statement on the last review requiring improvement by a given date, an employee shouldn't be surprised. Early in the morning of the date indicated, inform him or her of your decision. Be candid and unemotional but friendly. Cite the functions not performed satisfactorily and express appreciation for the employee's other contributions. Act concerned that the employment didn't work out, but don't apologize.

Say that as difficult as a situation like this always is, it is no doubt for the best because it will allow the employee to find a position for which he or she is much better suited. Offer any assistance you can provide to make the transition easier. Remind the employee of any noncompete or other agreements in force, and go over the status of all work in process, including the location of files. Be sure to collect any keys and company property. Finally, say that it would be best if the employee left immediately to avoid any potential embarrassment. Offer to be available over the weekend to allow removing personal possessions. Promise that the last paycheck, along with pay for any unused vacation time, will be forwarded within a week. Go over any benefits and when they expire.

Ensuring a clean separation. Promise another check, contingent upon everything being in order, of one or two week's salary depending upon the position occupied and the employee's length of time with the company. This check is to be issued only after you are satisfied that no company property is missing and computers and files have been thoroughly examined. Although expensive, this reduces the chances that the employee will walk

off with company property, sabotage computers, or file suit against you for breach of promise.

Be prepared for an emotional reaction. Sigmund Freud believed that the two most important things to an individual were love and work. Termination can be like getting dumped by a lover—emotionally traumatic. Keep your cool even if the employee gets angry or teary. Don't trade recriminations and don't change your mind regardless of what the employee promises. And never apologize. You've acted ethically and in the best interests of your business. If the employee is unreasonably upset or acts litigious, consult a lawyer.

Play it straight. To lie about the reason for termination or to agree to cover it up by providing a good reference or certifying to the unemployment insurance office that the employee was laid off can land you in trouble. As sympathetic as you may be to the employee's plight, play it straight. There's too much at stake to do otherwise.

Move on. You've just handled one of the toughest jobs any manager has to face. If you can do this, you can do anything. Don't agonize about the cost to the terminated employee, either. If it makes you feel any better, you may actually have done them a favor. It is doubtful whether staying on in a situation where the personal chemistry is bad, or where talents and skills don't match job requirements, is in the best long-term interests of anyone. Being terminated may be a shock, but it often forces the soul-searching that enables an individual to go on to bigger and better things.

SECTION THREE

Marketing

As *creatively talented individuals,* it is only natural many of us would think that only a small amount of marketing is necessary to achieve recognition and financial success. After all, it's the firm's talent that really counts.

Talent is important, but in today's competitive environment it is not enough. Knowing how to market your firm's services is equally important. If you don't constantly market, many potential clients will never know of your services, or only the wrong types of clients will know of them, or you'll end up working mostly for clients without enough money or sophistication to reward your talent and expertise.

Moreover, competition for design services is getting tougher every year. The days of relying on reputation and word-of-mouth referrals, of business coming in "over the transom," are long gone. Today, even the largest and most prestigious design rms promote their services aggressively. In addition to allowing them to hold their own among competitors, it also gives them a better chance at working with clients they want to work with, not the other way around; they are proactively seeking good projects, not merely waiting for whatever clients may happen to bring by.

If you plan to compete effectively in the world of design today, you must appreciate and implement the role of marketing. For most design firms marketing has three major components: positioning, promoting, and selling. Each is covered in a chapter in this section.

"All businesses overestimate their market and underestimate what they can charge."

Anonymous

CHAPTER 9 Positioning

HE FIRST PRINCIPLE of positioning—putting your company in the right place in clients' minds— is to understand the business you're in. If you think it is design, you're only partly right. Actually, it is more than that. It is the business of applying visual ideas and elements in ways that increase and enhance communication between your clients and their audiences. This gives a design business a lot of choices. Offer only design, or a full plate of creative and production services? Print, interactive, or both? Collateral, ads, packaging, or a little of everything? Go after one client type and industry, or pursue them all?

The second principle of positioning is to fit your product (your firm's talent and experience) as closely as possible to the needs of a group of potential customers. To what activities and markets are you best suited? How big is your market area and what types of clients are available? What's the best way to describe the services you offer?

⊕ Marketplace Trends ⊕

Anyone who tries to predict the future is a fool, so we're not going to try. But what we can do with confidence is to point out some recent trends. From them, you can draw your own conclusions on the effect they might have on how you position your company for future success. If you are serious about betting your future on the business of design you should consider the following.

INCREASING HIGH-END OPPORTUNITIES, DECREASING LOW-END. Designers who have been around more than a decade will recall the days when a significant amount of work in even prestigious firms consisted of low-end functions. It was the business of handling the crafts-like tasks that clients couldn't—easy layouts, buying type, preparing mechanicals, and dealing with printers. What this work lacked in creative satisfaction it made up for in profits. Those days are now gone of course, replaced by computers and software that let any office worker produce simple layouts and set type, and copy shops that will not only provide no-experience-necessary printing, but will gladly arrange for any other services needed.

What is not always apparent is that this trend is continuing. Every year the bar moves up a few notches; clients and nondesigners take over more of the tasks they used to call us for. Does this portend ultimate disaster? Not at all, for the loss is balanced by an increase in the number of high-end jobs. Nonetheless, it does portend a sea change in the way design is conducted as a business, for high-end jobs take more than just design skill. They also require an equal amount of strategizing and consultation, as well as enhancing clients' perceptions of sophistication and expertise. In this sense the world hasn't changed: the bigger the job and the more money that's involved, the more your clients expect of you.

GROWING COMPETITION FROM UNEXPECTED PLACES. The growth of the information sector of the economy has produced an explosion in the number of design firms. In addition, competition that used to come from other design firms now comes from everywhere: freelancers, advertising and PR agencies, in-house departments, interactive firms, even over the Internet. Where it will come from tomorrow, and in what form, is anyone's guess.

Actually, this is a blessing in disguise. It is easy to figure out how to react to competition when you can anticipate where it's coming from. But the reaction is usually the wrong one—lowering your prices. In contrast, not knowing the competition can encourage you to compete on a higher level; it can encourage you to promote services that add value to your design product, such as strategic planning, communications expertise, and better service. It can also encourage you to look for new ways of doing things, and new markets to enter. In other words, competition is not all bad. There's plenty of business for everyone. Smart firms focus on opportunities and how to go after them, not on what competitors are doing.

TECHNOLOGY IS AN OPPORTUNITY AND A TRAP. On the one hand, new technology allows you to easily experiment with more design solutions, automates much of the noncreative functions of the design process, lets you work faster and more productively, allows you to pursue new fields more easily, and might even make working with distant clients feasible. On the other hand, it is expensive both in out-of-pocket costs and in train-

ing and down time. Moreover, no sooner is a new technology comfortably integrated into a shop than it becomes obsolete and must be replaced or upgraded, often at a cost of thousands of dollars.

The future holds an increasing dependence on technology, increasing expenditures for it, and the increased risks that come with making the wrong choices. Design firms must be careful not to fall behind in implementing essential technology, but they must also be careful not to fall into the trap of jumping at the latest-and-greatest just because it's new and cool. It must fit with their capabilities and interests. Keep this old saw in mind: Early pioneers take most of the arrows; later settlers take most of the land. Balancing technology's real needs and hidden risks is a major challenge for all twenty-first-century design firms.

Is it Better to Specialize?

Specializing is perhaps the easiest way to position a design firm. It also fits into today's business trend toward more niche marketing. You see signs of specialization everywhere. Generic restaurants are out, ethnic ones are in; department stores flounder, specialty retailers prosper; TV broadcasters lose market share to cable TV narrowcasters; we're less likely to stop for a cup of coffee, more likely to go out for a Jamaican Blue Mountain Double Roast.

Specialization among designers is, of course, nothing new. Many of us have long promoted ourselves as being particularly adept in certain areas; for example, business-to-business, print collateral, or as a creative boutique. What's different today are the opportunities at the next level of specialization: specializing not just in business-to-business, but in a specific industry; not just in collateral, but in, say, capability brochures; not just as a creative boutique, but as interactive-media experts.

Whatever the trend, however, specializing is not as simple as just deciding to do it. It takes matching your specific talents, interests, training, and experience to the needs of available clients. If, for example, most of your experience is doing ads for retail clients, an historically underpaid area, successfully moving to higher-paying fashion clients will take perseverance. Not every area can support every type of specialty. As an example, becoming a specialist in publication design will likely require living near one of the country's few publishing hubs. Moreover, and whether it is the result of talent, training, or accident, many of us are too well established to switch easily. To compromise what we've learned to do well just to scratch a creative itch could be the height of business folly. So the first step in considering whether or not to become more of a specialist is to look carefully and objectively at what you have, and what you'll have to give up.

THE ARGUMENTS FOR. There are several very practical business reasons for specializing. Besides, if this is the way the rest of the world seems to be marching, why be out of step?

It increases income. The more clients believe you have a unique talent or expertise, the more they are willing to pay for access to it. Specialists and consultants usually can command more—per project and per hour—than generalists and doers. This holds especially true for smaller shops that lack the compensating name recognition and reputation of larger shops. Specialists are also more likely to be put on retainer, a cash-flow-beneficial arrangement. (See chapter 12 for more on retainers.)

It limits competition. There may be more jobs available then ever before, but there is also more competition. It can be difficult to even get in to see many clients. Specializing allows you to differentiate your services from the pack, get better clients, and reduce the competitors you go head-to-head against.

It reduces expenses. When your marketing is more focused, it costs less. Likewise with internal procedures. The more refined and standardized a firm's functions, the higher its productivity and the lower its costs. You don't have to worry about expensive technology upgrades that are used only occasionally, either. Any investments you do make in specific equipment, software, and education can be amortized over a more substantial client base.

It broadens your market area. Given the options available locally to most clients, there's little reason for them to consider creative firms outside their area. Except, that is, when an out-of-town firm can provide a talent or expertise not available or in short supply locally. Specialist firms are usually the only ones that can compete regularly on a regional or national basis.

It produces higher-level assignments. Since being a specialist implies expertise, clients are more likely to ask for strategy, planning, and budget recommendations in addition to creative work. This builds client loyalty. It also provides greater growth opportunities, more challenges, and higher potential profitability.

THE ARGUMENTS AGAINST. All the above are persuasive reasons for picking a niche and developing your business within it. But before you go out and tie your future to a certain industry, technology, or medium, you should also consider the following.

It increases short-term vulnerability. Once established as a specialist, that's the way you'll be perceived, for better or for worse, good times and bad. No problem as long as business remains good. But when there's a downturn, there will be no other types of work to fall back on. Even clients who know the breadth of your capabilities will be reluctant to provide projects outside your field. Many types of speciality work are seasonal or cyclical, too.

It increases long-term vulnerability. None of us can predict what's over the horizon. New processes or technologies may come along that will eliminate the very niche we choose. If, for example, you had gone into the booming typesetting field twenty-five years ago, chances are you would be out of business today. Making a living as a desktop publisher is a lot harder now than it was a decade ago, and any designer who has specialized in annual reports for more than a few years has been through the fallout that is the natural result of economic cycles.

It may produce creative ennui. Maintaining the quality of your product is crucial to happy clients and the prosperity that flows from them. Yet, when you handle the same types of assignments week-in, week-out, chances are that sooner or later the work will start to lose its edge and become formulaic. Likewise, it is difficult to keep talented staff motivated when the work becomes routine and there's little day-to-day challenge. Boredom kills creativity.

It may lead to a catch-22 dilemma. The more highly you specialize, the more likely you'll be to run into conflicts of interest. Many clients will be uneasy about your working with similar clients, especially when their jobs involve propriety information. Yet, as a specialist, chances are you will have to work with their competitors someday or risk having an unhealthy portion of your business tied up with just a few noncompetitive clients.

MAKING UP YOUR MIND. Today's design marketplace presents a paradox. On the one hand there's a growing demand for the business experience, sophisticated creativity, and marketing resources normally associated with firms that specialize. On the other hand, some clients seem to want everything—ads to Web sites—from one supplier. Is this an unreconcilable problem? Not necessarily.

One of the advantages of the growth of specialization is that it also provides far more outsourcing options. It is possible in nearly all metropolitan markets today to get most specialized services and help on an à la carte basis. So, if you only occasionally need such expert services as media buying or e-commerce site development, there's probably a nearby firm that can handle it for you. Likewise, there is probably a nearby temp firm that can provide an expert in a certain industry, market, or process to advise you or to impress clients. It is possible today to rent whatever you need, whenever you need it, for only as long as you need it.

When your need is longer term but still only occasional, it can be addressed by forming strategic alliances with specialty suppliers. The services they provide can be transparent to the client or offered jointly. Either way, it can be a cost-effective method of meeting specialized needs.

When your need is both long-term and steady, but not high in volume, the solution favored by mid-size and larger firms is to employ one or more

staff specialists (e.g., a package designer) in a mini, semi-autonomous department.

For larger shops that do wish to pursue specialized markets but not to redirect the firm's emphasis, the solution is usually setting up one or more separate, internal profit centers (e.g., public relations). This allows going after specialized business separately by promoting the benefits of independent but coordinated activities. It may also avoid conflict-of-interest situations.

Finally, there's no reason a firm can't be one thing to some clients and another to others. It helps to have a company name that is not indicative of specialization (e.g., "advertising"), and examples to provide credibility are, of course, required. Otherwise, what you are to any new client is pretty much what you say you are. In short, custom-tailor your presentations.

What About Broader Positioning than "Graphic Design?"

Creative Business surveys show that only about 50 percent of firms run by graphic designers and offering primarily design services identify themselves as such. Others use labels such as "marketing communications," "advertising," or "integrated media consultants." While such labels are appropriate for positioning some firms, they shouldn't be used without careful consideration. It is a positioning mistake to call your firm something it isn't just to try and attract a broader business base. It is better to be known as a good design firm working for sophisticated clients than a mediocre ad agency working for rinky-dink ones. The only firms that may have to use a broader label to generate sufficient business are small ones outside metropolitan areas.

This is not to say that you can't accept and handle a variety of design-related projects well. But the way you position your firm should be your primary focus, be it design, advertising, interactive media, or whatever.

When is a Design Firm Something Else?

The work of design firms is primarily project oriented. That is, each project is usually independent of others, even those that come from the same client. When the project is done the client relationship is ended, at least temporarily. In contrast, agency work is mostly ongoing assignments, such as advertising campaigns. They extend over a period of time and usually involve many separate projects, such as individual ads. If you are considering positioning your firm as an agency, whether advertising, public relations, or interactive, first consider the following.

THE LEGAL DEFINITION. While the word is often used casually, it does have a legal definition. Black's Law Dictionary defines an agent as "a person authorized by another to act for or in place of him . . . to transact all business . . . of some particular kind. . . ."

Whether or not one is a legal agent for a client is defined by the agreement between them. Having the agreement in writing ("letter of agency") is not absolutely necessary (it can be oral), but it is certainly desirable to avoid later conflicts and misunderstandings. (See the Letter of Agency in appendix IV.) An "agency of record" is usually understood to be an agency with an agreement designating it as the client's exclusive agent for a particular product or market. For clients with several agencies, it is usually the one that coordinates the media buying and scheduling.

Without an in-force agent agreement, it is inappropriate to use the word "agency" in a specific sense—i.e., for a particular client. However, it is appropriate to use the word in a generic, business sense—i.e., to describe the type of work your firm handles. In other words, if you look like a duck and act like a duck, feel free to call yourself a duck. Just don't call yourself Client's Duck without an agent agreement.

DOING AGENCY WORK. Here are the fundamental differences between firms doing ongoing and those doing project-type work.

Planning. Clients are much more likely to ask an agency for strategy, planning, and budget recommendations. While this provides more opportunities, it also requires marketing knowledge and an understanding of what is appropriate in various circumstances. It carries with it much greater responsibility and accountability.

Resources. Agencies need access to research and media resources. Basic media information can be obtained from such sources as *Standard Rate and Data*, and *Bacon's Publicity Checker*, which are available in most large libraries. More extensive media needs require staff or contracting with a media buying service. Small agencies nearly always contract out research to a market research firm.

Creativity. Agency work is more likely to be focused around selling products, whereas design is more likely to concentrate on organization, explanation, and decoration. The limited space and short viewer attention span of ads also encourages development of the "big idea," along with finely honed art and copy. Talented individuals can adapt to working in either style, but it takes desire and discipline.

Service. Ongoing assignments are very service-intensive. This not only means having staff adequate for regular client contact, but also staff to handle such things as media placement, insertion verification, follow-up analysis, and client billing.

Conflicts of interest. The more intensively you work with any client, the greater the possibility of a conflict of interest with a similar client. Conflicts are not usually a problem when working on project assignments. Projects for similar clients are normally separated by time, and minimal knowledge of client plans and trade secrets are involved. For example, doing brochures for two different banks at two different times would probably not compromise the interests of either. (Caution: It is always best to acknowledge previous work for a similar client to avoid any appearance of a conflict.) Ongoing assignments are a much different situation. Client contact is continuous, and it is difficult to be equally loyal to two competitors. More important, the agency is often entrusted with proprietary information. Because of this, agencies should work with only one client in any particular field—for example, only one bank, one auto dealer, etc. (For more on this, see chapter 13.)

Spec work. This is much more common in the agency world, where the stakes are higher. It may be necessary to be considered for some assignments. (For more on this, see chapter 13.)

GETTING PAID. The compensation system used for project and ongoing work is also somewhat different. Three systems, or a combination, can be used.

Commission basis. Most other agents (e.g., insurance, travel, real estate, etc.) work for a commission on the business placed on behalf of their clients. The commission is usually paid by the firm receiving the business. This was once the way it always was in the advertising business, and a media commission is still the norm for most large-budget accounts, particularly those involving broadcast time. In this arrangement, much of the preparation cost of advertising is "free" to the client.

The traditional media commission is 15 percent. As an example of working on commission, let's say you prepare and place a full-page ad in a trade magazine for a client. The cost of the space is $2,000. When the ad appears, you will likely get a bill from the publisher that looks like this:

1 page @ $2,000	$2,000
Commission @ 15%	– 300
Balance due	$1,700

You then bill the client the full $2,000, keeping the $300. (Note: The $300 commission is 15 percent as a markdown. It would be 17.65 percent if a $1,700 bill was marked up to $2,000.)

The agency commission applies only to the media cost and normally covers account service and occasionally creativity when the budget is media heavy. The agency charges the client separately for all production and ancillary services—research, photography, artwork, films, shipping,

etc. Outside purchases are typically marked up at 17.65 percent. (See the previous paragraph for why this figure is used.)

As you can probably surmise from this example, it is difficult to do profitable advertising on a commission basis without placing a significant amount of pricey media. Agencies working with small budgets, or working with large budgets requiring a high amount of creative or account service, nearly always work at least partially on a fee basis.

Fee basis. This has been the compensation norm for small-budget ad accounts for the last few decades. Today, most small-budget accounts are handled primarily on what's referred to as fee-for-service, sometimes supplemented by commissions. In this arrangement agency services are billed at one or more shop rates. Rates vary according to the level of talent and service performed. Typically, small- to mid-sized shops in metropolitan areas charge four rates: say, $150 to $175 an hour for senior creative or principals' talent; $125 to $150 for mid-level creative, media, and account service; $100 to $125 for junior creative; and $35 to $50 for administrative (clerical) work. To ensure profitability, shop rates should be more than three times the average cost of the salary of the employees in any given category. It is also important to segment tasks and keep accurate time records. (See chapter 13.)

The most straightforward way to work on a fee basis is for you to select the media and place the ads, but have the media bill the client directly. This eliminates any concern about getting hung out by late or no-pay clients. From the client's perspective there's also no possibility of "hidden" commissions going to you. If, however, the client prefers that you pay the media and bill them, it is appropriate to collect the media charge *before* the ad is placed. If there is any commission forthcoming, it is credited to the next invoice sent to the client.

The downside of working on a fee basis is that it eliminates the opportunistic profits that can come from placing the same inexpensive ads many times in expensive media. In other words, it is a conservative approach that minimizes both big profits and big risks.

Retainer basis. To be able to ensure immediate service when clients need it, many agencies work on a monthly retainer (guaranteed fee) basis. The why and how of setting up a retainer is covered in chapter 12.

❧ Mission Statements ❧

Once the decision on how the company should be positioned has been made, formalizing it will help ensure that it is followed. The larger the company, the more important it is that all employees understand its

approach to business. "Mission statements" (sometimes called "vision statements" or "values statements") are a way of doing this.

THE BENEFITS. The Magna Carta, the Mayflower Compact, and the Declaration of Independence are all mission statements—that is, they are simple declarations of a group's beliefs and goals. Although often parodied, mission statements nonetheless can be effective means of defining a set of unifying principles. They function as the foundation upon which a company's policies are later built. Or, to use another analogy, as the constitution upon which all its "laws" (procedures) are later based.

Helping to differentiate your business. The odds of long-term success in a competitive service environment are greatly increased by focusing on what you offer that is distinctive. A mission statement is a good place to start. It can provide the nucleus around which a solid business strategy and plan can later be written. Even if you already have a well-thought-out plan, the process of distilling it to produce a mission statement can provide a good reality check.

Making better long-term decisions. The world of design keeps offering up new clients and opportunities. Many will be perfect for you, some okay, a few disastrous. Which to go after, and with how much effort? A set of guiding principles can help you make these tough decisions. It minimizes the chances of pursuing business that does not fit your experience, game plan, or operating style. To paraphrase a cliché: do what you are suited for, avoid what you aren't, and prosperity will likely follow.

Finding and retaining good employees. Designers, especially younger ones, are motivated as much by idealism as money. A mission statement won't directly affect a company's procedures or working conditions, but it usually will do so indirectly by establishing standards that are difficult to ignore. Equally important, it reassures new employees that you provide an environment that they can feel comfortable working in.

Finding and retaining business associates. Although idealism isn't important in deciding whether to team up, either for a single job or a business partnership, the likelihood of being able to work together comfortably is. It can be tested by the extent to which both parties are comfortable with a set of basic operating principles.

Promoting better client and vendor relations. Specifically, it is reassuring for others to know that a business they are dealing with operates on a set of ethical principles. In the abstract, a well-run business is a more successful business, and successful businesses are always in more demand.

ACKNOWLEDGING THE DOWNSIDE. The most important step in preparing a mission statement is to acknowledge the downside right up front. If it is

not truthful, properly thought out, and carefully written, it won't be taken seriously. To be effective it must articulate the organization's core goals, values, and purposes, and it must do so in a sincere, believable, and concise manner. Flowery text, buzz words, clichés, and anything unrealistic, excessively idealistic, or self-congratulatory should be avoided. This is no small challenge, because this is a medium that seems to encourage simplistic pap.

THE ESSENTIALS. Since the needs and objectives of every design firm differ, so does every mission statement. There are, however, some essentials that apply across the board. Good mission statements always address three criteria: 1) they define what it is that makes the organization different; 2) they increase uniformity between the organization's various activities; and 3) they merchandise the organization's uniqueness to both employees and customers. The following are also important.

Be realistic. Nothing causes a loss of credibility faster than falsely idealistic or patently untrue pronouncements. As good as some ideals may sound, they shouldn't be included unless they are truly representative of the organization's beliefs.

Aim high. There may be nothing worse than false idealism, but a mission statement also needs to be something more than a simple reflection of everyday reality. It should state an organization's goals and aspirations, some of which may not be immediately achievable.

Eschew clichés. Try to avoid them by searching for fresh approaches. This takes perseverance because mission statements lend themselves to simplistic statements and idealism.

Keep it concise. In its essence, a mission statement is nothing more than a highly distilled version of an organization's core values. For even the largest organizations, this seldom requires more than a single page of text.

THE PROCESS. The benefits of going through the process are often as important as the results. It forces a firm's principals to confront business realities. It requires thinking about marketplace differentiation and long- versus short-term decision making. It focuses on the importance of cultivating the right type of customers and employees. And it emphasizes developing a consistent approach to business.

Answer three questions. 1) Why am I in business? 2) Which of my fundamental beliefs affect the way I do business? 3) What will help my business grow and prosper in the future? Write out the answers in as much detail as necessary. If you have an up-to-date business plan, you've already done some of this. A mission statement is just a more highly distilled, longer- term version, and one that's also more philosophically than strategically focused. (For more on business planning, see chapter 1.)

Boil it down. Take the answers to the three key questions and start editing. Keep culling and combining until you have up to a dozen short statements that capture the very essence of what the organization believes it is and wants to be. Then refine each of these statements into a positive, active voice. Be careful not to exaggerate or imply promises. For example, use words like "strive," "recognize," and "expect" to indicate a commitment without a guarantee.

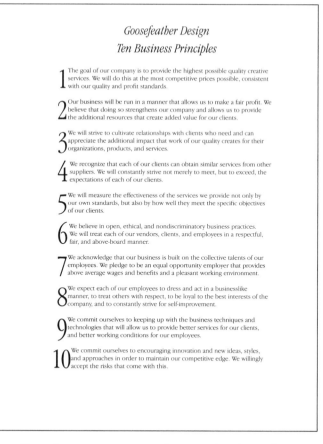

Typical mission statement for a graphic design firm.

Involve employees. As the final step before publication, try out a draft on selected employees. Give it a test drive. Doing so will help prevent against exaggeration, implicit promises, and later criticisms.

Review it periodically. Although mission statements should be carefully crafted with long-term verities in mind, they shouldn't be considered unchangeable. They should be reviewed and modified periodically to ensure that they continue to reflect the organization.

PUTTING IT TO GOOD USE. Despite how much time and creativity is involved in its preparation, ultimately the effectiveness of a mission statement depends on its use. The more places it is used, the greater its impact and the lower its cost. Here are a few suggestions.

• Publish it in the employee handbook (policies and procedures manu-

al)—to introduce new employees to the basic rules and culture of the organization

- Post it on employee bulletin boards—to remind them of the organization's values and policies
- Frame and posted it in the reception area and conference rooms—to impress visiting clients and vendors
- Use it as an element in performance evaluations—to promote operating consistency among staff
- Post it on your Web site—to differentiate your business from competitors by indicating how you do business, as well as what you do

❧ Positioning for the Future ❧

Wouldn't it be nice if time stood still? You'd never get older, your business would never need to adapt to change, and you wouldn't have to worry about your ability to remain creative and competitive. Unfortunately, change is not only inevitable, it happens sooner rather than later. So you have to be prepared to occasionally reposition your company.

In manufacturing businesses, not adapting to change usually means failing to produce the right products at the right time. The solution is to hurry back to the drawing board, retool, crank up the factory, and hope for the best. In the service business, however, the cause and effect are different, and not as dramatic. Because the product is intangible—a combination of skill, talent, knowledge, expertise, experience, etc.—it can't be simply retooled to fit a changing market, and customer erosion is much less visible.

More specifically, not adapting to change in a design business usually means continuing to go after the same clients with the same approach and intensity, even though their tastes and your capabilities are changing. The result can be losing business, getting fewer assignments, or making concessions (e.g., lowering prices) to keep clients happy. Moreover, the problem increases with age, caused by a combination of burnout and failure to retain a creative edge in the eyes of clients.

WAYS OF ADAPTING. As they age it is natural and inevitable for designers to lose some of their abilities to keep up with the latest styles and be competitive for certain types of assignments, as well as retain their enthusiasm and ability to maintain the pace required by some clients. Larger firms faced with clients who are unhappy over the design or service they're getting have the luxury of replacing the team working on the account. But

they do have to have the foresight to recognize the problem, and the resolve to address it.

For small- and mid-sized firms without these staff resources the situation is different. Addressing it usually requires ceasing to pursue clients and assignments that are no longer a match for the firm's capabilities, and replacing them with ones that are. In other words, when you can't easily change what you offer, you must change to whom you offer it. As difficult as this decision may be, making it is crucial to ensuring that your business remains healthy. Whatever the size of your firm, keep in mind the following three truisms as you contemplate how your business should evolve.

Experience, not trendiness, produces the most profitable projects. It's true, although one would never know it from looking at award shows. Truth is, much of the cutting-edge work we admire is produced in situations that are not profitable. Same, too, for working with many high-profile clients. The reality is that good, profitable projects usually come from clients who are more interested in experience, knowledge, and professionalism than the very highest level of creativity and service. With the exceptions of some product introductions, ad campaigns, and Web work, solid creativity—nothing too radical—is what most clients are looking for.

The business is communications, not design. It's easy to lose sight of this in our zeal to constantly innovate and create. While a higher level of design can often be more effective in breaking through visual clutter, this isn't always the case. For many projects and many clients, too much creativity gets in the way of good communication. The perspective that comes out of years of experience—knowing what's enough and what's too much—can easily offset any creative disadvantage that may also come with age. Assuming, that is, that the advantages of experience are properly positioned.

Personal chemistry counts for more than anything. By and large clients give business to individuals they like. The more they like you, the more reluctant they are to take business away from you. Whatever creative and service limitations you possess, now or in the future, they will be more easily overlooked if your personal relationships with clients remain strong.

SPECIFIC ACTION PLANS. Whether you are currently faced with the problems of a "graying business," or will face them later, here are some effective antidotes.

Strengthen your personal relationships. Think of this as a preemptive strike. First, examine your procedures to make sure that no clients will ever feel their projects are routine or their business is not greatly appreciated. Next, take a much more active interest in their businesses. Learn more about their markets and industries. Show interest in their products and process-

es. Express concern over their reverses, joy over their triumphs. Finally, resolve to get to know your very best clients better, especially those you genuinely like. Be interested in their personal lives, spring for an occasional lunch, include them as part of your social circle. One "good friend" can be worth ten other clients over the years to come.

Adjust your client goals. The smaller your business, the older you are, the more important it becomes to position yourself as a dependable, experienced resource, especially when dealing with younger individuals and organizations. This usually means less concentration on clients looking for cutting-edge creativity; less portfolio emphasis on innovative ideas, trendy concepts, and novel approaches. It usually means more concentration on clients who are looking for experience, perspective, and dependability; more portfolio emphasis on assignments that show professionalism, knowledge, and attention to detail. Begin thinking of yourself and your firm as a strategic creative partner to clients of all sizes; a marketing "guru" to small- and mid-sized ones. Whenever you are one-on-one with a client, make sure you dress and act the role.

Market more aggressively. Marketing becomes increasingly important as a design business evolves because it provides the sole means of influencing what types of assignments it gets. It is unlikely that new, reliable sources of business can be developed without first going through the marketing process of deciding what to go after, and then aggressively doing so. Lack of ongoing marketing is one of the major reasons why there are relatively few decades-old design businesses. When traditional sources dry up, too few firms have developed efficient means to replace them.

Stress accomplishments. Target clients who are a solid match with your current strengths when developing your marketing strategy. Then, when pitching them, stress who you have worked with (previous clients), what projects you've worked on (experience), what your work has accomplished (results). In other words, play the experience card. It is the strongest one in your deck. For example: "We've been solving problems like yours, for clients like you, for ___ years. During that time we've won our share of awards of course, but what matters most is the success we've been able to bring to our clients."

Don't contribute to the problem. In a practical sense your shortcomings don't exist until you start losing business over them. Furthermore, they are almost surely less important than you make them out to be, and they can be overcome. As you get older the business you lose on the creative and energy end of the spectrum can probably be made up on the experience and perspective end. Learn to consider "been there, done that" as a positive factor that provides a distinct advantage over younger competitors. Don't hesitate to exploit it.

Modify your pricing. Up, not down. If this sounds like flirting with the devil, keep in mind that experience and knowledge are always more highly valued in the marketplace than raw talent. They are your strongest attributes. (Most valuable of all, of course, is a combination of experience, knowledge, and talent.) It takes self-confidence and chutzpah, but higher prices usually lead to higher respect. Pricing too low will probably damage your credibility just at a time when you can least afford it.

Be realistic. A major contributor to burnout is the frustration that comes from working with unrealistic clients or pursuing difficult-to-get assignments. To avoid it, to keep yourself and your business healthy long into the future, you should readjust (not lower) your sights to what's currently realistic for you. If you can learn to recognize your changing abilities and constantly adapt your business around them, there's no reason you can't be as successful decades from now as you are today. Believe it or not, it is possible for age, success, and health to increase together. (For more on how design businesses often evolve, see "Three Stages of Growth" in chapter 14.)

CHAPTER 10 Promoting

P ROMOTION—making potential clients aware of the benefits of working with your company through ads, mailings, and other activities—is the second step in design firm marketing. It follows positioning, described in the previous chapter, and precedes sales procedures, described in the chapter following.

We all know the roles innovation and style can play in showcasing talent and creating impact. Not so immediately apparent is that format affects content, and that the medium is part of the message. Too often overlooked is that the goal is not just to create impact, but to do so in the most cost-effective way. The former is relatively easy, the latter much more difficult.

⊛ The Many Benefits ⊛

The business of most design firms is built at least partially on handling promotional projects for clients. If our clients consider promotion crucial to their businesses, shouldn't we do likewise for ours? The answer, of course, is yes. Realistically, however, it is always easier to see the benefits others will get from spending their money than those we'll get from spending ours. With this in mind, the following are ten reasons why your business should have regular and consistent promotional activity.

1. It can produce sales leads and assignments.

2. It can reduce costs by making personal selling easier.

3. It can strengthen credibility with existing clients.

4. It can create an image that attracts more upscale projects and clients.

5. It can introduce old clients to new services.

6. It can increase employee pride and morale.

7. It can make recruiting talent easier.

8. It can create awareness that increases a business's goodwill value.

9. It can lead to referral business.

10. It can intimidate your competition.

❧ Design Firm Fundamentals ❧

Most promotional fundamentals, such as good timing, message consistency, return on investment, and so forth, are no different for design firms than for their clients. Yet, to be truly effective, promotional activity for any type of business must also take into account its idiosyncrasies. When it comes to the design business, there are two important factors to consider.

THE REAL PAYOFF IS LONG-TERM. It is entirely possible to run an ad or drop a mailing tomorrow and get a great new project from it the very next day, but it is unlikely. Far more likely is that you will have to contact any good prospect for your services several times before getting a response. One reason is that this is usually what it takes for your message to sink in and appeal to the client's interests. Another even more likely reason is that your previous messages arrived at the wrong time. Many clients only need design services occasionally, or they need what they believe you can handle only occasionally. You may have to contact a client many times before your message arrives when they are about to make a decision. The more promotion you do, the more effective the overall effect.

FREQUENCY BRINGS IN MORE BUSINESS THAN IMPACT. For any given amount of money there are two promotional choices: you can do more expensive things less often, or less expensive things more often. Either way, you spend the same amount. The former is called "opting for impact," the latter "opting for frequency." Unfortunately, designers usually opt for impact and it is the wrong choice. The reason is that design business stability usually requires a variety of clients, each of whom calls only occasionally. The only way to ensure that they will remember to call you and not a competitor is through periodic reminders. Blowing your promotional budget on one or two big efforts, even when they are creatively

exciting and attract great interest, is seldom as effective as a series of lesser efforts implemented more often. It is better to constantly remind potential clients of your capabilities than to demonstrate them with elaborate promotions that are momentarily noticed and soon forgotten.

⊛ Advertising ⊛

This is the promotional activity that comes most readily to mind. It is, after all, highly visual and something you have probably done for clients. The major advantage of ads is that they produce a lot of exposure at low cost per reader. Second, they enhance the image of a design firm and give it credibility. They also take up less time—once prepared they can be run and rerun with little additional effort.

But there are also substantial tradeoffs. Perhaps most important is that ads large enough to demonstrate creativity are usually costly, given the frequency necessary for effectiveness. Any creativity is limited to the format restrictions of a publication, and readership is limited to a publication's circulation, which is seldom as specific ("vertical") as desired.

CONSIDERING EFFECTIVENESS. Services ads usually have to run at least a half-dozen times in a monthly publication, or twelve or more times in a weekly publication, to be effective. (In marketing terms, "overcoming the threshold of awareness.") This makes the media cost for advertising a design firm's services high, even when you run just a single ad. To determine whether a campaign will be cost-effective in generating business, start from the premise that the new business resulting should equal its total costs (production and media) within one year. Given that only about half the impact of an ad can be measured (the rest produces nontrackable business months or years later), this means that its true return on advertising investment (ROAI) is approximately two to one. As a rule of thumb, kill any ad campaign where the ROAI will be less than two to one; increase the frequency of any ad campaign with a ratio of more than two to one. Given this criterion, most design firms will find that advertising is not as cost-effective in generating new business as other media, such as a direct-mail campaign (see below).

There is, however, another factor to also consider: the role of advertising in maintaining and enhancing a design firm's reputation. The larger the firm and the smaller their market area, the more a consideration it should be. In these situations the effectiveness of advertising is not measured solely in the new business it generates, but also in how it reassures existing clients and lays the groundwork for sales representatives to call on potential new clients.

CREATIVE BUSINESS'S RECOMMENDATIONS. For design firms under a dozen employees Creative Business recommends against using advertising as the primary promotional medium. The disadvantages almost always outweigh the advantages, as outlined above. For these firms, we believe that advertising should be used only as an occasional supplemental medium, and only where the situation clearly warrants it. An exception would be where a sufficient schedule of ads could be cost-effectively run in local business media.

For design firms of over a dozen employees a modest advertising campaign is probably necessary to ensure that name recognition remains high. Assuming there is sufficient sales activity, it can be the primary promotional medium, supplemented as necessary by other activities, such as tailored mailings.

❦ Web Promotion ❦

This is a promotional area of much interest. In some ways a Web site is analogous to a glorified ad. What gives it even more potential, however, is that it can describe what you do and show examples of your work, inexpensively in full color, even with motion and sound. E-mail newsletters or bulletins offer an inexpensive way to keep current and potential clients aware of your activities.

CONSIDERING EFFECTIVENESS. Web sites are unusual in that they are a promotional medium that must be promoted to have any effect. Despite how impressive a site may be, it is unlikely a client will just stumble over it. It must be merchandised. Merely running the Internet address (URL) in other promotional material is not enough.

Regular e-mail newsletters or bulletins are a promising, if yet unproven, promotional medium. They are inexpensive to produce and offer great creative variety. The downside is that the tremendous volume of e-mail messages (SPAM) can greatly diminish their effectiveness.

CREATIVE BUSINESS'S RECOMMENDATION. Most design firms already have their own Web sites. If you don't, you should. Clients expect it, and it is a good place to showcase your work, clients, and procedures. The address should also be featured in all promotional material. But as of this writing the primary impact of design firm Web sites has been to supplement their other promotional activities by providing additional detail and credibility. There is little evidence that a Web site alone is effective in generating new business that is not directly Internet related.

As for regular e-mail bulletins or newsletters, they are worth a try, but should be designed and distributed in a way that not only demonstrates

communication sophistication but also clearly differentiates them from SPAM.

⊕ Direct Mail ⊕

Even in this electronic age promotional mailings are still the promotional medium of choice for design firms. There are several reasons why. The most appealing reason is that they provide considerable creative latitude; there are few format restrictions and plenty of room to show and describe your work. They can also accommodate a reply card for lead gathering. With a good mailing list the message can be precisely targeted with little waste. The mailings can be done quickly without the need for media contracts or commitments. Small mailings can even be printed on in-office color printers. Even though there is some cumulative benefit from regularity and continuity, it isn't as necessary for success as it is with most advertising. Promotional mailings do, however, require thought, advanced planning, and hard-hitting creativity to work well. Poorly implemented mailings can work against you. The effectiveness of any direct mailing will only be as strong as the mailing list used.

CONSIDERING EFFECTIVENESS. Strive for memorability; this is not the place for subtlety. If you are trying to set up appointments, concentrate on how your services can solve a particular marketing problem, leverage time, or provide more effective creativity. Don't try to cover too much, either visually or verbally. By doing several mailings, one subject to each, rather than one mailing covering several subjects, you can mount a very effective long-term campaign.

The typical response to mailers, measured by returned reply cards requesting a call, is from one to two percent. The ratio of converting these appointments into actual jobs is probably at best one in three. So before preparing a mailing, make sure the list you use includes enough good names to pay off your considerable investment in time, printing, and postage. But don't make the mistake of thinking mailings are only for getting appointments, either. Even when only one percent of the list responds, perhaps ten percent or more will remember your name. They may respond to your next mailing. They may refer to you when asked for a recommendation. Or they may remember and call you months or years from now. For these reasons you should also consider non-appointment-oriented informational mailings. Be sure to send them to existing clients as well as to potential new ones.

CREATIVE BUSINESS'S RECOMMENDATIONS. Direct mail should be the primary medium for all small- to mid-sized design firms, as well as many

larger ones. When done well and mailed to the right prospects, mailers create more immediate impact than any other type of promotion. They are nearly always more effective than advertising in getting portfolio appointments or reminding past and potential clients of your services. They also demonstrate a high degree of communications sophistication—that you can do for yourself what you sell to others. We recommend that a mailer be sent to a design firm's prospect/customer list every six months. If so, it is unlikely that anyone on the list will remain unaware of your services. And awareness is the essential first step in getting a prospective client to call.

❧ Reputation Building ❧

The better known you are, the more likely you will be on the short list of design firms that clients consider. Firms with strong reputations often get called by clients they might otherwise never hear of. When making a sales call, reputation is often the difference between getting an appointment and not. There is nothing more heartening than to hear a client respond: "Oh yes. I've heard of you. Let's set something up." Being considered more often with less effort can save thousands in promotion costs every year. Everything else being equal, promotion expenses of better-known firms are proportionately smaller than those for less well-known firms.

The stronger the reputation, the shorter the odds of beating out others for the assignment. Since clients are already predisposed to like what they see and hear, competitive pressures are eased, and presentations become more effective. So, too, when it comes to negotiating creative and pricing issues. Because a good reputation implies a degree of trust, well-regarded individuals and firms are less likely to have their creativity and estimates challenged or nitpicked. Once again, all other things being equal, better-known firms have more latitude than their less well-known counterparts.

Most of us recognize the importance of reputations in landing plum assignments. What we often don't recognize is that they aren't necessarily based on talent alone. Many reputations—for cutting-edge creativity, exemplary service, easy working relationships, etc.—are the result of carefully cultivated promotional activity, most commonly generating publicity about your firm, networking to build exposure, and using award shows to create a "buzz."

❧ Publicity ❧

While essential, traditional promotional activities such as mailings and ads are costly and oriented around specific objectives, such as getting enough

work to pay next month's bills. Publicity—getting mentioned in the press—is less costly and can have even more long-term impact. On the downside, you can't be sure when or how much publicity will be generated, or how much business it will produce. Thus, a combination of other promotional activities to ensure a certain volume of business along with publicity to enhance a reputation is the formula many successful firms use to ensure a continuous stream of quality assignments.

SHAPING PERCEPTIONS. No matter how good you think you are, when it comes to getting business, it's what clients think that's important. Moreover, unless your firm is highly visible, many potential clients never give you a thought. Given enough time and promotional money you might eventually develop the visibility you deserve. But generating publicity about your firm is faster and less costly. (Other ways of becoming better known are through networking, volunteering and pro bono work, and creative competitions. They are covered later in this chapter.) Even if your firm is already well known and its work highly regarded, more recognition never hurts. The more a design firm gets mentioned in the press, the bigger and more successful it will appear. The bigger and more successful it appears, the better the clients and projects it attracts.

THE FOUR RULES OF GENERATING PUBLICITY. Most publications get inundated with tips, pitches, and press releases. All have the same general objective: describe our company's products, tell our stories, say nice things about us. So, why are some companies successful at getting press mentions while others are ignored? Mostly because the successful ones know how to play the publicity game, the four rules of which are:

1. It must be newsworthy. There has to be a valid reason for a publication to mention a product or activity. It is what journalists refer to as a "news hook." Your desire for publicity is not a news hook. Anything you submit must be newsworthy or it will probably be ignored.

2. It must be informative and interesting. This doesn't mean to you. It means to your readers. Remember, publications live or die based on their readerships. No publication will print anything it believes its readers won't either find informative or interesting.

3. It must be short and easy. The shorter the item, the easier it is for an editor to use it, the better your chances of getting it run. For a product or activity this means preparing a one-page-or-less press release that can be used with minimal editing. For a feature story it can mean anything from a comprehensive outline to complete manuscript preparation.

4. It must not be blatantly promotional. Even though all publicity is self-serving, it must appear factual and objective. This means few adjectives, no hyperbole, and as many facts (versus opinions) as possible.

PUBLICITY OPPORTUNITIES. Here's when it is usually appropriate for design firms to send notices to the press: when first going into business; when changing addresses; when new staff has been hired; when a major project has been received (or completed); when a major award has been received. In these situations prepare a press release more or less in the standard format shown below. If appropriate, enclose a photograph with a brief, one paragraph caption taped to the back. Send your submission to the business editor of the local newspaper(s), to the editors of regional business and trade magazines (e.g., *Crain's Cleveland Business*, *AdWeek*, etc.), and to the editors of national creative magazines (e.g., *How*, *Graphic Design USA*, *Communications Arts*, etc.). If it mentions other individuals or firms, make sure you get their okay beforehand.

MAINTAINING FREQUENCY. How often newsworthy events happen in your company is, obviously, a function of its activities and size. But even a small firm usually has at least a couple of events a year worth publicizing. Furthermore, sending out a press release requires very little time or money.

THINKING BIG. If you have a large volume of activity or unusual publicity opportunities, it will probably pay to engage a local PR firm. They can usually increase the odds of your releases getting picked up. In addition, through their expertise and contacts they can sometimes arrange to get you interviewed by the news media or get a feature article published. (Think of a headline like this in the local business press:

(print on letterhead)

For more information, contact: Morris Minor

DATE: June 15, 0000
RELEASE DATE: July 1, 0000

SELDOM-DONE GRAPHICS REDESIGNS STAFF O'LIFE PACKAGING

St. Paul, MN. Seldom-Done Graphics has redesigned the packaging for Plains Baking Company's popular Staff O' Life brand all-natural breads. According to Morris Minor, Principal of Seldom-Done, the new design represents, "An evolution in combining contemporary graphics with more extensive consumer nutrition information."

Plains Baking first introduced the Staff O' Life line of six all-natural breads five years ago. The Company initiated the packaging redesign this year to provide even more of the healthy-eating tips and nutritional information that have become increasingly popular with consumers, as well as a hallmark of Staff O' Life products.

The newly-packaged Staff O' Life breads will be first distributed the week of July 15.

Seldom-Done Graphics provides packaging and other graphic design services to firms throughout the upper midwest from offices in St. Paul.

 # # #

ENCL: photograph with caption

Typical press release format.

"Unusual mix of talent and experience brings major national clients to local design firm.")

BECOMING A CELEBRITY. If you are also engaged in pure artistic activity, it presents another effective but often overlooked publicity opportunity. For example, having a one-person show at a local gallery would be very impressive to many clients. But don't just assume they'll hear about it. Make sure the press is not only notified but is also informed of your commercial activity. ("Ms. Talented is also a well-known local designer whose firm, Talented Design, works for such well-known corporations as. . . .")

BEING REALISTIC. Publicity is very difficult to control. Your efforts will often be ignored, what does appear may be changed beyond recognition, and it will take a long time to have any noticeable effect. Why even bother then? Because publicity is inexpensive, and very, very effective when you finally do connect.

❀ Networking ❀

Businesspeople would rather give business to those they know, and recommend those they are friendly with. The more businesspeople who know and like you, the more projects will come your way without direct promotional or sales activity. The best way to get to know more businesspeople is through networking.

BECOME A JOINER. To be productive at networking you should view your business needs as separate from your social ones. A local creative club—Art Directors', AIGA, GAG, etc.—can provide great social contacts but will probably do little for your business—everyone there is either a competitor or trying to sell you something. By contrast, the most productive places for business networking, especially in smaller communities, are local civic and business clubs—American Marketing Association, Women in Communications, Rotary, Kiwanis, Sales Executives, etc. Meetings of these organizations might not be as enjoyable to attend, but they are always more productive in making effective contacts. The networking rule is this: The best organizations to join are those where the ratio of competitors to clients is low.

BECOME AN OFFICIAL. Regardless of the organization, the way to get maximum benefit from membership is to be active, and to make it a long-term goal to be an official. This is not as difficult as it might sound. In any volunteer organization anyone who works hard helping out will likely end up in a highly visible, reputation-building leadership role.

BECOME AN EXPERT. Most organizations with regular meetings are constantly on the lookout for speakers. Informative talks to local civic clubs on such subjects as "Is your company's visual identity positive or negative?," or "New trends in advertising for small companies" will likely draw good audiences. There's a double benefit: they publicize you, while you get to meet several clients at once.

Volunteering and Pro Bono Work

The more your name and skills become recognized, the more likely you will be asked to help a worthy cause. Volunteering, especially in smaller communities, can substantially enhance your reputation in the business community. Serving with prominent local civic leaders in charitable organizations can generate the working-together respect that often develops into future opportunities in addition to charitable and psychic benefits.

Yet, there are always more worthy causes than the means to help out. Particularly when it comes to pro bono work, one could, quite literally, be a good citizen who works most or all the time gratis. This might be pro bono publico ("for the public good"), but it would also be non bono privato ("not for your good").

WHAT YOU CAN AFFORD. As much as you would like to help worthy causes, you cannot run a business like a charity. Except for those small favors that take only an occasional evening or two, it is better not to consider volunteering or pro bono requests until you achieve business profitability.

When it's okay: When you can predict cash flow that will cover all business expenses for twice as long as the work will last; when your yearly percent of billable time averages 60 percent or higher; when your yearly business plans and objectives are being met; and when there will likely be no significant changes in your business mix or procedures, such as new employees or large assignments.

Determining how much. As long as the above guidelines are observed, there's no "right" level of pro bono involvement. As with any charitable contributions, your preferences and conscience have to be your guides. The larger the firm, the more discretionary downtime that exists and the easier it is to plan for a certain level of charitable work. Creative Business knows of a few larger firms that actually budget for donating 2 to 3 percent of their total billable time. But most firms handle pro bono requests on an informal, "if they catch me at the right time" basis. A few individuals and firms underwrite everything—creative to delivery. Most, however, donate only labor, although often this is in conjunction with contributions from others, such as printers and paper merchants. If you don't believe

you can afford to take on even the creative portion of a project gratis but still want to contribute, an option is to offer the client a break on your normal price. For example, reducing your creative fee by 50 percent. However, because this provides an opportunity for the less than scrupulous to get work by "marking up before marking down," some organizations tend to be suspicious of such an offer, jeopardizing the goodwill that pro bono assignments otherwise generate.

WHERE IT IS MOST COMMON. Creative Business surveys show that the most common pro bono activity is within the creative community itself—designing for creative clubs and organizations. This is also the purest form of pro bono because altruism is usually the sole motive. From a practical standpoint, however, the most common activity is seldom the best. Organizations outside the creative community usually need more help. Working within the creative community produces few if any of the additional business-building benefits that usually accompany pro bono work done in other areas.

WHAT ABOUT TAX BENEFITS? Regardless of how generous you may feel, volunteering and pro bono work would be a lot easier if it were backed up by a tax benefit. Unfortunately, it isn't. The value of any labor donated, even to a not-for-profit or charitable organization, is *not* tax deductible. As for materials and expenses, because they are costs of doing business they do lower your tax base but they do not provide any additional tax benefits. (If you are prosperous and wish to share your good fortune, write a personal check to a qualified charitable organization. It will be tax deductible.) There is, however, one strategy that can produce something of a taxable benefit. Rather than donate creative time for a pro bono client that would normally pay for their own production, turn the tables: Ask if they will pay for the creative if you donate the production cost, which will be tax deductible. This way you will receive income that will at least partially offset your donation. (Because of the potential consequences, check with your accountant before making the offer.)

WHEAT OR CHAFF? Given the difficulty of turning down requests, having some ground rules helps. They ensure you aren't unduly swayed by an "opportunity" that is not in your best interests. If a request can't pass one or a combination of the following criteria, it's probably one that's best to decline.

Will it feel good? Donating your time to help out, or using your communications skills to create awareness, solicit action, or raise funds can be enormously satisfying. A pro bono project can also provide the type of challenge that may be lacking in everyday work, or offer a unique opportunity to spread your creative wings. But whatever you end up contributing,

it will only be satisfying if you are strongly committed to the cause. Otherwise, a good samaritan attempt will probably backfire.

Will the recipient also invest in the project? The more of a recipient's own time and materials invested, the more important they usually consider a project to be. Importance usually translates into being easier to work with, greater appreciation, and more satisfaction.

Will you get valuable recognition? The publicity and exposure that sometimes accompanies pro bono activity can considerably offset the cost of your donated time. It can even make some activities into very cost-effective marketing investments. Will there be a news release announcing your participation, or a credit line on what you produce?

Will there be an opportunity to network? Many activities provide an unequalled opportunity to meet and mingle with community and business leaders. Working side by side with executives from local corporations on a not-for-profit's board of directors or a fundraising drive can result in significant referrals and new assignments.

Will a favor beget a favor? This is the strictly-business evaluation: What are the chances of getting a direct benefit from your donation? Examples are: some type of IOU for redemption in the future; a swapping of services; a referral call; a much-desired introduction; the use of the organization's member or mailing list.

THREE PRO BONO CONSIDERATIONS:

1. *Your availability.* If your financial or workload situation is such that the only way you can accept a pro bono project is on a "as time is available" basis, say so right up front. Giving up a little time to save a lot of money should be a reasonable trade-off for any client organization. On the other hand, if you accept a pro bono project without any preconditions, you should treat it as a regular job. Putting it behind paying work—and the poor service, bad quality, and late delivery that will probably result—could wipe out any goodwill from accepting the project in the first place.

2. *Your employees.* The enthusiasm you have for a favorite charity or pet project may not be shared by your employees. Indeed, in some cases it could run counter to their strongly held beliefs. For this reason, it is always wise to check with employees before bringing any pro bono assignments into the firm. It is even better to give employees—particularly those who may be doing some of the work—a vote on which should be accepted and which rejected. Regardless of involvement or enthusiasm, never pressure an employee to donate his or her time.

3. *The recipient's organization.* Keep in mind that the very nature of a pro bono project often requires working with clients who aren't as organized and businesslike as clients you may be used to. In many cases this

means you'll not only have to be patient and flexible, but also build extra time into your schedule.

GUIDELINES FOR ACCEPTING PRO BONO WORK:

Make your participation well defined and finite. Whether you are approached about donating your time to a club committee, or handling a major print ad for a blue-chip charity, don't agree without knowing exactly what is required, and when it will end. If there is one universal complaint about volunteering, it is that it often turns into dragged-out or never-ending responsibilities. This is particularly important if you are handling a project for organizations that are not familiar with production processes and over-all costs. In these cases it is usually best to first describe three approaches you could take—bare bones, normal, and top quality. Then to relate the cost of each and how much you can afford to contribute. This helps avoid another common complaint: pro bono clients who are later disappointed in the results because of unrealistic expectations.

Insist on creative latitude. One of the strongest attractions of doing a pro bono project is the possibility of handling a different challenge and exper-imenting with it. You should never ignore any client's needs and objec-tives, but it is perfectly appropriate to insist on creative latitude as a pre-requisite. This can actually benefit both parties. From a client's perspec-tive, many of the most effective and memorable communications efforts turn out to be done pro bono—a direct payback of giving greater creative freedom. Plus, if you do end up producing work of this quality, you'll get the additional benefit of a knockout portfolio piece, as well as the recogni-tion that can only come from being an award winner.

Take charge. You should establish the schedule and procedures for all proj-ect work. It is also up to you to make sure the client adheres to them. Keep in mind that many not-for-profit clients can be quite leisurely in the way they work. Time may mean money to you, but it may not be as important to them. The client/supplier relationship should be different, too—a little less emphasis on all-out service, a little more on sharing. For example: the client should probably come to your place for meetings, rather than you go to theirs; you should limit the number of concepts you'll produce, and the time presenting them; client changes (AAs) should be collected and done all together; and so forth.

Explain everything you do. Much of what you provide to any client is intan-gible—thinking, strategizing, and concepting. When doing a project for a regular client, this often necessitates explaining the creative process so there are fewer problems, especially at invoicing time. Although invoicing isn't normally a concern with pro bono projects, it is nonetheless equally important to explain the extent and depth of all your efforts. If you don't

do so, you'll diminish the value of what you're providing, especially to less sophisticated clients, and this negates one of the reasons for doing the work in the first place.

Record your time. Record all time and expenses for a pro bono project just as you would any other assignment. This is important not only to help you track your own productivity, but it is the basis for the "invoice" you'll later send the client (see below).

GETTING FULL VALUE. Anonymity is not a virtue in business donations. Take care not to be tasteless or aggressive, but you should make sure nonetheless that you get full credit for your contributions.

Ask for a credit line. It isn't always possible, but when it is, it may introduce your work to a potential new client.

Distribute copies. Don't take the chance that your efforts will go unnoticed by current clients. Attach a "I thought you'd be interested" note and send a copy to everyone on your mailing list.

Arrange publicity. Ask the PR organizations of larger not-for-profits to send out a routine press release. For smaller organizations draft and send your own.

Send an invoice. Every project should result in an invoice, even when all or most of what you did was for free. Indicate the service performed and its value followed by the words "no charge." (For example: "Conceptual time—8 hours @$125 per hour = no charge.") Only by so doing will the client truly appreciate just how much value was received.

HOW TO SAY NO. No matter how altruistic and generous you are, you're bound to get asked sooner or later for a contribution you can't or don't want to make. Here's what to say when it's appropriate to dodge the volunteering bullet.

Plead busyness. This is the approach to take when asked to donate your personal time (versus professional efforts). For example: "I'd love to help, but I just can't. I'm absolutely snowed under right now. If I served on the committee, I wouldn't be able to give it the attention it deserves, and that would actually be a disservice to (the organization)."

Plead bad timing. This is the approach to take when asked to donate professional efforts. For example: "Thanks for thinking of us. We wish we could help you. Because we believe in giving something back to the community in which we work, each year we budget for a considerable amount of donated time and effort. Unfortunately, we have already committed the entire amount allocated."

Plead inappropriateness. This is the approach to take when asked to do a small favor. For example, a friend, neighbor, or relative needs an ad or

brochure for their small business, a local club, church group, or civic organization. In some cases they may be prepared to pay and believe they are doing you a favor by providing work. From your standpoint, the job is probably too small to be creatively stimulating, or to be of portfolio or publicity value. If it is for a charitable organization, it may not be one you particularly want to donate to. Furthermore, charging normal commercial rates may insult those offering to pay, yet even a reduced fee is probably too small to be worth the effort, especially if it detracts from larger assignments you are working on.

The best response in these situations is something like this: "Thanks for thinking of us. But the truth is, we're really not set up to handle work like this (anymore). It would probably be best if you went to someone who specializes in it, like Kinko's or AlphaGraphics. They can do a much better job than we can." Even take the job to the copy shop for them if it is appropriate. If not—that is, it would be insulting to turn the work down—try to accept the project on a "as-time-is-available" basis, do the work for free, and ask only that they return the favor sometime in the future.

❧ Creative Competitions ❧

The historical reason for award shows was that they provided creative individuals with quality affirmation that was difficult to obtain when work was not broadly evaluated. But there is also another, more recent aspect of awards: their commercial impact. An Academy Award-winning film has a dramatically increased "gate"; winning the Booker Prize makes bestsellers; an architect who receives the Pritzker will probably raise fees on the next commission. Don't these benefits also accrue to winners of our competitions? To some extent, yes. But seldom as much as we wish, and much less now than in times past. There are two major reasons. First is that the proliferation of creative competitions and the volume of acceptances allows just about anyone to be an award winner today. With less scarcity, there's less value. The second reason is a decline in standards. The "Everything is acceptable today" mentality conflicts with the concept of superiority upon which competitions must be based to be valid. Result: lots of award winning, but otherwise mediocre work.

DO CLIENTS CARE? The farther removed clients are from the creative process, the less they care about awards. Most clients never cared much, and they care even less now. As they should, most clients believe that your work should speak for itself. A proven ability to meet specific objectives, or liking what they see, is what's really important. The perception is usually that awards are immaterial at best and self-indulgent at worst. Clients

often view them as rewarding style and nuances that they can't appreciate, and don't want to pay for.

A significant exception to the above is clients for advertising services. Advertising award competitions are fewer in number and more focused on extensive, costly efforts (e.g., campaigns rather than individual projects). Because more is at stake, competition results are more publicized, and publicity confers value. In addition, and however imperfectly, judging is more likely to take into account actual marketplace effectiveness, as opposed to pure aesthetics. Clients are more interested because their staffs are more likely to be involved in both entering and judging. Their staffs can also use awards as internal budget justification when the direct sales results of ads are difficult to track. Plus, many sophisticated clients prefer to do business with a shop that can demonstrate that it is among the best in the ad game.

One other exception are creatively sophisticated clients, especially those with in-house creative groups looking for outside assistance. They also occasionally contact creative firms based on hearing about them through award competitions.

WHICH DESIGN FIRMS REAP THE MOST BENEFITS? The younger, smaller, faster growing, and more specialized the design firm, and the smaller their market area, the more important awards are. As an example, a small studio recognized for contributing theme and copy for a local, breakthrough PSA (public service announcement) will have the way paved for getting future ad assignments. Sweeping a local ad club show will quickly establish a talent-heavy start-up as a "hot shop." Multiple acceptances in prestigious national design competitions (e.g., AIGA, CA) will create the reputation that makes attracting top-notch talent easier. Being cited by a trade group (e.g., Packaging Design Council) will provide an imprimatur that opens some otherwise closed doors. In all these cases, awards can generate a commercially important industry buzz.

On the other hand, the larger, better established, and more diversified the firm, the fewer the benefits. In fact, most larger firms in major metropolitan markets enter award competitions very selectively. They realize that the cost of multiple submissions (preparation time and out-of-pocket fees) seldom provides enough benefit to make it an attractive business investment. Furthermore, as mentioned previously, much of the prestige value of awards no longer exists anyway.

PRACTICAL FACTORS. In addition to the considerations mentioned above there are two practical factors that should also be noted.

Clients. Selecting one of a client's projects for submission to a creative competition is flattering, especially if the organization's personnel were signif-

icantly involved. The client individual whose name appears on the entry form is also singled out for special recognition. Therefore, you may want to give thought to entering work done for clients with whom you desire a stronger relationship. You can't make a mediocre project into an award winner just to flatter a client, but it is good business sense to put as much emphasis on whom as on what you consider entering. Don't worry about not having the selected work accepted by the show. Your benefit will come from the goodwill created by submitting it. If it does get hung, it's a bonus. (Caution: Never enter work without first checking with the client. Some have rules about what they prefer suppliers to do, and whom they wish cited on entry forms.)

Employees. The possibility of working on award-winning assignments raises the performance level of employees. When an award is received, especially when presented at a public function, employees bask in peer recognition. Regular awards also make a firm more attractive to potential employees, especially younger talent. This can be an important incentive in a tight labor market. (For the effect of awards on employee morale, see chapter 6.)

MERCHANDISING FACTORS. As a rule, awards today are what you make of them; new work seldom flows automatically from their receipt.

Publicizing. Any award from a show worth the effort and cost to enter is worth the time to publicize. Unless it is mentioned in the business press, awareness will remain primarily among other designers (competitors). So if you don't send notifications (press releases) to media outlets, you'll lose much of any new-business-generating value. With the client's permission you should also send a copy of the press release to your promotional mailing list, including a sample of the award-winning piece to selected recipients. A release on winning an award is the ideal publicity vehicle. It is topical, has the "news hook" editors look for, and can be accompanied by a photograph. Several releases about award winning over months or years also builds an image of a high-quality, in-demand shop. This can not only be instrumental in generating new clients, but also in reinforcing relationships with existing ones, and making working procedures and pricing easier.

Talking it up. Likewise, an award not talked about is the same as an award not received. If significant, use it as an excuse to invite a selected client to a celebration lunch, or as an excuse for an office party for all clients. Look for subtle ways to weave it into client conversations, and consider adding mention to next year's holiday greetings. (Example: "Thanks to all our clients for a great year. Your support allowed us to garner five major industry awards.")

Decorating. Framed awards make great wall hangings. They impress visiting clients, and they constantly remind employees of a studio's emphasis on quality. To maximize impact, cluster them on the wall of a reception area or conference room; if you have many, dedicate an entire facing wall. Don't limit what you hang only to prestigious awards. The goal is maximum impact, so the more displayed, the better.

Web posting. Showing awards, and the work that produced them, on your Web site is similar in effect to office decoration. There is one additional advantage: they may be viewed by clients who never visit your office.

DEVELOP AN AWARDS BUDGET. Do this for the discipline it imparts, even though the number of potentially awardable projects will vary greatly from year to year. Try not to exceed the budget, and never do so excessively or for several years running. Don't necessarily spend it, either. The formula in the sidebar provides a guideline for what Creative Business believes is more or less appropriate.

CHAPTER 11 Selling

SELLING is a problem for many designers. We want desperately to believe that our talent should be all that is necessary to attract and hold good clients. Selling not only implies there's a need, but it's also a word fraught with negative connotations. Nonetheless, today's reality is that selling is nearly as important to long-term design success as talent. This holds as true for well-established shops and individuals in high demand as it does for those struggling just to get by.

How so? Because selling has several benefits beyond simply getting work. Selling means taking charge of the future by going after different types of assignments. Selling can iron out many of the boom-or-bust cycles that plague service businesses. Finally, no matter how well known you become, without selling many potentially great clients will never remember to call you.

⬧ Is the Web Changing Things? ⬧

As noted in chapter 10, having a Web site is essential for design firms of all sizes. But even the coolest site is of no help in pitching clients who don't know about you. So there are also Web sites that do that—provide an introduction, client to designer, or list jobs for designers to bid on. The appeal is that they can cut a firm's selling costs by doing away with prospecting, which is the hardest and least productive aspect of selling design. How effective they are, however, remains to be seen.

As attractive as making connections over the Internet through a third party seems, it is hard to imagine this being anything but supplemental to traditional sales activity for most firms in the foreseeable future. Chances are that building a successful, long-term-viable design business will continue to require what it always has—deciding which clients you want, then going after them (in other words, being proactive rather than reactive, as is the case when you simply list your availability or bid on a listed project). In addition, the very nature of the Internet encourages a low-bidder atmosphere that is potentially destructive to project quality and profitability.

This said, however, these sites are a new way to introduce your firm to clients who wouldn't hear of it otherwise, particularly if they are on the other side of the country or world. The barriers against working across long distances are falling as technology makes it easier and clients become more willing to eschew personal contact. If you are located in a rural area it may be a way to win some big-league jobs you'd never get a chance to bid on otherwise. Then, too, if you have work to farm out or are looking for employees, you may also find Internet job sites a way to connect with talent.

How Much is Enough?

The major sales problem with many design firms is inconsistent activity. They sell when they aren't busy, relax sales efforts when they are. As understandable as this is, especially with smaller, resource-thin shops, consistent sales activity is the only way to ensure consistent work flow. Relying on referrals or not following up on advertising or mailings almost guarantees that there will be boom and bust periods, meaning some periods when staff is overworked and others when it is difficult to meet payroll.

OUR RECOMMENDATION. Design firms should consistently devote around 20 percent of labor hours and fee income (AGI) to all marketing activities. While this includes the promotional activity covered in the preceding chapter, by far the largest component of it should be for salaries—the hours principals spend selling, and the salaries or commissions of sales representatives and account service personnel. What this means is that roughly one full-time salesperson should be devoted to "feeding" every five creative employees in firms with a healthy mix of clients and assignments. (Having too few clients will reduce the amount of sales activity necessary, but it is a dangerous trade-off.) This sales/creative ratio holds up for diversified firms of all sizes doing project-oriented design work.

Although a salesperson should be actively involved in account service, his or her primary role is new business development. Therefore, the ratio of account service time to new business prospecting time should seldom rise above 30 percent.

WHAT IF THERE IS A MIX OF DESIGN AND ADVERTISING WORK? Recommending a sales/creative ratio for these shops is not as straightforward. The reason is that advertising clients require account service, whereas with design work once the project is in-house the person who sold it should be able to turn it over to a project director and go on to look for new business. How many sales representatives/account executives are necessary and how responsibilities are divided is a function of the firm's particular mix of business.

WHO SHOULD HANDLE IT? In firms with fewer than four employees, a principal nearly always does the selling. But, assuming the growth will continue, by the third or fourth employee a decision should be made. Either the principal should continue handling sales and delegate most daily creative direction and management responsibilities, or a salesperson should be hired to take over that function and leave the principal free to devote the time necessary for other responsibilities. The major reason for considering a salesperson earlier rather than later is the inability of many principals to delegate daily creative and management decisions. They continue to try to do it all, often with the result that nothing gets done well. A secondary reason is that a good salesperson will usually do a better job. Thirdly, if the firm continues to grow, a professional sales staff will be necessary anyway. Why put off the inevitable?

It should also be recognized, however, that hiring a salesperson rarely frees principals from all sales involvement. They are still normally required to close sales. Most small-firm clients, and the major clients of large firms expect a principal's personal involvement. What a salesperson handles is the hard part—prospecting, portfolio showing, proposal writing—which leaves the principal with the relatively easy part of providing credibility and confirmation.

WHAT ABOUT PART-TIME SALES HELP? Though it is possible to have part-time, outside salespeople, our experience is that it seldom works well. One reason is that unlike other job functions that are more or less adaptable to flextime, calling on clients and servicing accounts requires being available during most regular business hours. In addition, we believe salespeople should be paid at least partly by commission (why is covered later in this chapter), but it is difficult to make acceptable commissions without working full-time. Sharing salespeople with one or more noncompeting firms is also possible but, again, seldom practical. Because of the nature of the cre-

ative process, clients who provide good assignments usually want to entrust them to an insider—an employee—not an outsider. For this reason, the talent rep model, common for photographers and illustrators, seldom works for designers, even freelancers.

WHAT ABOUT FINDERS' FEES? If part-time and shared salespeople are seldom practical, encouraging others to refer you is. But it should be supplementary to, and not a replacement for normal sales activity. It is usually best handled on a "You do a favor for me, I'll do a favor for you" basis. Nonetheless, there are times when a reward, a "finder's fee," is appropriate. This is especially true when you are not in a position to return the favor, or when someone has invested considerable effort on your behalf. In such cases, Creative Business recommends a finder's fee of between 5 and 10 percent of fee income, and 25 percent of markup income (for example, 25 percent of 25 percent).

◉ Hiring Salespeople ◉

Hiring sales talent is more difficult and often even more important than hiring creative talent. It can be more difficult because the personality of a good salesperson—extroverted, insistent, impulsive, focused on the kill not the meal—is often polar opposite from that of the rest of the staff. Further, without a portfolio for you to evaluate, it may be hard to tell just how much substance lies behind the polish. The hiring process can be even more important than for creative talent because salespeople become the public face of a company. They form a new client's first impression of a firm and its capabilities. In addition, much of what they do is outside the shop, where there is little or no opportunity for management intervention or oversight; they are on their own, yet what they say and do has a profound impact on the business. The quality of repeat clients may be in the hands of the creative staff, but the quality of new clients is mostly in the hands of the sales staff.

UP-FRONT CONSIDERATIONS. Given the importance of salespeople and the difficulty in selecting the right ones, there are several essential issues to consider before looking.

You'll need a sales strategy. What is it you want the salesperson to accomplish? To simply assume the sales activity you now handle? Go after certain types of clients? Go after certain types of work? Increase sales by some percentage? Shift the project mix from low-profit ones to higher-profit ones? Without a strategy you might look for the wrong type of person. Or you might find the right person who ends up calling on the wrong prospects at the wrong time. Even world-class sales talent can't help you achieve what you can't first define. So if you don't already have a business

plan, including a specific section on business development (sales strategy), it is best to develop one before going any farther. (See chapter 1 for guidance.) Ultimately it is important for all salespeople to contribute to a firm's sales strategy, and it should be part of their job description. But at least initially, and for better or for worse, the salesperson will have to rely on what you already have in place.

You'll have to rethink responsibilities. At minimum this means a detailed job description that fits into your organization's structure (see chapter 4). But it should also mean considering all the things that can't easily be put in writing: the daily working relationship you desire; how much interaction with clients will be your responsibility and how much theirs; what the firm's business practices are and how will they impact the salesperson's opportunities. Getting full value from a sales professional takes a commitment to working together toward mutually agreed upon goals. While a good salesperson has to be a self-starter, you must be willing to provide input and support. Also recognize that a good salesperson will make your job more challenging; will force you to think more about your business goals, strategy, and promotional tactics. Can you accept and act upon this input, even if it is not what you want to hear?

You'll have to provide adequate compensation. Salespeople are motivated primarily by money, not by the opportunity to be involved with great design, and not by the opportunity to work in a "cool" shop. You must be willing to accept that how much money they make is immaterial as long as their efforts result in more profit for your business. It is even okay when they make more than you, assuming they are building equity for your business. When a salesperson is paid on commission (our recommendation), and again assuming the work is profitable, there should be no limit on take-home pay. When they work on salary they should be compensated at the same level, and have the same prestige and clout as the most senior creative person in a firm. Further, since most clients need to be reassured that everyone they deal with is important, it is also wise to give salespeople impressive titles—such as vice president of marketing, or director of new business development. Scrimping on the compensation of a salesperson is a shortsighted and common situation among small- to mid-sized design firms. Most larger firms have learned not to make this mistake.

You'll have to provide the necessary tools. Salespeople spend a lot of time on the telephone, so they require an isolated, quiet office. Besides the telephone, it should be equipped with a laptop computer loaded with their choice of contact management and presentation software. Secretarial needs (preparing proposals, etc.) should be given priority. A mobile telephone should be provided, along with a PDA (personal digital assistant), and a high-quality leave-behind piece for sales calls.

THE RIGHT KIND OF APPLICANTS. As a rule, the best salespeople for design firms are individuals who have previously been involved in some facet of creativity. Highest on the preferred list are graphic designers who, for a variety of reasons, now prefer to sell design rather than do it. Also prized are printing and paper salespeople who wish to be involved with a more creative product. They have previous sales experience, understand the business, and have client connections. Advertising agency account executives can make good salespeople, particularly when there's a desire to get more heavily involved in design or interactive work. Note, however, that they might be more service than sales focused. Former magazine space reps should be considered as well. Don't necessarily rule out those without creative or communications experience in your search, however. Traditional salespeople often work out fine, especially in larger shops where they are one of several reps.

HOW TO GET APPLICATIONS. The best approach is to put the word on the street that your firm is looking. Talk about your needs among peers at creative club and similar meetings. Ask printing salespersons you deal with if they know of any good creative reps, or others who are looking to get into a slightly different line. Ask the same of paper salespeople. You may also want to advertise in either the local business press (small community), a medium such as *AdWeek* (larger metropolitan areas), or on one of the specific Web sites devoted to job listings. (See chapter 4 for general hiring information.)

HOW TO SCREEN APPLICANTS. If you've personally been involved in sales activity in the past, you probably already have a good sense of what it takes to find, develop, and keep a stable of clients. If you haven't, it would probably be good to get some experience before screening sales applicants, or turn the process over to someone in your organization who has. Those who haven't been involved in the selling process usually have unrealistic expectations about what it takes, and what to look for.

Plan on narrowing the list of applicants down to about a half-dozen, based on experience and a short telephone conversation. Ask each of those selected to come in for an in-depth, one-hour interview. For the first fifteen minutes or so, explain your operation and needs. Then ask about the candidate's background and why he or she is qualified for and wants the job. When explaining your operations, note particularly how interested the applicant is in the quality of your portfolio. Anyone who does not show honest enthusiasm about the value of your design is probably not worth considering. In addition, note any ability and enthusiasm regarding going after new types of work or markets.

By definition, good salespeople have a different set of skills and objectives than most of the creative staff, so don't hold it against them. They should be

more polished, more aggressive, and have a certain nonchalance about rejection. When necessary they should also become clients' in-house advocates. Most important, they should be more interested in the salability of the work than in its craftsmanship and quality. In today's buyer's market, where clients have so many choices, good sales talent is the ideal complement to good creative talent. Each enhances the other by making sure that all interests—quality and business, firm and client's—are constantly addressed.

INVOLVE THE STAFF. Although hiring decisions are always the principal's responsibility, it is a good idea to have key creatives involved in the interviews for the top three applicants. They should play a role in deciding who will be presenting their work. Including them in the selection process also builds morale.

DECIDE ON COMPENSATION. Firm principals are often dissatisfied with the salespeople they hire because they combine unreal expectations with unreal compensation. Here are guidelines for the three compensation options.

Commission. This is the method Creative Business recommends for design firms doing mostly project work. Paying salespeople on a commission basis not only provides a strong performance incentive, but it also minimizes a firm's cash-flow exposure. (No sales, no pay.) In addition, it removes the artificial earnings ceiling that jeopardizes the very entrepreneurial spirit every good salesperson must possess to be effective.

On new client work the standard industry commission is 15 percent of a project's fee income (AGI). On work from existing clients ("house accounts") slightly less commission (7 or 12 percent) is common in order to provide an incentive to find new clients. Some firms feel, however, that reducing commission costs more in incentive than it promotes in new business. On accounts that accompany a new salesperson, 20 to 25 percent of fee income is typical for the first project, 15 percent thereafter. On markup income, the salesperson typically gets 15 percent of the firm's markup (i.e., 15 percent of 25 percent). Commissions are paid, either directly or into a draw account, only after the client pays.

Most salespeople working on commission expect to have a draw arrangement—i.e., they can draw a modest regular salary from an account that is periodically replenished by their commissions. If commissions don't equal the amount drawn and the salesperson leaves or is terminated, the firm loses the money paid out. For this reason, most draw accounts are expected to be balanced at least every six months.

When it comes to expenses, everything is negotiable, but the following is more or less typical. The firm covers all advertising and promotion, portfolio expenses, office space, computer, support services (telephone, copies, faxes, proposal preparation, etc.), taxis, and transportation (including auto mileage). As for client lunches and entertainment, some firms

pick up the tab, some don't. The consensus on this issue is that these expenses are often covered for experienced, productive reps, but seldom for new ones or those not performing up to sales goals or expectations.

For tax purposes, commissioned salespersons are considered employees. Most design firms also provide the same benefits given to salaried personnel.

Salary plus commission. This is most appropriate where there is a mix of sales and account service responsibilities, or as a temporary step before ultimately moving the salesperson to commission compensation. The difficulty of having a salary plus commission arrangement is setting the appropriate ratios. Some firms using this system initially set the salary component at a low- to mid-level professional salary and the commission at 10 percent of fee income. They later adjust the mix when they have experience on the actual amount of sales versus account service time. Although adjustment may be necessary to reach a fair compensation package, it often looks arbitrary to the salesperson, particularly if it results in less take-home pay. As a guideline for what is appropriate, the total compensation possible (not necessarily what is paid) should be comparable to the salaries paid to senior creative staff.

Straight salary. Creative Business believes this is usually only appropriate for firms with true account service needs—traditionally advertising and PR agencies. Design firms requiring account executives usually either have too much business with too few clients, or should assign client service to project or production managers.

NONCOMPETE AGREEMENTS. Have the salesperson sign one as a condition of employment. Doing so will make clear that you take your business seriously and will fight for it when necessary (see chapter 5).

❀ What to Expect from a Salesperson ❀

Unlike new creative hires who typically fit into an established work-flow pattern with other employees, new sales hires are generally on their own, even when there are other salespeople around. Almost by definition, being a salesperson means working alone, often outside the company. It also means that expectations based on experience with creative employees often have to be adjusted.

GETTING UP TO SPEED. Selling design is a process of developing relationships. Occasionally a cold call results in an immediate sale. The client and the salesperson hit it off, and a project just happens to be waiting. But more often it takes time. The bigger the clients and the more lucrative their proj-

ects, the more important relationships become, and the longer it takes for sales activity to pay off. Unless a new salesperson brings along a roster of established clients, it will usually take several months before even the most energetic efforts return more than they cost. Be prepared to give a new salesperson six months or more to prove he or she has what it takes. During this time there should be progress in making good contacts and an increasing number of sales. By the end of the sixth month, however, he or she should either be earning salary or draw, or be on the verge of doing so. If not, it may be time to cut your losses and start looking for someone new.

RESPONSIBILITIES. Initially a salesperson's function is to prospect, introduce the company, solicit projects, and ensure that clients are satisfied. Once earning his or her keep, however, it should also include helping to set marketing goals, devising selling strategies, determining pricing, recommending promotional activities, and even advising on the hiring of specific types of talent. This inclusion of overall marketing responsibilities has mutual benefits. For principals, it provides additional, often more objective opinions on how to help grow the business, and it allows the further delegation of responsibilities. For salespeople, the more authority they are given in other aspects of marketing, the more enthusiastic and effective they become in selling. Perhaps the major benefit, though, is that it makes them more sensitive to the need not just to search for new clients and projects, but to search for the most profitable ones.

OBJECTIVITY. Fulfilling a customer's needs with the right—not necessarily the absolute best—product is the formula for long-term success for every business, including design. No one understands this any better than someone who has to meet with clients everyday and listen to their needs. This makes a salesperson not only the in-house advocate for them, but also brings into the shop a level of objectivity usually missing otherwise. In their effort to do the best possible work, designers, including principals, are often blind to what the client really wants. A good salesperson keeps them focused on meeting the client's objectives (see "The Perils of Perfection" in chapter 16).

❋ Qualifying Clients ❋

There's an evolutionary process in most design firms that goes like this. They start in business scared, hungry, and accepting any work that's offered. Once business stabilizes, they take the tentative step of turning down occasional unsavory jobs, only to find that it helps, doesn't hurt, their bottom line. So, they start qualifying more and more clients. There is nothing wrong with evolution, but it does take time. It is better to speed

up the process by qualifying—making sure clients meet your standards—early on. The sooner you learn how to recognize which clients are desirable, the sooner you can take control of your business, and the more stable and profitable it will become.

Qualifying guidelines follow. Avoid or weed out anything that can't pass them. Although this carries some short-term risk, it nearly always pays off over the long run. Work that can't qualify usually diverts effort away from that which is more rewarding, saps creative energy, lowers self-esteem, and reduces the time available to pursue better work.

THEY'RE A GOOD FIT FOR YOUR FIRM'S TALENT AND SKILLS. Regardless of how much excellence and versatility your firm offers, you're better suited for some clients than others. The closer your talents and skills match a client's needs, the more enjoyable and profitable their projects. So concentrate on clients who are most appropriate for your unique combination of talent, service, and experience.

THERE ARE FEW NEGOTIATION HASSLES. Negotiation is, and should be, a factor in every business transaction involving service. Negotiation should be characterized by a friendly and realistic give and take, not by haggling over price or excessive demands. Clients who haggle demonstrate a lack of understanding of what you do or have a difficult-to-work-with personality. Either way, it portends an unrewarding experience.

YOU DON'T HAVE TO EDUCATE THEM. You're not in the education business. Clients who need to learn the basics always do so at your expense. Unless there is a clear payoff down the road, set aside any tendencies you may have to instruct uninformed clients about the design process or creative quality. Stick to clients who are already informed.

THEY VALUE YOUR BRAINS MORE THAN YOUR HANDS. Given today's high capital costs (for computers, etc.), you must charge relatively high fees for everything you do. Yet clients understandably resist paying high fees for routine labor. The solution: Concentrate on clients who need, and are willing to pay handsomely for value-added design and marketing services. Leave the rest to those less perceptive than you.

YOU CAN OFFER THEM A HIGH ROI. ROI stands for "Return on Investment." The more money clients can make off the work you produce, the more they will be willing to pay you, and vice versa. Good clients shop for value. Work that motivates and persuades has a far higher return on investment (value) than that which merely decorates.

THERE'S A HIGH SEM RATIO. SEM stands for "Someone Else's Money." The farther removed an individual is from the direct impact of the cost, the easier he or she is to work with. The toughest are entrepreneurs spending

their own money; easiest are executives of large organizations working with a loosely controlled budget.

YOU ENJOY THEM, THEY APPRECIATE YOU. The work is more satisfying, the quality goes up, and they become easier to please. The best client/designer relationships are ones in which there is mutual liking and appreciation. You solve their problems; they provide more and better work.

THEY MATCH YOUR LONG-TERM GOALS. Where do you want your business to be ten years from now? The type of clients you work with today will affect the future course of your business. Take charge by directing your future business, rather than letting your business direct your future.

THERE'S A POSSIBILITY OF A STEADY STREAM. Concentrate your efforts where it will produce the greatest impact. Go after clients you know have multiple projects and adequate budgets. It takes as long to sell a client the first time around whether it is for a one-shot assignment or a future stream of them.

THEIR WORK WILL BE PROFITABLE. Fun, challenge, prestige, satisfaction, creative freedom, peer recognition, personal chemistry—all are important aspects of a good client relationship. But nothing is more important than the profitability of the work. Without it, eventually you won't have a business, and then nothing else will matter.

⊛ Talking the Talk and Walking the Walk ⊛

Second to not doing enough of it, the most common mistake made in selling design services is describing the process and its results in a way more meaningful to you than to the client. In other words, covering what you think is important for them to hear, not necessarily what they want to know. Sometimes this is because we feel we know best what a client is really interested in. But mostly it's because we haven't thought it through. We say what comes naturally to mind.

Another common mistake is not differentiating ourselves from our competition. This, too, is natural because most of us feel that what really sets us apart is our style and talent, and that this is obvious. The reality, of course, is much different. Clients select design firms for a variety of reasons. Usually of equal or greater importance to style and talent are such factors as personal chemistry, price, experience, service, reputation, and convenience. Therefore, being able to clearly describe what is offered that is different from competitors is crucial to successful selling in a competitive environment.

Also important in selling is recognizing just how important a particular design project is to the client. Most fall into one of three categories: 1) those that have the highest impact on client revenue—packaging, e-commerce sites, ad campaigns, branding exercises, etc.; 2) projects with high visibility, but that are not revenue-crucial to clients—annual reports, capability brochures, etc; and 3) smaller, less highly visible projects—individual ads, brochures, etc. How you pitch a client depends on which of these categories their project falls into. The rest of this chapter explains each of the three categories and the right pitch to use.

❧ Pitching Revenue-Crucial Projects ❧

Clients with projects that involve betting large sums of money on the impact of your services—e. g., the creative supporting a major product roll out—are quantifiably oriented. Their world is ruled by the ups and downs of numbers: total impressions, share point changes, incremental return on investment (ROI), and so forth. For instance, a brand manager who can increase the sales of a consumer product by a tenth of a percentage point through a package redesign could earn millions more in profit for the company, and probably a large raise, too.

So when pitching this type of project, pricing is seldom a make-or-break issue. More important is convincing the client that your efforts, whatever the price tag, will have greater return on investment than those of your competitors. Credibility takes a combination of knowledge, talent, and resources.

THE CHALLENGE. These assignments are more likely to lead to a conflict between your (probably) qualitative world view and the (probably) quantitative one of most clients. To most of us, excellence is subjective—the result of our applied talent, skill, and experience. Even to the extent creative excellence can be made objective, it is usually possible only after the fact, and seldom according to the criteria we establish (e. g., good taste versus sales volume). To clients with these types of projects, excellence is easier to define: it produces better results (higher numbers), and it also happens to be whatever they personally prefer.

There is, of course, nothing new in all this. What is new is the extent to which it becomes more important every year. Probably the most significant reason is that clients have recently become much more bottom-line oriented. Compounding this is a simultaneous increase in competition— more design firms out peddling more capabilities than ever before. Thus, the challenge in selling to this market is now threefold: 1) Persuading clients that you are totally in sync with their definition of excellence; 2) that you have more sophistication than your competitors in providing the

analysis and strategy that lead to bottom-line results; and 3) that your project management ability is equal to your creative ability. As a rule, the more revenue-crucial a project, the broader the role a client will want you to play and the more interested they are in the process you use.

THE APPROACH. Use the traditional problem/solution approach when first showing your work, but greatly expand on it. It is far better to go into detail about a few projects than to say a little about many.

Select half a dozen examples of work that are as similar as possible to what you believe the client is interested in. Then construct a three- to four-minute case about each and practice delivering them. Include why the previous client selected you (e.g., specific experience), their objectives, your research, the strategies you devised for meeting the objectives, the process you followed to assure implementation, and the results achieved. The goal of the case histories is to show new clients that your creative process is well structured and objective. This is particularly important if, like many of us, you routinely do many of the things mentioned above, but do so more intuitively than formally. In addition, chances are that learning to articulate your procedures will also help you to understand them better, as well as suggest ways to improve them.

If some of your past clients didn't operate in ways that lend themselves to good case histories, don't be afraid to apply a little literary license. Never mislead a client, but a little exaggeration is probably all right if you could and would have done what you describe. Put another way, don't be so scrupulously accurate that less sophisticated past clients jeopardize your chances with a more sophisticated potential one.

THE VOCABULARY. Using the right words in the telling is as important as the case histories themselves. To show what we mean, we've taken the following simple explanation of a packaging redesign and translated it into a vocabulary much more suited to winning high-level projects.

The original: "The client asked us to improve this package and bring it up-to-date, mostly to increase overseas sales. We used (elements) to make the design more contemporary, and also increase consumer visibility." Straightforward. There's nothing wrong with this, but it's not very convincing.

Now here's how the same process would sound in a vocabulary better suited to the occasion: "The client's objective was updating the franchise and allowing easier global line extension. Our research indicated that the best way to accomplish this was to adopt (elements) to trade off existing core equities, telegraph value, and lead to stronger shelf facings. The system we created provides an instantly recognizable, sustainable identity that has formed a strong emotional connection with consumers located throughout the world."

As the above should illustrate, what you say can be every bit as important as what you do. Never try to BS your way through a presentation, but also never underestimate the role of language in persuasion. Developing an appropriate vocabulary is well beyond the scope of this book. But it isn't difficult. It normally involves nothing more than listening carefully to how your clients discuss their business. The best way to be taken seriously in any specialized market is to learn how to talk the same lingo.

A STRATEGIC FOUNDATION. Despite what you may or may not have done in the past, winning a revenue-crucial project in the future will require demonstrating that your work is strategically grounded. Depending on the extent of the project and sophistication of the client, one or more of the following will be necessary.

Gathering information. This is the necessary first step. For projects at this level, information gathering—knowing the client's business, doing a competitive analysis, understanding purchaser motivations, etc.—should take from 20 to over 50 percent of the job estimate. The bigger the project, the more riding on its success, the higher the percentage. But whatever the scope, it must, as a general rule, be of equal or greater importance than the creative. Equally important, it must appear to the client to have a very high priority.

Typical nondisclosure agreement.

Reviewing the marketing plan. This is seldom a factor for larger clients with sophisticated staff and resources. But it often is an important one for smaller clients with ambitions. Reviewing, imputting, or even writing a marketing plan from scratch will not only help you understand and influence clients' marketing objectives, but will also give them additional confidence in your capabilities. If you feel less than adequate in this area, read the primer, "A Designer's Short Course in Marketing" in appendix IV.

Conducting a visual audit. Looking at client and competitor materials is always a requisite. The only question is how thoroughly to do it. For multifaceted projects requiring consistency across many items and media, such as corporate or product branding, Creative Business recommends a formal, independent audit. And for all types of high-level projects, a formal audit is helpful in clarifying client objectives, market trends and conditions, and effective strategies. Regardless of how formal, audits are usually best conducted immediately upon receiving the assignment. This allows whatever knowledge and information that results to be used as raw material for follow-up questions, activities, and strategies.

Contracting for market research. A well-directed creative effort is the best creative effort. Researching both customer and market can provide the direction when done right. Doing it right means doing it professionally—either internally with client staff or outside. If you are asked to contribute, subcontract unless you have expertise in conducting focus groups, customer intercepts, preference polling and so forth. It will ensure it is done right, and bringing in an expert also impresses the client. A listing of market research specialists can be found in the Yellow Pages. As much as market research up-front helps to set direction, also keep in mind that too much research (testing) of concepts can backfire. Strong emotional response, the essence of breakthrough creativity, is very difficult to measure quantitatively or accurately. Adhering too closely to concept testing often produces safe yet mediocre results. At some point a well-educated gut is still the best indicator of all.

The creative brief. All the above boils down to the creative brief, the jumping-off point for an effective project. It reduces client/creative misunderstandings, and it helps keep everyone on the creative team focused on the same target.

PROTECTING IDEAS. Your pitch and your portfolio should be enough to sell most clients. But sometimes clients may ask for an up-front demonstration of just how you would address their particular problem. In other words, to provide speculative creative.

In Creative Business's experience, especially outside the advertising field, spec work is usually requested by clients who are either naive or dishonest—either way, a bad risk. Even with reputable clients and large assign-

ments, the odds are typically long, making it a rather bad bet (possibly except if you have an idle staff, high potential, and an ideal fit).

If you are asked to make a spec presentation, we suggest you ask the client to sign a nondisclosure agreement similar to the one on page 202. It is probably adequate for most situations, although it is always good to get the input of an attorney when dealing with legal contracts. A nondisclosure agreement won't offer airtight protection, but it will serve to make the client aware that you consider your ideas proprietary. If the client will not agree to sign a nondisclosure agreement, you'll then have to decide whether to continue, having made a statement about taking protection of your ideas seriously. (For their own protection it is against the policy of some companies to sign such agreements.)

Finally, keep in mind that even with a signed agreement your ideas themselves are not protected. Only tangible expressions of ideas—concepts, sketches, drafts, etc.—are covered.

❖ Pitching High-End Projects ❖

Well-paying, high-end projects increasingly involve more than just solutions to creative problems—that is to say, more than just organizing and presenting visual information. Today, competing for these projects usually requires demonstrating additional, value-added knowledge and services. Of course, this has always been the case for some projects and clients. But only in the past decade has it become common to high-end projects and clients. In the not-so-distant past, we were often hired exclusively for the uniqueness of our creativity. Right-brain (artistic) thinking was our department; left-brain (analytical) thinking was theirs. But things are different now. Now, clients look for both right- and left-brain capability.

This is partly because high-end projects seldom exist independently anymore. They are usually at least partially defined according to other client activities—past, present, or future. This interconnectivity means that those who pitch them also have to impress the client with their knowledge of broader strategy and marketing issues. For instance, the key to getting a plum multimedia assignment may be how quickly one can grasp how it fits into a client's overall marketing strategy.

There's another reason today's clients look beyond creative competence. It is their recognition that high-end design efforts nearly always require some measure of analytical thinking if they are to be truly effective, as opposed to merely gratuitous. That is, these clients require whole-brain thinking.

YOUR CHALLENGE. Simply, you must impress clients with your analytical as well as your creative ability. If you don't think this way naturally, it will take developing a desire to do so, then training and practice. But it is pos-

sible, and important. Despite folklore to the contrary, there is nothing inherent in the design process that in anyway inhibits analytical thinking.

To set the stage, orient your promotional materials around your ability to do strategically sound work. There's no need to mention or describe the creative aspects of your past assignments. It only dilutes the message and will be apparent anyway by the design of your materials and the examples you pick to illustrate them. Remember, strategy requires talking; creativity requires showing. Use more or less the same approach when presenting your work. Unless guided by other client interests, put most of your emphasis on the up-front process (interviewing, research, and analysis), along with end results (sales or impact); put less on discussing the creative process.

If you make pitches as a team, split the presentation. Have one team member discuss strategy considerations, the other creative executions. With a copy/art team, the writer usually takes the former role, the designer the latter. However, switching roles within the team often produces a bigger impact. Smaller organizations should also do a split presentation with the shop principal discussing strategy, and a senior designer the executions. Larger organizations should follow the same model with a sales/account representative and creative director playing the respective roles. (See below.)

THE IMPORTANCE OF POSITIONING AND TITLES. Most clients take a creative firm's name as an indication of its focus. For example, it is far more difficult to persuade a client to give an annual report to an advertising agency than a PR agency, or to assign an ad campaign to a design firm over an ad agency. Not impossible, but more difficult. Thus, being seriously considered for high-end projects usually requires positioning your firm within one or two chosen markets. If you haven't already done this, it will probably be necessary, especially in metropolitan markets where there are numerous choices for clients.

How to position your firm is a personal and difficult choice. On one hand, strong identification with one or two markets will allow you to compete more effectively for lucrative high-end projects. On the other hand, it will probably cut off business from other market segments. A possible alternative, especially for larger firms, is establishing separate positioning for different market segments, for example, as "consultants for strategic branding" when going after corporate ID work, or "specialists in multi-discipline communications" when going after marketing literature. (Positioning is covered in detail in chapter 8.)

In a similar vein, it is important to consider the position and title of the individuals pitching high-end projects. Their functions and titles reflect their authority and determine their credibility. Job titles also make a clear statement about an organization's priorities. As examples, sales and

account reps should have titles like "vice president of strategic and marketing services"; creative directors, "executive vice president of creative strategies."

KNOWLEDGE OF MARKETING. Not all high-end projects have a direct marketing objective. Some, such as corporate identities, annual reports, and Web sites, are only peripherally associated. Nonetheless, all high-end projects require the techniques of communication and persuasion as defined by marketing. So, regardless of the project, understanding marketing principles is important. It is today's common language between the client and creative worlds.

Most creative individuals and firms employ the rhetoric of marketing. But Creative Business's experience is that few practice what they preach. Marketing is more than applying your skills in organization, decoration, and exposition, as considerable as they may well be. If you don't already have a solid marketing background—academic training, corporate experience, or intensive dealings with savvy clients—study up. As a starter, see "A Designer's Short Course in Marketing" in appendix IV.

YOUR OPPORTUNITIES. Expanding or breaking into high-end projects is relatively easy compared to the revenue-crucial projects described earlier. Don't let lack of experience hold you back. Landing high-end projects often takes little more than a combination of talent and chutzpa, although specific experience certainly helps.

With new clients. Trade on the discontent many clients have with your competitors—they're good at catchy concepts and decoration; bad at understanding what's crucial to a client's business. Focusing on strategy and marketing issues can be worth more than a dozen samples of "cool" work. If you also have convincing samples, so much the better. If you lack samples of the type of work you are pitching, address this right up front, before it becomes a negative in the client's mind. For instance:

"You'll notice that I'm not going to show you (many/any) examples of (type of work). That's because this is an area our firm is just now pursuing. We've found that the strategic and marketing experience we've gained over the years working on similar projects has recently become particularly relevant to this area, and most other creative firms haven't yet developed our expertise. In addition, being new to this type of work gives us a fresh creative perspective. And, of course, the problem-solving ability and communications skills I will show you this morning are far more important than any specific experience."

In many cases this explanation will be enough when combined with a sophisticated presentation and proof of talent. If not, you may also wish to offer a price incentive, "In order to strengthen our portfolio in this area. . . ."

With regular clients. Most clients type-cast design firms. That is, they think of us only in terms of one, or perhaps two, types of assignments, even though we may be capable of handling many other types. This is human nature, often abetted by the way we position ourselves. Sometimes we are guilty of taking existing clients for granted. Breaking a client's mental mold is often no more difficult that formally introducing your additional capabilities. In other words, pitching them just the way you would pitch a new prospect.

Next time you're calling on a regular client, ask if you can set up a time to "Show a few of the things we've been doing lately for some of our other clients." Even if you have nothing to show in the area where you wish to get more work, you'll still find it easier to pitch a regular client than a new one. It is better to practice in front of friends, and your chances of success are greater because it's easier for any prospect to take a chance on a known entity.

Creative Business surveys show work from regular clients to be up to 20 percent more profitable on average. One caution, however, don't be so seduced by the ease and profitability of getting more work from a regular client that you become overly dependent on them. (We define "overly dependent" as more than 25 percent of income from any one client.)

When pitching a regular client on new types of work, use more or less the same appeal as previously described for pitching new clients.

THE SECURITY BLANKET. The higher the project level, the smaller the design firm, the more a client worries about possible "what ifs." Recognize this concern up front and address it proactively. Emphasize whatever will make it a non-issue—your size, experience, longevity in business, client roster, etc.

BECOMING AN APPROVED VENDOR. Many large organizations use a system of approved vendors to control their purchasing activities. Unless your company's name is on this list, you can't be awarded a significant job. So whenever calling on large organizations, ask if they have such a list. If so, try to get your name added to all the job categories you feel comfortable working in, even if you don't get an immediate assignment. Being on the list is sometimes all it takes to get an unsolicited future bid on a project.

⊕ Pitching Moderate-Visibility Projects ⊕

For many of us, our "rent-paying" work are small- to mid-sized single projects like ads and print literature, often done for repeat clients. Each of these projects is, of course, important in its own right. At the same time, few are crucial to a client's overall image or long-term revenue stream. Awarding these jobs does not involve as big a decision for a client as do

revenue-crucial or high-end projects. There have also been fewer recent changes in this marketplace—what motivates clients today is pretty much what has always motivated them. But this does not necessarily make pitching these projects any easier. Indeed, because lower-level decision makers are often involved, pitching them can be as hard or harder.

Competition can also be more difficult. While only a few well-qualified design firms are normally considered for top projects, everyone—freelancers to firms employing dozens—are usually in the running for these types of projects. This is also a market under greater budget pressure. Media opportunities have lately been expanding faster than client budgets. The result is that many clients are required to spread their budget money more thinly than ever before. This not only affects the number of projects, but also exerts pricing pressure on the projects clients do undertake.

YOUR CHALLENGE. Most clients for these projects are simply seeking the best combination of talent and dependability for the price. The crucial factors are "how good?," "how reliable?," and "how much?" Whether you have a small firm or one with dozens of employees, orient your presentations around these three concerns. The difference between how small and large firms make presentations should only be the manner in which these client concerns are addressed.

Showing talent. To you, demonstrating talent may mean emphasizing the style, innovation, and craftsmanship of your work. But to most clients it is more convincingly shown by the variety of challenges you have met and solved. The greater the variety, the more impressive your portfolio. (Only up to a point, however. Six to twelve samples should be all that's necessary.) This definition of talent can put smaller firms at a competitive disadvantage. Unless, that is, it is recognized, addressed, and compensated for when discussing working flexibility and job pricing.

Addressing reliability. The ability to stick to commitments, to deliver what is promised when it is promised, rates at least as high as talent on these projects. The bigger their firm and the smaller yours, the more important this issue is. To minimize reliability concerns, stress any relationships with prestigious clients, even when the work was not otherwise of portfolio quality. Don't let personal pride stand between you and what clients are probably more interested in. It is sometimes better to show mediocre work done for recognizable clients, than great work for obscure ones. When making your presentation, put special emphasis on activities that build client confidence—promptness, enthusiasm, quick response, no surprises, working ease, religiously meeting your obligations, etc.

Proving value. Value is the relationship between what you deliver and what you charge. However you price a project, it is seldom as important as the

perception of the value clients will receive. Value to your clients is the only criterion by which you should ever allow your prices to be compared. Because of lower overhead and more pricing flexibility, the ability to provide more value is usually, but not always, the strong suit of freelancers and smaller firms. If you are in this position, emphasize it. It can go a long way toward countering client concerns over any perceived weaknesses, such as portfolio variety, firm size, and reputation. If you represent a larger firm, recognize that clients probably perceive you to be more expensive, so stress the many value-adding benefits (e.g., scale economies) that can accrue from working with your firm.

WHAT CLIENTS LOOK FOR. A Creative Business survey of client sensitivity found major discrepancies between what designers think is important, and what clients think. They are listed below, not necessarily in order of importance.

Style. This is that subjective element best described as the distinctive "look" and "feel" of one's work. In a portfolio it is the similarity and recognizability of the samples. Most designers feel that the stronger their style, the better. It is their signature, and it reflects their distinctive worldview. But clients often view style quite differently. To them, too strong a style can imply a lack of flexibility, that all projects end up looking or sounding the same, regardless of differences in audiences and business objectives.

Creativity. This is the ability to provide unique solutions to specific problems; in other words, the degree of innovation with which one addresses a challenge. It is both the essence of our business, and why clients hire us in the first place. But here, too, it can mean different things to seller and to buyer. There is no such thing as being too innovative for most creatives. Many clients, however, want just enough innovation to ensure differentness, but not so much as to be outré. To them, too much creative emphasis can get in the way of their message or create an image they are uncomfortable with. Stressing creativity too strongly, especially if it appears gratuitous, can result in being passed over for routine projects.

Experience. This is how often a design firm has done similar projects, and how familiar they are with the client's specific business or industry. Experience is a prerequisite for many clients, especially in insular and esoteric industries. They are only comfortable with creative individuals and firms who have it. Ideal is an industry expert who has done similar projects hundreds of times. On the other hand, most creatives feel, and rightly so, that their talent and experiences are by and large transferrable to any challenge, any type of business. Moreover, too much familiarity usually results in formulaic approaches; lack of extensive experience is usually a benefit, because it guarantees a fresh creative perspective.

Attention to detail. To clients this is rather general: clearly explaining how a concept will translate, showing the product to its best advantage, and remembering the names and titles of company personnel. To designers it usually is much more specific: the nuances that are created by using a slightly different PMS color or the precise kerning of a headline. In addition, clients are often critical of the extra time and cost of "gilding the lily"—i.e., perfecting what they believe is already good enough to meet the objectives of the project.

Speed. Most clients want projects completed by tomorrow morning. Sometimes this is the result of today's business pace, sometimes it is caused by simply starting late. Whatever the reason, clients place a high premium on an ability to quickly grasp complex information and rapidly provide a creative solution. Most have little understanding of the creative process, or the design business. Designers, on the other hand, are schooled in the process of "working things through"—exploring multiple approaches, trial-and-error elimination, and constant refinement. In addition, all design businesses have the very real consideration of juggling multiple clients and projects while simultaneously maintaining orderly work flow.

Chemistry. This is the comfort level a client experiences with a designer. Although it is affected by all the considerations above, equally important are a client's personality and individual preferences and idiosyncrasies. Designers usually underestimate its importance. Subjective (emotional) factors such as personal preferences are often as important in making a selection as more objective criteria such as relevant experience. Once underway, how smoothly a project proceeds often depends on how well everyone gets along, especially in situations requiring close interaction. When it comes to problems, concerns, or areas where business interests may conflict, clients will be forgiving of individuals they like, unforgiving of those they don't.

SECTION FOUR

Operations

This section is about maintaining the viability of your business. It covers the crucial aspects of pricing your work, working with clients, daily operations, and dealing with financial and personal issues. Such matters may not be the sexiest aspects of running a design business, but they are essential to establishing stability, which is, in turn, essential to enjoyment, profitability, and financial security.

The truth is, many design firms fail the test of long-term stability. Whatever success they enjoy is short-lived. Think: How many design firms do you know that have been around for several decades? Probably not many. Of course, by itself this is not necessarily bad. To enjoy running a shop for a few years and then to close it and go on to a new challenge with money in your pocket is certainly an acceptable lifestyle choice. But it is the less common situation. Much more common are firms that close their doors because of personal or business difficulties: the principals are burned out, clients have become a pain, the business is out of control, and they are either losing money or not making what their talent could command elsewhere.

The five chapters that follow are a guide to how to handle the daily routine aspects of design business ownership. Equally important, they provide guidelines on what it will take to eventually close or sell off your design business and end up with money in your pocket.

"The same thing happened today that happened yesterday, only to different people."
Walter Winchell

12 Pricing Your Services

ESIGN FIRMS make money in three principal ways—fees, markups, and commissions. How each of these is priced affects your competitiveness and your bottom line. In addition, pricing brings up several other issues, ranging from when to offer retainers to providing volume discounts to considering noncash compensation. Although pricing is only one of several factors that are crucial to the operational success of a design business, getting it right is what most of us worry most about.

❀ Hourly Fees ❀

The standard for pricing most creative work is hourly fees times labor hours worked, the same method used by other professional services, such as legal, accounting, and management consulting. Pricing based on usage and exposure is suitable for some types of creative projects (mainly illustration, photography, and editorial writing), but most design work is estimated and billed based on the time it takes to accomplish it. Anything else is outside business norms and foreign to most clients. As much as we may fantasize about pricing based directly on the contribution our work makes to a client's bottom line, there is just no other way that has more advantages and fewer disadvantages than time-based pricing. (The inherent difficulties in value-based pricing are covered below under "Can You Price by Value?")

INDUSTRY AVERAGES. At this writing, hourly fees charged by successful design firms range from $75 per hour to over $200. Project prices are based on work hours, then adjusted up or down as conditions warrant.

THE BASIC CALCULATION. Time-based pricing must be based on a realistic appraisal of a firm's financial needs. In essence, this means totaling its labor and overhead costs, then dividing the total by its average working hours. The result, after adding in a profit margin (typically 15 to 30 percent), is the hourly rate that must be charged to make an acceptable return on invested time. Although there are many other factors that affect profitability, the major one is the extent to which this calculation is accurate. Many firms with profitability problems haven't done the calculation, done it inaccurately, or not done it recently. The problem isn't the method, but applying it.

Pricing jobs by labor hours also raises a question, however: How many labor rates should there be? Just one "shop" rate for all billable individuals, or several rates depending on the individual or function involved?

A LITTLE HISTORY. The market for design services as we know it is relatively young. Until a few decades ago, most design work was handled by advertising agencies or in-house groups. The few freelancers and other firms in the business (e.g., studios) existed primarily to serve them. Handling work was different, too. Every project involved several separate, hands-on steps often done by individuals at a given level or with certain specialities, such as preparing mechanicals. This environment put a strong emphasis on the craft side of the business. Creative strategy and development, and the respect and professionalism that accompany them, were the province of only a few senior individuals.

Given these conditions, having many labor rates based on the skill applied to each separate task was nearly universal. Indeed, it was not unusual for large ad agencies to have up to twenty-five separate rates, ranging all the way from typing to the creative consultation time of the principals.

TODAY'S SITUATION. That's the way it used to be. More recently, the booming information sector of the economy has brought many new opportunities, along with new ways of doing things. Technology has transformed the creative process, most noticeably taking the emphasis off craft-like functions, which are handled better by computers, and placing it on creative thought, which is handled better by humans. One result is that while many firms today still have multiple labor rates, they have far fewer. Moreover, the trend toward simplification will likely continue. There are several reasons why.

Fewer, more linear tasks. The process of getting to the end result—ad, brochure, annual report, etc.—has become faster and easier. There are

fewer discrete tasks and fewer individuals involved. It is the norm today in many firms for one individual to handle an entire job—concept to print- or Web-ready files—at a single computer workstation. It is increasingly difficult to separate individual tasks when determining labor rates.

Higher capital costs. The benefit of fewer tasks and the higher productivity it brings with it comes at a price: expenditures of several thousand dollars annually per employee for new and upgraded computers, peripherals, software, and ongoing maintenance fees. The overhead (versus salary) component of labor costs is rising, and it is the same for most employees.

More sophisticated clients. Several hourly rates on an estimate or invoice can lead to the impression that a firm is a collection of craftspeople instead of a team of qualified professionals. It also puts more emphasis on doing than thinking, and too many hourly rates can make invoices more difficult for clients to understand and lead to nit-picking. The simpler a creative firm's invoicing practices, the more professional it will appear to clients, and the faster they will be paid.

OUR RECOMMENDATIONS. Creative Business surveys show that about 50 percent of design firms use multiple rates today, and about 50 percent use a single rate. When firms of more than a dozen employees are excluded, the figures are down to about 60 and 40 percent respectively.

One rate for most shops. We recommend that most design firms under a dozen employees use a single shop labor rate. Most of the labor on any project is billable creative time, and the small amount that isn't (corre- spondence, accounting, invoicing, etc.) should be treated as an overhead expense. Sometimes called a "blended" rate, it should be derived from a high-middle average of billable labor costs. This emphasizes that the work is done by an integrated, professional team. It will be acceptable to most clients as long as they do not perceive a significant difference in the vari- ous skills required for their projects (for example, paying creative rates for what are obviously clerical functions).

Four rates for some shops. Although the number of rates charged by firms has declined over the years, there are still two areas in which having sev- eral has its advantages. The first is larger firms where several significantly different skill levels are the norm on many projects. When this is the case, clients will often expect to be billed at different rates based on activity. Several rates can also be a benefit to the design firm. By pricing services closer to actual cost while still making a profit, larger firms can better com- pete on price with smaller ones.

The second situation in which multiple rates are common is agency work, where a substantial percentage of what is billable falls into the cler- ical and administrative area (placement orders, etc.). These billable func-

tions should be invoiced at fees substantially below those charged for creative activity.

Whatever the situation, in most cases we recommend basing rates on functions, not directly on the salary of the individual performing it. Further, we recommend limiting the number of rates to four, one clerical (the lowest), and three creative—high (creative director/principal), middle (designer/art director), and low (junior designer/junior art director). Having just four rates addresses client concerns about not overpaying for certain types of activity, and is reasonably easy to administer. It also provides some pricing flexibility. We believe anything more than four rates based on functions is counter-productive in today's marketplace.

ENSURING PROFITABILITY. Whether you choose to estimate and bill your work with one or several rates, there are some things you should keep in mind.

Do a 3x salaries check. A single billing rate should be three or more times the hourly average of a shop's creative salaries. When using several rates, each should be three or more times the hourly average salaries of those individuals who will be billed at that rate. If your rate-setting calculations (see "The Basic Calculation" above) don't produce a 3x multiple, refigure until they do.

Keep an eye on who does what. With a single rate, having a high-salaried person do a menial task will reduce your profit margin. If you use a tiered-rate system, a high-salaried person doing a low-billable function will murder it. Avoid both.

Be consistent. Given the many business and project variations, different prices at different times are to be expected. But the basis on which pricing is calculated—your hourly fees—should be the same for all clients in all situations. Raise or lower project prices by adjusting work hours, not by monkeying with your hourly rate(s).

Monitor productivity. Tasks that used to take more time are constantly taking less, a benefit of improved technology. This is a blessing when it results in more time for creative development or greater billable efficiency. But it is a curse if labor rates aren't occasionally adjusted upward to compensate. Less project time has to be billed at higher rates if shop income is to stay the same and the high capital cost of what permits these new efficiencies is to be covered.

◦ **Price by Value?** ◦

Let's address this question before we go any further. Why isn't it possible to price your design work by its value to the client rather than by the time

it took to do it? Or is there some way to get additional compensation later—a performance or incentive bonus? To answer these questions we need to look first at the way others are pricing.

STANDARD PRACTICES. As covered previously, most design firms price jobs using a combination of how many labor hours will be involved and what clients will pay. The difference between younger, less experienced firms and older, more experienced ones is primarily where they put the emphasis.

Less experienced firms. They usually start by considering what clients will accept—a combination of what is believed to be the client's budget and how competitors will price. Only later, if at all, do they modify this figure based on how much work will be involved. This procedure often results in accepting jobs that are not profitable. Its subjective nature also makes it nearly impossible to know after the fact which jobs were or were not profitable, or to monitor any of the key indicators of a business's efficiency.

More experienced firms. As firms become older and principals more experienced, they usually become more businesslike. The emphasis shifts away from what-the-traffic-will-bear guesstimates, to a costs-plus-profit approach. More sophisticated firms determine their hourly costs based on overhead and profit needs. They then use this figure (or figures), their labor rate(s), to multiply by the number of estimated hours involved. The result is a job's base price, to which a "contingency factor" (typically 10 to 15 percent) is often added. At this point the client's budget, competitive factors, and market worth are considered. If the price is subsequently lowered (or raised) because of them, it is a rational decision taken in light of market forces and with knowledge of its impact on profitability.

Most firms. While the above defines both the least and most experienced firms, the majority actually operate someplace in between. Their principals acknowledge that pricing should be based on costs plus profits but often lack the will to do so or lack sufficient data. So they make educated guesses—sometimes profitably, often not. If things are slow there is little incentive to think of a job's profit or worth because any work is considered better than none.

THE PROBLEM. Most design work today is performed under an arrangement whereby the supplier (you) establishes a value for their work up front before its real value can be determined. In this sense, providing design services differs from most other industries. For example, when a manufacturer sells equipment to one of your clients, both parties usually know what to expect. The manufacturer provides specs that the client then uses to relate to the performance that can be expected.

Even most service businesses provide a much more predictable price/value expectation. There is, for example, always the potential for a value upside in legal and accounting services, but it is limited. Only with highly creative, and therefore unpredictable, services is the ultimate effect and value largely unknown in advance. This can be a problem for both supplier and client.

With this as background, it is now possible to look at what would be required to establish a procedure for pricing by potential value, or incentive pricing.

It has to be mutually attractive. To work, potential-value and incentive pricing must be beneficial to both parties. Most likely this would mean giving clients a price break (discount) at your expense now and possibly getting more money (a premium) at their expense later. Without this quid pro quo it is doubtful that any client would agree. So, the first question to ask yourself is whether you would really prefer such a system. Yes, there's a chance there will be substantially more money in the long run, but there's an equally strong chance there won't be any. In the meantime you'll have less money to cover your expenses.

Even if you are willing to take this risk, there's another one you should consider. Since the only motivation for clients is reducing immediate costs, this approach will appeal mostly to those who are hard bargainers or on a shaky financial footing. Further, it's possible that a client who is agreeable to providing a high-performance premium will expect a low-performance rebate.

There has to be an agreement on what constitutes value. Unfortunately, every method for evaluating a creative effort has a measure of difficulty. It is next to impossible to base value only on creativity because of its subjective nature. Tracking sales is only valid when all the influences beyond your control—pricing, distribution, sales activity, etc.—are neutralized. Evaluating readership scores or Web hits requires a base line for comparison and is also affected by numerous external factors—media environment and placement, Web-site promotion, etc. In short, there is absolutely no certain, quantifiable way to determine value in a creative effort, and what means do exist require sophisticated techniques beyond the reach of all but the largest design firms and clients.

There has to be a procedure for rewarding value. Even where there is an agreement on determining value or incentive, there are still the issues of regular monitoring and payment. Only in the publishing and entertainment industries are there clear precedents for royalty payments based on sales. (Publishers' royalties vary widely, but average 10 percent of the list price of the item.) Moreover, generally authors are dependent upon their publisher's honesty, since verifying sales and royalty accounting is time-con-

suming and costly. Thus, for a client this pricing approach involves unfamiliar monitoring and payment systems, and for a supplier it poses legitimate concerns about dependability and trust.

A joint venture may be necessary. One way to satisfy both parties is to form a joint-venture partnership. Although common in other businesses, they require both participants to be on a more or less equal footing. Not, in other words, in a client/supplier relationship. Joint ventures are unrealistic for all but larger firms, or a few uniquely collaborative creative efforts (e.g., marketing a calendar).

Isn't creating value what you get paid for anyway? For all of the above reasons, value and incentive pricing are much talked about but seldom acted upon. There is also one final consideration: The reason clients hire a design firm in the first place is to enhance the value of their products and services. So, the issue is not about charging more for added value, but charging more for an extraordinary amount of added value. When put in this perspective, even if it were possible, additional compensation would be hard to justify for any but the most extraordinary of creative successes.

The bottom line. Occasionally a creative effort will create far, far more than what a client pays for. Occasionally it will bomb and produce far less than the client pays for. But most creative efforts do what they are supposed to—produce a good value for the client's money. Like it or not, this is the way the game is played.

HOW TO MAKE IT A NON-ISSUE. Being paid before the true value of your efforts is established can be a problem or an opportunity. Here's how to focus on the opportunity.

Work on enhancing short-term profitability. Rather than dreaming about what could be, concentrate on improving what is. Price your work high enough and don't consider any marginal assignment until cash flow is secure, or unless it has a guaranteed payoff (e.g., gaining experience in a new field).

Do value-added marketing. Start promoting yourself as a unique value-added marketing resource, not just another design source. It makes it easier to charge clients what your work is really worth. Not to oversimplify things, but how much clients are willing to pay depends on their perception of value received, and perception can be manipulated. (See section 3.)

Sharpen your estimating. Profitability will probably improve and the need to find ways to make up for shortfalls will probably decrease. The ability to make a little more on many jobs is far less risky and more remunerative than trying to make a lot more on a few jobs.

Don't provide discounts to start-ups. They're not deserved and seldom pay off. Many start-ups are amply funded with venture and other capital. But

regardless of their financial status, what you produce—identities, ads, etc.—are easily among their most crucial needs. There is no reason for your firm to subsidize theirs. Most other suppliers don't, why should you?

Beware of the "any income is better than none" trap. In the short-term this may be true. But in the long-term it is self-defeating because low pricing has a way of turning into normal pricing. Be as concerned about lowering your pricing as lowering your creative standards.

When placing ads, work on a commission-plus-fee basis. Try to have the fees cover all creative and production, and most account service. The media commission can then partially cover account service with the balance being your value-added bonus—the more an ad is run, the more checks you receive. (See "Commissions" below.)

❧ Markups ❧

Markups are fees added to invoices for outside services purchased for a specific project. Nearly all design firms charge them. They are compensation for the expertise, research, and negotiation time that's usually required, as well as for the cost of administrative paperwork and the time value of money. Equally important, they are compensation for risk; you are normally responsible for paying your suppliers regardless of when, or even whether, you are reimbursed by your clients. For these reasons, never be defensive about applying a reasonable markup on anything purchased outside for resale.

Creative Business surveys show that markups on most outside items and services (delivery charges, service bureau fees, other creative services, and miscellaneous materials) range from 15 to 30 percent, with the single most common markup being 25 percent (multiplying supplier invoices by 1.25). Markups on printing, however, are often an exception due to higher costs and greater risk. Many agencies charge the traditional markup of 17.65 percent (see below).

❧ Commissions ❧

As discussed in chapter 9 (see "When Is a Design Firm Something Else?"), pay for developing and placing ads is often partly or wholly covered by media commissions. The traditional media commission is 15 percent. If, as in our previous example, you prepare and place an ad whose space cost is $2,000, you bill the client for $1,700 and take a $300 or 15 percent commission. (Note: The $300 commission is 15 percent as a mark-down, but it would be 17.65 percent if a $1,700 bill was marked up to $2,000.) The

agency commission covers account service and sometimes creativity. The agency charges the client separately for creative, production, and ancillary services—research, photography, artwork, films, shipping, etc.

⊛ Noncash Compensation ⊛

Work for money, not for promises! No matter how often you get this sage advice, there are always new temptations. Yet, the promise of more lucrative work tomorrow if you cut prices today seldom pays off. What about working for tangible payment that's not money? How about bartering for a client's products? How about accepting equity in the client's company?

BARTERING FOR GOODS. Put simply, bartering is a nonmoney exchange of your services for a client's products.

The upside. Since the retail price for most products includes substantial distribution and other costs, clients should be able to provide them wholesale at a much reduced price. This gives you the opportunity to trade a single dollar's worth of your services for several dollars worth of value in their products. Nonmoney transactions are also difficult to tax. Although the fair market value of goods or services received is supposed to be reported to the IRS and state authorities as taxable activity, the reality is that most of it isn't.

The downside. Bartering is seldom the bargain it first seems. The price clients offer to barter their products for is often only marginally lower than what they could be purchased for through a discount retailer. You seldom get the selection and variety of options available at retail, either, and the products offered may not be your first choice. As for tax evasion, it is both illegal and risky. Furthermore, since the cost of purchasing business goods is tax-deductible anyway, there is usually little real advantage. Finally, and most important, bartering cannot provide what most design firms need most—cash flow.

What about barter networks? These are organizations set up to put firms in touch with each other, usually for a small fee. The appeal is getting work you wouldn't get normally in exchange for services you need anyway; for instance, trading with a nearby accountant—your brochure services, his or her tax services. Barter networks do provide a way for small design firms to fill what might otherwise be dead time with productive work. But because most of the firms in barter networks are small, they seldom result in long-term, profitable connections. Moreover, here as elsewhere the less money involved in the project, the less sophisticated the client and the harder to work with. To investigate barter networks do a Web search starting with www.barter.net.

Creative Business's recommendation: Only consider barter when you don't need cash and what is offered would be purchased anyway—ideally for personal, not business use.

COMPENSATION IN CLIENT EQUITY (STOCK). This sounds like a real twenty-first century opportunity. A client in a fast-growing industry (say Internet services) would like to offer you equity in their young company in return for your services. Now, we've all heard about dot-com millionaires—employees of start-ups who were partly compensated in equity (a share of the company's assets). This could be your chance to join them. Or at least become just a little richer. What do you need to know first?

The upside. Actually, exchanging services for company equity is nothing new. With start-up companies it nearly always means being given the opportunity to purchase stock at a low, under-market price (an "option") once it is offered to the public. Pre-IPO (Initial Public Offering) options are common. (When a company converts from private to public funding ownership shares are exchanged for stock, usually at a substantial increase in value. Publicly traded stock is also turned more easily into cash.) So the upside is that having options in a company before it "goes public"—that is, starts publicly selling stock to investors—often results in financial gain.

The downside. There is a downside, especially for an outsider (you). Most significantly, there is no precise way to determine the value of pre-IPO stock options. So it is hard to determine what you should exchange for them. This is, of course, mostly true for their employees, too. They willingly accept it, however, because the options they are given are a bonus in addition to their regular compensation. It is an extra incentive to work hard because doing so may result in a financial windfall if and when the company goes public. Put another way, if the company strikes it rich, so will they. But if it doesn't, they will still get paid, albeit probably not as much as if they were working for straight compensation.

Why the offer? Offering options in lieu of cash is a way for young companies to save money. In theory, a supplier's fees will be more than covered by the future value of the stock. At the same time, the company gets the services for free, so everyone supposedly wins. (The supplier's fees are actually paid by investors in the company's stock.) Nonetheless, there is a price to pay. At the very least you'll have to wait for your reward or the company may not go public. Or if it does, its stock might sell at under the option price. However lucrative options might ultimately be, you still can't use them to pay next month's rent.

Doing due diligence. Due diligence is an investor term for scoping out an opportunity before investing in it. In this case, it primarily means knowing the company's business plan. Aside from the normal information

about product, market, and potential, you also need to know how much venture funding is backing the company, what its rate of expenditure (burn rate), what its plans are for additional private funding, and when it expects to be ready to launch its IPO. If all of this is in a written document, so much the better. But keep in mind that unlike an investment prospectus, even the most impressive business plan is not a legal document. (A prospectus is issued at the time of the IPO and must conform to strict Securities and Exchange Commission regulations.)

Reaching an agreement. When negotiating how many options to trade for, value your time at least 50 percent more than the options' "strike price"— the price at which future stock will be available to you. This is to compensate for your risk. For example: $10,000 worth of services for options worth $15,000. (Probably the options will be filled from a pool of stock that the company will retain after it goes public.) If the company agrees, ask them to draw up an agreement with all the legal details. Then take the agreement to a lawyer for review and fine-tuning. Finally, before committing yourself check with your accountant to make sure you are fully aware of the tax implications.

Creative Business's recommendation: This is a gamble. Only consider accepting equity when you don't need the cash, and would have put a similar amount of money in another investment vehicle.

❀ **Working on Retainer** ❀

One of the major concerns for any design firm is ensuring a predictable cash flow. Regular assignments from a client not only provide it, but they also lower the cost of sales. (Work from repeat clients can be up to 20 percent more profitable than work from new clients.) One way to ensure regular assignments, predictable cash flow, and lower sales costs is to set up retainer agreements.

WHAT A RETAINER IS AND ISN'T. In our business a retainer is an agreement that sets aside a certain amount of time in a given period for an established fee paid regularly by the client. Retainer agreements are usually for a period of six months or one year. (In some professions—e.g., accounting and law—a one-time deposit against future billings is also called a retainer.) A reduction in price is usually part of a retainer agreement. But retainers should not be confused with other agreements that promise lower prices in return for a volume of work. Although sometimes mistakenly referred to as retainers, they are in fact merely volume discounts. There is more commitment by both parties in a retainer agreement. (See "Should You Provide a Volume Discount?" below.)

Like all good business arrangements, retainers are an outgrowth of a mutual need. As already stated, ensuring predictable cash flow is a major concern for all design businesses. For clients, having an experienced, trustworthy resource "on call" can save both time and money. Retainers are most common among public relations firms and their clients. The reason is that good public relations requires staying abreast of a client's business. In addition, when there is a crisis, PR services are required immediately. No client wants to run the risk that their needs won't be swiftly addressed because of unfortunate timing or a heavy workload. In the latter case, paying a PR firm a retainer is a type of insurance, analogous to paying firemen to sit in a firehouse just in case there might be a fire to fight.

Although particularly suitable to the PR business for these reasons, retainers are also appropriate for design firms. They are worth considering whenever there is a substantial volume of work for a client over an extended period of time, and whenever frequent client contacts or immediate response is important.

ADVANTAGES AND DISADVANTAGES FOR YOU.

Advantages. To reiterate, the primary benefit of a retainer is predictable cash flow, the equivalent of a regular paycheck. The client pays a stipulated amount each month, regardless of how much or little work is under way or planned. Each month can be started fresh, or any unused or excess work hours can be "banked" against the future. In this situation, time accounting is brought up to date every several months, or at the end of the retainer period. Banking retainer time provides more client flexibility and so is often preferred by them. On the other hand, it can result in scheduling difficulties and increased record keeping for you.

Regardless of how often accounting is done, when the client provides more work than can be accomplished within the time allocated, it is billed separately. Pricing is usually at the same discounted rate used in the retainer, but not always. On the other hand, if the client does not use all the time allocated by the retainer there is no refund; the logic being that the time was set aside and therefore was not available to sell to other clients. Once gone, time cannot be reclaimed.

Disadvantages. The most significant disadvantage of a retainer agreement is simply that it allocates a percentage of your billable hours to a single client, for better or worse. Even in the best scenario a retainer means responding more or less immediately when the client calls, regardless of your work load. In the worst scenario it could mean spending a considerable portion of your work time on low-profit and/or uninspiring assignments. If you aren't careful, it may also result in being treated as an in-house supplier. When this happens, when there is too much familiarity, it is easy for a client to unintentionally take advantage of you.

In addition, allocating a large block of time to any one client, month-in month-out, may label you with an unwanted reputation. You may become identified with certain types of work; clients competitive with your retainer client may pass you by; and your ability to compete for larger, more exciting assignments may be limited.

Finally, there is the danger of being seduced by easy money. When retainers provide a significant portion of income, it is easy to let marketing efforts slide. If this happens, your business will be vulnerable when the retainers end, as all do eventually.

ADVANTAGES AND DISAVANTAGES FOR CLIENTS.

Requests to consider working on a retainer basis occasionally come directly from knowledgeable clients. But often it makes sense for you to propose the arrangement. In either case, you need to understand what is and isn't appealing.

Advantages. The major benefit of a retainer for many clients is a promise of preferential treatment. This is particularly important to clients who are already providing a significant volume of ongoing work. With a retainer, they receive special recognition. In essence, the perception is that they become your Number One Client.

For other clients, the major benefit is cost savings. Work done on a retainer is typically provided at a 10 to 15 percent discount. In other words, if your normal labor rate is $150 per hour, work done as part of the retainer would be billed at $135 or $128. Work in addition to that covered in the

Retainer Agreement

This will constitute an agreement between (client) and (agency/individual) for (graphic design/writing/public relations consulting/advertising) services for the period (date) to (date).

During this period, (agency/individual) agrees to devote up to (number) hours per month on assignments to be determined by (client). Work will normally be performed at the offices of (agency/individual) (client) but occasionally may take place at other locations, as required. Work priority and scheduling will be at the discretion of (client). Work will normally occur between the hours of 9 to 5 on weekdays.

Payment for these services will be to (agency/individual) at the rate of $000 per month and will be made for the following month no later than the 30th day of each month that this agreement is in force. No invoice will be submitted.

Services in addition to (hours) per month will be made available by (agency/individual) at the rate of $00 per hour and will be billed separately. Any expenses exclusive of normal overhead are not included in this agreement and will be invoiced separately. Examples of such expenses are: delivery services, long-distance telephone calls, travel beyond 25 miles from (agency/individual) (client) facilities, and meals when traveling. All invoices will be net 30.

All materials furnished by (client) will remain the property of (client) and will be returned upon request, or no more than 10 days from the termination of this agreement.

The results of any and all work performed by (agency/individual) for (client), including original creative work (with the exception of _____), will remain the property of the (client). (Client) may use this material in any way deemed appropriate.

This agreement may be terminated on 30 days' written notice by either (agency/individual) or (client). In case of termination, (agency/individual) shall make a reasonable attempt to finish work in progress.

(Insert more paragraphs here with other terms and conditions as may be appropriate.)

(Signed) (Signed)
(Name) (Name)
(Title) (Title)
(Creative company) (Client company)
(Date) (Date)

Sample retainer agreement.

retainer may or may not be provided at the same reduced rate, depending upon the competitive situation.

Another important consideration for all clients is that they can count on you being around long enough to justify making investments in training or getting you up to speed. This can be especially important in complex client organizations or when dealing with sophisticated products and markets.

Disadvantages. The primary concern many clients have is paying for time that may never be utilized, especially if they have budget concerns or a short-term focus. In addition, there's a perception that retainers encourage make-work projects. Some clients also fear that with a retainer it is more difficult to supervise their suppliers, and that it may be difficult and time-consuming for them to apportion the monthly payment among various jobs and budget accounts.

SHOULD YOU, OR SHOULDN'T YOU? In considering whether to encourage a retainer agreement, ask yourself three questions:

How important is cash flow? The more volatile your income, the smaller your cash reserve or line or credit, the higher your fixed expenses—the more a retainer makes sense.

How enjoyable is the client and the work? Retainers encourage closer relationships and spawn more work. If you enjoy the client and the assignments, the 10 to 15 percent you give up will seem like a bargain. If you don't, it will seem very costly.

What percentage of your income will it be? It is financially risky to have any one client, on retainer or otherwise, represent more than 25 percent of your income. No two clients should represent more than 50 percent of your income. In short, one or two small retainers can provide much desired financial stability, but too much of a good thing can be a financial disaster just waiting to happen.

❧ Provide Volume Discounts? ❧

The more someone buys, the cheaper the price should be. This expectation, usually referred to in business as a "volume (or quantity) discount," is common among many clients. When dealing with other vendors, they expect to automatically receive, or at least negotiate, a special price for a certain amount of business. Should you offer the same? Probably not. How come? And how do you make a convincing case for not doing so if asked?

THE ARGUMENT FOR THEM. Volume discounts are a way for companies to increase sales to customers by passing along some of the cost reductions

they generate through higher volume. These discounts are seldom arbitrary or altruistic; they are usually based on lower costs. Put another way, they aren't provided as a favor to the customer; they are just smart business practice.

As an example, when a manufacturer makes more items, manufacturing costs usually drop. Likewise, when a retailer sells more items, stocking costs usually drop. By passing along some of these cost savings, more sales are encouraged, which drives costs even lower, which encourages more sales, which drives costs still lower, and so on. It's a win-win situation for all parties.

HOW DESIGN BUSINESSES ARE DIFFERENT. The savings that are possible in mass manufacturing and retailing (sometimes referred to as economies of scale) are seldom achievable by small service businesses. It usually takes about as long to do something the hundredth time as the first time, and since most functions are labor intensive, an action that takes as long, costs as much. So, there are few cost savings to pass along to clients, which invalidates the very rationale behind volume discounts.

Some routine projects appear to be exceptions, but in actuality are not. Take a newsletter, for example. By first creating a template it is possible to reduce future work time. But the reduction is not volume-dependent. It actually comes about from designing one job (the template) in such a way as to make doing the second (the ongoing newsletter) easier.

About the only justification for a volume discount is that the more you work with a client, the more efficient your procedures will become. With unfamiliar clients there is always some amount of wasteful, getting-up-to-speed activity. Working with any previous client is more cost effective because marketing expenses are reduced.

WHY IT MIGHT NOT MAKE SENSE EVEN FOR STEADY CLIENTS. Even when it makes sense from an efficiency standpoint, keep in mind that giving a volume discount stimulates more of a given type of business. This isn't always a good thing.

The work may not be profitable. When dealing with a tough client or a highly competitive situation, profit may not be sufficient to provide a discount. Or there may be a high hassle factor. These aren't clients you want to reward, regardless of the volume of work provided.

More business from one client may increase your vulnerability. A volume discount gives away profit while at the same time compromising your independence by increasing your dependency on one client. It also usually results in less assignment variety. Worst case scenario: You give up profit, become overly dependent on one client, and have to scramble to find replacement business when the client drops you later on.

You may forgo more profitable business. Most of your profit comes from selling time, and there is only so much available. If you sell it to one client at a cheaper rate, it isn't available to sell to others at a higher rate. In addition, when you are very busy you are less likely to do the prospecting that will lead to more profitable business.

HOW TO HANDLE A CLIENT WHO ASKS. Despite the negatives, there are benefits to stimulating more business from one client. Familiar clients are more likely to give the type of assignment you couldn't get from new clients. Collecting is usually easier. Most important, it usually improves your crucial cash flow. If these benefits outweigh the negatives previously described (i.e., it's a good business decision) agree.

However, an even better solution is to ask to be put on a retainer. This provides the same benefit to the client (a discount) but ties it to predictable cash flow. In rare situations where a straight volume discount makes business sense, Creative Business suggests 10 percent.

⚜ Give a Break to Not-for-Profits? ⚜

The client world is divided into two groups—for-profit and not-for-profit organizations. Most of us have worked with both types and we have learned to accommodate their often different operating styles. At the risk of perpetuating stereotypes, not-for-profits tend to have smaller budgets, less clearly defined needs, less sophisticated personnel, and do more decision making by committee. For-profit organizations are more likely to operate in opposite ways. These differences are not universal, but there is one undeniably common difference: not-for-profits often enjoy a pricing discount. Sometimes it is provided by design firms as a matter of policy, sometimes at the client's request. Whatever the motivation, the question is, is it warranted?

THE RATIONALES. Basically, there are two reasons for providing a not-for-profit organization with a pricing discount. The first is philosophical. Giving a break to organizations dedicated to the common good seems to be the socially responsible thing to do. The second reason is practical. Many not-for-profit organizations expect to receive a discount. If you don't provide it, you may not get the assignment or lose the client. When everyone else seems to do it, can you afford not to?

WHY IT MAY NOT BE THE RIGHT THING TO DO. The impulse to give something back to organizations we all benefit from is admirable. But don't be naive. Look at the effect on your business, and also look at how the specific organization operates.

It may not be as typical as you think. Most other vendors do *not* provide not-for-profit discounts (for example, local utilities and those providing routine supplies). Furthermore, the senior staff are often paid competitive salaries. Given this, do you still feel comfortable being one of the few who subsidize a not-for-profit's operations?

It mixes business with charity. Since your overhead and labor costs are the same regardless of who you work for, any discount comes directly out of your pocket. In actuality, a price reduction is a charitable donation. But unlike charitable cash donations, the value of a pricing discount is not tax deductible. Further, the organization may not be a charity you would otherwise support. Charitable activities and business activities should be kept separate. Mixing them makes financial management much more difficult.

It may mean forgoing better business. Time spent working on a low-profit job is not available for pitching clients with better-paying, more creatively exciting assignments. Moreover, not-for-profit clients are often less organized and more difficult to work with, so the result may be working harder for less money.

It encourages more of the same. One happy client begets another. This is normally good news, but not if it leads to an increasing amount of low-price assignments. If you aren't careful, low-price work can become the norm of your firm. In turn, this will diminish your appeal to better-heeled clients.

WHY IT MAY NOT BE THE PRACTICAL THING TO DO. What if you feel it's necessary to provide a discount to get the business? If so, consider the following.

You can always estimate low. If you really want an assignment, simply low-ball the estimate. Indicate that the price is an exception from what you would normally charge because you want to work on this assignment, build your portfolio/experience, or because it is a slow period. Whatever the reason, don't call it a not-for-profit discount. If you do, you'll set a precedent that will haunt you in the future.

You shouldn't have to accept cut-rate jobs. Not every client should be able to afford work of your quality. If you don't feel comfortable turning down 10 to 25 percent of jobs for price or other reasons, chances are you have made insufficient marketing efforts. Address the problem, not its effect.

You can always do it pro bono. This is the no-obligation way to make a meaningful contribution. It leaves you in control. (For how to do it right, see chapter 10.)

HOW TO RESPOND. "We work hard to keep our prices as low as possible.

This requires us to operate on a very small profit margin. The only way we could provide a discount to your organization would be to increase our prices to others. We've decided it is fairer if we don't favor, or discriminate against, any type of client. We also don't inflate our prices in order to later mark them down. If you take into account the additional quality, service, and dependability we provide, you'll find that we actually provide a better value, even at a slightly higher initial price."

Raising Prices without Raising a Flap

Raising prices is one of the toughest challenges for any company. Whether the company is General Electric or General Design, the question is the same: will the increase in revenue offset the (possible) loss of customers? Never an easy question to answer. In addition, design firms—especially smaller ones—have two other concerns: in most cases the principal is also the messenger, and unlike manufacturing companies who can blame raising prices on the rising costs of raw materials, design companies sell mostly time, making justification complicated.

Despite these difficulties, price increases are a necessary fact of business life. How often to do it, and how to inform clients when you do, can have a major impact on profitability

BUT FIRST . . . Raising prices is only one way to increase profitability. Other options should be considered first. Most not only provide a more immediate effect but also skirt the problem of client approval.

Are all clients treated equally? When you charge lower fees to some clients, you must charge higher fees to others, or make up the difference out of your own pocket. Either way, this is a bad practice. Charge all clients—big, small, profit, and not-for-profit—equally.

Are you managing effectively? Here are some common trouble spots to look at: inaccurate time recording; workflow bottlenecks; consistently exceeding estimated time by fine-tuning; high employee turnover; bad cash flow predictions; inefficient employees; too many unproductive meetings.

Are your performance ratios in line? Keep an eye on key business indicators such as: accounts receivable collections, billable time, work backlog, marketing costs, salaries, quick ratio, and debt-to-asset ratio. (For more on ratios, see chapter 15.)

Are you charging for everything? Is all job time recorded and billed? Are all pass-on expenses itemized and billed?

Do you have minimum fees? To keep small jobs from being money-losers,

you probably should have a minimum charge: one or more day's billable time for all jobs; one or more hours for all work on a job.

WHEN IT MAKES SENSE. One of the benefits of being self-employed is that no one else limits how much you make. But it is also difficult to determine what you should be making. Here are some guidelines to help you determine when it's probably time to consider a price hike.

Low salary. Self-employed persons should be able to pay themselves at least 75 percent of what they could make working for someone else. (A spread of up to 25 percent, the difference between 75 and 100 percent of potential, can usually be justified by tax savings and a lifestyle choice.) If you know that you could be making at least 25 percent more in a salaried position, and are running your business efficiently, it is probably because your firm is not charging enough.

The numbers don't add up. The price any business charges must be based on a realistic calculation of its costs. This can be roughly established by adding all expenses (labor plus overhead) for a given period (six months or longer) and dividing it by the number of hours actually billed. The result is the hourly rate that must be charged just to break even under current circumstances. The hourly rate you charge in the future should be 25 to 50 percent higher than this to allow for profit, expansion, a financial cushion, new equipment, etc.

Low return on labor investment. Each billable employee should average billable time that is at least three times his or her salary. If not, either the employee is overpaid or your billing rate is not high enough. (In firms with several levels of employees, use a blended or average rate.)

No price pressure. We all wish for clients who never question pricing. But it's probably better if the wish doesn't come true. When clients never question, it's usually because prices are well below market level. Likewise, if you don't occasionally lose jobs on price. (You probably should lose 10 to 25 percent of all jobs bidded, depending on how qualified are the leads, amount of repeat business, etc.).

Industry norms. What do others charge in your market? Your pricing should be near the top of the level for others of your level of talent and experience. Compare your job prices to those published in the *Creative Business* newsletter, or the Graphic Artists Guild's *Pricing and Ethical Guidelines* (*PEG*). (Caution: Creative Business surveys indicate that *PEG's* prices are often 10 to 15 percent high.)

It's been too long. When was the last time? If your prices have not risen recently, you are probably making less now than before. Viable businesses are stable or grow, they don't shrink.

HOW MUCH? It is usually best to raise rates in no more than $20 increments and no more often than once a year. If your prices are still below what they should be, plan on an annual increase until they reach the right level. When considering the effect on job prices, keep in mind that it is difficult for a client to easily accept a perceived job increase of more than 15 percent.

TWO JUSTIFICATIONS. The best way to justify a price increase is to try to view it from your clients' perspective, not your own. To them, there are only two universally supportable reasons, and even these often raise questions. (See "Countering Objections" below.)

Higher costs. It is common knowledge that inflation has produced a steady rise in overall prices over the past several decades, so referring to continually rising operating costs (labor, materials, supplies etc.) is a common justification. In addition, the technological revolution in our industry also continues to result in rising costs (new types of hardware, computer training, upgraded software, etc.).

Product quality. The quality of any product determines its value and its price. (A Mercedes and a Chevy don't sell for the same amount.) If the quality of your work (your product) has demonstrably improved, rational clients will consider a price increase that reflects the new level justified. How do you improve product quality? Through more specific experience, a higher level of creativity, winning awards, working with more prestigious clients, and better service.

Your desire to make more money or pay your staff higher salaries is never a justification for a price increase. That's your problem, not your clients'.

PSYCHOLOGICAL PREP. Whenever discussing pricing it is always wise to remember the role psychology plays in price acceptance. When you raise prices, it is even more important to keep the following in mind.

Be matter-of-fact, not defensive. Price increases are a legitimate response to a business's increase in costs or quality. Being defensive won't make the increase any easier to sell, but it will make it appear less legitimate.

You get what you pay for. It's a cliché, but most people, clients included, believe it. When raising prices, your task is to convince them that your value has increased more than your prices.

Perceptions affect reality. Whether a client believes your work is over-, under-, or appropriately priced is strongly affected by impressions. All other things being equal, a well-dressed, personable, and articulate professional can charge more than someone lacking these qualities.

There's no "right" price for a job. Every job presents a different challenge that can be addressed in different ways at different price levels. The fact that you have previously done a similar job at a certain price, or that the client has a certain budget figure in mind, should not determine pricing.

There's always someone cheaper. Clients looking for lower prices can find them. What the client cannot find elsewhere is your quality, service, and dependability at your price. Don't let unnecessary concern scuttle a needed increase. Deal with it.

Most will spend more. Good clients will nearly always spend a little more on a service they need from someone they like. It is unlikely that clients who have been pleased with your service in the past will bolt based upon a small price increase.

DOING THE DIRTY DEED. Start using your new, higher pricing structure the first of next month. Don't agonize over implementation. Just do it! Chances are that it will be more significant to you than to most clients.

New clients. Unless new clients have some way of comparing the old with the new pricing structure, there's no need to inform them.

Existing clients. For most competitive projects it is not necessary to inform clients of an increase in pricing. How you arrive at a competitive job price is your business. For repeat or similar assignments it is probably better not to inform the client in advance. Wait until presenting the estimate. Then say, "By the way, you'll notice that this price is slightly higher than last time. I've had to raise my fees since then because of rising costs."

On jobs where clients are aware of your hourly labor rate, it is best to tell them before estimating on the job. ("Since the last time we worked together, we've had to raise our fees to keep up with our higher business costs. This job will be estimated on our new labor rate of $x per hour. Even so, I know you'll still find our prices well below the market rate for work of this quality.") In the case of direct hourly billing it is best to give a month's notice.

Special clients. As a business changes, it is a natural process for some clients to drop away and others to be added. Profitability growth usually means smaller ones will be replaced with larger ones. As explained previously, it is better not to discriminate for or against any single client. So, how do you handle a long-time, loyal client who perhaps can't afford your new prices? Take the client out to lunch and discuss your impending price increase in a social setting. Indicate you appreciate all the business you have received over the years, and hope the client can afford to continue working with you in the future. If not, however, you understand their situation and will help them find someone to replace you. Don't make the mistake of giving special clients a price increase dispensation. If you do, your business will be subsidizing their businesses.

COUNTERING OBJECTIONS. Most good clients will go along with a modest price increase. But a few may have problems. Here's how to defuse the more common ones.

"But we budgeted based on the past." The client has set a budget based on lower previous costs, and now doesn't have the funding necessary to do the job at the new, higher price. What do you say? "I'm sorry I didn't give you more warning. I didn't realize it would be such a problem. Because it is my error, I'll gladly do the job this time for the same amount I charged before. In the future, however, I'll have to charge you the same prices I charge my other clients."

"What inflation?" When making the case for higher costs, the client counters that right now there is no significant inflation. Prices are stable. Your response "You're right about the economy overall. Unfortunately, this isn't the case in the communications industry. Here the prices for labor, materials, and supplies continue to rise. Besides, I haven't raised my prices in several years."

"Aren't your higher equipment costs offset by productivity increases?" Computers and software cost a lot of money. But they're supposed to result in productivity gains and lower prices. This has happened in other industries, why not communications? "Our industry is still in the technology-accumulating stage. We've managed to absorb most of the high conversion costs ourselves, but we can't absorb them all. Our technology investment has already paid off in faster service, higher quality, and the ability to offer greater variety to our clients. Ultimately, I expect it will also pay off in greater productivity and stable prices. But that's still in the future."

"This is a rather steep price increase isn't it?" The client sees an estimate based on your new pricing and comments on the size of the increase. "Actually, our fees are only 10 percent higher this time than before. In real terms this is just $x, which is only x percent of the entire job, including printing. The bottom line is that this is only a couple pennies for every brochure that will be printed."

"Your prices are getting too high." For a price-sensitive client the price increase appears to be the last straw. What can you say that might save the account? "Even with the increase, our prices are still lower than others for similar quality work, and we believe that quality is important because it provides more market impact. In other words, when value rather than just cost is considered, we are still very, very competitive."

"I hear what you're saying, but the price is still too high for us." Not every client can afford your work. Not every client needs the quality and service you provide. Try to modify the job specifications to make working on the project possible within the client's budget. If that's not doable, prepare to bite the bullet. "I'm sorry to hear that. As much as I'd like to be able to meet your budget, I'm afraid I can't do it and still make a profit. I hope, however, that we will be able to work together on another project in the future."

Remember, the whole point of raising your prices is to allow you to make enough on good projects so you can afford to turn down not-so-good ones. Don't jeopardize it by caving in to unrealistic client price pressure.

❧ Determining Client Budgets ❧

You probably shouldn't come right out and ask what a client's project budget is. The implication is this: Whatever the budget, once you know it, you'll find a way to spend it! Yet, not knowing whether their budget and your talents are a match could waste everyone's time. Moreover, because all service activities are expandable and contractible, if you don't ask you won't know whether the client has an adequate, good, or best effort in mind. Asking about budgets is one of those damned if you do, damned if you don't, situations.

So how do you handle it? There is no totally risk-free way. There are, however, some things that will help reduce the possibility of misunderstandings.

UNDERSTANDING CLIENT BUDGETING. A common misconception among designers is that client budgets are the result of extensive management consideration—in other words, that the budget for any given project or program is set by client managers only after a lengthy review of priorities and finances. It is, therefore, a true reflection of what they want and can afford.

Actually, this isn't even close to reality. The reality is that most organizations set budgets arbitrarily and more by happenstance than managerial science. This is especially true in areas where the client has little expertise, or where the return from the amount budgeted (ROI) cannot be easily measured—the very definition of most design projects and programs. The smaller the organization, the more this holds true.

In many organizations a typical budget-setting exercise simply consists of guesstimating what someone thinks something should cost, or it consists of extrapolating cost figures from a similar, past project, or is simply what the client feels is affordable, despite whether the figure is realistic or not.

Whatever budget is set is seldom carved in stone, either. The more specific the item, the more this is true. For example, a corporate marketing department may have to keep within its total budget for promotion but can overspend lavishly on some projects as long as it cuts back on others. In other cases, a budget may be simply a guideline, much like an individual's budget to keep expenses in line with income.

The point to remember is that there is nothing sacrosanct about a client's budget. It may or may not be realistic. To the extent that it's possible to

work within it, it should certainly determine the extent and development of a project or program. If it is inadequate, there should be no reluctance to ask that it be increased or the client's plans modified. In short, a client's budget problem affects what you do and how you do it, but it is never your problem to solve.

QUALIFYING NEW CLIENTS. The easiest way to minimize the importance of the B question is to work with clients who have a high probability of realistic budgets. Sometimes this eliminates the necessity of asking altogether; other times it just makes it easier to bring up the subject. The following are ways to get a good read on which new clients are budget-sophisticated.

Use an up-front filter. Creative Business recommends using a two-step process when new clients contact you for a project. The first step, sent in response to an inquiry, provides general "how we work" information; the second step follows up with a proposal that provides specific project development detail. By making your working procedures, including representative fees and prices, clear up front, the first part of this two-step process can be an effective way to inform those with inadequate budgets that you are probably out of their price league.

Look at who else they've done business with. Finding out which other creative firms the client has used in the past is probably the best single way to determine a new client's budget sophistication. If the previous firms they have used are at your level or higher, chances are their budgets will be adequate.

Note how often they purchase creative services. Frequent purchasers are usually aware of going market rates, and they seldom require any time-consuming education about the creative process. Conversely, clients who purchase creative services only occasionally often have unrealistic expectations.

See how big they are. Bigger doesn't automatically mean larger budgets and more sophistication, but there is a strong correlation. The larger an organization, the more likely it is to know the true value of your services, and to have professional budgeting procedures and qualified managers.

Look at their reaction to your portfolio. Recognition of good work doesn't necessarily indicate realistic budgets, but there is a strong correlation. It is less likely that a client who recognizes and appreciates effective work will have a major budget problem.

Consider how concerned they are about price. Price is important, but it is only one of several issues that clients should consider when reviewing your capabilities. Any clients who put price as their highest priority will almost certainly have a budget problem. Moreover, even if you agree to work within their budget, their mindset portends trouble later on.

Check the SEM (Someone Else's Money) factor. The farther an individual is from the direct impact of cost, the more pricing flexibility he or she will show. Toughest negotiators are entrepreneurs spending their own money; easiest are executives of large organizations.

THE RIGHT WAY TO ASK ABOUT PROJECT BUDGETS. As much as we'd all like to work only with clients where budget determination isn't an issue, it is not always possible. We may not want to turn down work from new clients just because it involves budget negotiation. And what about well-qualified, familiar clients with whom there is budget uncertainty? Despite the circumstances, Creative Business believes that there is only one right way to get a feel for a client's budget, and it is not by asking directly. Rather, it is by determining where within a range of adequate, good, or best approaches a client's perceptions fall. Here's how we would go about it when a single project is involved.

With a new client. After showing a selection of your work, ask which items were most similar to what the client has in mind. Then, after the client has indicated which are closest in size, style, and complexity to the project, say something like this:

"Of course, we develop every project around the specific objectives and budget of our clients. But, projects similar to this normally run in the range of $x to $x." (Give a range of at least 100 percent.) "The lower figure reflects a simple, no-frills approach; the higher one is where there is complex development and the client desires maximum impact. Most projects fall somewhere in the middle. Where within this range would you think is appropriate for your project? With a figure to start with, and after we get all the details, we can then work up a proposal that will meet your needs and fit your budget."

With a familiar client. The approach is similar to the above, but acknowledges your past relationship.

"Given our experience working together, I know you're aware that we can handle this project in several different ways. For what you've indicated you have in mind, they would range from a simple no-frill approach of around $x, up to around $x for complex development and maximum impact. Can you give me an idea of where within this range you think would be appropriate? With a figure to start with, and after I get all the details, I can then work up a proposal that will both meet your needs and fit your budget."

WHAT ABOUT ONGOING PROGRAMS? Ongoing program work—advertising campaigns, maintaining Web sites, etc.—is fundamentally different from project work when it comes to budgets. In most cases, there is an acknowledged budget; the client simply wants to know what you can

accomplish within it. Since the goal is to spend the budget, albeit wisely, there's no need for tact in asking how much it is.

HELPING CLIENTS CONSIDER THEIR BUDGETS. Occasionally clients may ask you to come up with "a plan based on a budget appropriate for a firm of our size." How much should it be? How to justify it? The following are a few sources that provide general guidelines.

One readily available source, useful for considering advertising budgets, is the data published by *Advertising Age* magazine (www.adage.com). Early each summer it reports advertising-to-sales ratios for several hundred industries, a useful guideline for seeing whether a particular client's ad budget is in line with the standards of its industry. Another reference point is Creative Business's recommendations for a client's sales literature budget. By our calculations it should be more or less as follows: for heavy industrial products up to two times the company's advertising expenditure; for most business-to-business products about a third less than for ads; for considered-purchase consumer goods usually two thirds less than for ads. The Graphic Artist Guild's *Price and Ethical Guidelines* (www.gag.org) can also provide guidelines for a number of specific design projects, and there are several Web sites that do the same for average Web pricing. It must be emphasized, however, that any published figures should be used as nothing more than rough guidelines. At best they represent only averages, which are often inappropriate for a specific client. For instance, well-established organizations typically spend less than average on promotional activities; younger, more aggressive organizations typically spend more. Organizations sometimes have a year or two of intense activity when launching new products followed by a year or more of little or no activity.

BUDGETING METHODS. The only appropriate way for an organization to set a budget is by reviewing its needs, then allocating its resources against them on a priority basis. Outsiders (you) can help by providing input on representative prices and relative efficiencies, but only the client can establish priorities.

One way to initiate this process for well-established clients is to suggest an audit of all their current programs and materials. Use this as a base to suggest what they should consider adding or changing and what it would cost.

Otherwise, when clients want your help ask them to put together a "wish list" of any activities or items they believe would be beneficial to them. Then ask them to rank each on a scale from 1 to 5 using the following cost/benefit relationship: 1=required; 2=crucial; 3= important; 4=supplemental; 5=to do only when other priorities are covered.

Now take the list with its priorities and prepare a very rough estimate of the total cost (creative, production, and media) for each item or activity

on it. Add up the totals within each of the five rankings, including a factor of 25 percent to compensate for the estimate's roughness and contingencies. Present these figures, making sure to stress that this exercise is only for the purposes of budgeting, and actual costs may differ at the time of production. The information will, however, provide an objective means by which a client can decide which activities and items are affordable and prepare a budget accordingly. Helping a client prepare a budget is normally a paying (consulting) assignment, although the price is often discounted based on the potential for new work that may result.

COMING TO A PRICE AGREEMENT. Whether arrived at objectively or by happenstance, client budgets are nonetheless the standards against which proposals are measured. You must be within their budget ballpark, or be prepared to justify why.

How close? Ordering design services is not like ordering products. Some things can be specified (e.g., number of pages), but many others (e.g., creative time) can't. This aspect provides considerable flexibility in meeting client budgets. If your pricing falls within plus or minus 25 percent of their budget figure, you should be able to meet it by increasing or decreasing the amount of creative versus production time involved—in other words, to move the project up or down on your adequate, good, or best efforts scale. When you are this close, it is usually better to compromise on the way you would approach a project than to lose it over a price/budget mismatch.

How much negotiation? Some is a good thing. It helps ensure that you've thought through your pricing and the client has thought through their needs. But extensive negotiation usually forshadows a problem-prone relationship. Almost without exception a client who hassles you on meeting a budget figure will also hassle you on procedures, the quality of your work, or the way you schedule it.

The only appropriate way to meet a budget that is outside the plus or minus 25 percent ballpark is to see whether it is possible to meet the client's objectives by modifying the project specifications, and thus the work involved. Faced with this situation and a reasonable client, say you would like to go back to your office and do some refiguring. Then come back with a new proposal that shows how the client's objectives and budget can be met by a different approach than the one budgeted for. In short, try to find a new way that fits both your pricing and their budget. If this is not possible, or the client objects, it is probably better to turn down the work. If you do decide to meet a low budget figure, make sure the client understands that you are making an unusual exception, and why. For example: "Your budget is well below what we normally charge for work of this complexity, but it would provide a great portfolio piece for us. So

we'll be happy to handle it under these terms if you'll allow us to also use it for promotional purposes."

Talking a client up. It's okay when clients agree independently that what they want is out of synch with what they have budgeted and agree to raise the budget. But don't try hard to persuade them. Doing so can set up a situation where they feel the need to justify the extra cost by making extra demands upon your time—a no-win situation. Every salesperson knows that the only satisfied customers are those who make up their own minds. Since your business depends in large measure upon repeat clients and complimentary word-of-mouth publicity, the only customers you can afford are satisfied ones.

TWO TYPES OF BUDGET FIGURES. A budget figure before assigning a project is a different animal than a budget figure afterward. Beforehand it is a goal or aim-point; afterward, a commitment—theirs and yours.

Once a proposal is accepted, in most cases the price agreed upon will be entered into the client's database of committed funds and a purchase order assigned. The assumption is that whatever the amount specified, the project will be delivered at or below that price. In other words, even though you may have specified that your price was an estimate, clients start treating it as if it were firm. Given computerized bookkeeping procedures, it is probably necessary that they do so. However, it needn't lock in your estimate price as long as you work within their system. This means recognizing that the amount entered into their computer will have to be increased if your invoice will exceed your estimate. Otherwise, it probably won't be automatically paid. Whatever the reason for the increase, as soon as it is apparent that an estimate was too low, ask the client to issue a revised purchase order for the new amount. This in turn will trigger an increase in the project budget and allow the client's computer to pay you on time. Trying to raise the amount after the job has been completed invariably causes problems.

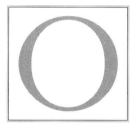

13 Working with Clients

NE OF THE MAJOR differences between service and other types of business is the buyer/seller relationship. Rather than having to broadly meet the expectations of thousands of mostly anonymous customers, service businesses must meet the needs of only a relatively few clients, but in a much more intense manner. Client needs are also much more demanding and the costs of screwing up much greater. Simply put, maintaining good client relationships is crucial to a design business because without them you can't have a good business.

☙ Give 'Em What They Need or ❧ What They Want?

Let's start with a dilemma as old as the design business itself: When working with clients, especially for the first time or on highly conceptual work, how closely should you follow their wishes?

On the one hand, as a supplier in a service business it's your obligation to give clients what they ask for, what they've contracted you to accomplish. You're a hired gun whose efforts should be directed by the wishes of your clients, not your own wishes. On the other hand, you also have a professional obligation. It is to provide clients with the best possible results within their budgets. After all, it is professionalism—a combination of talent, experience, service, and opinion, that they are paying for. To hold back not only shortchanges them, it also diminishes the value of your services. As you're undoubtedly aware, there is no simple answer to this dilemma.

Every client, every assignment, requires a different mix of taking the lead versus taking direction.

TODAY'S REALITIES. While every client and assignment may be different, there's little doubt about one long-term trend. Each year there are fewer and fewer areas where craftsmanship and an ability to follow directions are all that's required. Moreover, those areas that do remain have become low-profit commodity services.

Bread-and-butter design work—polishing concepts, preparing artwork, etc.—is terminally ill, made obsolete by electronic production. The good news is that this trend leaves most mid- and high-end design assignments unaffected. Moreover, it shifts the overall emphasis away from tasks performed and towards the additional value we create. This results not only in an opportunity for more financially lucrative work, but also more of the type of work that's personally rewarding.

The bad news is that today's clients are a lot more knowledgeable, opinionated, and unforgiving. They are also emboldened by the many alternatives now available to them.

Thus, the bottom line is that sustaining a successful design business today requires a delicate balance when it comes to client relations. It means taking enough specific direction to meet client needs, but also contributing enough knowledge and expertise so that clients get the best possible results and value. In today's competitive environment, project management ability is usually as important as creative ability.

MODIFYING PERCEPTIONS. Clients don't share responsibilities with design firms they do not believe are qualified to handle them. So before considering how much direction is appropriate, first consider how clients perceive you.

Positioning. In the long run you can't pretend to be something you aren't and get away with it. Nevertheless, it is important to recognize that less than 50 percent of perception is usually based on reality; more than 50 percent is based on activities that create impressions. Put another way, it is often possible to change clients' perceptions of your capabilities—your "position" in their minds—by the things you say and do.

As examples, the description "freelance" would exclude you from many high-level corporate assignments. "Art director," "writer," and "illustrator" carry a stronger connotation of executor and doer than of thinker and planner. Don't expect high-level assignments if your firm has a low-level name like Wee Hours Graphics. Don't err in the other direction, either—e.g., Imaging Consultancy—unless you have the horsepower to back it up. Conversely, using "services," as in "design services for business," conveys a sense of broad offerings. Words such as "strategic" and "marketing," as in "strategic marketing design," convey a sense of depth and understanding. A statement elucidating your business, as in "25 years of problem-

solving design," can also positively affect perceptions. Such a tag line not only helps define your uniqueness, it can distinguish you from your competitors. (For more on positioning, see chapter 9.)

Pitching. It is human nature for clients to simplify things by categorizing suppliers. Most associate a design firm with only one or two types of work. Remember this tendency when pitching new clients. Orient most of what you say and show to a few strengths that mesh with the client's interests. A strong focus is usually necessary to create the type of perception that will gain immediate trust. Say a lot about a little, not the other way around. Later on, as described below, you can build on these initial impressions.

Promoting. What you become known for can be greatly affected by what you say about yourself. For example, a subtle way to let clients know of your other capabilities is to mention them in casual conversation. ("I think you'll be interested in an experience I just had when working on a....") Regular promotional efforts not only help define the league in which you are capable of playing, but also demonstrate that you can do for clients what you have done for yourself. Campaigns that constantly emphasize different skills or talents broaden the perception of your capabilities. Many small, complementary efforts are far more effective—both in maintaining awareness and in changing perceptions—than an occasional all-things-to-all-clients blockbuster. Of course, you can also promote different skills to different types of clients at different times.

However you decide to promote your services, the more you create the impression of delivering what Richard Saul Wurman labels "information architecture," the better. The larger your firm, the more this is true. Clients should see your expertise as constructing unique, interesting, understandable, and persuasive communications.

Servicing. The professionalism with which you handle assignments also influences client perceptions of competence. There is no precise definition, but competence usually requires at least the following: knowledge—how much do you know and care about the client's business?; responsiveness—do you project a sense of working together?; confidence—do you convey assurance while avoiding hubris?; enthusiasm—are you excited about the work?; flexibility—are you friendly and easy to get along with?

Being more assertive. Being responsive to client needs does not mean being obsequious. Equally important to conveying competence is questioning what you don't understand and challenging what doesn't make sense. In short, being pleasantly assertive.

The right attitude. When it comes to the most effective way to communicate, you're the expert. This is not because you're any smarter, or even more talented than your clients. It is because of your specialized training, and the

fact that you deal with similar problems every day of the week. Clients do not. Because of this, you know what works best, and how to get things done most cost effectively. As an outside expert hired to solve a problem, you should expect to take the initiative. It is the client's obligation to define the budget, timing, and objectives (results desired); it is your obligation to determine how to best accomplish them.

Establishing credibility. Clients will be flattered by interest in their business and impressed by your thoroughness. The more intelligent questions you ask, the more easily clients will later accept your ideas and concepts. The more knowledgeable you are, the more confident you will be in justifying your work. (See the "Assignment Questionnaire" in chapter 7.)

Resisting unrealistic requests. While occasionally jumping through hoops for a client is appropriate, doing so on a regular basis is not. Nor is easily acquiescing to anything your professional judgment tells you is wrong. Good suppliers abide by their schedules and convictions, and good clients know it. The client is not always right.

TAKING CHARGE. The higher the value of an assignment, the more direction the client expects. Certainly any job worth thousands of dollars requires substantial participation on your part.

Set the schedule. Rush jobs excepted, you should set a project's schedule, insisting on the time needed to do a good job. If necessary, be willing to occasionally turn down work to maintain your standards. As tough as this may be in the short term, the long-term respect and additional work it produces will be well worth it. Clients seek out those whose work and standards they respect.

Limit input. Too many different ideas and opinions diffuse focus and vitiate creativity. Restrict creative input sessions, presentations, and approval routings to no more than a half-dozen individuals. Assign one person as the coordinator and arbitrator of any disagreements or conflicts among client personnel.

Please yourself. Keeping in mind the client's objectives, concentrate on meeting your own high standards. Because creativity is so subjective, it's better not to try to second-guess client likes and dislikes.

Limit choices. Too many creative approaches can be confusing and convey a sense of "It makes no difference to me which you choose." Even if you prepare two or three approaches, it is usually better to initially present only one concept—your recommendation of what works best. Show alternatives only if requested. For logos, marks, identity programs, and packaging, show a progression of many refinements leading up to one recommendation.

Control the presentation. Never present to a group of more than half a dozen if you can help it. Start by summarizing the client's input and objectives. Then explain your work by showing how everything is designed to meet one or more objectives. Involve your audience in a discussion by relating their input to the results. Challenge any changes that would not meet the objectives as effectively; accept any that would.

Keep your eye on the prize. The prize is the compensation (fee) you get for your efforts. Ultimately, what to do and how to do it is the client's choice. If you disagree with what the client wants, express your concerns, but do it willingly. Then smile all the way to the bank. If you disagree strongly, have the courage to resign the assignment.

❁ Coping with Client Incompetence ❁

One of the ugly little secrets of the world of design is that some clients are incompetent. There's no other way to describe certain requests and activities, an inability to make crucial decisions, behavior that's arbitrary and irrational, wasting time and money, constantly dropping the ball. Chances are you've already run into one or two such clients. Chances are even better that you'll run into a few more. As the old saying goes, they come with the territory.

Running any service organization requires occasionally overlooking client inadequacies. You have to grin and bear them, and learn to work around them. If you don't, you risk your paycheck. So learning to cope with client incompetence is essential business insurance. It is also a crucial factor in keeping the morale and enthusiasm that are vital components in maintaining product quality.

PUTTING THINGS IN THE PROPER PERSPECTIVE. There are as many personality types and working styles as there are human beings. Even the most adaptable individuals can't work comfortably with everyone. Some clashes are inevitable.

How often? Anyone running a design organization should be adaptable enough to work productively with 90 percent of clients. If you can't, if you believe that more than one in ten of your clients are incompetent, you should ask yourself why. Is it just a run of bad luck? Have you pursued the wrong ones? Or, perhaps, are you the real source of the problem? You might have picked the wrong business for your personality, be in the wrong role within your business, or be suffering from burnout. (For more on burnout see "The Three Stages of Growth" in chapter 14.)

Different chemistry? Also keep in mind that a problem client may actually be perfectly competent, but have a personality and style that's the opposite of yours. What they view as normal, you view as abnormal, and vice versa. When this is the case, the answer to enjoying a normal client relationship might be as simple as finding someone else to handle the business internally. If that's not possible, it's best to resign their business with no hard feelings.

Clueless or malicious? There's a big difference. Inept and clueless clients are frustrating and waste time. But they're seldom a business threat. Inept and malicious clients, on the other hand, often cause long-term damage. Don't consider all ineptness the same. Be tolerant when dealing with the former; ruthless with the latter.

The Peter Principle (a managerial rule formulated by Laurence J. Peter that states, "In a hierarchy, every employee tends to rise to his level of incompetence"). The types of incompetence outlined below are personality faults, which are addressable. Not covered are individuals whose incompetence is caused by occupying positions beyond their capabilities.

RECOGNIZING THE CHARACTERS. It's easy to see character faults in others, easy to overlook our own. It is also easy to fall into the pop-psychology trap when assessing others. There are, nonetheless, several character types that are not only common among creative-service clients, but that clearly stand out as well. Listed below in order of increasing danger to your business are the five most common. If you haven't experienced one or more of them already, you surely will.

The Nice Persons. They define their jobs not by doing what is right and necessary, but by keeping their co-workers happy. To the Nice Person efficiency and results are always lower in priority than avoiding tough decisions and potential conflicts. More than anything else they want to be liked.

The effects: Trying to please everyone results in an inability to make decisions and causes extra work through multiple changes. Projects fall behind schedule waiting for a consensus. In turn, this often necessitates extraordinary effort by suppliers to get projects back on schedule.

Dealing with it: Stress that with creative efforts it is never possible to please everyone, and that the guaranteed unhappiness caused by higher costs and missed deadlines will be far worse than any possible short-term discomfort caused by taking action. Better to have a little pain now than a lot later.

The Wafflers. These are individuals who can't make up their minds. Because they fear decision making, they've developed procrastination into a high art. They ignore schedules and deadlines. Only the most critical needs ever

get addressed. They can often be found where there is little incentive for action, such as not-for-profit institutions or bureaucratic organizations.

The effects: Delays increase costs, necessitate rescheduling, and increase the chances of mistakes. In addition, the input of the last person talked with often determines the Waffler's current beliefs, so changes are common. Anyone incapable of making big decisions is also likely to overcompensate by focusing on small ones. This is seen in questioning the reasons for project delays and cost overruns after the fact.

Dealing with it: Be aggressive and take charge. Rather than waiting around for action, make some assumptions and proceed. Later, tell the Waffler it was necessary to do so to keep the project on schedule and save money. The client may change what you did, but at least you will have got his or her attention and resolved issues that would otherwise have dragged on.

The Brownies. They always agree with the boss. Most often this is out of a desire for personal advancement. But it is sometimes out of loyalty to the institution and its leader. Whichever, there is little worse than insecure individuals with fierce loyalty and limited perspective. These are company people who have chosen sides. If you're not on theirs, you're in trouble.

ASSESSING CLIENT COMPETENCE

The following are telltale signs of incompetence. Steer clear of a client who exhibits more than two.

• **Doesn't challenge you about your work or capabilities.** It might indicate a Nice Person whose inability to risk an uncomfortable discussion could mean trouble later when you need him or her to make tough decisions.

• **Requires you to make several presentations.** Presentations to several audiences can indicate your primary contact is a Nice Person, a Brownie, or a Waffler. Whichever, they can't make a decision on their own. Except for extensive projects or account shifts, one presentation should be enough.

• **Critiques your portfolio.** Clients should be interested mostly in whom you've worked for and what results you've produced. Be wary when the focus is more on style than substance. You may be interviewing an Expert.

• **Focuses more on how you work than why.** These individuals are probably more interested in hiring a mere doer than a thinker/doer. This is a characteristic of Experts and Dictators who already know exactly what they want; they simply want someone to execute it.

• **Negotiates excessively.** Negotiation should be characterized by a friendly and realistic give and take, not by haggling. Individuals who enjoy this process often have an Expert or Dictator personality, which will probably result in additional challenges later.

• **Requires education.** Anyone who needs to know more about the basics always learns at your expense. It is a characteristic of Nice People, who ask questions out of the need for kinship and of Wafflers, who believe it will help them make decisions.

• **Is in a big hurry.** The rush may be legitimately caused by forces beyond anyone's control. But it may also be caused by Wafflers who waited until the last minute and now expects you to make up for their tardiness.

The effects: The Brownies' fear of making a decision until the boss weighs in causes delays and rescheduling. When they mistakenly predict or interpret what the boss wants, the misdirection requires later redos and changes.

Dealing with it: Look for ways that will make Brownies feel more secure and ingratiate them with the boss. For instance, try to get an early decision from the boss by suggesting that the Brownie point out the potential cost of delays. This will score points. If the Brownie is misinterpreting the boss' desires, ask to be present so that you can help answer any questions the boss has. This would ensure that you produce (under his or her direction, of course) exactly what the boss prefers.

The Experts. They seek an acknowledgment of their training or experience and have strong viewpoints on what is right and what works best. They might have taken courses in art, literature, or advertising 101 and feel especially qualified to critique your efforts. Or they may dictate that you follow a certain approach because they "know what people in our industry will respond to."

The effects: At best, wasted time educating the Expert on what will work and what won't, as well as making numerous refinements to better address their desires. At worst, being forced into a choice of either producing ineffective, substandard work or resigning the business.

Dealing with it: First compliment the Expert: "It's great being able to discuss this with someone who understands (or can offer strong guidance). Not all my clients are so involved." Then try to take the discussion out of the realm of the subjective and into the objective, where results, not taste or opinions, count. Say that both your (considerable) experience and recent developments indicate that the approach you recommend is the most cost-effective. Back it up, if possible, by citing quantitative results doing similar projects for similar clients.

The Dictators. They relish power and its (ab)use. Dictators may be on the way up, trying to build a reputation for toughness, individuals passed over and clinging to the remnants of authority, or bosses who manage through fear and intimidation. In small companies the Dictator is often the owner.

The effects: Whatever your talent and expertise, it is often the Dictators' way or the highway. This is okay if they agree with you, bad if they don't. Everything—creativity to invoices—is likely to be challenged. Subordinates often are afraid to make decisions on their own, so when Dictators are unavailable, you're out of luck.

The only thing that will work is meeting strength with strength. Dictators are often impressed by anyone who will stand up to them, mostly because no one within their organization dares to. Conversely, acquiescing will only make matters worse. Speak up and challenge Dictators.

State where they are wrong. The worst that can happen is losing a client who is otherwise not worth keeping. On the other hand, you may save the business while also making a big impression and getting more business from their employees.

COMMON APPROACHES. As different as each personality is, there are two general approaches to dealing with them.

Addressing their self-interests. In their own ways each of the above is responding to a personal need—to be liked, to be able to make decisions, to conquer insecurity, to be acknowledged, and to exercise power. Recognize these as common human failings. If you wish to continue to work with these client types, you must make an effort to work around their problems, but only up to the point they start to compromise your integrity or the client's respect. If this isn't possible, have the courage to resign the business.

Ruling out an end run. Notice that in none of our suggestions for dealing with these client types is there any mention of going over their heads and appealing to their bosses. The reason is very practical: it seldom works out. This is because the first obligation of supervisors is to support their staff, right or wrong. Even if you were to get a sympathetic ear, chances are nothing would change. When word gets back to incompetents that you tried to do an end run, they will become even more difficult to work with. Unless you have an unusually close relationship with the supervisor, don't even try. Your choices are to learn to deal with it, or to resign the business.

MINIMIZING RISKS. There is no way to eliminate occasionally having to deal with incompetent client personnel. Even when your primary client contact is perfect, there are often others within his or her organization who can make any project trying. There are, however, several ways you can minimize your exposure.

Market continually. A design firm that needs to take any business that comes along will always end up with a disproportionate share of incompetent clients. Not only will these clients have escaped the screening process, but some will probably already have been turned down by competitors. Their wisdom can become your misfortune. The only way to avoid this situation is through proactive marketing—pursuing reputable clients you'd like to work with. (See section 3.)

Consider the organization. There are great and not so great individuals in organizations of every size and type. Nonetheless, the higher professional standards of larger organizations reduce the odds of getting stuck working with a lemon. Keep in mind, too, that some types of organizations tend to attract certain types of personalities: Wafflers to not-for-profits, Experts to engineering and technology firms, Dictators to entrepreneurial enterprises.

Aim high. This may or may not be in your control. But remember: the higher the position of your primary client contact and the better your relationship, the fewer problems you will have with the rest of the staff. This is especially true when you just happen to hit it off with a Dictator.

Learn to say no. Being selective about accepting clients and projects is a measure of a creative firm's maturity. It not only reduces the psychic costs of being in business, but it often has minimal financial cost. Projects that require dealing with incompetent clients are usually less profitable and often take time away from pursuing better projects. As a benchmark, most successful freelancers and multiperson firms alike find themselves declining 10 percent or more of opportunities that come their way because of project or client incompatibilities.

Be firm about unacceptable conditions. Client respect for your talent and time doesn't come automatically. It is something earned through your professionalism, which includes drawing the line where necessary on unacceptable conditions and requests. Wimps not only get no respect, they also get the worse projects.

Listen to your gut. More than anything, your gut will tell you whether or not you can have a comfortable relationship with a client. If it doesn't feel right, have the courage to decline the business, address the problem now, or learn from your mistake by vowing to never again knowingly put yourself in a compromising situation.

WAIT IT OUT? Chances are any individuals who strike you as incompetent have had the same effect on others. If they are in crucial positions (and are not the boss) they will probably be replaced sooner or later. Therefore, when the problem is just one individual in what is otherwise a profitable account, it usually pays to stick it out. Otherwise, you may resign the business only to find the incompetent leaving soon after. Once on the outside, it can be difficult to get back in.

SAY GOODBYE? This is the alternative to waiting out an incompetent's departure. When the situation is truly intolerable and no relief is in sight, it's time to talk about severing your business relationship.

Inform the individual of the problem and say that it has resulted in intolerable working conditions. Be diplomatic and nonjudgmental. Also indicate that part of the problem may be your procedures or working style. But no matter. The client is not benefiting from your expertise, and you're not making any profit. So, unless the client can agree to some changes, it would be better if he or she worked with someone else in the future. Focus on how the changes you suggest will be better for the client—personally, and businesswise.

If the client respects you and is concerned about getting good work, this may be all that is necessary to implement change. On the other hand, if the

client won't recognize the problem, it is likely to be your resignation speech. So, don't make it unless you intend to follow through.

If it ends up being goodbye, be gracious and do all you can to help ease the transition. Thank the client for the opportunity and express regret that it didn't work out. Suggest other individuals or firms who might be able to help. If you are in the midst of a project, offer to turn over the files and provide a discounted invoice for work to date. As difficult as it may be to do this, it will probably be necessary to get any money. It is a small price to pay for getting out of a bad situation. (For more, see "Outgrowing and Resigning" at the end of this chapter.)

⊕ Conflicts of Interest ⊕

One of the differentiating characteristics of a service business is personal relationships. Servicing clients' needs, versus merely selling products, requires a degree of intimacy with their businesses. Whether the project is a one-time shot or part of an ongoing series, it involves listening to objectives, being privy to secrets, then developing unique solutions to address them.

It is only natural in this situation that a client would not want you to be simultaneously talking to competitors, nor to share your talents and skills with them. Yet you have your own somewhat contrary business interests. Excluding potential clients from consideration reduces your creative and financial opportunities, especially if your expertise lies in a specific industry or you are located in a market with limited possibilities. If you limit yourself to only a few clients, your business becomes financially vulnerable if one leaves.

TWO TYPES OF WORK. Broad generalizations are always risky, but the more extensively you work with any client, the greater the possibility of a conflict of interest with a similar client. In addition, the type of work usually determines the extent of client sensitivity.

Project work. This is makes up most of the business of most designer firms. Each assignment stands alone. It may be for a new client or an existing one, but there is no ongoing commitment by either party. With a few notable exceptions, properly separating work for two or more similar clients will avoid any conflicts.

Ongoing commitments. This involves providing services that require insider knowledge of clients, products, and plans, such as much advertising work. Sometimes this is through a formal arrangement (e.g., an agency-of-record agreement); sometimes it is merely implicit. In either case, any work for similar clients or in similar industries will nearly always be a conflict.

DEFINING CONFLICTS. Everyone's definition of conflict is different, and clients certainly have a stricter interpretation than yours. But the following will provide some generally accepted industry guidelines.

In project work. Most project work—brochures, annual reports, individual ads, Web sites, etc.—requires only short-term or superficial knowledge of clients' proprietary information. Further, any potential projects for similar clients are normally separated by a period of time. Thus, what little proprietary information you are given is probably no longer current when you work with a competitive client anyway. So, in most cases there is no real conflict of interest, although there may be a perceived one. For example, it is unlikely that even doing identity programs for two different banks simultaneously would actually compromise the interests of either. On the other hand, designing brochures for two competitive technical products within a few weeks of each other probably would. The same holds true with packaging for competitive brands.

Whatever the actual situation, to be on the safe side Creative Business recommends a separation of a month or more between even the most routine projects for competitive clients. For more important products and very competitive clients, add another month or so. Whenever an

assignment involves acting as a marketing partner or strategic planner or requires proprietary knowledge that is not short-term in nature, use your common sense and look at the situation from the client's perspective. In addition, we believe that it is always best to acknowledge previous work for a similar client. This avoids any perception of a conflict. Although this might occasionally result in losing an assignment, it is usually better to face the possibility now than an angry client later on.

In ongoing commitments. In advertising and public relations work it is impossible for the same account team to be equally enthusiastic and committed to the interests of two competitors. Even in larger firms, where different individuals can be assigned to different accounts, it is nearly impossible to maintain the confidentiality of proprietary information between the two teams and their clients. (In some cases larger agencies have set up separate divisions to avoid this problem.) Because of this real (versus only perceived) conflict, advertising and public relations services should never be provided to more than one competitive client at a time. Typically, this means only one bank, one auto dealer, etc., within a geographic area. For some clients and some situations it can also mean only one industry. Most clients require this assurance in writing. (See

HOW TO GET MORE RESPECT

The type of respect that leads to greater input and higher-paying lobs has to be earned. Here's what clients look for:

APPEAR IN DEMAND. The busier clients believe you are, the more desirable you become, the more they respect your opinions.

LOOK AND ACT THE ROLE. You won't get asked to fly with the eagles unless you look like an eagle. Your style, appearance, office location, and overall sophistication must be appropriate to the client.

RECOGNIZE WHAT THE CLIENT HIRES YOU FOR. It usually isn't your artistic skill. It usually is your ability to produce results, sell more product, change minds, make a significant impact.

EXPRESS INTEREST IN WHAT THE CLIENT IS INTERESTED IN. Their focus is their business, industry and market. Whenever you are with them it should be yours.

TALK THE TALK. Creative talent is not enough. You have to know about marketing or the client's products or industry to have your opinions treated with respect.

BE OPINIONATED, BUT NEVER INFLEXIBLE. State your opinions. Fight for what you think is important. But don't go to the mat over minor details.

TAKE NOTHING PERSONALLY. In business, rejection is not personal, just a statement that what you are offering is not, in the client's opinion, appropriate.

EXHIBIT CONFIDENCE. Confidence begets confidence. Personal mannerisms–hand shakes, eye contact, comfort level, etc. are often as important as what you produce.

BE BUSINESSLIKE. Be on time for appointments, maintain regular office hours, keep clients, well informed.

"Providing assurance" below for wording.) The only regular exception is when agencies continue to place work already created for a previous client while working on creativity for a new client. (Pitching a bigger client when working for a smaller one should be avoided by all but the most experienced firms.)

DEFUSING POSSIBLE PROBLEMS. The most important step in avoiding client problems is recognizing the difference between real and perceived conflicts of interest, then to step gingerly in those areas of possible sensitivity.

When showing your portfolio. There's no reason not to show what you've previously done for a competitive client. Indeed, hiding it could result in problems later on. When showing the work, emphasize the industry (or product) experience it provided. Never denigrate the previous clients or their products. Indicate that you did the best job you could for them, just as you do for every client. If you are asked if you know anything about a competitor's plans, say that you don't, but of course couldn't divulge it even if you did.

When a new client has a problem with your previous clients. Assure your client that you have no ongoing contact, and that your policy is not to talk to a potential competitor during or for at least several months after completing an assignment. Stress that the knowledge and experience you've gained from past relationships will dramatically shorten your learning curve and result in better work at lower cost. Although usually not stated, the implication should be that their competitor actually did them a favor by paying for your education.

When a client makes unrealistic demands. If faced with a client who wants you to agree not to work for any similar companies (example: another noncompetitive bank), say that as much as you would like to agree, you can't. The nature of your business (or your expertise) requires that you work from time to time with similar companies. To turn down this work would not be in your business's best interests. Then say that you are very careful to follow industry standards for accepting such assignments—they must be either not directly competitive or well separated by time.

When developing creative for a similar client. Be especially careful that whatever work you produce is totally different from anything done for the client's competitor. This may sound like common sense, but it is an easy mistake to make. Many of us have a trademark style we're so used to that we're no longer aware of it. Work produced for competitive clients that is even remotely similar in approach, style, or content will bring howls of protest from both sides. To play it safe, get someone else to view your creative for possible similarities before showing it.

PROVIDING ASSURANCE. Regardless of whether there is a real conflict of interest or just the possibility of client concern, it is wise to address it formally. We suggest putting the following or its equivalent in every agency-of-record agreement or proposal for a stand-alone project:

"As an independent contractor, we agree to devote our best efforts to producing cost-effective (advertising) (a brochure) for (company) (product). We further agree not to act in this capacity for any company, products, or services that are directly competitive without your consent for (the period of this assignment) (____ month[s] from the date of assignment completion)."

WHAT ABOUT NONDISCLOSURE AGREEMENTS? Nondisclosure agreements are usually required by clients who have assignments involving proprietary technologies or significant new products. They typically hold suppliers responsible for safeguarding information that is entrusted to them and require that any information disclosed in the course of a relationship be treated confidentially.

Although often disconcerting in wording and implication, there is seldom any reason not to sign a nondisclosure agreement. Moreover, it is necessary to obtain certain types of assignments. There is one caution, however: If valuable client material is entrusted to your care, check with your insurance agent about your insurance and possibly adding bailee's coverage, which is expensive additional protection covering the loss of materials in your possession. The premiums, often several hundred dollars for even moderate coverage, should then be factored into your fees. (For insurance recommendations, see chapter 3.) (A nondisclosure contract is shown in chapter 11.)

WHAT ABOUT WORKING WITH OTHER CREATIVES? A freelancer who occasionally works for your competitors should not be a problem as long as he or she has not recently worked on assignments for clients who compete. The issue here is usually not conflict of interest, but personal comfort level. Don't let your sense of pride and ego stand in the way of a rational business decision. Work with the best outside suppliers you can find, regardless of who else they occasionally work with.

❧ How Many Concepts? ❧

Let's say a new client has given you a job and you've promised to show them three different approaches or concepts. When you make the presentation they dismiss one concept, but love the other two. In fact, they love them so much they decide that they want to use both—one for the present assignment, one for another job that will come along later. Do you charge them for the second concept, and if so, how much? Or have they already paid for it as part of the three concepts you previously agreed to provide?

WHAT DO CLIENTS PAY FOR? Most business disputes are the result of a basic misunderstanding between two parties, usually buyer and seller. This particular situation—what is the client entitled to?—is ripe for misunderstanding because both parties look at it from different angles.

Your viewpoint. Your business's products are ideas and their execution. They are all you have to sell, and there are an infinite number of ideas for solving communications problems. Thus, the creative process involves trying out many to come up with a few that work effectively. Those that don't work—discards in various degrees of refinement—are thrown back, saved for another day, another situation. Determining the right idea for a particular situation is also highly subjective, so by comping up more than one idea you please the client by offering choices. It also relieves you of whatever discomfort you may feel in making a single recommendation. Nonetheless, your assumption is that the client is only paying for one idea and all the others will be considered discards.

Their viewpoint. They've given you a project, one aspect of which is to provide three concepts. Since only one concept is normally used, they expect that the other two will be for naught—simply tossed away. At the same time, they believe they have bought and paid for all three. Rather than waste one, they tell you they have found a good use for it. What's your problem? There's nothing in your proposal or estimate about purchasing only one concept. Besides, you have already developed the three, and they aren't asking you to do anymore work than you've previously agreed to.

Trade practices. Clients pay creative vendors to produce an item—an advertisement, brochure, mailer, etc. Ethically and probably legally (the circumstances may make a difference), the vendor is under no obligation to provide any of the intermediary work or tools. This includes thumbnails, sketches, concepts, layouts, artwork, computer files, films, etc. Think of it this way: Whatever the type of job, the assignment is to provide a finished product. The vendor gets to dispose of all prototypes in the manner he or she feels is most suitable.

AVOIDING THE PROBLEM. But, by taking a hard line you may win a battle but still lose the war if you anger the client and jeopardize future business. With this in mind, consider these suggestions.

Be sure to put it in your proposals. Insert the following or a similar paragraph under the heading "Ownership" in all your proposals and estimates:

"All materials used in the production of this project—including original and reproduction artwork and computer generated instructions, formats, and files—remain the property of (your firm). All ideas, sketches and concepts remain the property of (your firm) and may be used in the future at our discretion."

Limit what you show. As important as it is to put the above words in your proposals, recognize that many clients won't read them, and if you ever need to call a client's attention to them, you face a potentially delicate situation. The best solution is not to put yourself in this situation in the first place. Despite your intuition and training, and however many concepts you actually prepare, our experience is that it is usually best to start out by showing only one, not several.

Begin your creative presentations by first going over the client's communications objectives in detail. Then comment on how you've examined several alternative directions. Without showing anything, briefly explain each of them. Finally, bring out one concept as your recommendation: "After much consideration and trial and error, this is the approach that I believe will work best in your specific situation." Explain enthusiastically and in as much detail as necessary how it meets each of the client's objectives. Romance it. Don't volunteer to show other concepts unless the client has a problem with your recommendation or specifically asks to see others. To further stack the deck for your recommendation, any other concepts you show should be more conceptual, less polished. (Exception: for some types of assignments, particularly identity or package design work, it is probably better to show the entire evolution of an idea—all the roughs leading up to your recommendation.)

Limiting the number of concepts you show will minimize the possibility of clients wanting to use more than one. In addition, offering several choices can confuse some clients and often leads to "cherry picking"—selecting elements from each concept and asking that they all be combined in a new effort.

What if a client wants more options? If a client specifically asks you to "bring back several approaches" when giving you the assignment, say that you will, of course, develop several but that you'd prefer to first show the one you believe will best meet their needs. After that, you would be happy to show other alternatives if necessary.

HANDLING THE PROBLEM. But now let's get back to the situation at hand. For whatever reason, you have a client who has seen several concepts and now wants more than the single one you believe was included in the agreement. What do you say?

Develop a rationale. Try not to get into a discussion of what the client should or should not be entitled to, or industry practices. Instead, explain the creative development process and how it benefits every one of your clients. Indicate that when you work on a project you actually come up with dozens of ideas and creative approaches. Some are just thoughts, some end up as rough sketches, and some are more fully developed as concepts. Although only one of the many ideas and approaches you consider usual-

ly makes it into the finished piece, none is ever discarded. All are remembered, act as future idea starters, or are saved in some form for possible recycling.

Indeed, many of your ideas, usually modified and developed more fully, are later used in other projects. This process—i.e., constantly generating, but never discarding ideas—benefits all clients and every project. It ensures a higher level of creativity, and it reduces creative costs. Constantly looking for and trying out new ideas and approaches stretches your brain and allows you to come up with great concepts quickly. And quicker is cheaper.

In short, the brainstorming and exploration you've done for others in the past benefits clients today. Future clients will benefit from the brainstorming you do while working on present projects.

Offer an alternative. Tell the client that in addition to handling complete projects, you provide à la carte concepts and ideas to some clients. If they wish, you can treat the additional concept(s) as a separate job.

"Since ideas are my stock in trade, I'm afraid I can't provide you with more than one concept for the estimate I gave. However, given (how well the project has gone so far… our past relationship, etc.), providing the other concept you liked wouldn't be a very large additional charge" (See "So what's a fair charge?" below.)

Don't shoot yourself in the foot. While the above makes sense for most projects and clients, occasionally it doesn't. When a good client asks for a second concept it is often better to acquiesce. At the same time the client should recognize that you are making an exception from your and the industry's normal practices. Here's what to say in this situation: "Your request is a little unusual because, as I'm sure you know, normally only one accepted idea or concept is included in each project. However, given (our past relationship… how easy you have been to work with, etc.), I'm sure I could make an exception for you in this particular case."

In other words, give them what they are asking for. But do so in a way that further enhances your relationship. When you send your invoice, make sure that any extra concepts are listed as separate, "no charge" line items.

SO WHAT'S A FAIR CHARGE? Depending on how important the concept is to the impact of this type of project (concepts can make or break an ad but are often a minor element in a capability brochure), Creative Business recommends that additional concepts be priced at 50 to 100 percent of the first one. (As a guideline, phase one of an estimate, the developmental phase, is usually considered the conceptual part of a project.) An additional fee should be charged for any time spent in refining or polishing the additional concepts.

⊛ Give Up Computer Files? ⊛

Clients asking for computer (job) files is one of the most common situations faced by today's design firms. Should you give them up? Do you have to? How should you respond to a client's request?

THE LEGAL ISSUES. It is the commercial norm that the tools used to produce work remain the property of the producer unless sold separately. Put simply, customers purchase an end product, not the means by which it was produced. By and large, the courts have held that films, printing plates, artwork, computer files, etc., are considered tools of production. Thus, a customer purchasing a print from a photographer is not automatically entitled to the negative. When customers purchase printed material from a printer, they are not normally entitled to the films or plates used in manufacture. In the days when design was done on paper, mechanical art was not normally included in the purchase. Today, computer files are considered tools of production and are not normally included in a client's purchase. That is, they remain the legal property of the creative firm.

This said, it should be noted that legal precedents are constantly challenged and evolve as new situations arise. It could be argued, for example, that under certain conditions preparatory materials do rightfully belong to the client, and to withhold them may reduce a client's commercial options and is, therefore, restraint of trade. Or that a purchaser has ownership rights to anything specifically identified in an invoice. Or, in the case of an electronic end product (e.g., Web projects), they are not really preparatory material at all, but the actual product itself.

THE BUSINESS ISSUES. Whatever the legal situation, the reality is that most clients believe that they own "their" computer files. In their minds it is nothing less than work they have paid for and have legitimate rights to. If they want them, they expect you to deliver them. Another reality is that many clients have legal staff that may threaten to sue to obtain the files. Even in the likely event you'd win in court, the cost of defending your position could make it an expensive victory.

Given these realities, Creative Business strongly recommends preventive action; specifically, that every proposal or estimate contain the following paragraph or its equivalent, and that it be signed by the client:

"This proposal is for the purchase of one creative approach (concept) to be selected by (client) and executed by (design firm). All other ideas, concepts, or designs described or exhibited remain the property of (design firm). All materials used in the execution of this project—including artwork and computer-generated instructions and formats—remain the property of (design firm)."

Such provisions answer the questions of many clients before they're asked. For others, they'll provide a basis upon which to transfer ownership. They will provide protection against unwarranted lawsuits. In addition to the above proposal language, we also recommend that you contact every service bureau, printer, or Web developer you work with and have them agree, in writing if warranted, that your electronic files will never be copied or provided to anyone without your written permission.

WHAT SHOULD NEVER BE PROVIDED. Regardless of your desire to cooperate with a client, the following should never be provided because to do so might make you party to copyright infringement:

Type fonts and applications programs (software)—in most cases your usage licenses are nontransferrable. Clients must buy their own.

Photos and illustrations—permission for additional reproduction or modification must be obtained from the copyright owner.

WHEN AND HOW TO SAY "NO PROBLEM." It should be common sense not to debate ownership with good, ongoing clients. In most cases, provide the requested files with a smile and without charge. Any future loss of revenue from revisions, printing, etc., will more than likely be made up by the additional business that comes from goodwill. Consider any small cost incurred as an account service expense.

It is wise, however, to discuss with the client the possible ramifications of trying to work with your files, especially if they are relatively unskilled. You don't want a good relationship to be endangered should problems arise later. It's also usually good business to give up a file when a steady client wants a part of it for a job you aren't directly involved with, such as asking for a graphic you've developed to use on their Web site. In cases involving substantial time (e.g., cleaning up and copying a complicated file) you might want to levy a service and media charge. You might also want to bill for any substantial problem-solving time that the client requires later.

WHEN AND HOW TO SAY "MAYBE." Not every ongoing client provides the experiences or volume that make favors appropriate. Others are one-time (no opportunity) clients. In these cases cooperate, but not at your expense. Treat requests for your electronic files on this basis: "We don't normally do this, but I don't see why we can't make an exception in your case. There will, however, be a charge for the time involved as well as the media." (See "How to set a price" below.) The reason for the service charge? Accessing the files, stripping out proprietary data, and cleaning them for easy use by others involve more than simple copying.

If a client you'd like to keep asks for the files to economize on future work (taking the project in-house, for example), also inform them of the

trade-offs in doing so. You created the files around your own idiosyncrasies and procedures, so the more complex they are, the less likely it is that the client will be able to work with them as efficiently as you can. Plus, you'll also have to charge if the client needs help sorting things out and for correcting any future mistakes. They might also have to purchase fonts or even software. When all this is added up—the service charge, reduced efficiency, software costs, and possible future help—it might turn out to be wiser to keep you doing the work.

WHEN AND HOW TO SAY "NO WAY." When dealing with clients with whom you'll never work again, it is still important to handle every inquiry diplomatically. A well-reasoned explanation why you can't provide files is far less likely to provoke an angry client reaction, or end up in a costly legal wrangle. Here's what to say:

"Our files contain proprietary information. Working out creative solutions, then laboriously preparing grids, templates, and style sheets, is challenging, detailed, and complex work. It involves many proprietary 'tricks of the trade,' combinations of talent, training, and experience that lead to fast and efficient ways of working. Because we are a service business, these procedures are our company's competitive edge. They are not only part of what makes us unique, they are also an integral part of every job. To allow them to fall into the hands of others is to risk losing the very secrets upon which the success of our business has been built. As much as I'd like to cooperate, I'm afraid I can't."

NEVER SAY "I'LL LOSE MONEY." When producing items with a long life, you may be in the habit of charging less than you should, relying instead on repeat business for profits. Similarly, you might be in the habit of charging proportionately more for work on the back end of a project (e.g., printing) than on the front end. The rationale in the first situation is that low-balling the price the first time around allows you to be more competitive. In the second situation, it is usually because it takes more skill to justify the high cost of mostly intangible creative work than it does more tangible items such as printing. In both situations the expectation is that you will make up on the back end what you feel uncomfortable charging for on the front end.

These pricing practices are increasingly outdated and problematic. Today, more and more clients expect the flexibility of shopping around for follow-up revisions and reprints. Others want to hire an individual or firm for creative input while bringing production work in-house or giving it to someone with lower prices. For these reasons, it is increasingly important that pricing procedures be uniform. The hourly rate for most clients and functions should be the same. Job pricing should be based on estimated hours worked times hourly labor rate. By adhering to this procedure, most

work—big job or small—will be more or less equally profitable. Plus, there will be one less reason not to give up your electronic files willingly.

NEVER SAY "YOU'LL MESS IT UP." No, you probably wouldn't come right out and say this, but you may be thinking it. Is your ego overruling business sense? Your name probably doesn't appear on the piece, so what difference does it make? What if they botch things up, then call you to fix them? Treat it as a separate project. Charge on your normal hourly basis, and count every minute. When only a small amount of work is involved you may also want to consider a minimum fee (typically, a half day's work).

HOW TO SET A PRICE. There are two ways to set prices for giving up your computer files, depending on your willingness and feeling toward the client.

Your conversion time and costs. The file(s) will have to be located, reviewed, cleaned and/or modified, isolated, and copied. This will involve several hours of labor. In addition, there's the cost of the media. Set a minimum fee, rounding up the hours to the next half day.

The value to the client. How much a client is willing to pay for electronic files depends on how much it will cost to recreate them from scratch. Your service fee should probably not exceed 25 to 50 percent of the original creative fee. If it is more, chances are the client will go elsewhere.

⊛ Danger Signs ⊛

Learning to recognize problem-prone situations can mean the difference between having satisfying client relationships and profitable workflows, or neither. Here are a few of the more common situations that arise when working with clients and how to deal with them.

"WE'D LIKE YOUR ESTIMATE ON (A HUGE) PROJECT." *Situation:* A client calls about a project that's so large it is hard to consider all its aspects, and some aspects are only loosely defined. How can you price it realistically without taking a huge risk? *Reality:* You should never estimate a price on something that can't be defined. On very large projects even a rough estimate is risky because conditions nearly always change. The only fair way to price this type of assignment is to break it into chunks and price one chunk at a time as you go along. *Answer:* "Given the scope of this project, it's impossible for me to give you a realistic price for the whole thing right now. I suggest we break the project into three phases. I'll give you an estimate on the first phase now. Then, as the first phase unfolds, I'll be able to see how

much work is really involved and provide you with a reasonably accurate estimate on the second phase, and so on."

"REDUCE YOUR FEES NOW AND YOU'LL GET ALL OUR WORK LATER ON."
Situation: A cash-poor company asks you to work for lesser fees now on the promise of getting all their work later, when their company will be much larger and more prosperous. *Reality:* Most companies that ask you to work now for future payoff won't be around in the future. Even among those that are, personnel and business changes will make this promise an easy one to forget. *Answer:* "As much as I would like to, I'm afraid I can't. Our fees are based on our actual costs and a small profit, and there just isn't any room for reduction. In a business like ours, we have to watch our margins very carefully. If we didn't, we wouldn't be around in the future, and that wouldn't be good for either you or us."

"WE'LL TRADE: OUR MERCHANDISE OR STOCK, YOUR TALENT." See "Noncash Compensation" in chapter 12.

"PLEASE GIVE US YOUR NOT-FOR-PROFIT DISCOUNT." See "Give a Break to Not-for-Profits?" in chapter 12.

"JUST COPY THIS. IT'S EXACTLY WHAT I'D LIKE." *Situation:* A client hands you a copy of a brochure (or any other item) and asks you to produce something just like it. Their motivation could be honest admiration, or they may see it as a way of saving on creative time and money. *Reality:* A client has the right to ask for, indeed demand, anything. On the other hand, your obligation as a professional is to recommend what you believe works best. Respond as follows, knowing that if the client still insists on doing it his way, you'll be fulfilling the function of low-value doer, not a value-added thinker. Drop the client after this assignment. *Answer:* "My experience is that what works well in one situation (or for one product or company) almost never works equally well in another. Given your unique objectives, product features, and customer benefits, I know I can produce something different and even more effective than this."

"IT'S UP TO YOU. WE DON'T KNOW WHAT'S APPROPRIATE." *Situation:* This, the opposite of the situation above, may sound ideal. Carte blanche. But it usually isn't. Good results require a client to first define assignment parameters—objectives, formats, budgets, etc.—then allow you the freedom to provide the best solution. *Reality:* Clients who give little or no direction are usually as big a problem as those who give too much. It just comes later in the process—after you develop concepts that turn out not to be what they really had in mind. *Answer:* "Let me ask you a few questions about what you're trying to achieve. Then, I'd like to show you some

examples of work we've done for our other clients. You can tell me which come closest to what you feel would be best for you."

"WE'LL NEED TO CUT A FEW CORNERS ON THIS JOB." *Situation:* The client has a budget or deadline crunch. But they still need the job. So they ask you to sacrifice creativity and quality to do something of a "down and dirty" job. *Reality:* Here again, the client is the boss. But before you take on this assignment, remember this: the bad taste of poor quality will linger long after the temporary pleasures of fast and cheap have been forgotten. Is the money from this "one-time stand" worth the potential risk to your reputation? *Answer:* "Actually I'm afraid it isn't that simple. Our shop procedures can't really be changed for just one job. It also doesn't take us any less time to come up with a bad concept than a good one. I can, however, promise that we'll do the job as efficiently as possible, and we'll make sure we don't add any extra frills or embellishments."

"WE'D LIKE TO SEE SEVERAL DIFFERENT CONCEPTS." *Situation:* The client wants you to develop several concepts from which to choose one. *Reality:* Concepts shouldn't be thought of as a bunch of bananas from which customers get to pick the tastiest. Rather, good concepts should be thought of as a marriage of original thinking and strategic planning. There are usually only a couple good solutions to any creative problem. And working them through takes time and effort. *Answer:* "I will, of course, be considering many different approaches. But my experience is that there are usually only a couple that stand the test of being truly innovative, strategically sound, and financially practical. To keep within your budget I can only develop the best one (or two) of these. If it turns out not to be appropriate I'll still be able to go back and develop some of my other ideas quickly. This way you don't have to pay for a lot of wasted effort."

"LET'S USE ONE OF YOUR CONCEPTS FROM LAST TIME." *Situation:* The new job is similar to one done before. So the client asks to use one of concepts you developed last time but didn't use. After all, they reason, they paid for all those concepts. So why not save a little time and money on this new job? *Reality:* This is one of the risks of showing multiple concepts when dealing with ongoing types of projects (e.g., annual reports, ads, etc.). Using a previous concept reduces both your creative stimulation and profit potential. Furthermore, the previous concepts, developed under different objectives, probably aren't equally appropriate in the new situation. *Answer:* "Unfortunately, I never keep files or copies of concepts that end up not being used. I used to do this and it just got too complicated. I'm sure I can recreate a concept based on a certain idea, but I'm afraid that there won't be much, if any, cost savings. It's probably

better to start from scratch." (Also see "How Many Concepts?" earlier in this chapter.)

"TO SPEED THINGS UP, I'LL WORK ALONG SIDE YOU." *Situation:* It's a detail-intensive rush job. Rather than waiting to see what you come up with, the client suggests that they come to your office and work with you. Having them right there will eliminate the need for later changes and revisions. *Reality:* Ever try working with someone peering over your shoulder? It seldom works because most of us can't create under this type of pressure. In addition, your working style and environment may not be something you want to share with the client. *Answer:* "It sounds good, but I'm afraid it wouldn't work because of the way we operate. We usually find that coming up with an idea takes a lot of 'blue skying,' some of which we do at odd hours. Soon after we come up with an idea, we need to do the rough concepting in somewhat of a hurry, without interruption, before we lose it. Then we put everything aside for awhile before going back to refine it. Unfortunately, this isn't a process that lends itself to sharing, as much as I'd like to."

"DON'T WORRY ABOUT THE PAPERWORK." *Situation:* It's a rush job, needed yesterday. The client doesn't have time to get a purchase order through the system, sign off on changes, or read proofs later on. But not to worry, the individual is willing to take "full responsibility." *Reality:* Let's hope there are no problems because "full responsibility" is probably meaningless. Without official authorization (purchase order, letter of agreement, etc.) an organization may disavow responsibility for the actions of its employees. Should there be a costly error, you may just find yourself abandoned by someone who turns out to have neither the resources nor the backbone to take responsibility. *Answer:* "I need something in writing. This is a huge risk for us to take otherwise. If, God forbid, you got run over by a truck on the way to work tomorrow morning, we'd be left with absolutely no proof of authorization."

"DO WHATEVER YOU HAVE TO DO TO GET IT DONE ON TIME." *Situation:* The client agrees on a price, but then there are lots of changes, the job drags on and costs escalate. Before you know it, the job is well over budget. But the client is happy and says not to worry and do what you have to do to meet the delivery date. *Reality:* Long after this conversation and the job is delivered, the bill will arrive. The client may go into sticker shock because the extent of the overage was unclear, and may even ask for an adjustment. Taking preemptive action often avoids this situation. *Answer:* "To continue I'll need a new purchase order or a letter from you authorizing the additional costs. This way you'll be sure to budget the correct amount, and I'll know not to exceed the new number."

"THE BOSS CAN'T MAKE IT, BUT LET'S GO AHEAD ANYWAY." *Situation:* It's a big assignment and this is the crucial, objective-setting meeting. But the boss, the approver and check signer, suddenly gets called out of town and can't attend. What should be your reaction? *Reality:* It all depends on how much responsibility the boss delegates, but if you don't know, play it safe. Postpone the meeting. Otherwise, you'll probably find yourself proceeding based on direction that later gets changed. *Answer:* "Given the importance of this assignment we'd like to postpone the meeting until (name) gets back. If we can set up something by next week, we'll be able to make up the time without any problem."

"I CAN'T MAKE IT. SO GO AHEAD WITHOUT ME." *Situation:* You have a crucial input meeting with client personnel. But your client contact, who is scheduled to attend with you, calls and says she can't make it. So you're on your own. *Reality:* The contact should be there to introduce you, act as an information filter, and provide clues on the pecking order of individuals (whom to listen to). Without guidance, you may come back with input that puts you on the wrong strategic and creative track. Try to explain this. If your contact still can't make it, prepare to do a little homework. *Answer:* "I understand and I'm disappointed. Given the meeting's importance, when I get back I'll prepare an executive brief (summary) of what was covered and in what direction it will take me. This way you can correct any misinformation I obtained before I start working on the project."

"I'D LIKE TO GET A FEW OTHER OPINIONS." *Situation:* The individual to whom you show a concept, or with whom you discuss an idea, wants to gets opinions from others: a boss, subordinates, spouse, or even friends. *Reality:* Requests like this usually show a misunderstanding of creative contributions. Usually implicit is that you are interested only in design, and that your sole role is to dress up material, not to add substance or value to it. *Answer:* "Our experience is that soliciting the opinions of others isn't usually appropriate unless they have been equally involved in the project. It really isn't fair to put them on the spot unless they have full knowledge of all you and I have already been through. With all due respect, uninformed opinions usually just muddy the water."

"WE'D LIKE YOU TO REDO WHAT WE ALREADY HAVE." *Situation:* Being asked to redo another's effort is not unusual. Sometimes it is to save money; sometimes to fix what has been screwed up; sometimes because clients think only they have the knowledge required. *Reality:* Here also, these requests usually show a misunderstanding of creative contributions; that you are interested only in design, and that your sole role is to dress up material. *Answer:* "Our experience is that the only way we can give our clients the creative impact they need is to start projects from scratch. This

not only allows us to approach the project from a fresh perspective, but it also ensures that you get the full value of our objectivity. Doing it that way doesn't cost that much more, but it adds tremendously to the value we deliver."

❂ Surveying Client Happiness ❂

Service businesses have a concern that those selling products don't usually have: getting a good read on customer satisfaction. Businesses that sell products quickly see from cash receipts how well they have met customer expectations. Sales soar for well-liked, appropriately priced products; they sag for less-liked, too-expensive ones. The relationship between a sale and meeting customer needs is less direct for service businesses. Except in cases of major dissatisfaction, a sale still takes place. But what may not happen is a repeat sale, or the opportunity to be considered for better projects.

Of course, any successful service business develops a good feel for customer contentment. But it alone may not be enough; sometimes what you don't pick up on can also be important. The very process of being direct—asking—often has benefits of its own.

WHEN ASKING MAKES MOST SENSE. Small creative firms working directly with senior client personnel probably won't find out anything they don't already know. When relationships are close—you working directly with individuals with overall responsibility—there's little benefit. The very process of formally asking may seem to the client to be overkill. More often, however, especially in larger client organizations, projects are the responsibility of mid-level personnel, and your staff, not you personally, may be mostly involved. In these situations an inquiry into client satisfaction is informative and appreciated.

The bigger your company and the bigger theirs, the more important asking is. Put another way, the farther removed project responsibility is from both client and creative firm management, the more fruitful it is to inquire. There's little worse than you not knowing what's really going on or a client feeling taken for granted. There's also another promotional consideration: differentiating your services. Surveying client happiness is a way to set your firm apart. It is especially effective in industries where there is a lot of similar creative competition. (Surveys of client happiness with your competitors—i.e., those having the aim of soliciting new business—are different in nature and shouldn't be confused with surveys of your own clients.)

HOW WELL DID WE MEET YOUR NEEDS?

Dear Client:

Occasionally we poll our clients regarding the quality of our services. Client selection is random, and because we mail to several clients simultaneously, answering can be anonymous if preferred.

We do this because we recognize that our clients have a choice of suppliers, many of whom offer services of similar quality. What has always set us apart, and where our surveys come in, is our unusual ability to listen and adjust to our clients' needs, and by doing so provide the best value in the (city) area.

To help keep us on our toes, we need to know how successful, or not, our recent work for you was. We also need to know if things went as you expected, or didn't. Of course, you can always tell us directly, face-to-face. But sometimes it takes a while before you know. Or you would prefer to report anonymously. Our surveys provide this opportunity.

So I would like to ask you to take a moment, check off the appropriate answers, then mail the survey back to me. A postpaid envelope is supplied—not only to make things easier, but also if you wish to keep your comments anonymous. (If anonymity is not a concern, feel free to provide your name along with any specific comments.)

Thank you again for working with us in the past. I hope we will have the opportunity to serve you again in the future. If I can be of any specific service, don't hesitate to call me directly.

Sincerely,

I. M. Smart
Principal

1

SMART DESIGN
CLIENT SATISFACTION SURVEY

1. How well have we presented all our capabilities and services to you?
 ☐ Very ☐ Moderately ☐ Not well ☐ Poorly

2. How important has our experience been in deciding to work with us?
 ☐ Very ☐ Moderately ☐ Little ☐ Not important

3. How important has our style/creativity been in deciding to work with us?
 ☐ Very ☐ Moderately ☐ Little ☐ Not important

4. How knowledgeable and professional have you found our staff?
 ☐ Very ☐ Moderately ☐ Not very ☐ Poor

5. How well have we helped you define the objectives of your project(s)?
 ☐ Very ☐ Moderately ☐ Not well ☐ Poorly

6. How well have we met the objectives you set for what we've handled?
 ☐ Very ☐ Moderately ☐ Not well ☐ Poorly

7. How efficiently did we handle scheduling and production?
 ☐ Very ☐ Moderately ☐ Not well ☐ Poorly

8. How have you found the value (price÷results) of our services?
 ☐ Very ☐ Average ☐ Acceptable ☐ Poor

9. Overall, how do we rate compared to your experience with similar firms?
 ☐ N/A ☐ High ☐ Acceptable ☐ Low

Any comments? _____

2

Sample client survey.

THE APPROACHES. The way to ask depends on relationships and what you hope to learn. Inquiries about the overall satisfaction of ongoing clients are usually best handled in one-on-one reviews; those regarding specific jobs usually best handled impersonally with survey forms.

One-on-one reviews. It is easy to keep abreast of day-to-day and job-to-job satisfaction for clients who provide a continuous stream of work. But maintaining strong and intimate relationships over time usually requires something more. It usually also requires a means of staying sensitive to overall satisfaction. Not to keep tabs on it is to risk being blindsided by concerns that may ultimately lead to sudden client departure.

The key to maintaining sensitivity to issues that are not readily apparent is to have an annual (or more often, if warranted) review of your firm's performance by your clients. The objective is to further reinforce the idea that they are special, and that their concerns warrant special consideration. We suggest doing this at an occasional one-on-one lunch, the creative firm principle hosting the key client individual in surroundings conducive to discussion and befitting the client's importance. Doing this

on the "boss-to-boss" level helps keep the focus on the big picture, not details, while the social environment helps keep everything productively informal and cordial.

Informal should not mean unprepared, however. Have a loose agenda in mind: areas of potential improvement; things that might make working together more efficient; capabilities the client may not be aware of; possible opportunities of mutual benefit. As a way of preparing the client and making the meeting more significant, outline your talking points in a letter similar to the one opposite.

Whatever the agenda, keep it simple enough to discuss easily in a couple of hours. Let the client direct pacing and adjust content. Keep in mind that just having such occasional "summit meetings" is as important as what you get out of them. (The medium is also the message.)

Mail surveys. This is usually the most efficient means of getting a read on the satisfaction of occasional clients. It is also impressive to the client because it creates the sense not just that your firm cares, but that caring is routine. It is not unique to the client or a particular project, but rather is representative of a way of doing business.

Once or twice a year send a survey form to your contact persons at selected clients. Skip around. Try to cover every client at least once, but only mail to any given client once every two years or so. (Any new client should be covered in the next mailing.) Even though you will probably be able to determine the identity of those who respond, treat it as an anonymous client polling.

The questions asked should, of course, be specific to your firm and interests. There are, nonetheless, a few general rules that will make the survey more impressive and add to its usefulness: It should come from the creative firm principal; it should go to the contact person at the client, not his or her boss (to provide a sense of empowerment); it should be no longer than two pages; questions should focus on how well expectations and business objectives were met; questions should be industry-specific if you specialize; questions should be short, direct, and mostly answerable with a pen stroke (little writing needed); a postpaid envelope should be provided for return.

Telephone surveys. They can be particularly impressive, assuming that they are conducted by professional researchers. But this also makes them expensive.

Fax surveys. They are an annoyance to some clients and offer little in the way of benefits.

Web surveys (e-mail). They don't, at present anyway, carry the same weight as mail surveys, although they are easier for a client to respond to.

WHAT TO EXPECT. Not a lot. But, then, don't let this be your criterion. Again, it is the act, not necessarily the result, that's important. The very process of conducting a survey forces you to think about what's crucial to your clients and your business and perhaps even to sit down to discuss it. The response to most surveys is poor—feel lucky if one in five is returned. Take whatever results you get with a grain of salt. Responses usually have a positive bias because of the human tendency to want to avoid being critical, especially well after the fact. Happy clients are also much more likely to respond than unhappy ones. (Unless a client is really upset, in which case the response may be much more negative than is actually warranted.)

One-on-one meetings can be more instructive, but only if you learn to read between the lines. Here, too, it can be difficult for clients to be totally honest. They may be reluctant to mention certain issues, feel that they can't adequately articulate their feelings, simply want to keep their feelings private, or praise your work as a way of making you feel good.

However the results are obtained, asking clients about their satisfaction probably won't provide anything other than early warning signals. Indeed, it is not unheard of for a client to dump a supplier when all signs are positive. Politics, business directions, and personal feelings can all change in a heartbeat. Finally, testimonials from past clients are a good way of impressing future ones, and surveys are a good way to get them. This alone can make the effort worthwhile.

⊛ Outgrowing and Resigning ⊛

The client you once pitched so hard, the one with the big plans and bigger budgets, turns out to be a nit-picking, nickel-pinching client from hell. How do you get out of this situation and cut your losses without losing your shirt? Or maybe you have the little-client-from-heaven dilemma. They are the exact opposite—wonderful people who were much appreciated back when times weren't so good. But that was then. Now their small assignments and excessive service have become a financial and creative sink hole. How do you get out of this situation, cut them loose, without losing sleep over it?

Whenever you have one of these or similar situations it is time to drop the client, and to convince them while doing so that it will be beneficial to them.

SITUATION 1: BAD CLIENT, BAD BUSINESS. This usually involves clients who agree to project schedules, then later ignore them. Typically, well into the job information is still missing; there have been too many meetings; they are very difficult to deal with; and they may be unhappy with what

you've done. In short, there's lots more work to do, but no way you can cover it within your estimate.

Face it early. Inform clients of the problem as soon as you realize its extent. Go over the proposal to reacquaint them with what was supposed to happen and how it formed the basis for your pricing. Then summarize what actually happened and what changes are necessary to get the project back on track. Prepare a new estimate showing how much more time and money it will take. Offer two options. Option 1 is to continue on the new schedule and estimate. Option 2 is for you to bow out now, which will allow them to hire someone else before the project has gone beyond the point of no return. Tell them that in the absence of agreed upon changes, it is in their best interests to replace you.

Eat a little crow. Take responsibility for most of the problem. Say that your concern now is ensuring that they still get what they need, on their schedule. If necessary you'll help find your replacement and happily turn over all your work-in-progress. As painful as this may be, it will greatly enhance your chances of getting paid.

Give a discounted invoice. Now explain that given the unfortunate way the project turned out, you will only be invoicing for half of the time you actually put into it. (Of course, only you know how much this was.) Thank them for the opportunity and apologize again for the way things turned out. If they object to paying, stress their legal obligation and your intention to seek counsel if necessary. Compromising on price is probably a small price to pay for getting out of a worsening situation.

SITUATION 2: GOOD CLIENT, BAD BUSINESS. This usually involves long-term, loyal clients whom you've outgrown. There is little financial risk in dropping them (the risk is doing nothing), but you should be concerned about handling it right.

Don't feel guilty. You shouldn't try to be all things to all clients. The key to long-term business prosperity is matching your expertise (talents) as closely as possible to the needs of specific types of clients. While good relationships are an important component of satisfaction, most client work must remain profitable. You shouldn't continue to handle it when it isn't.

Make it a benefit. The best time to cut a loyal client loose is soon after completing a job, and over a relaxed lunch. Say that when reviewing the last job you became concerned that the client is no longer getting the service you used to give, or is paying a lot for what they do get. The situation will probably get worse in the future as you continue to grow. Say that as much as you hate to acknowledge it, the client is paying a price for your firm's growth—either in poorer service or higher costs.

Ease the transition. Now say that honesty compels you to admit that it would probably be better if the client worked with someone else in the future, someone who can give the personal service and low prices you used to provide. You know of several individuals or smaller firms who would be ideal. You would be happy to introduce them, even select one if they wish. Offer to turn over all your files, or anything else that will ease the transition. Be careful to describe the change only in terms of what is best for the client. Do not imply that you have grown too important for them—just too big to provide the service and prices they require.

CHAPTER 14 Grow the Business?

ROWTH FOR THE SAKE of growth alone is seldom a valid strategy for a graphic design business. Service businesses—accounting, law, architecture, design, public relations, advertising, etc.—seldom reap the economies of scale that push manufacturing businesses constantly to expand. In fact, many well-known design firms have remained more of less the same size for years without apparent ill effect. Others have grown and shrunk as clients have come and gone.

It is, of course, unlikely that a designer working off the kitchen table will be considered for a major corporate identity project. But small-, mid-, and large-sized firms alike all have a shot at recognition, profitability, and longevity. Growth for its own sake accomplishes little. It may provide the route to larger clients, bigger assignments, and more money. But, on the other hand, it is equally likely to jeopardize creative output, increase overhead, and make life less enjoyable. In short, growth always impacts three key areas—product quality, profitability, and quality of life.

⊕ How Big? ⊕

If there is just one thing to keep in mind about growth it is this: design businesses become vulnerable as soon as they exceed the interests and capabilities of their principals.

By nearly any measure, design organizations are very small businesses. A handful of the very largest, multiple-location ones have a few hundred

employees. In most metropolitan areas, the largest design studios have a staff of fewer than fifty, and the majority have less than a dozen. In other words, size has never been essential to either creative reputation or economic viability. Nonetheless, size and the resources that accompany it do matter for certain types of assignments and clients. The increasing capital cost of running a design business, coupled with the growth in cross-media and interactive assignments, indicate that we will probably see an increasing number of opportunities for larger organizations. Even so, as previously covered in chapter 9, there will probably be ample opportunities for both small and large firms in the foreseeable future.

So, what's the right size for your firm? Although to some extent the answer is affected by happenstance and unpredictable future events, much more crucial is what you actually want. Don't make the mistake of not knowing when your capabilities and interests are out of synch with the realities of running a business. The following will give you an idea of the advantages, disadvantages, and vulnerabilities of design firms at four different size levels.

WORKING AS A FREELANCER. This is where most of us start out. You're probably beyond this stage, but you may want to return to it someday. Creative Business surveys indicate that slightly more than half of all designers who are self-employed longer than five years work as freelancers.

Principal's personality. Enjoys working alone; strong self-confidence/discipline; moderately competitive; would rather not supervise others; not always well organized; prefers/needs to work at home; low-level client contact no problem; somewhat motivated by money; slight interest in business detail; not comfortable with investing.

Advantages. Minimal investment; no long-term commitments; requires few business skills; no personnel worries; more pricing latitude; low expenses; can work from a home office; can more easily work flexible hours.

Disadvantages. Loneliness; lack of peer review and creative feedback; some clients won't consider a freelancer; hiring temps or others for overflow work is time-consuming and costly; work flow tends to be feast or famine; it is difficult to wear all hats—proprietor, salesperson, bookkeeper, and creative director—at the same time; ceiling on earnings capability.

Vulnerability. Inability to devote adequate time to prospecting for new business; becoming stale creatively; losing self-confidence; lack of cover in emergencies.

RUNNING A SMALL SHOP (2-5 INDIVIDUALS). Having a few permanent employees has the attraction of more stability, opportunities, and profit. On the other hand, the whole character of your business changes. When

you have employees, success depends partly on your ability to manage the creativity and productivity of others.

Principal's personality. Prefers to work with people rather than alone; enjoys control, but values input; competitive; moderately comfortable delegating; moderately well organized; enjoys organizing as much as doing; hates losing work to larger firms; motivated by money; moderate interest in business detail; understands investment concepts.

Advantages. More resources to compete for bigger assignments; each new employee can provide up to forty more billable hours, and every hour can generate additional profit; delegating routine tasks can free you to concentrate more on what you really like to do; it is easier to take sick days, holidays, and vacations.

Disadvantages. Finding and keeping good "commercial" talent is a time-consuming task; the need for commercial office space, business insurance, and more computers, software, desks, and office equipment increases overhead; bookkeeping and accounting costs go up; each additional employee increases cash-flow concerns; more working capital and a higher line of credit are required; you need to devote more time to sales.

Vulnerability. Overhead expenses that increase faster than income; a hiring mistake can cost thousands of dollars in wages, benefits, and lost business opportunities; inability to make tough personnel decisions when they're called for.

RUNNING A MID-SIZED SHOP (6-11 EMPLOYEES). Having from half a dozen to a dozen employees is potentially efficient for a design firm, but also problematic. This size is big enough to compete for nearly all assignments and to take advantage of most operating efficiencies. But it also requires considerably more structure and management time than smaller shops, which are typically more collegial and informal.

Principal's personality. Enjoys a structured environment; enjoys organizing as much as doing; comfortable delegating; very well organized; enjoys training and educating; appreciates role of marketing; comfortable with planning; personal style/ego secondary; enjoys challenge of personnel management; possessive about clients; highly motivated by money; strong interest in business detail; interested in investing.

Advantages. Sales volume is now adequate to support a professional sales rep, bookkeeper, and office manager; only at this size or larger are many systems and procedures cost efficient; greater staff depth and diversity can attract a wider variety of assignments; senior-level employees are more likely to be attracted by the quality of assignments, and the possibility of higher pay and benefits; some potential for building salable equity.

Disadvantages. General overhead expenses—office lease, equipment, etc.—often increase dramatically, especially if growth is rapid; more senior-level employees increase salary and benefits costs; management chores can end up taking most of your time, leaving little time for creative activity; formal personnel policies and management systems must be implemented.

Vulnerability. Smaller profits with bigger headaches unless costs are contained and management systems are efficient; key employees may leave, taking important clients with them; excessive involvement in every aspect of the business; burnout.

RUNNING A LARGE SHOP (12+ EMPLOYEES). Aside from fast-growth exceptions, design firms with more than a dozen employees have typically established the systems and procedures required for longevity. Assuming a diversified mix of clients, they can expand or shrink as market conditions warrant with little concern about changing the character of their businesses.

Personality. Enjoys business-building activity; enjoys setting direction for others; very comfortable delegating; enjoys long-term planning; considers marketing crucial; considers size an attribute; enjoys challenge of personnel management; philosophical about losing jobs; enjoys high-level client interaction; somewhat motivated by money; moderate interest in business detail; very interested in investing.

Advantages. Recognition, reputation, and business goodwill ensure a certain amount of work, lowering the cost of sales; no client or assignment is too large; a wide range of staff talents and salaries allows more competitive options; capital resources are sufficient to pursue any type of opportunity; professional management allows you to be actively involved in the creative product; best potential for building saleable equity.

Disadvantages. Management layers can have a negative effect on the creative product; high overhead may require prices too high for many clients; you can easily become isolated from important aspects of the business; running a large organization may not be as rewarding as running a smaller one.

Vulnerability. Not leaving sufficient capital in the business; not planning adequately for business continuity and succession; complacency.

SIZE MATTERS. Whatever the current size of your business, and whether or not you wish it to grow, it usually helps if clients perceive it as somewhat greater than it really is. Whether you run a two-person firm or a fifty-person one, it is usually better to be perceived as larger, older, and more

accomplished than may actually be the case. There are four major reasons why bigger is usually viewed as better:

1. Backup—the larger the project, the more at stake, the more clients will worry about your ability to get it done on time and on budget.

2. Stability—since designers come and go, size and longevity implies stability, which makes clients more comfortable.

3. Reassurance—because design is often esoteric and always subjectively evaluated, a history of working successfully with many other clients provides a dose of confidence for less-than-secure clients.

4. Size—clients are nearly always larger, but the closer your firm's size is to theirs (or their department in larger firms) the better they will relate to you.

This is not to suggest that you be dishonest about your business. Rather, it is to suggest taking pains to minimize possible client concerns. This can be essential for small- and mid-sized firms pitching large clients, and it can also be important for large shops pitching very significant assignments. Creating an impression of greater size makes growth easier. If you desire to stay the same size, or even to downsize, it makes it easier to increase your prices, thereby keeping the same income while working less.

❧ Size Control ❧

As the preceding should indicate, growth and larger size are not always good. Sometimes it is better to stay small or downsize. Here are some suggestions on how to be small and profitable.

PICK A NICHE. Don't try to be a creative generalist. Focus instead on an industry or certain services. Specialists don't work as hard and can charge more. (See "Is It Better to Specialize?" in chapter 9.)

ADJUST YOUR PRICING. The best long-term way to reduce work volume is to raise prices. Less desirable clients and assignments will gradually drop away, leaving the better ones. You may even end up making more while working less. (See "Raising Prices without Raising a Flap" in chapter 12.)

FOLLOW YOUR HEART. Aggressively pursue assignments you want, walk away from any that give you bad vibes. It may take courage initially, but it will help ensure that growth is natural, pleasant, and manageable.

REMEMBER, IT'S YOUR LIFE. Whatever you decide—change focus, resign clients, downsize by laying off staff—make sure it is the right decision for you. Then don't look back.

What's the Right Business Mix?

No surprise, the world of design is changing rapidly. Whatever you're doing now, chances are you'll be doing it differently, or doing something totally different, in the future. The old saying, "If you want to be successful, you better not be in the same business ten years from now" has never rung more true. Of course, what your business will be in ten years is a function of many variables—desires, talents, clients' needs, technology, economics, and plain old luck. But while all these and other variables are either unique or unpredictable, there are two constants that we can consider today. Whatever else may occur, it is likely that in the future, as now, every creative firm will be able to choose to engage in two different types of activity: 1) services versus products work; or 2) project versus ongoing work. The attractions and pitfalls of each of these two types of activity need to be constantly evaluated as conditions change.

THE SERVICES/PRODUCTS WORK MIX. Many design firms sell only their creative time. Others sell a mix of time and products—often design services plus printing. In the latter case, the printing is brokered (subcontracted) as both a convenience to the client and for the extra money to be made.

Who's doing what. While the size of clients and jobs is not the only factor involved, by and large the smaller both are, the more likely a design firm will be involved in the full, concept-to-delivered-piece activity. Larger, more sophisticated clients are more likely to want to separate the purchasing of creativity from printing. They usually have a purchasing department that considers this to be its responsibility. Printing can be more clearly specified than creative work, and purchasing gives the company greater control over what is usually the most costly and competitive portion of a print project. For broadcast and interactive projects, many clients are unfamiliar with the production skills required and want to get everything from one source.

Advantages and disadvantages. Providing everything, concept to delivered piece, gives clients the convenience of one-stop shopping and one-source responsibility. It also gives you greater control over the end product. However, the major advantage, especially with print projects, is the opportunity for additional, "easy" profit by marking up the cost of production. Indeed, the profitability of many smaller design firms is often as depend-

ent upon selling printing as on selling creative services. Markups can be whatever the traffic will bear, but typically average above 25 percent. So aside from the desires of clients to control purchasing, why wouldn't you also want to broker printing?

The primary disadvantage is financial risk. You become responsible for paying the printer regardless of whether the client pays you. Getting stuck by just one deadbeat client can easily wipe out years of markup profits. Instances of design firms going bankrupt by taking on print responsibility for clients who later stuck them are countless. For this reason we recommend against purchasing printing unless you have available capital (liquidity) equal to your financial exposure. If you cannot meet this criterion, you cannot afford the risk. One way to get some of the capital needed is to insist on progress payments equaling two thirds of the total estimate (printing included) before the job is turned over to a printer.

Sometimes there is a competitive selling advantage when clients purchase their own printing: "We will help you select a printer, but unlike other firms we do not purchase and markup printing. This often results in substantial savings for our clients." This approach provides clients with a greater sense of financial control and makes your services appear less expensive. Moreover, the loss of printing markups may not be all that significant if time spent working with the printer (e.g., checking press sheets) is billed as the quality-control part of the creative fee. Getting a sales commission (up to 5 percent of the job bill) from a printer who bills direct is sometimes also possible. But be open about it. Otherwise, it will probably look suspiciously like an undercover payoff to a client who finds out later.

Firms that sell mostly creative services—i.e., are not involved with reselling a significant amount of outside purchases—also have simpler bookkeeping. For them, gross income is a true measure of profit-making volume. All income can be counted. When there are significant sales of outside purchases, AGI (Agency Gross Income, or fee income) has to be calculated instead. A firm with a high sales volume but low AGI appears deceptively large when it is actually no better off than a firm with sales equivalent to the other's AGI but that only provides creative services.

THE PROJECT/ONGOING WORK MIX. The other business-mix factor to consider is how much of your work falls in the category of individual projects and how much can be categorized as ongoing assignments. Design firms do mostly project work—assignments with a clearly defined beginning and end. When it is over, the relationship with the client ends unless another project happens to be forthcoming. There is no additional commitment or responsibility from either party. In contrast, advertising and

public relations agencies work mostly on ongoing assignments—i.e., campaigns of materials. They do more work for fewer clients over longer periods of time.

Why the mix matters. Handling project and ongoing assignments is not mutually exclusive, but the relative amount of each does have implications. Perhaps most important is the impact on a firm's positioning. A potential client looking for design services may pass by a firm calling itself an advertising agency. Conversely, a client looking for advertising expertise may not call on a design firm that does advertising occasionally, regardless of how strongly it is promoted. Although the effects of categorization are certainly much less prevalent today than in the past, they are still a factor. (For more on positioning, see chapter 9.)

Ongoing assignments also often necessitate an agent agreement that defines significant commitments and responsibilities. Conflicts of interest are defined differently, too. Last but not least are organizational and management differences. For example, the higher the proportion of ongoing assignments, the more marketing and sales (drumming up new business) is replaced by client service (keeping existing business). Because of this, sales reps are usually compensated by commission, account executives by straight salary. The makeup of staff can also be quite different, depending on how much of a shop's activity is creative (more in design firms), and how much is administrative (more in advertising agencies).

Determining factors. The smaller a design firm and the more rural its location, the more likely it is to have to rely on a mix of project and ongoing assignments. Larger firms, especially in metropolitan areas, usually have the luxury of concentrating on a preferred area of activity. Regardless of your firm's size or location, however, smaller clients often want one source to coordinate and handle all communications activity. Even larger clients sometimes look to a project-oriented (design) firm to handle work that may get lost at their advertising or PR agency. Clients of any size can be so impressed by a demonstration of creativity that they decide to use a design firm to supplement an established agency. For all these reasons, every firm should be aware of both the rewards and pitfalls of accepting ongoing assignments.

Advantages and disadvantages. The upside of a mix of ongoing and project assignments is the opportunity to stay busier by meeting more client needs. Often, too, there is the added satisfaction that comes from being more intimately involved with the client's business, and the ability to make a real difference.

The downside is that the more ongoing assignments you handle, the more vulnerable your business can become. Because ongoing assignments take more time and effort, you work with fewer clients. The fewer clients

you work with, the more at risk your business is when a client is lost. A significant mix of ongoing and project work also changes how you operate, usually making things more complicated. As for profitability, assuming you work on a fee basis (see chapter 12), there is little profitability difference between project and ongoing assignments.

Your choice. The collective talents, desires, and experiences of your firm should be the major factors in establishing its focus. Don't dilute it. Attempting to be all things to all clients all the time usually results in universal mediocrity. Although it takes courage, turn down work that stretches your capabilities or talents. It is the only way to sustain a viable organization. To help you keep your eye on the ball, we suggest you prepare a plan outlining your specific businesses goals and objectives and stick to it. (For help on how to do this, see "The Need for Business Planning" in chapter 1 and the sample business plan in appendix IV.)

⊕ The Three Business Stages ⊕

Now that we have considered the general advantages and disadvantages of growth and mix of business, it is time to look at another aspect of size—a business's stage. That is, where it is on the young-to-mature-to-old continuum. Why? Well, one reason is to provide additional perspective to improve the business planning process previously discussed in chapter 1. But equally important, especially for firms that do little or no yearly planning, is that understanding business stages also helps make for better choices.

Although few of us think of it this way, being in our own business is like being on a journey—that is, there will be a beginning, middle, and end to it. By considering the opportunities and problems that can occur at each of these three stages in advance, the trip ahead can be a lot more rewarding and pleasant.

STAGES AREN'T AGE-, SIZE-, OR SPECIALTY-RELATED. Personal lives and business events are chronological in nature—i.e., each day, each event, pretty much follows the one before. But business stages don't necessarily follow in order, and they aren't dictated by a business's age, size, or speciality. For example, some new design firms immediately take on all the characteristics that mark them a Stage Three (over-the-hill) business; some decades-old firms have all the characteristics one might think of as being indicative of a Stage One (immature) business. Likewise with size—some large firms are Stage Two (in-the-groove) businesses, but so are some small ones. Whether they are pure design firms or do a mix of design, advertising, PR, and interactive work makes little difference. More important than

their age, size, or speciality are their procedures. Stages are determined by how organizations respond to everyday challenges and opportunities, not by their longevity, billings, or staff. Moreover, the three stages are not equal. Stage Two is the best place for most firms. It is what immature creative companies should aim to be, and what those over-the-hill should try hard to get back to.

STAGE ONE–IMMATURE. Although age does not determine which stage a business occupies, most design firms in business fewer than five years are stage one organizations. That's because they have not yet acquired the maturity—wisdom, judgment, and procedures—that are essential components of business organizations that have long-term viability. It may, or may not come in time, but for Stage One companies it is not here today.

The positive side. By itself, immaturity is not bad. In fact, there are many desirable characteristics of a Stage One business. Perhaps most important is the joy of being one's own boss. This is a freedom envied by most of the rest of the world, and one often taken for granted, especially later on. Also common is the enthusiasm and willingness to experiment that often results in unusually fresh and innovative ideas. Then, too, naivete and a lack of negative experiences can lead to opportunities that more seasoned firms overlook. For smaller Stage One firms, size also can allow flexibility in all aspects of operation—pricing to personnel.

The negative side. There are, however, more than enough negatives in Stage One businesses to outweigh the above positives. All Stage One businesses suffer from one or more of the following: a lack of adequate capital; inadequate health and other insurance; bad working habits; the absence of formal business procedures; and ill-advised partnering or other arrangements. Other common negatives shared by Stage One firms of all sizes include: having one or two dominant clients; inadequate marketing efforts; lack of long-term thinking or planning; not knowing one's costs of doing business; charging too little; not investing in the business's future; poor organizational skills; arbitrary personnel management; constantly operating in a crisis mode.

If some of the above describes your company, it is more than likely still at stage one, regardless of any other indications of success, such as current profitability. Business stages are an indication of long-term viability, not present conditions, good or bad.

Typical progress. Because every design firm is a combination of different talents and experiences working with different markets and clients, it is difficult to predict when a firm is ready to leave Stage One behind. Some new firms manage to move through it in a few years or even months. Some others, a decade old and still hanging in there, never quite acquire the skills

needed. As a rule, most firms of five persons or more should move beyond Stage One within five years; firms with fewer than five persons should do so within three years. If your company is younger than indicated, and you've been eliminating the negatives as you gain maturity and experience, don't worry. But also don't relax. The important thing is to recognize the negatives that could mire your business at Stage One, and work to eliminate them. Further, it is crucial to do so without losing any of the positive Stage One attributes, such as freshness and enthusiasm.

STAGE TWO—IN THE GROOVE. Regardless of its size or age, this is where a creative firm should be. A place that's fun, creative, and stable, although never one of total comfort. Few Stage Two firms possess all the characteristics outlined below, but they do have enough of them to make work life both pleasant and routine. This combination—personal enjoyment and business stability—is the secret to long-term viability.

Work flow. Maintaining two to four or more weeks of work in the pipeline is their highest priority. Their secret? Nothing more profound than consistent, amply funded marketing.

Cash flow. They recognize that it is as important in the short-term as profit is in the long-term. They typically generate it through realistic pricing, progress payments, aggressively managing payables and receivables, and keeping substantial working capital.

Pricing. It is based on the costs of doing business, not arbitrary what-the-traffic-will-bear guesstimates. Prices are adjusted up or down depending on individual job circumstances, but the starting point is always "our costs plus a fair profit." (For more on pricing see chapter 12.)

Diversity. The greater the number and variety of clients, the more protection there will be against client cutbacks and industry slumps. The more types of assignments handled, the greater the insulation against seasonal and industry cycles.

Talent. It is nurtured because it determines the quality of the product, and the quality of the product determines the quality of clients and assignments. The age-old formula: Provide a stimulating environment, look for diversity, hire only the best, encourage experimentation, and reward amply.

Management. Best described as consistent, predictable, and seldom arbitrary. Everyday procedures are routine. Performance indices and business ratios are monitored. There's a willingness to invest in the future, and there's some form of planning.

Perspective. Principals realize that to be a totally mature business is to be dying one. So they stay young by constantly redefining what they offer, how they offer it, and to whom they offer it.

Profitability. Principals' earnings are greater than the salary they would draw if working for someone else and comparable to what other business professionals with equal responsibilities make.

Enjoyment. This is the bottom line because running a creative business is tough without it. Indeed, as will be seen below, the loss of enjoyment is often the first indication that a business has moved on to Stage Three.

STAGE THREE—OVER-THE-HILL. Stage Three design firms are best described as tired. They are on the downward slope, whether they recognize it or not. Sales, clients, profit, etc., can all look relatively good because they can be lagging indicators. The problems of Stage Three firms are attitude and flexibility. As might be expected, more older firms fall into this category than younger ones. Half or more of all shops over ten years old probably qualify. Most highly represented are those with one principal. But for the reasons following, age and size are not the determining factors; all ages and sizes can fall into this category.

Resenting clients. This is the most telling characteristic of a Stage Three firm: more than occasionally resenting the demands of its clients. Not every client should provide a pleasant (or neutral) experience. But when many don't, something is wrong. Design firms are service businesses, and providing good service requires mutual respect. You don't have to respect all your clients, but you do have to respect most. When you believe that more than an occasional client makes dumb demands, wastes your time, or can't recognize your talents, you need to find new ones. Or more likely, make an attitude adjustment.

Burnout. Every principal's tolerance level is different; one individual's killer workload is merely stimulating to another. But we all recognize burnout—too much work, too little pleasure, for too long. When this type of pressure continues, month after month, it's a sure sign of a Stage Three company

Too much experience? Having lots of it should be positive: it enhances client comfort and reduces the time needed to get up to speed. But for Stage Three firms it often results in a "been there, done that" weariness. This exhibits itself as a lack of originality, general ennui, and a paternalistic attitude toward client requests.

"Can't do" versus "can do." The essence of a successful design business is its ability to problem solve. Often this means exploring the unfamiliar. Stage Three firms approach problems from a narrow viewpoint that limits their solutions to what they want to do or what they find comfortable. They dismiss other approaches as too difficult, impractical, or a waste of time.

Wrong size. Design firms enter Stage Three when their size exceeds the

capabilities of their principals. Most problematic is the transition from small firm (2-5 employees) to mid-size firm (6-11 employees). It usually requires new procedures and a new way of looking at business.

Not investing. The need to constantly invest in new equipment, procedures, and opportunities has long been taken for granted in other industries. It is a new phenomenon among design firms, and lacking among those in Stage Three. We are in an industry that is being transformed by new technologies. As expensive as it might be, not to keep up is to guarantee decline.

OTHER CONSIDERATIONS. It should be apparent that there are some elements of each of the three stages within every design organization. What matters is overall performance. It is formed by hundreds of individual and daily actions. Each of these can be defined, analyzed, and modified as a business evolves or grows. In addition, there are several other factors, not as readily recognized or addressed, that can affect business stages.

Culture. Every organization has one. With smaller entrepreneurial companies it is initially an extension of the founder's personality. For example, a company begun by a fast-paced individual likely operates in overdrive; one formed by a laid-back individual probably runs at a relaxed pace. Modifying the culture of a design firm is particularly hard because of the personal relationship most principals have with their businesses. Nonetheless, most successful, Stage Two firms have evolved a culture that is usually described as middle-of-the-road: businesslike, friendly, efficient, and professional. In other words, they have overcome such business-damaging personality traits as a frenetic pace (it usually leads to employee stress and low morale) or operating procedures that are too relaxed (they usually result in loss of billable time and missed opportunities). A very strong company culture is often (albeit not always) detrimental to business.

Age. The age of the principals has an effect. Younger designers typically have more energy, willingness to experiment, and appreciation of current trends, but this is often offset by lack of experience and the misjudgment that can accompany it. Older designers typically possess the efficiency and wisdom that comes from experience, but usually are less energetic, and less in touch with trends. The absence of family and other obligations among younger designers encourages more freedom of action; accumulation of responsibilities among older designers encourages more deliberation. Because of these and other age-related factors, it is our experience that the age range of principals at successful, Stage Two design firms is normally from thirty to forty-five. Stage Two principals who are younger have an unusually mature business sense; those who are older have learned the lessons of business survival very well.

Clients. Those with style- and trend-driven projects often prefer younger firms; those with market- and strategy-driven projects more experienced ones. Significantly, the most profitable work, the work that is the bread and butter of Stage Two firms, usually comes from corporate clients who are also somewhat middle-of-the-road and only occasionally style- and trend-obsessed.

WHAT TO DO ABOUT IT? There is, of course, a lot of subjectivity involved in evaluating which stage a business is at. Many of us looking at our own businesses will give ourselves the benefit of any doubts. On the other hand, designers tend to be insecure, which negatively affects some self-evaluations. Perhaps the single best test is the simplest one: if your business is not routine and enjoyable, it is probably at stages one or three. If you can describe your business as "comfortable but not complacent" it is probably at Stage Two.

In making your own evaluation keep in mind that the stage of a business is not as important as the recognition that three business stages exist, and that most firms experience each one at some point. Moreover, the long-term (many years, if not indefinite) success of a firm requires it to maintain most of the attributes of Stage Two. If your firm is not there today, it should be on its way (from Stage One), or on its way back (from Stage Three).

If you find your business at stages one or three, and you enjoy most of the benefits of being self-employed, set objectives for changing its negative aspects without giving up its positive ones. Usually all this takes is recognition and the will power to make changes. If, on the other hand, achieving the business objectives you set appears impossible or doubtful within a few years, seriously consider whether running your own business is in your long-term best interest. Do some brainstorming to decide what your personal (lifestyle) objectives are. Then examine your options. Finally, start planning the steps now that will allow you to achieve them.

⊛ Managing Growth ⊛

As discussed at the beginning of this chapter, most design businesses don't have the growth imperative that faces companies in other industries. In addition, and also worth considering is that growth can be measured in more ways than just increased revenue or firm size. Some of these ways are directly associated with more employees and income, but others are at odds with it. Deciding on and managing your firm's growth is more complicated than merely increasing your resources to handle more projects from an expanded client list.

EXAMINING YOUR NEEDS. Unlike larger organizations that are controlled by the collective abilities of professional managers, the prosperity of design firms rises and falls on their principals' foresight and decision making. Therefore, a fundamental question needs to be answered before contemplating any growth: What do you really want? As the old saw has it, "Be careful what you wish for, because it might just come true."

The attractions of increasing the size of your company are that it (probably) will provide a better shot at getting higher-level projects, attracting better employees, having more consistent work flow, working with larger clients, and making more money.

But growing a design firm doesn't come without its trade-offs. Increased size will surely mean more management headaches, less creative involvement, more personal stress, more financial risk, and even the possibility of ending up with less, not more money.

The point is, growth does not necessarily make a design firm better, more prosperous, or its principals happier. It may, but then again it may not. It shouldn't just happen. It should be the result of some serious soul searching first.

FACTORING IN THE ECONOMY. We all know it is risky to expand in bad times. What we often forget is that it can be equally risky in good ones. At least in bad times there is an appreciation of a design business's vulnerability to general economic conditions. In good times this tends to be overlooked, and a business's strength is often attributed more to its particular blend of talent and skills than to the overall economic climate.

Whether a business's strength is based mostly on hard work or the climate makes little difference as long as the good times roll. But when the economy slows, it makes a huge difference. Then, clients stop spending at the same rate, but the bills for growth—newer computers, long-term facilities leases, etc.—continue unabated. When this happens, those design firms that have been careful not to overextend themselves are the ones left standing. The seeds of future disaster are often sown in what are otherwise the best of times.

OTHER WAYS OF GROWING. Big or little, good economy or bad, every design firm should always be growing. But growth should not be defined only as an increase in size. Other types of growth are of equal or more importance. Growing should be as much about improvement as expansion.

More profit. There's an old retail truism: "You go bankrupt on volume when every sale costs you money." It is the same with growth. Only a fool grows a business without first being assured that its profit will increase accord-

ingly. If larger turns out to be less profitable, the business should shrink back. Size means nothing. Profitability means everything. (See chapter 15 for more on profitability.)

More variety. A size increase without a variety increase is usually either a bad business judgment or a bad creative judgment: a bad business judgment because too much dependence on a few clients can leave a firm vulnerable; a bad creative judgment because the talents and skills that form the foundation of creative businesses can easily atrophy without the stimulation that comes from constantly addressing different challenges.

More good projects and clients. Overlooking quality on a quest for quantity is a serious mistake. A few good projects and clients are worth many not-so-good ones. Good projects and clients promote working efficiency, provide more stimulation, increase morale, and lead to more profit. Every design firm should make bettering its client/project mix a priority, whether or not it also has growth in mind. Indeed, when the focus is on increasing quality, an increase in size often follows automatically.

More enjoyment. A small, privately held company depends on the energy and enthusiasm of its principals, and this diminishes when they cease to enjoy what they do. When a business expands to the point where it is less enjoyable, it is nearly always less successful—financially and creatively—then it was before.

GROWTH PREREQUISITES. The strength of the foundation upon which a business builds determines how much success it will enjoy. No company should contemplate growing without first meeting at least the four following criteria. To do otherwise will merely compound an existing problem. Meeting these criteria is particularly important for small to mid-sized companies, which are as likely to grow fast as gradually. A sudden acquisition of several clients or projects can dramatically increase a firm's size and vulnerability.

Billable efficiency. This is a crucial indicator of a firm's ability to handle growth because it measures productivity. When you divide actual (not estimated) billable hours by total payroll hours (all billable and nonbillable employees) the result should be in the 50 to 75 percent range. A low figure suggests that better management, not growth, is the key to making the business more successful. A figure above the range usually indicates bad tracking or inadequate attention to fundamentals. Whatever the problem, it should be addressed before increasing the business's size.

Pricing. A firm's labor rate(s) must be derived from analyzing its costs, then adding a profit margin. In the absence of an up-to-date calculation there is no way to know whether growth will be more or less advantageous from a

financial standpoint. In addition, and with some possible adjustment for geography, in today's economy hourly rates should be $90 an hour or higher. Growing a firm today with lower hourly rates, even outside metropolitan areas, is likely to attract more less-desirable types of clients. Chances are that the firm will simply end up trading profitability for volume. Better to be smaller with higher fees than larger with lower ones.

60/6 rule. Without a clear desire to grow, as opposed to just staying ahead of the workflow, you shouldn't hire staff until the pain is so great, and the work so consistent, that you absolutely must. As a rough calculation, this usually means you or affected staff members working approximately sixty hours a week for up to six months attempting to keep up. Instead of hiring staff sooner, it is nearly always advantageous to pay overtime, hire temps, or farm work out to freelancers. Adding staff should be the last resort.

Cash flow. All design businesses come with a built-in problem—variable demand. Keeping work flow and income consistent from month to month is difficult. The more a firm grows, the more potential this has to occasionally raise havoc in meeting obligations. The only solution to a potential cash flow crisis is to maintain adequate liquidity. Most firms contemplating growth should have a minimum of 10 percent of Agency Gross Income (AGI) available. Cash is obviously preferable, but a line of credit is okay as long as it is tapped only to cover temporary shortfalls. Also important to cash flow are progress payments, accounts receivable management, and retainers for certain clients.

OTHER CONSIDERATIONS. Although not prerequisites or mission-critical, the following also need to be kept in mind.

How much is safe? It is easy for a business dependent on talent and client relationships to quickly outstrip its competence. Although every principal and organization has different capabilities, keep the following Creative Business safe growth guidelines in mind: Firms with two to five employees—no more than 75 percent; firms with six to eleven employees—no more than 50 percent; firms with twelve to twenty-five employees—no more than 25 percent; and firms larger than twenty-five employees—probably no more than 15 percent in a single year.

Number of clients. Growth that comes mostly from one or two clients can be dangerous if it increases dependency. As a rule, when a firm gets more than 25 percent of work from one client, or 50 percent from two it is too dependent.

Insurance/benefits. Larger firms are more vulnerable than smaller ones and need more protection. Employees often expect more in the way of benefits, too. So be sure to have your insurance coverage and benefits package

reviewed. The good news is that even with expanded coverage the cost as a percentage of AGI usually falls with larger size. (Freelancers often spend up to 15 percent, but most firms seldom spend over 5 percent annually.)

Policies and procedures. Design firms grow mostly by adding staff. Staff efficiency is what produces profit. Clearly understandable, written policies and procedures, including job descriptions, are what keeps staff informed and efficient.

POST-GROWTH DANGERS. Even when all the reasons to do so are valid, growing exposes a company to risks it wouldn't otherwise face.

Adding staff faster than income. The percentage of income spent on salaries and benefits (up to 70 percent) should remain roughly the same after growth as before. If not—if the salary percentage increases—either the billing rate of the new employees is too low, or you need to find more work to keep them busy. Either way, it is a problem. The billing rate for new employees should be at least three times their hourly pay. When you use a blended (shop) rate, recalculate it to include the salaries of the new employees. If the problem is not enough work, increase marketing efforts.

Facilities overkill. Too much new space, in too fancy a building, decorated too lavishly, spells financial trouble for any company growing into new facilities. (Remember, rent is a fixed overhead expense.) To keep expenses in line with industry standards, rent, including utilities and cleaning services, should be around 6 percent of AGI. Two hundred square feet of space per employee should also be adequate. As for how much to spend on moving, a good benchmark is recouping costs, either through new business or greater efficiency, within a year. If the move can't be justified on this basis, it can only be considered a speculative investment.

Reduced marketing. A firm whose work load has caused it to reduce its marketing efforts severely is a firm that has grown out of control. Why continue marketing when there is no longer an immediate need? To iron out fluctuations in work flow and to move up to better projects and clients. Marketing is at least as much about positioning and controlling the future of your business as it is about bringing new work in-house. (See section 3.)

Product changes. A design firm's product—a combination of its style, innovation, and quality—will change as it grows larger. New employees will introduce new creative approaches, and larger size usually requires new ways of doing things. In addition, principals will have less and less time to act as creative directors. The management challenge for principals is to

ensure that creative standards remain high while they assume broader responsibilities, and to assemble a staff diverse enough to offer the creative variety necessary to attract the additional clients a larger firm requires.

CONTROLLING GROWTH. Design firms often grow for two wrong reasons: One is a misguided notion that it is necessary for profitability, a situation covered previously. The other, covered here, is a response to increasing business demands, even when they don't make sense.

Raise prices. If you are facing the need to grow and would rather not, but still find the additional revenue tempting, try raising your prices. When prices go up, demand usually goes down, but profit often stays the same. Price increases don't have to be announced, they just need to show up in estimates. They can even be raised or not on a case-by-case basis, depending on the attractiveness of the project and client. Whether done across the board or selectively, price increases also have the side effect of culling out smaller, budget-sensitive projects and clients, while having less effect on larger ones.

Establish criteria. There's no law saying you have to accept every project or client, especially when you are already busy. Set standards and don't be afraid to decline whatever doesn't meet them, such as minimum fees, a desirable client, stimulating work, the possibility of establishing a long-term relationship, and a good profit margin. Despite any misgivings you may have, when handled professionally turning down work seldom results in unhappy clients or losing future business. Indeed, the more selective you are in whom you work with and on what projects, the more clients will respect you. And the more clients respect you, the more they will want to work with you.

GROWTH DANGER SIGNS. Expenses seldom increase or decrease at the same rate as income. Nor is security necessarily tied to company size. To maintain or increase profitability and security as size changes, keep your eye on these key indicators.

Liquidity. Divide short-term assets (mostly receivables) by short-term liabilities (mostly payables). Try to keep this number (the quick ratio or liquidity index) constant, ideally between 1.25 and 2.0.

Billable time. Compare it month to month from employee time sheets. Most firms average 50 to 75 percent. The higher the percentage the better. Be concerned if it starts slipping.

Income per employee. Divide monthly sales by number of employees. Allowing for seasonal variations, be concerned if the long-term trend is

down not up. (As a benchmark, industry average is about $9,000 of monthly income per employee.)

Number and size of clients. Getting more work from fewer clients can be risky, especially if one or two account for most of the increase. It is best to keep the income from any one client to less than a third of your total, and to have no more than half of your income in the hands of two clients.

❖ New Business from Old Clients ❖

Receiving another assignment from a good client is often the most profitable type of work. Creative Business surveys show that new assignments from previous clients average from 15 to 30 percent more profitable than assignments from brand new clients. The learning curve is less, there are economies from knowing client idiosyncrasies, and client trust provides more pricing flexibility. Working with known individuals and procedures is often more personally satisfying, too.

A good ratio for small to medium-sized creative firms (one to twelve employees) is two jobs from repeat clients for every one from new clients (66%). Larger firms, which can afford more sales representation, often operate comfortably on an old-to-new ratio of one to two (33 percent). Of course, these figures assume that not too much of the business's total comes from one or two clients.

TWO PROBLEMS TO OVERCOME. Despite the attraction, there are a couple stumbling blocks in getting more work from previous clients.

First, many of us tend to take previous clients for granted and don't solicit them with the same zeal we do new ones. Or, we don't follow up on the built-in advantage we already have over competitive firms.

Second, clients tend to categorize us, to identify us with only certain expertise or abilities. It is a natural tendency of individuals, you included, to think of others in terms of only one or two distinctive characteristics. In other words, most likely you'll come to mind only when the client is looking for the particular type of talent or experience they associate with you. No matter how good and versatile you are, when it comes to getting different types of work from current clients, you're no better than their perceptions of your qualifications and experience. You can't assume that they will eventually come to appreciate the full measure of your talents. Indeed, the more work of one type you handle, the more likely you are to be pigeonholed. Therefore, if you want to get new types of business from cur-

rent or previous clients, you have to actively promote your services in a way that breaks the typical client mindset.

What if you have talent but little experience in the type of work you want to go after? Don't fret. Chances are, the good chemistry previously established will overcome any minor limitations. Sometimes the only way to break into new types of work is with clients who like you well enough to take a chance.

WAYS TO BREAK THE CLIENT MINDSET. Try one or all of the following techniques to help introduce clients to the full breadth of your capabilities.

Distribute job samples. Whenever you complete a different type of job, buy samples from the printer or client. Mail one to every client who may not be aware of your ability in this area. Attach a short, personal note: "I thought you'd be interested in seeing this." Even better, if you are calling on a client for another type of job, present the sample and talk about it. If you do this just two or three times a year, showing a different type of work each time, every client will associate you with a variety, not just one or two types of work.

Make presentations. You can actually pitch existing clients more easily than new ones. Call and say, "I've been doing a lot of (type of work) lately and it occurred to me that this is one area in which we've never worked together. I'd love to come over and show you what I've been doing. Can we set up a time?"

Talk up your versatility. Be on the lookout for ways to mention the different types of work you are doing. For example, when a client asks, "How are you?" Don't just say "Fine" or "Busy." Be specific. Say, "Actually, I've been quite busy. We just finished a Web site assignment for ABC Corporation and we're about to start on a series of product ads for the Smith and Smith Agency." Or weave mention of another assignment into casual conversation. For example, "You know, I've really been enjoying this project. Right before this, we were doing a complex corporate identity program that involved … so the change of pace has been great." Or simply ask for a different type of business. For example, "I was thinking this morning about how well this project has gone. Can you tell me who handles (other type of work) in the organization? I'd love to work with them as well."

Get on vendor lists. Many large organizations have lists of preferred or approved vendors for certain types of work. Unless your name is there, you probably can't be hired. Whenever you call upon large clients, ask. If they have such lists, make sure your name is added to all the job categories you feel comfortable working in.

Matching capability to market demand is one of the trickier aspects of running a design business. Manufacturing businesses can cushion demand variability by adjusting their inventories up or down. But our services can't be stockpiled. Each project is different, and delivery requirements are often inflexible.

Whether you manage a creative staff of a couple or dozens, your firm pays an average of 160 salary hours per employee per month. Too little work for employees obviously costs you money in under utilized capacity. But too much work can be costly, too—in requiring overtime pay or temp help. Equally important, too much work can jeopardize product quality, employee morale, and delivery schedules. Freelancers and small firm principals who work too many hours often neglect crucial, nonbillable activities.

Maintaining profitability requires balancing client demand and shop capability so that 50 to 75 percent of labor hours are billable. But how can a firm stay within this range when it is impossible to predict when clients will call? Or how large their projects will be?

LEARN FROM OTHER SERVICE INDUSTRIES. While profitability ratios are unique to every industry, problems caused by variable demand are not. Every service business has to wrestle with the effect demand instability has on its profitability. If, for instance, you think you've got problems, consider those of a typical airline. Every hour of every day they have to sell so many seats. Every one that goes unsold is a profit drain. On the other hand, if they oversell they face irate customers. Likewise, the same is true for hotels, restaurants, and other businesses that, like you, sell an inventory of expiring, reservation-based services.

So how do other service industries address this problem? More or less in the same ways we recommend you handle it.

STAFF FOR THE NORM, NEVER THE EXCEPTION. As unpredictable and variable as business may be at times, your shop has a normal activity level. Whatever it is, it should be the basis on which staffing is determined. As an example, if your firm billed 15,000 hours last year, and this year's numbers are running roughly the same, total staff should be about a dozen individuals. (The math: twelve individuals provide 25,000 yearly labor hours and a billable efficiency of 60 percent is 15,000 hours.)

If there are more employees your firm may be the victim of sloppy time accounting or have a work flow management problem. Or, it may also be staffed for occasional, as opposed to normal, activity. In the latter case staff reduction is the only cure unless there is more steady business on the horizon. The need to handle occasional peaks of activity should be

addressed only by temporary methods. Usually this means more work hours. Where this is not enough, temporary help is the only other solution. However much overtime and temporary help might raise your labor costs, it will be less than the cost of keeping staff around for occasional peaks of activity.

KEEP THE MARKETING FAUCET TURNED ON. A major mistake made by many design firms during times of peak activity is turning down their marketing efforts. Why market when you are already booked to capacity? In the context of demand variability there are two reasons. (There are also several others. See "The Major Benefits" in chapter 10.)

The first reason is that the purpose of marketing today is to bring in business for tomorrow when you might, indeed, need it. It can take a long time before some marketing efforts pay off, especially for high-prestige, high-profit projects. Firms that wait until they have a not-enough-work problem usually end up riding the feast-or-famine roller coaster.

Another reason to continue marketing despite your activity level is that many projects end up being delayed, and some others will disappear entirely. This often leaves large blocks of scheduled time suddenly not billable. The only way to ensure consistent work flow and to iron out the peaks and valleys of demand is to make your marketing efforts consistent, month in and month out. Whatever problems marketing at times of peak activity may cause, they are less than those caused by infrequent or inconsistent marketing.

DON'T BE AFRAID OF OVERBOOKING. The possibility of getting too much work at the wrong time is often the reason given for reduced marketing efforts, especially among smaller firms with minimal flexibility. The reasoning is that long-term success depends on building a reputation for delivering high quality work on schedule. Over promising and under delivering can kill a hard-won reputation fast. Yet, as valid as this concern is, it is also overrated. Problems caused by overbooking are rare.

Creative Business surveys find that most firms average getting only about 50 percent of the competitive, multibid projects they are asked to bid on by new clients. The success rate of competitive assignments from existing clients averages about 75 percent. In other words, there's a strong likelihood that not all proposals will be accepted anyway. Smart firms bid on more work than they can comfortably handle. In addition, many projects received stall, or end up going nowhere. As examples, anything involving a new product launch will almost certainly be delayed, while projects like annual reports and trade show exhibits often start later than scheduled, although typically without affecting the delivery date.

Good business management requires taking these factors into consideration. It also requires considering the fact that the availability of shop hours

is somewhat elastic. Most firms can handle an internal workload of up to 50 percent more than normal for at least several weeks. This means individuals can work up to sixty hours a week to get through an overbooking crisis if necessary. Not comfortable, but doable. Any excessive work load caused by overbooking could also be assigned to temporary employees, or it could be farmed out to freelancers. In the latter case it might even lead to a more virtual style of handling the projects of some clients.

The downsides of overbooking—the extra costs of overtime, farming work out, or hiring temps—although substantial, are nearly always less in the long run than the cost of not aggressively pursuing business.

TURN THE WORK DOWN IF NECESSARY. Turning clients and projects away is the backup scenario. It is not ideal, certainly, but surely better than missing deadlines or doing substandard work. It probably will have much less long-term effect on your business than it might at first seem. Truth is, many client priorities and deadlines, like budgets, are more wishes than absolutes. Projects often don't have to start or finish on the dates indicated. They are merely aim dates. There is more flexibility than indicated.

Leveling with a client about your workload problem might be all it takes to put off their project for a week or two. The implication should be clear and positive: you'd rather give up their business than jeopardize the quality and service you provide to every one of your clients.

What about clients that have real deadlines or that won't, for whatever reason, wait? Or how about that much-sought-after client who finally calls, only to be turned away? Don't worry about them. Among the most positive things that can happen to a creative firm is for clients to discover that it's in great demand. The more popular clients perceive a firm to be, the more they will want to work with it. Suddenly, clients who only reluctantly considered you will suddenly wait in line to work with you.

Even though it is a last resort, turning business away can actually turn out to be a blessing in disguise. What you lose today might come back tomorrow several fold.

The point to keep in mind is that taking in or turning away projects should be an objective business decision. Don't let unrealistic insecurities—"If we turn away clients they might never come back"—color your decision making.

❀ Electronic Help ❀

An increasing problem as a firm grows larger is how to keep track of all the data necessary to ensure that every job produces maximum profitability—all the job tickets, estimates, budgets, schedules, purchase orders,

change records, time sheets, invoices, and statements. While some of us may still prefer to use individual paper-based records or stand-alone software programs, the increasing complexity of jobs and business considerations often makes an integrated software package a better choice.

Indeed, many firms discover by accident that an integrated electronic approach to management is desirable at some point on their growth path. The impetus is often the realization that no direct tie exists between work flow and billing, or that data entry has become wastefully redundant (e.g., duplicate entry for estimates, work-in-progress reports, invoices, etc.), or that critical data often drops through the cracks (e.g., one or more time sheets is not entered).

DO YOU NEED IT? If you are a shop with five or more employees, or are smaller but handle lots of transactional data, there's a good chance that the right management software could propel your business farther and faster than whatever you are doing now. Here are five key indicators of a need.

Low billable efficiency. If you are consistently below the 50 and 75 percent billable efficiency range (or don't know what your efficiency is), you either need to seek the reasons why, or help in tracking time more carefully.

Deadline-based operations. If the modus operandi of your firm is deadline-based rather than budget-based, chances are you are losing money. Time is probably allocated to meet job deadlines, not to meet job estimates. The result usually is writing off a significant amount of work time when invoicing.

Duplicate data entry. The more times and places the same data is entered, the more it costs you; the more often it is shared, the more you save.

Unhappy clients. Client frustration because no one knows the status of a project except the person working on it and, more importantly, missed deadlines and blown budgets, are sure ways to damage your business. Regular, weekly status report updates on all projects in-house—automatically obtainable with most integrated software packages—can keep employees and clients well informed.

Organization. Continuing to store critical business data in your head becomes increasingly difficult as your company grows, and it also means you never actually leave work behind. Trying to organize an efficient, cross-referenced paper filing system is almost as tough. With an integrated software package, all critical data is in one organized, easily accessible database.

THE OPTIONS. If any of the above is a problem, you should consider implementing one of the integrated management software programs designed for creative services companies. At this writing these include AdMan

(www.admansoftware.com), Clients & Profits (www.clientsandprofits.com), DesignSoft (www.designsoft.com), StudioManager (www.tokerud.com/studiomgr.html), Traffic Office Manager (www.cormoranusa.com), and Job Order (www.joborder.com).

Although costly (typically several thousand dollars, including training), most larger design firms have implemented one of these programs and ultimately come to swear by it. It should also be noted, however, that the learning curve is steep and that successful implementation takes reorienting the firm's procedures as well as an insistence that all staff utilize it.

Financial Issues

T IS UNUSUAL for a design firm principal to be in business solely for the money. Lifestyle and the quality of work the firm produces are nearly always more important than money. By and large this is a good thing. A design business shouldn't fall into the category of a we'll-do-anything-necessary-to-make-a-buck business. But too much emphasis on product quality and lifestyle can also be a curse when financial issues are neglected. At the end of the day, a design firm is still a business, and financial issues are at the heart of all businesses. Think of it this way: the better off your company is financially, the more freedom you will have to do the type of work you want to do, and the better your lifestyle will become.

⊕ Funding Operations ⊕

"It takes money to make money." This may be an old business saw, but it is no less true today. Businesses that don't invest in keeping equipment and procedures up to date fall behind competitors that do, and may eventually atrophy. Those that don't invest in new ways of doing things seldom grow. You're probably well aware of this. But what is probably much less clear is just how much money it takes, and when and how to invest it. Most problematic of all, where will the money come from?

Funding a design business used to mean little more than purchasing drawing boards, flat files, felt-tip markers, desks, and typewriters. Equipment life was measured in decades. Even rapid growth could usual-

ly be funded out of ongoing revenues or an occasional personal loan. Today funding is a lot more complicated. Staying competitive requires keeping up with the computer technology curve, installation of constantly improving peripherals, and frequent software upgrades, to name just the obvious culprits. The needs for capital investment continue to grow.

So, what's the better way to handle your funding requirements? Do it only by reinvesting profits? Borrow money? The former can mean a cash-starved operation, slow growth, and missed opportunities. The latter can put your future at financial risk and be costly in interest charges.

THE NEEDS. Before considering how to arrange funding it helps to have an idea of what typical design firms require today. Here are three guidelines.

Tools. The tools of production currently average about $10,000 annually per employee when averaged over several years and all expenses are calculated—computers, peripherals, new software, software upgrades, outside consultants, training, downtime, installation, getting up to speed, insurance, taxes, etc. Firms heavily involved with interactive media often spend more. Even freelance designers average more than $5,000 annually, when all costs are considered. Although ongoing expenses should always be covered out of the firm's revenue stream, capital expenses, such as new computers and peripherals, may require an additional funding source.

Cash-flow cushion. A design firm should have financial resources that will allow it to meet three months of average overhead in case of problems. To see how close you come, first add up all your normal monthly outlays—overhead, salaries, miscellaneous expenses, etc. Then add up all your liquid assets—checkbook balances, savings, money market funds, etc. (Do not include accounts receivable or illiquid items such as stocks, CDs, or retirement funds.) In compiling these figures it is usually better to take yearly totals and divide by twelve since the numbers often vary from month to month. If your average assets are less than three times the average monthly outlay, the deficiency should be covered by a bank line of credit equal to that amount.

Growth. This is, of course, determined by opportunity and ambition. There's no way to put a number on what's appropriate for you. What we can do, however, is remind you that growth is seldom an imperative for a design company. Also, that financing is usually the least of a firm's growth problem, and that the attractiveness or unattractiveness of growth should be considered in more ways than simply more clients and higher revenue. (See "Managing Growth" in chapter 14)

WHAT'S AFFORDABLE? Before looking for outside funding to provide new tools or growth consider the following affordability tests.

What will be the return on investment? However calculated, capital spending should provide a clear benefit (return) that outweighs its cost (investment). An investment that does away with the need for outside services or that allows you to pursue a new opportunity should return its cost (including loan interest), plus a 20 percent yearly profit, or return on investment (ROI). If this is not possible, it is probably better not to make it. The 20 percent ROI figure also applies to investments that result in a competitive advantage or an improvement in business efficiency (example: faster computers), although this is much harder to track. The ROI on some other investments, such as office location and furnishings, while equally important, is nearly impossible to compute. Your gut feeling will have to suffice. Keep in mind, though, that while spending on items that strengthen internal morale and the company's marketplace image can be crucial, it is easy to go overboard. The investment still has to provide benefits that outweigh its cost.

What's your debt-to-equity ratio? It should remain lower than .60 (debt no more than 60 percent of equity). To find yours calculate debt by adding up accounts payable, known tax liabilities (sales, income, payroll), and deposits for client work yet to be done. Also include the total current fixed obligations, such as equipment leases, equipment loans, and lines of credit. If you are doing this before making a major purchase, add in its cost. Now figure your equity by adding up the depreciated value of your furniture, fixtures, leasehold improvements, and equipment. Add savings, cash, and accounts receivable. Here, too, count the value of an item to be purchased. Finally, divide debt by equity.

What's your quick ratio? It should be at least 1.25, and ideally 2.0 (current assets from 125 percent to 200 percent of liabilities). To calculate it, pick a point in time, like the end of the month. Then compare the results from month to month. First, add up current liabilities. Include accounts payable, known tax liabilities (sales, income, payroll), deposits for client work yet to be done, and any outstanding equipment leases and loans. Be sure to also include all credit card debt and the balance on lines of credit. Second, figure your current assets, which are savings, cash, and accounts receivable. Third, divide assets by liabilities.

OTHER CONSIDERATIONS. Here are four things to keep in mind when considering a loan or lease.

Appreciating versus depreciating assets. Business equipment items are depreciating assets. That is, their value diminishes immediately upon purchase and continues until there is no value remaining. Depreciating assets should always be paid off faster than they lose their value. Appreciating assets are scarce items, or ones not obsoleted by changes or exhausted by use. The best examples are real estate or a long-term lease. Although there

is no guarantee that anything, including real estate, will appreciate, there is a strong possibility. Borrowing to acquire a depreciating asset usually subtracts from a business's equity; doing so to acquire an appreciating asset usually adds equity. In addition, if the borrowing is to acquire business real estate it also eliminates leasing concerns and may have tax advantages.

Is it required to do business? If there's no way you can enter or stay in business without certain items, and no cash is available, borrowing becomes necessary. The danger comes from including as "essential" items that really aren't. It is easy to get carried away and include more than you need when taking out a loan. ("What's a few hundred more dollars spread over a couple years of payments?")

Will you miss an opportunity? The previous rationale and caution apply here. Is this a real opportunity or just an optimistic projection? It is true that you have to spend money to make money. But equally true is that risk and reward are closely related. The investment required to tap a great opportunity always carries great risk along with it. If you find yourself faced with an overwhelming need to expand based on a new opportunity, try to get an outside, objective opinion before making a financial commitment. Putting borrowed money on the line dramatically increases the fallout that comes from making a bad prediction.

Strengthening your business's credit rating. A history of having loans and paying them off on time is a crucial element in building a good business credit rating. A good credit rating also is crucial for getting good terms from suppliers. Taking out an occasional loan is beneficial for no other purpose than maintaining your credit worthiness.

OPTION #1—INTERNAL FUNDING. Funding your needs internally sounds like the ideal whenever possible. There are no outsiders to deal with, no applications or forms, no interest charges or fees. What more needs to be said? Well, the ideal and the reality are somewhat different. Most businesses, including creative ones, have to get outside funding at some point. Here's why:

The profitability problem. A business can't fund purchases or activities out of profits that don't exist, and most design businesses don't make a profit. They pay their bills and reward their principals, sometimes even generously. But they don't make a profit. That is, they don't leave money in the company for such necessities as capital improvements. Occasionally this is out of greed and shortsightedness—the principals' desires to take home as much as possible, as soon as possible. Sometimes it is for valid tax reasons (see below). Most commonly, though, it is because they haven't factored profit into their pricing. Whether pricing is done on an hourly-fee or per-

job basis, a profit margin should always be included (typically 15 to 30 percent). Profit is not simply what, if any, money is left after all business costs are covered. It should be planned for in every project. (For more see "Looking at Profitability" below.)

The culture problem. We live in an age when debt is aggressively marketed and credit easy to obtain. When it's so easily available it's tough to wait until needs can be internally funded. Keep in mind, though, that the easier money is to get, the more expensive it becomes. You could, literally, end up paying twice as much for a purchase as necessary. Internal funding is always much less expensive. The more your business saves, the more it earns. Access to easy money also diminishes the rigors of determining what's truly needed and what isn't. Internal funding, trying to come up with the money out of your own resources, reduces the possibility of overbuying or overexpansion. It is sometimes called the "cash availability test" of need. Put another way, the more difficult the money is to come by, the more carefully it will be spent.

The accounting problem. Internal funding also has implications that are specific to every business. For example, leaving money in a C corporation at year end increases its taxes. It may be better as an alternative to show no profit and have principals loan the corporation money for internal funding out of their salaries. Whatever your situation is, be sure to go over funding ramifications with your accountant.

The liquidity problem. As indicated previously (see "Cash-flow cushion" above) a design firm should maintain liquidity that will allow it to weather a short-term crisis, such as the sudden loss of a major client. In some cases it may be better to keep cash in a high-interest reserve account while borrowing to acquire capital equipment. The cost will be minimal (interest paid minus interest earned) and you'll be able to retain your cash reserve for emergencies.

OPTION #2—BANKS. They're usually the least expensive source of outside funds. Interest rates for commercial (business) loans typically run two or three points above the Prime Rate (the Federal Reserve Rediscount Rate). This is a couple percentage points below consumer loans, and can be up to ten percentage points lower than credit card cash advances. When applying for bank funding keep in mind that banks are not in the risk or venture capital business. They only lend money on sure things and for specific purposes. (For information on venture money, see "An investor" below.) The bank that handles your company's checking and depository accounts is the first place to apply. They already know something of your financial history and they should want to keep you as a customer.

If you are a woman or minority, you should make sure that where you apply is either a Small Business Administration (SBA) Certified or

Preferred Lender. Although many banks can make SBA-guaranteed loans, Certified and Preferred Lenders are more likely to, and they cut down the average loan processing time. (For more information visit the SBA Web site: www.sba.gov.)

The more financial activity you can generate with any bank, the stronger your position will be when applying for funding. If you currently use more than one bank—e.g., for personal and business accounts—it may be wise to consolidate all your accounts when arranging for funding.

Loans and equipment financing. For most equipment purchases bank rates are lower than those of equipment leasing companies, and with a bank loan you own the asset and are free to dispose of it whenever you wish. As for ease, you've probably heard the old saying about banks only lending money to those who don't need it. Well, lately it's been turned around: if you can't get a secured loan you probably don't deserve it. Banks are more receptive and competitive than at any time in history. Even so, you'll almost certainly have to provide a personal guarantee to obtain a loan in your company's name.

Lines of credit. Unlike loans and financing, which are for specifics, lines of credit are to cover occasional cash shortfalls. Because they are not for a specific purpose and are less secure, they are somewhat harder to obtain. Nonetheless, most design firms should have one, preferably tied to a checking account overdraft feature. (See "Cash-flow cushion" above for our recommendation.) A caution is also in order here, though. Lines of credit are tempting. They should be reserved for emergency needs only— meeting payrolls, cash-flow slowdowns, covering bounced checks, etc. Don't fall into the trap of funding operations or capital expenditures from a line of credit.

OPTION #3—LEASES. It is nearly always easier to qualify for a lease than a loan. Down payments are usually minimal, dealers often handle paperwork, and when the lease is over you simply turn the item in, or purchase it for a sum agreed upon in advance. With a few exceptions (autos with high resale value, multi-unit purchases, etc.) interest rates are usually higher than with straight commercial loans. In addition, leases usually lock you into a payment schedule with no freedom to dispose of the item (or only with a high penalty).

The pitch. Chances are you've heard leases described this way: "New (computer systems, etc.) drop in value so fast, and the technology changes so rapidly, you're better off leasing, not owning." While it is, indeed, easier to upgrade most leased equipment, it is rarely cheaper. Trading up to a newer model and extending the lease term is a convenience, but payments usually go up at the same time. The more you trade up the more costly it becomes. It can be difficult to get out of the leasing cycle. Then too, and

despite rapid advances in technology, there's usually little or no imperative to replace an item before it is paid for anyway.

Two types. Operating leases are essentially rental agreements. With them it is possible to "expense" the cost as it is used rather than depreciating it for tax purposes. This may or may not be a benefit in some situations. Check with your accountant before signing a lease. Financial leases are simply another, usually more expensive way of purchasing an item over time.

OPTION #4—ALTERNATIVES. In addition to the traditional ways of funding, the following options are also available. They are listed in order of declining attractiveness.

Yourself. Taking out a home equity line of credit (second mortgage), borrowing against personal savings, or taking out a loan on insurance policies will get you a better interest rate than any commercial loan or lease. The only downside is that your firm will not be strengthening its credit history.

State and local programs. All states and some regions and cities have development funds available for selected small businesses, especially those run by women and minorities. Check with your state Office of Economic Development or local Chamber of Commerce.

An investor. He or she could be a relative, friend, or interested party (an "angel"). The upside (usually) is low interest and flexible terms; the downside (often) is giving up some control and possibly losing a friend. As for professional investors, such as venture capitalists, it is unlikely you will be able to attract them. The stakes are much too low for even the smallest serious investor.

Sharing ownership. Selling a portion of your company to employees or outsiders will raise funds, but it will also raise management and control issues. Don't attempt it without legal advice. (See chapter 1.) As for selling shares publicly, it is not possible without meeting the stringent requirements of the Securities and Exchange Commission (SEC), which will make it impractical.

Credit cards. Perhaps you've heard a story similar to this one: The principal of a successful company says that back when the company was small he had to resort to "maxing out my credit cards" to obtain growth capital. Now his successful company has to fight off bankers offering to help finance expansion. Assuming your funding need is to back a "sure thing," might this be a viable funding alternative? Probably not. Money obtained this way will usually be at the highest interest rates allowed by law (up to 30 percent). This means that the return on whatever the money is used for must be tremendously high for it to be a wise financial move. It is hard to project a normal situation where credit card financing would be beneficial for low-margin creative companies. This is in addition, of course, to the

reality that if the need were indeed for a "sure thing" you almost certainly could get funding through conventional channels.

⊕ Figuring Profitability ⊕

Profit is the sine qua non—the indispensable element—of every successful business. Whether big or little, brimming with talent or lacking it, if it doesn't have a deep-pocketed angel, a business either makes a profit or sooner or later it will be history. But how to define profit? What is acceptable? What is not?

These are relatively simple questions to answer when asked of larger businesses, especially publicly held corporations. Profit is the income left after all of a company's expenses have been paid. If it is more than what their investors could have received elsewhere, profitability is good; if it is less, profitability is not so good. But among small, privately held companies—single or multiperson—the situation is different. If the investors also work for and manage the company, they may prefer to pay themselves high salaries, which will reduce the funds available as profit. Yet, as both employees and investors, they will personally end up as well off as if the company paid them less in salaries and distributed more to them as profit. In short, a company with high salaries and little or no profit could be better off than one with low salaries and more profit. In fact, where the company is a C Corporation, this is often a tax strategy employed to minimize tax obligations. (Caution: See the comment about unreasonable compensation under "Our method" below.)

Further, with small companies profitability isn't necessary to attract more capital or maintain share prices. So there's no imperative to produce profits to please outside investors. Finally, there is the question of how appropriate the concept of profitability is for sole proprietorships, Limited Liability Companies (LLCs), Partnerships, and Subchapter S Corporations. For these types of organizations any income left after expenses is treated for tax purposes as the principals' income anyway.

WHY YOU SHOULD CARE. Even when an organization is privately held and its owners are also employees, it helps to recognize the importance of profitability. Here's why.

It's the accepted way of keeping score. With the obvious exception of not-for-profits, profit is the recognized benchmark for evaluating most firms' performance. It should also be for design firms. Merely covering expenses

and paying oneself a good salary may not be enough to provide what you, and others, need to make informed decisions. You may also need some measure of profitability.

It's the language of business. Profit drives what clients make, how they make it, how much they spend, and where they spend it. Gaining their trust requires the ability to think as they do—to talk their talk and walk their walk. Otherwise, you're considered just another creative, and your work will unlikely be treated with the respect that's afforded a fellow businessperson.

It helps you resist price pressure. A design firm's profit is the aggregate of all its project profits. Knowledge of the big picture increases the chances that each individual project will be priced profitably; there's less chance of feeling guilty about, apologizing for, or caving in to pricing pressures.

It helps institutionalize your business. Tracking profit is an important component of institutionalizing a business—standardizing its procedures and making it independent of the principals' idiosyncrasies.

It provides a basis for profit sharing. If your firm provides bonuses or has a profit sharing plan, payout should be based on reaching a predetermined profit level. (For how to figure employee bonuses, see chapter 6.)

It may be necessary. A consistent profit is often a crucial factor in negotiating a line of credit, raising investment capital, or planning to sell a business. In such situations the more profit a C Corporation shows, the better.

It may have tax implications. This is the other side of the aforementioned. It is usually beneficial for tax purposes for principals of C Corporations to take out most of its proceeds as salary. In other words, to reduce corporate profit. On the other hand, it may be necessary to show a profit occasionally. Otherwise, the IRS may determine that the corporation is not a real business, just a hobby. Only your accountant can tell you what is best for you.

OUR METHOD. For the reasons above, we think all design businesses—large and small—should calculate the amount of their income that represents profit. For Sole Proprietorships, Partnerships, LLCs, or S Corporations, this will be a new exercise. For C Corporations, it will be an addition to existing profit calculations, but need not change the amount declared as profit for tax purposes.

Rather than use the salaries employee-owners pay themselves to calculate profit, Creative Business recommends using salaries typically paid to managers having similar responsibilities. (See the sidebar "Salaries to Use to Determine Profit" on page 308.) Any amount remaining in the

Income (AGI)	Salary
<$100k	$ 45,000
$100/200k	$ 60,000
$200/400k	$ 75,000
$400/600k	$ 85,000
$600/800k	$ 95,000
$800k/1.25m	$125,000
$1.25/2.5m	$150,000
$2.5/3.5m	$175,000
$3.5/4.5m	$200,000
$4.5/6.0m	$225,000

Salaries shown are intended only for calculating the profitability of privately held creative service companies whose owners are also employees. They should not be used to determine the pay of specific individuals.

Salaries are reasonable remuneration for managers of United States creative service organizations with the yearly dollar responsibility indicated when prepared in 2001. Companies with two or more principals should add 50 percent to the figure shown.

company after all other expenses are taken care of we call profit. Ideally, principals receive their regular paychecks on this basis, and the profit is paid out occasionally as a "profitability bonus." The total yearly payout, salary plus profitability bonus, would be the same as before, just split up and defined differently.

For C Corporations, actual (taxable) profit needn't be affected by this method. The profitability bonus calculation can be paid out as a salary to avoid the double taxation that might come if it were declared as corporate profit. (Caution: High-earning principals should be wary of "unreasonable compensation" to avoid corporate profits. If you should be fortunate enough to be earning several times what is shown in the sidebar for a given level of responsibility, be sure to check with your accountant.)

This method of profit determination for companies with owner-employees is essentially no different from that used by larger companies where managers' salaries are set by others using independent criteria, never by themselves. It is also the method used to determine profitability when doing business valuations. (In accountant-speak, this is called "purifying the income statement.")

As an example, let's say you are the sole principal of a firm with AGI of $1 million, who took

a salary (everything after all expenses were paid) of $175,000 last year. Your firm showed no profit. Using our calculation (see the sidebar) a suitable salary would have been $125,000, and if so, the firm would have had a profit of $50,000 (5 percent), which would be paid to you separately as a profitability bonus.

HOW MUCH? The salaries in the sidebar are based on what you could expect to be paid if you were hired to manage a creative service operation of the sizes indicated. If the salary you take out of your company annually is lower than what another operation of its size typically pays for a manager, your company cannot be considered profitable, even though it may provide you with an income. Meeting all a company's obligations, salaries included, is not the same as making a profit.

If your annual salary is higher than the amount shown for running an operation of its size, the difference between this amount and your salary is a reasonable approximation of your company's profitability. (To determine profit as a percentage of sales—your profit margin—divide profit dollars by AGI dollars.)

When doing profit calculations, also keep in mind that salary and profit are just two of several ways principals are rewarded. Company benefits are not included in the calculations, nor are such perks as expense-paid travel, entertainment allowances, and company cars. A rich mix of these won't show up in salary, and will depress profit. Yet, they add significantly to the appeal of being a shop principal.

Some profit should be expected each year using our profit determination method. It is, however, difficult to say just how much, other than the more the better.

Founders of design firms are seldom typical entrepreneurs. The attraction of running a business is usually less pure financial gain, more a combination of loving the work, doing it in an environment of their own choosing, and making enough to enjoy a good, often stylish, lifestyle. Partly because of this, and partly because of the volatile nature of service businesses, design firms are not terribly profitable as a rule. Private firms, where the owners are not employees, or they are but don't set their own salaries, struggle to achieve a 10 percent profit. Even large, publicly traded advertising agencies report profit margins that rarely exceed 10 percent. (By comparison, typical Fortune 500 corporations have profits that range from 10 to 35 percent.)

There is also another factor when considering the profitability of smaller design firms: whatever the profit, it shouldn't be tied to the performance of one or two individuals or accounts. When this is the case it is far less desirable. Indeed, a high profit under these circumstances may say more about a business's vulnerability than how well it is doing.

Perhaps the best way to determine what profit should be for an owner-run business is to look at the value of the talent of its principals in the open marketplace. When viewed this way, the difference between the principals' compensation working for their own company and what they could expect to be paid as employees of another firm equals the real profit of working for themselves. For example: if total compensation for two principals was $150,000 and they could only command total salaries working somewhere else of $120,000 ($60,000 each), the profit of their business would be 20 percent, or $30,000 divided $150,000. If they could command higher total salaries than $150,000 working somewhere else, there is no profit—it is a profitless firm run for its lifestyle benefits.

FACTORS THAT AFFECT PROFITABILITY. Once there is a uniform way of measuring profit for privately held firms with owner-employees, looking at ways to improve it can be more productive.

Pricing. This is a no-brainer: higher prices produce higher profits. If your profits are low, it may be because you are pricing your services on outdated cost-of-doing-business calculations. As an indication, if you haven't raised prices within the past year or so, chances are your firm is less profitable than before.

Overhead. Another no-brainer: higher costs equal lower profits. While keeping an eye on all expenses is important, be particularly watchful of staffing. It is the largest expense category for creative service companies. Total pay and benefits (yours included) should be no more than 70 percent of income. If higher, either employees are paid too much or clients are charged too little.

Clients and jobs. Certain industries (e.g., publishing) have a history of paying low prices, which leads to low design firm profits. Certain assignments (e.g., packaging) have higher profit potential. Some clients are easy to work with, some not. All things being equal, larger clients and jobs usually produce higher profits than smaller ones.

Marketing. This is the way to change an insufficiently profitable mix of clients and jobs. Although in the short run low marketing costs—spending less on promotions, sales commissions/salaries, time pitching new clients—can boost profits, in the long run it works the other way around. When handled correctly, marketing is an investment that ultimately leads to more profitable work. If you (or, God forbid, your clients!) believe otherwise, you're in the wrong business.

Repeat versus new clients. Projects for current or former clients can have lower marketing costs and there's less nonbillable time getting to know the client. This can increase profit potential. Offsetting it, however, is the tendency to pass many of these savings along in lower prices. Nonetheless,

the result can be a profit increase of up to 20 percent on these jobs. As attractive as this additional profit is, it is also dangerously seductive. Having too few clients, even very profitable ones, makes a creative firm vulnerable to client whims and idiosyncrasies, and, of course, to the sudden loss of a substantial chunk of business.

Budgeting. Firms handling mostly ongoing assignments (e.g., advertising) can improve account profitability by the way in which they budget. They should first decide on the profit percentage they want to achieve (for these purposes we recommend 25 percent). Then, after conservatively estimating account income, they should subtract this profit from it. What remains is what the account can afford for expenses.

Estimating. The fastest way to improve profitability for most project-based firms is to adhere to, or increase, time estimates. Most of us are pretty good at estimating how much time is required for any given task. But most are also very bad at sticking to it. Creative Business's experience is that many employees put more time into a given task than called for in the job estimate. If it were deliberately figured on the high side (i.e., padded), actual time and billed time end up roughly the same and there is little profit impact. If not, and the client can't be billed for the difference, jobs end up costing more than anticipated and profit falls. Recognizing and addressing this problem will probably have a greater effect on the profitability of a shop than several new clients and assignments. The ability to make a little more on many jobs is far more remunerative and less risky than trying to make a lot more on a few jobs.

Billing rates. The cost of any employee's time, yours included, is the same despite the activity engaged in. So if you use tiered labor rates (different ones for different functions) make sure the billable rate for a given function is high enough to make a profit on the employee performing it (usually at least three times hourly pay). Or don't allow higher-paid employees to handle low-billable functions. If you use a blended rate (one hourly labor rate for all functions) make sure that it is a representative average of shop labor costs multiplied by three.

Discounting. It is seldom less costly to do a job for one type of client than another. Most discounts based on client status (e. g., a not-for-profit, a mom-and-pop, or a start-up) are paid for out of your profitability. Moreover, when less profit is made on some jobs and clients there is a tendency to try to compensate by making more on others. This can lead to a competitive disadvantage when going after the very jobs that are the most desirable. (See "Give a Break to Not-For-Profits?" in chapter 12.)

The low-profit trap. In the short-term a low-profit job is better than no job at all. But, if accepting such jobs becomes a common practice, low pricing

and low profits can easily turn into normal pricing and no profits. Be as concerned about lowering your profit standards as lowering your creative standards.

Specialization. All other things being equal, an individual or firm that specializes—in an industry or a certain type of project—has greater profit potential. Specialization produces higher-level projects and clients, limits competition, and reduces costs. Although there are also many downsides to specialization, profitability is not one of them. (See "Is it Better to Specialize?" in chapter 9.)

Size. Finally, there is a common and mistaken belief that a firm's size and its profitability are synonymous. Bigger shop, proportionately bigger profits; smaller shop, proportionally smaller profits. Well, this isn't necessarily so. Larger shops are better able to compete for larger, more potentially profitable projects. But, larger shops also have higher overhead. So it pretty much equals out. Unlike other industries where size can produce scale economies, size and business costs among creative service companies increase linearly. Don't confuse income or number of employees with profitability. The most profitable size for a creative firm is simply the size at which its principals can run it most efficiently. (See "How Big?" in chapter 14.)

❧ Improving Billable Efficiency ❧

Time is the lingua franca of the design business. While there are many things—talent, experience, service, etc.—that differentiate each of us, the one thing we all have in common is that we all sell time. Even if you are one of those individuals who doesn't always price jobs based on time estimates—that is, you charge whatever you think the traffic will bear—in essence you are still selling your ability to accomplish so much activity within a given period. (We do not recommend this method as the norm because it camouflages how well a firm is or isn't actually doing.)

LIMITED OPTIONS. Companies in other industries can look at many different options to improve profitability without raising prices. They can, for example, negotiate lower prices on raw materials, or buy more efficient manufacturing machinery, or streamline distribution channels. In contrast, our options are limited. We can either: 1) get more accomplished within a given period—i.e., bill multiple clients for the same time; or 2) bill for more of the finite hours that are in every day. Practicing time management and recording is the only way to accomplish either.

TIME MANAGEMENT. Before going into the specifics, we should first dispel any notion that time management is antithetical to creativity. Quite the

opposite. In the commercial environment in which we work, it usually increases, does not decrease, quality. So while this is about increasing profitability through time-management techniques, keep in mind that it needn't come at the expense of your creative product.

Minimizing work-flow inconsistency. Large variations in work flow—being either overloaded or having little to do—is one of the more costly problems among creative businesses of all types and sizes. During busy periods stress runs high, service is jeopardized, and profitability often suffers because of inefficiencies and being too busy to keep track of extra costs. During non-busy periods, costly facilities, equipment, and personnel are underutilized. As common as boom or bust cycles are, they are not part and parcel of a design business. Aggressive, well-directed, and consistent marketing can substantially reduce variable work flow. Thus, a solid marketing plan is among the most important components of time management.

Maintaining motivation. Despite a strong commitment to marketing, some work flow variability usually still occurs. Most firms have ways, albeit often informal, to keep employees motivated during the panic times (through comp time, parties, gifts, etc.). But few also have a way to keep employee motivation high during slow periods, when it can be equally important. (Note: Comp time should be time taken off the job, never relaxation on it.)

A productive studio is a happy studio. When employees are not productively occupied, morale and quality suffer. To avoid this, keep a house projects list consisting of tasks such as installing software and equipment upgrades, training, reorganizing files, entering award competitions, and working on promotional materials. Treat each project or task just as you would one from a paying client—i.e., assign it to an account number and make sure all time is recorded. Doing this is the only way to keep a handle on nonbillable, "house" time.

Keeping meetings productive. Meetings are the biggest time waster in many design firms. To combat the problem, require that any meeting of three or more employees be authorized by a firm principal or creative director, and that every one have a leader, an agenda, and a time limit. Firms of three or more employees should have weekly review (staff) meetings; those with more than a dozen employees should probably have several, organized around clients or functions. Here, too, rules are necessary: held at the same time every week (preferably early Monday morning); all appropriate employees required to attend; organized around an agenda by a shop principal or production/traffic manager (not freewheeling discussions); everyone to give a status report with emphasis on activities of group interest; over in an hour and a half at most. Of course, all client meetings should be recorded as billable time.

Adhering to time estimates. Arriving at a price that will be both competitive and profitable takes skill in figuring out how much time a job will actually take. Experience, breaking it down into its components, and having good records help, as does job-to-job estimating consistency. (For assistance see the estimating worksheet in appendix IV.)

The hours estimated for each function of each job should provide the basis upon which work flow is scheduled. When starting any given task, whoever is working on it should be aware of the time allocated and use it as a guideline for how much effort is appropriate. Entry should be at the end of the task, not reconstructed later from memory. Most importantly, what

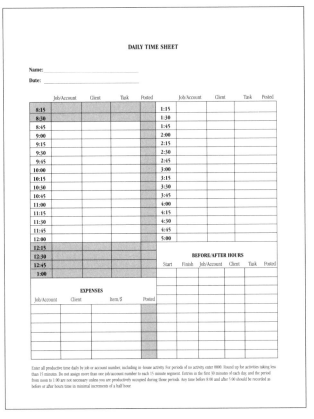

Sample daily time sheet.

is entered must be the time the task actually takes. Under no circumstances should the recorded time be adjusted to meet the estimate. When this is the case it is impossible to accurately track how long a job really takes, profit calculations fly out the window, and job records become an invalid data source for future estimating.

If, as often happens, a task takes longer than was estimated and an adjustment is necessary to keep within the client's budget, this decision should take place later, at the time of invoicing. Adjustments should never take place at the working stage. Only the failure to accurately track and record time can cause more lost profit than ignoring a job's estimate during production.

Time recording. Every minute of every billable person's work day must be accounted for, including the principals in firms where they function in a

billable capacity. No exceptions. Time recording provides the data upon which a firm's billing and profitability are based. Incomplete or inaccurate recording ultimately hurts everyone—principals who earn less profit, employees who receive fewer raises.

The normal means are time sheets filled out daily and turned in weekly. As an alternative, time keeping may be accomplished automatically with software, providing all an individual's activity occurs at a computer work station. If some activity happens elsewhere, data must also be entered manually into the program. (See "Electronic Help" in chapter 14.)

A representative time sheet is shown opposite.

Confidential

EMPLOYEE PRODUCTIVITY RECORD

Name: _____ Month: _____

Week 1: Payroll hours
 ÷ _____ billable hours = _____ % billed
 x $ _____ billable rate = $ _____ income
 + $ _____ overtime fees
 − $ _____ overtime costs
 $ _____ weekly income
 − $ _____ weekly salary
 Profit contribution $ _____

Week 2: Payroll hours
 ÷ _____ billable hours = _____ % billed
 x $ _____ billable rate = $ _____ income
 + $ _____ overtime fees
 − $ _____ overtime costs
 $ _____ weekly income
 − $ _____ weekly salary
 Profit contribution $ _____

Week 3: Payroll hours
 ÷ _____ billable hours = _____ % billed
 x $ _____ billable rate = $ _____ income
 + $ _____ overtime fees
 − $ _____ overtime costs
 $ _____ weekly income
 − $ _____ weekly salary
 Profit contribution $ _____

Week 4: Payroll hours
 ÷ _____ billable hours = _____ % billed
 x $ _____ billable rate = $ _____ income
 + $ _____ overtime fees
 − $ _____ overtime costs
 $ _____ weekly income
 − $ _____ weekly salary
 Profit contribution $ _____

Monthly totals:
 Billable efficiency _____ %
 Profit contribution $ _____

Sample employee productivity form.

Copy or borrow from it as appropriate. It is based on an eight-hour work day with a one-hour lunch break and assumes that all an individual's time is billable at a single rate. For accounting reasons, we do not recommend an individual use different billing rates for different tasks.

For recording normal working hours it uses time segments rather than providing blanks to record starting and finishing a task. We believe this method is better because it helps maintain accuracy, and is also simpler for the reporting individual. It breaks the day into fifteen-minute segments. Some firms may prefer thirty-minute segments; some principals may wish to record by the hour or half day.

A short list of house account numbers should be provided for nonclient activity (e.g., computer glitches). You may also wish to provide a short list of terms to standardize the reporting of tasks. We do not recommend the

use of task ("function") codes except in large organizations with automated data collection. The "posted" column is for entering the date when the time is recorded against the job or account.

Note that the first half hour of each day is not normally recordable because it represents setup time. Nor is an individual's lunch break. Exceptions to recording these periods should be made during busy times when individuals are occupied by billable work. (There's no free time at day's end because professionals should be expected to perform shutdown functions after normal working hours.)

All entries should be made immediately after a task is completed, or at least by day's end. They should never be reconstructed later from memory. To emphasize the importance of prompt and accurate entries, we recommend that time keeping be one of the factors considered in employee performance evaluations, and that employees be aware of the fact that they will be evaluated on it. Each individual's time sheet should be collected at the end of the week by the appropriate individual—project/production/office manager, bookkeeper, or principal—for entry into job/account records on Monday morning.

PRODUCTIVITY TRACKING. In addition to making sure that clients are billed for time spent on their jobs, time sheet data is also helpful in tracking nonbillable house account and inactive time. Most principals seeing the amount of non–income-producing effort for the first time are surprised by its extent.

By transferring time sheet data to a productivity record it is also possible to get a fix on individual efficiency and profitability. The more productive an individual is, the more he or she earns for the company, the more you can (and should) pay out in salary, and vice versa. A record of each employee's productivity provides an objective measure useful whenever considering salary adjustments.

Maintaining such records is, of course, labor intensive. Too much emphasis on productivity can also diminish the importance of other aspects of performance—creative quality, friendliness, client relations, etc. For these reasons, we recommend looking at productivity only two or three times a year. The objective in doing so is to note trends, recognize over- and underperformers, and maintain awareness of overall firm productivity.

However often employee productivity is viewed, also keep in mind that in many instances it is beyond his or her control. For example, employees working on crash-prone computers, those given insufficient direction, and those not provided with an adequate work load will fair poorly through no fault of their own. Nonetheless, monitoring individual productivity is important. When results are compiled and averaged for all employees

(including nonbillable staff), the result—the firm's billable efficiency—provides the single best long-term index of its health. An employee productivity form is shown on page 315.

⊛ Balance Sheets and Income Statements ⊛

These are the way to keep an eye on the financial condition of your company. At minimum they should be automatically prepared yearly by your accountant from the figures used to file your company's tax return. If they don't accompany your tax returns, ask. You, your bookkeeper, or your accountant also may want to prepare them more often. For many larger firms it is a monthly exercise.

BALANCE SHEETS. They are divided into short- and long-term, with one year usually forming the dividing line. Short-term (current) assets include cash and items that can be turned into cash within one year; receivables (what clients owe you); investments; work-in-progress; and payments made in advance. Long-term assets include the fair market value of equipment owned, real estate, etc.

Typical balance sheet for an eight-person firm.

ABC Design
Balance Sheet
December 31, 0000

Assets—Short-Term or Current	
Checking Account	$ 60,031
Savings/Investments	$ 6,434
Accounts Receivable	$139,048
Loans Receivable	$ 2,214
Tax Escrow	$ 19,961
Prepaid Expenses	$ 23,294
Work Completed But Not Billed	$ 38,345
Total Short-Term	$289,327

Assets—Long-Term or Fixed	
Equipment & Facilities (Fair Market Value)	$ 33,765
Less Accumulated Depreciation	− $ 28,612
Total Long-Term	$ 5,153

Total Assets	$294,480

Liabilities—Short-Term or Current	
Accounts Payable	$ 120,837
Not-Yet-Billed Payables	$ 21,000
Salaries Due	$ 62,750
Taxes due	$ 30,103
Loan/Lease Payments Due Within One Year	$ 12,200
Total Short-Term	$246,890

Liabilities—Long-Term	
Loan/Lease Obligations Beyond One Year	$ 9,700
Total Long-Term	$ 9,700

Total Liabilities (Debt)	$256,590

Owner's Equity	
Retained Earnings	$ 37,890

Total Liabilities & Owner's Equity	$294,480

Liabilities. Like assets, they are divided into short- and long-term. Short-term (current) liabilities are obligations that must be paid within one year, including installments on long-term debt; accounts payable (what you

owe vendors); taxes you owe but haven't paid; and pending obligations like payroll, pensions, and taxes. Long-term liabilities include bank loans, loans from other sources, mortgages, leases, etc. In each case, payments for the current year should not be included in long-term calculations.

Owners' equity. As defined above, the difference between assets and liabilities always equals owners' equity. And it is the same regardless of the number of owners. Note, however, that owners' equity is not necessarily equivalent to what you could sell the business for. (For more on valuation and cashing out, see chapter 16.)

ABC Design
Income/P & L Statement
December 31, 0000

Revenues

Gross Sales	$1,076,343
Less Pass-Through Income (Printing, etc.)	—$ 260,000
Non-Sale Revenues (Interest, etc.)	$ 780
Other	$ 1,444
Agency Gross Income (AGI or Net Revenue)	$ 818,567

Operating Expenses

Payroll/Benefits	$ 502,000
Payroll Taxes	$ 30,068
Insurance	$ 3,050
Professional Services (Legal/Accounting, etc.)	$ 5,200
Rent, Utilities, Maintenance, RE Taxes, & Cleaning	$ 60,000
Equipment Leasing, Repairs, & Maintenance	$ 61,000
Telephone, Internet & Communications	$ 7,500
Office Supplies, Shipping & Postage	$ 9,000
Depreciation & Amortization	$ 43,000
Promotion (Materials, Advertising, etc.)	$ 18,000
Travel & Entertainment	$ 7,200
Donations	$ 1,000
Pension Contributions	$ 10,200
Other	$ 1,455
Total Operating Expense	$ 758,673

Net Profit Before Corporate Taxes	$ 59,894

Typical income statement for an eight-person firm.

INCOME STATEMENTS.

These show your profits and losses on a monthly, quarterly, or yearly basis. They often bridge the time period between balance sheets. They should list all revenue (income), all expenses (costs), and profits (the difference between income and expenses).

Revenues. These include sales less pass-through income (e.g., what you paid printers for jobs you marked up) and any other income. The total is usually referred to as AGI (Agency Gross Income). It may also be referred to as net revenue.

Operating expenses. These include payroll, payroll taxes, rent, utilities, travel and entertainment, etc. Many of these categories can be broken down further. If so, your analysis will be more useful, and you'll be a step ahead in figuring your taxes, which treat certain categories differently.

Profit. In simple terms, this is, of course, what's left over after you subtract expenses from income. As indicated previously, however, (see "Figuring Profitability" above) "profit" to an owner-operated business can be somewhat different than that of traditional, manager-operated ones.

⊛ Benchmarking Trends ⊛

A series of balance sheets and income statements are indicators of financial progress. But their format often hides what is probably the most important financial indicator of all—are the trends up, stable, or down? Are you personally getting ahead? How fast? For, regardless of yearly numbers, it is the trend—activity averaged over several years—that counts most. As crucial as current figures may be in providing short-term information, they can also generate false long-term signals.

Success, after all, is more than just drawing a good paycheck and paying all the bills; success also involves institutionalizing your business—i.e., ensuring that it has a life beyond its present circumstances. Only by tracking key indicators over time can one get a true indication of business and personal financial progress. As an example, any company can have one or two good or bad years. But are they the result of luck, or of good or bad business practices? Is change warranted? If so, in what areas and how quickly? Service businesses also are more vulnerable to economic fluctuations than others. When things get tight, nonessential services are among the first things cut back, and vice versa when clients feel prosperous. Does your company's situation simply mirror the state of the economy, or is it at least partially independent of it?

There is the management factor to consider also. Given enough creative talent, anyone can be successful for a few years. But extended success always takes business management skill. A downward trend can provide a warning of inability or bad practices before it is too late to make changes, or even to opt out of the self-employment career choice. Finally, no style, no business, no marketplace, is ever static. Just as keeping an eye on aesthetic trends is important to maintaining your creative edge, watching business trends is important to maintaining your competitive edge. Trend watching provides early signals about how things are evolving.

The trend tracking form reproduced on page 320 is a way to compare the financial data that affects your business and personal life over a period of time. It provides a way to monitor criteria that are predictive benchmarks for most design firms. It works equally well for shops of all sizes.

As illustrated, the form is set up for yearly input, the situation appropriate for most firms. When closer monitoring is helpful, however, it could as

easily be set up for monthly, quarterly, or semi-annual benchmarking. (Each of the thirteen criteria on the form is explained in the form "Calculating Trend Indicators," which is intended to be reproduced on the obverse.) Other criteria can be added or subtracted to custom tailor it to individual needs and concerns (for example: tracking average accounts receivable). The criteria used aren't nearly as important as the discipline involved in benchmarking. Even assuming that much of this information has never been gathered before, the process shouldn't take more than a few hours for each of the periods covered. If you use job tracking or accounting software, it should go even faster.

Confidential

Five-Year Trend Tracker

	Last year ±*	Year -2 ±*	Year -3 ±*	Year -4 ±*	Year -5
Business					
Billable efficiency	__ __	__ __	__ __	__ __	__
Quick ratio	__ __	__ __	__ __	__ __	__
Income per employee	$__ __	$__ __	$__ __	$__ __	$__
Percentage of business from one client	__ __	__ __	__ __	__ __	__
Average hourly rate	$__ __	$__ __	$__ __	$__ __	$__
Debt-to-assets ratio	$__ __	$__ __	$__ __	$__ __	$__
Agency Gross Income	$__ __	$__ __	$__ __	$__ __	$__
Profitability	$__ __	$__ __	$__ __	$__ __	$__
Equity	$__ __	$__ __	$__ __	$__ __	$__
	__	__ __	__ __	__ __	__
	__	__ __	__ __	__ __	__
Personal					
Weekly work hours	__ __	__ __	__ __	__ __	__
Yearly vacation days	__ __	__ __	__ __	__ __	__
Retirement funds	$__ __	$__ __	$__ __	$__ __	$__
Net worth	$__ __	$__ __	$__ __	$__ __	$__
	__	__ __	__ __	__ __	__
Other					

*Increase/decrease from previous year

Five-year trend tracker.

THE FOLLOW-UP ACTION PLAN. As important as trend tracking can be in its own right, it is even more so when tied into yearly business planning, as covered in chapter 1. It helps the process in the following ways.

A call to action. Formal business planning is the process that every principal knows he or she should do, but often never gets around to. If this describes you, that is, you haven't done any yearly planning recently, perhaps trend tracking can be the first step. It may be just the incentive you need to do things a little better in the future. The trend tracking numbers may point to a serious deficiency that can be addressed only by planning specific actions. Even if this is not the case, identifying ongoing strengths and weaknesses will reveal the benefits of long-term

planning, as opposed to just short-term problem solving. Analyzing progress, or lack of it, is an essential prelude to moving a business from mere happenstance to some measure of predictability. For studios of all sizes, business planning is simply a way to encourage long-term, positive trends. As a general rule, the greater your potential, the grander your dreams, the faster your growth, the bigger your operation, the tougher your competition, the worse your trends—the more you need planning.

Calculating Trend Indicators

Business

Billable efficiency. Divide the actual (not estimated) billable hours by total payroll hours (all employees). The acceptable range for creative services companies is 50% to 75%.

Quick ratio. Divide short-term assets (receivables) by short-term liabilities (payables). Because assets and liabilities can fluctuate considerably, averaging is best. The acceptable range for creative services companies is 1.25 to 2.0.

Income per employee. Divide AGI (see below) by total number of employees, including principals. (For part-time employees use fractions; freelances divide by 1.) $118,000 yearly or $9,000 monthly or higher is recommended.

Percentage of business from one client. Divide total income by number of clients in the same reporting period. 25% for more from one client is risky. Generally, the lower the percentage the better.

Average hourly rate. Divide AGI (see below) by total billable hours. There is no "right" rate, but *Creative Business* surveys show that $75 an hour is often the minimum needed to cover expenses and make a small profit. Most firms need to charge substantially more.

Debt-to-assets ratio. Divide company assets by its long-term debt. The figure should be in the range of .20 to .60.

Agency Gross Income (AGI). Subtract any pass-through expenses from total receipts. (Common examples: printing bills that were marked up, net media bills.) What remains—AGI—is primarily creative fees and markup income, a creative business's spendable revenue.

Profitability. For these purposes (only) include the value of all disbursements to owners/shareowners—salaries, bonuses, monetary benefits (e.g., company car)—as well as any retained earnings. (Traditional profit measures—e.g., ROI—are usually inappropriate for privately-held companies because the owners affect profitability by how much they take out in salary and benefits.)

Equity. In the absence of professional valuations, only Net Asset Value (NAV) should be calculated. The worth of a company's reputation ("good will") is not only subjective, but it may not have any dollar value because it may not be transferrable to a new owner. NAV is determined by adding all tangible assets and subtracting all tangible liabilities. Freelancers should take care to keep company and personal assets separate.

Personal

Weekly work hours. Estimate a weekly average.

Yearly vacation days. Count total taken.

Retirement funds. Total the amounts in your 401k, Keogh, IRA, or other tax-advantaged accounts.

Net worth. Add all personal assets (home, auto, money in bank, etc.) than subtract all personal liabilities (mortgages, loans, etc.). For this calculation exclude tax-advantaged retirement accounts.

Other

Use this space to enter factors which may have an effect on trends.

Trend tracker instructions.

Encourages confidence. To be taken seriously, both as a process and a result, business planning should produce a business plan that will serve as a blueprint for future activity. But confidence in any plan requires that it be based on something more than wishful thinking or gut feel. Trend tracking provides the objective data upon which a credible plan can be built. Trend tracking also makes planning easier because in many cases changes point not only to a problem, but to its solution. For example, declining billable efficiency with consistent sales probably indicates a need to tighten time-recording procedures. Billable time is probably going unbilled.

Provides visual impact. Business plans can be dull documents, which is perhaps one of the reasons why they are less than popular among creatives. Converting trend data into charts and graphs, easily done with software, not only provides an opportunity to add visual relief, but also helps communicate a plan's important points faster and easier.

Ensures objectivity. A major problem with small company planning is overcoming the built-in optimism of the principal(s). Optimistic enthusiasm is a crucial ingredient in the entrepreneurial mix, but it should never become the basis for business planning or strategies. For that, only hard, objective facts are appropriate. To base a plan on enthusiasm, wishful thinking, or insufficient data makes the process a wasted exercise, and if a business plan is also for use outside the company (e.g., to convince a banker to grant a line of credit), it makes it suspect. The data upon which any plan is based is one of the first things considered. For a business plan to have investment credibility (your time or an outsider's money) it must be based upon hard data. Including key business indicators and their trends as an appendix to a plan provides a reader with an objective view of the past and a credible view of the future.

Promotes regularity. By tracking several performance criteria over time, the beneficial effects of planning are usually readily apparent. In turn, this increases motivation to do planning on a regular basis. A mistake many design firms make is to consider planning only when it is forced by such circumstances as a business downturn or trying to impress a creditor. Then there's a sudden scramble to produce a convincing document that summarizes the business and its opportunities. Yet to be truly effective, business planning should be a regular process. The most successful businesses, especially in a dynamic marketplace like design, are those that are proactive and constantly attempt to shape their markets, rather than reactive, sitting back and allowing their markets to shape them.

Is a reality check. It is easy to read into one year's results confirmation of a previous year's plan. ("Even though the numbers don't show it yet, I'm sure we made the right decision to….") Only trend tracking—looking at the long-term picture—provides the crucial insight into your business and the way it is really performing.

⊕ Avoiding Risks ⊕

The business risks each of us face are similar. Some of the more common ones—too much business from one client, financial overextension, expenses out of line with income, going after the wrong types of work, etc.—have been covered previously. But while these types of risky behavior are a threat, they tend to be long-term and unlikely to precipitate immediate, life-or-death business crises. Not so with the less common risks, the ones caused as much by bad luck as bad judgment. Although less frequently encountered, they are all the more dangerous precisely because they are relatively rare and unexpected. Presented below are nine examples of bad luck occurrences

that resulted in sudden business risk—in some cases disastrous, in others only a momentary setback. All are based on real-life situations.

LOSING YOUR ABILITY TO LIVE OFF YOUR TALENT. This is a doomsday scenario, and one of the more common calamities facing principals of small design firms: you, the driving force of your company, are suddenly unable to work, and the money dries up.

The situation. The principal of a two-employee firm is involved in an auto accident. It puts him in the hospital for several weeks. But even when he gets out he's still unable to resume calling on clients. The multiple leg and back injuries he received require six months of intensive therapy.

Hospital expenses and therapy are taken care of by health insurance. But the principal's inability to call on clients means sharply reduced income. Savings are quickly depleted, and the firm is forced to lay off one employee and has to struggle to get by.

How it might have been avoided. No one can predict or prevent accidents. We are all vulnerable. This is why we should all have disability insurance in addition to health insurance. It is the only way to insure against lost income. Adequate key-person disability insurance is especially important for principals of small firms where there are no staff resources to contribute ongoing income. Guidelines for purchasing disability and other types of insurance are in chapter 3.

AN EMPLOYEE DEVELOPS A CASE OF STICKY FINGERS. Greed, temptation, misplaced trust, and lax procedures can be a lethal combination in any business, as the following story amply illustrates.

The situation. A six-person firm has been in business for nearly a decade. The two principals of the S corporation have kept their prices low, worked hard, and split modest but growing distributions. Reputation and income have continued to increase, but for the past two years they have been offset by even higher expenses. The result is falling distributions to the two principals.

Concerned, one of the principals spends a weekend poring over records looking for ways to tighten procedures. Mostly by chance he notices that several client payments seem low. On checking invoices, he discovers discrepancies between what was invoiced and what had been recorded as paid. On Monday morning he confronts the firm's full-time office manager/bookkeeper. The truth comes out. She had recorded some payments hundreds or thousands too low. Then she had written checks to herself for the differences, forging the signature of one of the principals. The cancelled checks made out to her were destroyed when they were returned from the bank.

The bookkeeper was a competent, well-liked, and trusted member of this small firm's "family." Yet over the course of two years she had embezzled some $40,000. Her explanation was that she had started by temporarily "borrowing" to pay off overdue bills, but couldn't pay the money back and had gotten in over her head. She had always intended, she said, to return what she had taken.

How it might have been avoided. Embezzlement at this level is typically committed by individuals (sometimes including partners) who do not fit the crook profile; they are otherwise honest, upstanding citizens whose financial lives (and ethical compasses) have gone awry. To diminish the risk of getting ripped off, we recommend the following standard procedures: Have your bank mail cancelled checks directly to your home address. When you receive them, scan them for irregularities, being sure to question any expenditure that is not clear, or any vendor you do not recognize. If you have a partner, we recommend having all checks signed jointly and mailed to the home of the partner who is not normally associated with purchasing activity, then having the bookkeeper reconcile them with the company's books.

AN UNEXPECTED AUDIT AND A BIG SALES TAX BILL. Every state has different rules on what is and isn't taxable. This makes it tough to generalize on "what and when" sales tax issues. We can, however, say that more items seem to be eligible every year, and the risks of making a mistake are high.

The situation. A two-person firm, not sure whether some items are taxable, opts not to collect tax on them. Besides, the owner reasons her firm is too small to ever be the subject of a sales tax audit. Dozens of invoices over several years are affected. A random audit of one of her clients by the state revenue department discovers items that the state considers taxable. In turn, this leads to a full audit of the designer's business, in which the state finds many more such items. By their reckoning, they've missed out on a total of $12,167. To this figure they then add another $4,370 in penalties and interest and present her with a bill for $16,537, payable immediately.

The designer hires a tax attorney (cost: $2,500) who is able through challenge and negotiation to get the total, including penalties and interest, reduced to $10,000. He is also able to retroactively collect $3,809 from clients. When all is said and done, the designer's liberal definition of nontaxable items has cost her $8,691, not to mention a few sleepless nights.

How it might have been avoided. A business has a legal obligation to accurately collect and transmit whatever taxes are determined appropriate by authorities. Do it wrong and you have to make good on your mistake (usually with penalties and interest). All this is notwithstanding that the rules on what is and isn't sales taxable are often imprecisely defined. Thus, the

only safe policy is to collect sales tax on questionable items as well as those clearly defined as taxable. Adopting this policy won't affect your bottom line and it will help protect you. What about clients? Since sales tax is a burden on them, might they object to your ultraconservative interpretation of the tax laws? Probably not.

Our experience is that most clients don't question what is and isn't taxable. In the occasional case where they do, explain your policy and tell them that you will be happy to discount that amount from their bill, but you would like a statement that they had questioned the taxability of the item and had decided not to pay the tax you had applied. Having made a good faith effort to collect, you should then be clear if the state later comes looking for money. Never assume that you are too small for a tax audit.

A LAWSUIT FROM A DISMISSED EMPLOYEE. Proper documentation is crucial whenever an employee is terminated. It can help avoid an expensive, improper-dismissal lawsuit for discrimination or violating local or state employee-rights laws.

The situation. Janet was a very talented junior designer hired during a time of rapid expansion at a twelve-person firm. The only job description was an explanation of her duties by the firm's principal, along with what was in the ad she answered. It was soon apparent that Janet was obsessive about her work, was not a team player, and had difficulty working with the firm's major client, a manufacturer of heavy equipment. A need for her to change her attitude was discussed on several occasions over the next two years. But her talent, the hope for change, and the hassle of hiring new staff during a time of high activity kept the principal from taking any more specific action.

During this time she was given an automatic raise after six months and a performance review after eighteen months. At the review a small "inflationary increase" was given along with an admonition: "Things have got to change in the future." Nothing was put in writing. Shortly after the performance review, the firm's business took a major turn for the worse. Over the next several months income dropped by a couple hundred thousand dollars, and the principal decided to reduce staff by one. As the most troublesome employee, Janet was the logical choice. Two weeks after she left, the principal was informed that Janet had brought suit against him and the firm for $250,000, alleging sexual discrimination. Her claim was that she had been dismissed because the principal believed she "did not fit in" with the all-male culture of the largest client, that a male employee had been hired later and not let go, and that she had performed the duties for which she had been hired "entirely satisfactorily." As proof of her performance she referenced her qualifications, the job as described in the ad she had

answered, the assignments she had worked on, and the fact that she had received two raises in just two years.

Now, skipping ahead, here's how it all played out: the case was settled out of court for $15,000 after two years of legal wrangling. Legal fees added another $20,000 for a total hit of $35,000. The additional cost of business disruption and emotional stress was not tallied. Significantly, only the tenuous nature of Janet's suit kept the costs this low.

How it might have been avoided. 1) Always hire an employee for a job whose requirements have been clearly set down in writing (a job description); 2) do a formal, written evaluation of an employee's performance based on their job description at least yearly (if the job description no longer fits the employee's functions, change it); 3) don't give a raise when performance has been unsatisfactory, and make sure all raises are based on objective criteria; 4) if termination for cause seems likely, inform the employee in writing and give him or her several months to change habits; 5) be sure to have solid justification for laying off any employee who was not the last hired; and 6) carry Employer Practices Liability insurance, as described in chapter 3.

AN EMPLOYEE WALKS AWAY WITH CLIENTS. You work hard to find and establish relationships with good clients, and you accept that you can lose them for many reasons. But does this have to include one of your own employees stealing them away?

The situation. Jane and Joan run an agency with a staff of ten and half a dozen steady clients. Each client is the responsibility of one of three account reps. Their largest client has been working with the most senior account rep, Charlie, for four years. One Monday morning Charlie informs Jane and Joan that he is quitting to form his own business. And, surprise, Largest Client has decided to continue to work with him in his new endeavor. A call hoping to save the business is to no avail. The client states that "Charlie is handling everything anyway, and now he'll be able to do it without the higher overhead of your firm."

How it might have been avoided. In a service business it is folly to try to prohibit clients from working with whomever they want. On the other hand, it is equally foolish for you to introduce employees to a client, let them learn clients' businesses on your payroll, then passively stand by as they set themselves up as competitors.

To protect your interests every employee should be required to sign a noncompete agreement—new employees when joining the firm, existing employees now. (Caution: Noncompete agreements should be checked by a lawyer. It may also be necessary to provide some form of consideration in return for an existing employee's agreement.) A noncompete agreement that restricts an employee from working with clients for several months

after leaving won't (and shouldn't) keep serious individuals from going out on their own. But it probably will prevent an employee from taking the easy route by setting up a new business with clients you've supplied. In short, it will prevent you from subsidizing an employee's entrepreneurial dreams.

Equally important is constantly demonstrating to clients that meeting their needs takes a combination of strategy, creativity, service, and experience. In other words, your firm offers much more than the skills of a single employee, no matter how talented he or she may be. (For more on noncompete agreements, see chapter 4.)

A NEW LANDLORD CANCELS AN EXISTING LEASE. Risks in contractual arrangements don't always come from what is specified in black and white. They can just as easily come from what is omitted.

The situation. A design firm is well ensconced in a signature building with six years left to run on a very favorable lease. The lease also has a renewal option, which includes a modest rent escalation clause. Given all this, the firm has just spent thousands customizing their offices to make them more efficient for employees and more impressive to clients. Then, out of the blue, they learn that their landlord has gone bankrupt, the building's mortgage holder is foreclosing on the property, and their lease will no longer be valid. They suddenly face two expensive options: renegotiate with the new landlord and hope for the best in order to retain their current address, or seek new space in what has recently become a hot real estate market.

How it might have been avoided. A standard "recognition" or "nondisturbance" clause in a lease will probably ensure that it remains valid through a change of building ownership. Otherwise, tenant occupancy is usually at the discretion of the new landlord.

A DISASTER DESTROYS EVERYTHING. How well could you cope if fire, earthquake, or flood struck your business? And would others know how to carry on if you weren't around?

The situation. Leo and Sarah, sole shareowners in their eight-person firm, were in Asia on a holiday during a fire that gutted their offices. They couldn't be reached for three days and it took them two more days to get home. Until they made contact, employees were at a loss about what to do. Should the insurance companies be contacted, and who were they? How could they get the fire department to release the contents of the fireproof safe that contained all the backup files of work-in-progress? How do they go about maintaining uninterrupted phone service?

When Leo and Sarah returned, confusion replaced the initial panic. Were all clients contacted and jobs rescheduled? Where could they locate office space quickly? Which employees could temporarily work at home?

Which replacement equipment should be rented, which bought, and who should handle this?

How it might have been avoided. Any disaster is disruptive and chaotic. But damage to a business (versus its property) can be reduced by thinking about what could happen, and preparing a plan for coping. A day or so doing this can easily minimize weeks of disruption. Every business needs a contingency plan that covers actions to be taken, specific personnel responsibilities, and individuals to be contacted. It should also include equipment inventories, locations of backup files, and temporary service providers to contact. Finally, it should authorize a responsible outside party (e.g., a relative, or a lawyer) to make necessary decisions in case the owner is unable to do so. See the emergency planning form in appendix IV.

A VALUED PARTNER DIES. The fewer individuals sharing ownership of a business, the more interdependent they are on one another. The sudden death or disability of one is traumatic enough without the added trauma of dealing with financial and business succession issues.

The situation. Three individuals—one art director, one copywriter, one account person—have an S corporation agency and share equally in work load and profit distributions. They work well together and their three-person firm prospers. Then, five years later, one of the partners suddenly dies.

The agency's productivity not only drops by a third, but the two remaining partners are obligated to continue to give a third of the profit distributions to the diseased partner's widow. The only way to end this obligation and move on with a new partner or employee is to buy back the one-third share of the agency the widow now owns. But what is a fair price? Trying to agree soon turns grief into acrimony. Meanwhile, productivity and profitability suffers.

How it might have been avoided. In setting up their business the partners failed to protect each either in three important ways: 1) They didn't establish a procedure to provide for future valuation; 2) they didn't require that a partner's shares automatically revert to the corporation at a predetermined value in the event of his or her death or disability; 3) they didn't take out "key-person" insurance policies on one other. (One thing they did do right, however, was incorporating to limit their personal financial exposure.)

The easiest (but usually least accurate) way to value a business is to agree in advance on some multiple of sales. Even better is to agree on a valuation procedure that will be required upon transfer of any shares. (For more on valuation procedures and a valuation worksheet, see "Valuing Your Business " in chapter 16.)

Requiring that an individual's shares revert to the company at a predetermined value in the event of death or total disability can be accom-

plished by a statement to that effect in the corporation's by-laws. Key-person insurance is simply a life or disability policy that the company takes out on a principal. The policy's face value (what's paid out on death or disability) should be adequate to fund the purchase of the diseased or disabled partner's shares. Purchasing life insurance for this purpose is common and reasonable; disability insurance for key individuals usually entails a thorough investigation and relatively high premiums.

SOMEONE STEALS YOUR IDEAS. Copyright laws do not protect ideas. Ownership or copyright protection can only be claimed for the specific ways in which an idea is implemented—i.e., a sketch, description, etc. You risk your livelihood whenever you discuss an idea before actually getting an assignment.

The situation. A designer/consultant with strong experience in a specific industry contacts a potential client. The contact is so impressed with his background and portfolio that he's asked back a week later to pitch the marketing staff. Several days after this he's asked to meet with the vice president of marketing.

The vice president is very complimentary and starts discussing the firm's upcoming need for direction in entering a new market. She indicates that she's been unhappy with their agency's response and asks what the designer would do differently. The designer discusses a specific approach as a way of demonstrating that he would outperform the agency. The vice president comments, "Exactly. I wish I could get my staff and the agency to think like that." The designer leaves on a high note, sure he's nailed the job. But he never gets it. More disturbing, some time later he sees his idea being implemented by the agency. When he calls the vice president to complain, she's unavailable. The initial contact person can say only that on reflection it was decided to stick with their agency and "an agency of their calibre doesn't need to steal ideas."

How it might have been avoided. Don't volunteer ideas as a way of proving your capabilities unless you are also willing to see them appropriated. If a client asks how you would handle a challenge, give a very general response, or demonstrate your capabilities by explaining how you previously solved a similar problem for another client. If pressed for more specifics, say something like: "As much as I would like to, it really isn't possible to come up with anything I'd feel comfortable with on such short notice. Good ideas take lots of reflection, development, and testing. This is what I do the first week or so of every assignment." (Possible exception: For a very substantial, long-term campaign, consider asking the client to sign a nondisclosure agreement such as shown in chapter 11. Try to stick to one pitch per assignment except in unusually promising circumstances.

The more times you need to call on a client to sell your capabilities, the more likely it is that you will give away ideas in the process.

NOT WITHHOLDING REQUIRED TAXES. For an employer not to withhold and remit employee payroll taxes on time is a severe offense. The penalties are so stiff (a fine of up to a 100 percent of the amount not paid), and the solution so easy (employ a payroll service to handle everything), that few employers fall into this trap. A trap they often do fall into is misclassifying a temporary worker.

The situation. Bright Interactive is a five-person firm in the upper midwest. Three years ago a national manufacturer asked them to design a particularly challenging e-commerce site. To handle the technical side of the project they utilized the services of a freelance programmer. She had unusual programming skills, had recently become a mom, and was looking for part-time work. As this and other projects grew in size and complexity, the programmer was soon spending up to half of every day at Bright, and when each project ended, a new one came along that required her unusual talents.

This year the programmer was audited by the IRS. All the expenses she had deducted from her tax returns as an independent contractor were disallowed. Although several reasons were given, they boiled down to the fact that she had no other clients, hadn't established a business before accepting Bright's first assignment, and her activities there had been more or less constant ever since. According to the IRS she was, therefore, not engaged as an independent contractor, but in an "employee relationship." The problem spilled over to Bright when the IRS sent notice that the firm owed federal unemployment insurance and Medicare and Social Security taxes on "salaries" paid to the programmer. The firm was also assessed three year's worth of interest and a penalty fee. Two months later, the state's revenue department informed them that uncollected unemployment insurance and workers compensation fees, along with interest and penalties were owed. Total bill: $5,680.00

How it might have been avoided. Recognize that your definition of "employee" and that of taxing authorities is probably different. They look beyond whether or not an individual is permanently employed to consider over a dozen working-relationship criteria. To ensure that freelancers you hire will be considered as independent contractors for tax reasons, be sure they have a well-established business, also work for other clients, submit estimates and invoices for payment, work on projects or timetables specified in advance (not open-ended), and dictate their own working conditions and schedules. If there is any question, first seek the advice of your accountant.

Even safer is to hire freelance help through a temp agency. This can be up to double what hiring a freelance off the street costs, but there will be

no worry about employment status. You also typically get a larger selection to choose from.

NOT CONSIDERING COSTS WHEN SETTING FEES. The simple pricing formula that's been followed as long as there's been business is this: add up costs, figure in a profit, and price to cover both. Any business that ignores it runs the risk of losing customers by overcharging or losing money by undercharging.

The situation. Paul started his broadcast design business five years ago after being laid off from a local TV station. Based on his industry experience he set his initial pricing at an average of $85 an hour (he bills different functions at different rates) and has raised it over the years to its present $130. His business has thrived, partly due to his contacts and experience, partly to his willingness to constantly invest in the latest technology. He now has a staff of three and dominates the local broadcast design market. Yet in each of the past two years Paul's net income has actually gone down. Last year his before-tax personal income was $57,000, the year before, $68,000.

How it might have been avoided. In the absence of any history of actual business costs, most newly formed firms arbitrarily set their fees based on what others are charging. But as soon as feasible they should start monitoring their costs and adjust fees accordingly. Paul never did this and therein lies his problem.

The business of broadcast design is particularly technology intensive. Last year Paul spent nearly $35,000 on new technology and computer servicing. This alone added some $10 to his hourly costs. Staff raises and other overhead increases added another $7 hourly. Prices, last raised two years previously, were out of synch. Charging for some functions at much lower rate than others also fails to recognize that they are performed with the same expensive equipment. Moreover, new technology has actually speeded up some functions, reducing billable hours. And some lower-rate functions were being performed by Paul's most highly paid employee.

Sitting down and analyzing his work flow and costs was a wake up call that led to a new, costs-plus-profits approach to pricing. As a result, Paul adopted a single labor rate of $175—$110 plus a $65 technology charge. Because of the significance of the increase, he informed regular clients in advance, explaining that it was necessary if his firm was to continue to provide them with cutting-edge technical solutions. Although he did lose some lower-level projects, most clients went along with it.

Lessons learned: 1) Business prices must be related to business costs. 2) Well-respected creative firms have more pricing elasticity than they realize among regular clients.

NOT FOCUSING ON THE RIGHT BUSINESS. When first starting out it is usually advisable to take whatever work you can get. But once established, you should focus on improving clients and assignments. Although the means to do this is marketing, even before that it takes adopting the right mindset. Without it you can run into the same kind of financial situation illustrated by a firm we'll call Mindset Studio.

The situation. Mindset's founder, Mindy, has been a self-employed illustrator since graduating from art school five years ago. She got her start doing illustrations for children's and parenting books and magazines. Mindy offered a distinctive style with fast turnaround. As her reputation has grown, so has her work load, especially from agency and corporate clients. She recently took on a full-time assistant to help out. Only one third of Mindset's assignments are now editorial. But they take up about half of its labor hours, and contribute less than a quarter of its income. Most editorial clients still insist on working directly with Mindy, so her new assistant's time is often not productively utilized. Mindy recognizes the problem but is at a loss how to deal with it. She is loyal to the clients who have built her business, many of whom have come to depend on her. She also likes many of them personally and has difficulty saying no to some of their requests.

How it might have been avoided. Discriminating for (or against) certain clients is usually bad business. Like many self-employed creatives, Mindy has allowed her personal feelings to cloud her business judgment. The first priority in business is ensuring profitability. It is not about winning popularity contests. The business world is a place for rational and ethical decisions, not a place for sentimentality-based decisions. There is no ethical obligation to continue to work with any client. It is also natural for a business to outgrow clients. Mindset is now in the unfortunate position of subsidizing its editorial clients by working for them at lower rates than agency and corporate clients. Mindy's sense of loyalty is misplaced, particularly in light of the fact that it is highly unlikely that this loyalty would be reciprocated if the tables were turned (i. e., if clients had to sacrifice to support her).

Mindy immediately needs to raise her prices to editorial clients to match those she charges to agency and corporate clients. If they can't afford it, that's their problem, not hers. If she ends up losing most editorial clients (a third of her business) she should get rid of her assistant until business picks up again.

NOT HAVING ENOUGH CAPITAL. We all know the old saw about how it takes money to make money. Banks and financial institutions can help move the

process along by providing missing financial leverage. But trying to borrow your way into prosperity is a very risky strategy, as we'll see below.

The situation. Kent has always had big ambitions. He started his design business on a shoestring and was able to build it into a five-person firm with creative billings exceeding $800,000. He pays himself very well ($150,000 last year), but has only modest personal savings and has never left any money in the business.

Last year opportunity knocked and Kent answered. He took on all the communications functions of a local division of a national corporation. It involved hiring three new staff, making media commitments, and purchasing computer and peripheral upgrades. To cover working capital needs, Kent negotiated a $25,000 loan from a bank, but only after he agreed to guarantee it with accounts receivable. New computers and peripherals ($11,500) could only be obtained with a two-year lease. Nine months after getting the new business, the national corporation was bought out, and the local division closed down. In addition to losing future work, payment for work already done was delayed for months. Even after laying off excess staff, monthly obligations outweighed income for several months. The two-year lease obligation for the new computers and peripherals was non-cancelable so Kent was stuck with them and their lease payments. The bank took much of the company's cash flow for months. Kent dodged bankruptcy only narrowly.

How it might have been avoided. Kent's long-term mistake is not investing in his company's future. He should have left a small portion of what he had been paying himself over the years in the company. The absence of accumulated capital meant he had to pledge future cash flow and take on a bad lease. With even a small amount of capital as collateral he could have negotiated better loan terms. Further, if he had paid cash or used traditional financing for the computer upgrades, he would have had something of value he could sell off if problems arose.

In the short term, Kent's mistake was overextending himself and his company based on projected business. Expansion to meet future demands is always risky, but it is excessively so unless mostly self-financed. Without any capital resources he should have foregone this opportunity, or only accepted it if he could get the client to finance the computer upgrading.

How much capital a design firm should have depends on its ambitions and opportunities. As a minimum guideline, Creative Business recommends that firms with many clients should have a minimum of 10 to 15 percent of yearly income readily available (liquid); those with only one or two significant clients or grand ambitions, more. Principals often look only

at growth and size as indicators of their success. Actually, these are usually poor indicators because they are temporary. A far better indicator, albeit an invisible one to outsiders, is accumulated capital. Well capitalized companies make more money because they can minimize the high costs of borrowing, and they have less pressure to compromise reputation and creative quality in order to maintain cash flow. They also have the freedom to pursue more new business opportunities with less risk, and they have transferable equity for future cash-out.

CHAPTER 16 Personal Issues

PERSONAL ISSUES—the way a principal relates to his or her business—are important for three reasons. One should be obvious: running your business, the activity that occupies the majority of your waking hours, should be a mostly pleasant experience. If it is not, you should change procedures or find another line of work. Life is too short for compromise. The second reason is that as your firm's boss, the way you handle personal issues affects its culture and productivity. Well-adjusted individuals run well-adjusted firms. Third, some day you'll have to face the ultimate personal issue: the sale or dissolution of your business. How you handle it could be among the most important decisions you'll ever make.

⊕ The Perils of Perfectionism ⊕

"Anything worth doing is worth doing well." You've probably heard this well-known axiom time and again. What could be more true? Especially if the quality of your firm's work is one of the competitive strengths of your business. But, there's one problem: the axiom is only partially true. That's because those who strive too hard to do things well often end up trying to do things perfectly. They confuse excellence with perfection. They reach for goals that can't be prudently achieved.

Having perfection as a goal can be a problem for the principals of all types of small businesses. They begin focusing on insignificant details. Far

from allowing them to attain greater business success and personal satisfaction, seeking perfection often does exactly the opposite. Nowhere is this more apparent than in the design business. Belief in perfection is inherent, part of the persona of many of us. We intuitively feel the need to tweak something until it's perfect—constantly refining a treatment until it feels just right. This belief in perfection usually has been reinforced in our training as well. Remember all those "working it through" design exercises?

If we ever harbor doubts about the pursuit of perfection, there are constant cultural reminders about its sanctity. As Mies van der Rohe famously summarized, "God is in the details."

So it may sound like heresy to say that doing things too well can be as costly as not doing things well enough. Certainly in a practical business sense, if not in a pure artistic sense. Putting quality in proper perspective is an important business skill. How close to perfection is appropriate, and under what circumstances?

DOES THIS SOUND LIKE YOU? The pursuit of perfection is something all creative people are affected by, but some more than others. Read the following statements and see how closely they describe you.

Never relaxing. The drive for perfection is often rooted in insecurity. Perfectionists are usually happiest when beginning a task and often become jittery when not performing a worthwhile activity or mentally tackling a problem. They also tend to undervalue the worth of their activities and are usually impatient with their progress, as well as that of others.

Setting impossible objectives. Having just-out-of-reach objectives is the way individuals strive to improve themselves. But having way-out-of-reach objectives is setting oneself up for failure. Individuals should be able to achieve most of the objectives they set for themselves. Perfectionists usually do not.

Obsessing over details. Perfectionists often give as much attention to details as significant events. Priorities can get mixed up, and even small details turn into major goals. They also tend to get upset when minor things don't go right. To use the popular metaphor: by focusing so closely on the trees, they often get lost in the forest.

Having little sense of achievement. A goal achieved is a challenge overcome and should be celebrated as such. Rather than savoring their successes, perfectionists quickly set another, more difficult task for themselves. The result is a business and personal treadmill that runs ever faster and faster.

Expecting the same of others. The desire to do everything just right can make perfectionists difficult to work with. For firm principals this often means losing sight of the fact that employees can't be expected to have the same drive and dedication they have.

Not delegating. When an individual has a personal view of perfection, it is difficult to believe that others can do things equally well. This usually leads to unnecessary meddling in their work or an inability to delegate responsibilities to them.

THE ALL-TOO-OFTEN EFFECTS. Here are the business effects that usually follow when you exhibit any of the above perfectionist tendencies.

Productivity declines. When the actual time it takes to do jobs regularly exceeds what can be billed, as often happens when one insists on achieving perfection, firm productivity falls and profitability nosedives.

Job profitability is reduced. Unless you are lucky enough to work with open-ended budgets, the way to improve job profitability is to spend less time than budgeted, not more. Extra time spent in the pursuit of perfection subtracts from profit. Put another way, every extra hour you spend comes at your, not the client's, expense.

Marketing suffers. A common, and often fatal, entrepreneurial flaw is exaggerating the importance of product quality at the expense of marketing. Although product quality (creative excellence) does result in getting better clients and jobs, it only does so up to a point. Beyond that, stealing time from marketing to perfect quality is a trap. Long-term viability requires nothing less than a strong and consistent marketing effort.

There's too much regulation. Because perfectionists have difficulty accepting things that are not precisely what they desire, those who run organizations tend to overregulate. This diminishes employee incentive, the source of the creative product's innovation and excellence.

Morale drops. Perfectionistic bosses are often oblivious to the negative effect that nit-picking can have on employee morale. To be effective, criticism has to be seen as substantial and constructive, not petty or destructive. Trust and responsibility are among the most powerful morale builders.

Health is affected. Competing with other design firms is enough to give anyone ulcers. Competing against your own tough standards just increases the health risk. Anyone wishing to stay in this business for the long haul must learn pacing. If not, they will either have a short, stressful career or a long, unhappy one.

SEVEN COPING STRATEGIES. Totally changing one's persona is difficult, maybe impossible. But recognizing and minimizing perfectionist tendencies is achievable. Doing so is good for business, and at the same time it usually increases one's overall enjoyment of life. All it takes is practicing a few nonperfectionist strategies:

Be realistic. The world is not perfect and you don't have to be. Excellence in business—creative, financial, or administrative—is all that's required,

perfection isn't. Try to get in the habit of analyzing what's essential and what isn't. Prioritize activities. Include in your plans only what's really necessary. Bite the bullet on everything else.

Recognize that there's a place for everyone. You don't have to be something you aren't suited for to be commercially successful. Regardless of your size or talent, there's a market for your services. Spending time building your business will probably pay better dividends than perfecting your craft.

Modify your goals. Resist setting goals that are too optimistic. Achieving modest goals builds confidence, failing to achieve grander ones destroys it. As a reality check, ask others who may be affected to evaluate whether your goals are reasonably achievable or will require a herculean effort.

Learn to trust. Recognize that your way is not the only way. There are usually other styles and methods to accomplish a given objective. Not doing things your way or failing to meet your personal standards merely produces a different and not necessarily worse result. It seldom results in disaster. Look for activities that can be handled by others, then delegate.

Avoid micromanaging. Concentrate on strategizing, planning, creative direction and monitoring shop efficiency. Develop systems and procedures to allow the firm to run productively without your minute-by-minute involvement. To the extent possible, give responsibility for developing these systems and procedures to those who will be most affected—the staff.

Listen to colleagues. Perfectionism seldom springs up overnight; it's a life-long habit. Subtle signals from colleagues—the furrowed brow reaction—often indicates when you have crossed the line from concern to obsession. When you sense it, ask for feedback. Try doing things differently for a change.

Make time for personal work. As bad as perfectionism can be in the world of commerce, it is nearly always a benefit in the world of fine art. Recreational painting, drawing, art photography, etc. provide a near perfect outlet for perfectionist impulses. Setting aside time for recreational creativity satisfies an individual's desire to achieve perfection and avoids the feeling of compromise that accompanies commercial creativity.

SO, HOW MUCH IS ENOUGH? When does attention to detail become an obsession with perfection? It's impossible to say exactly. Although perfection can be defined in some fields (a perfect number in math or a perfect rhyme in poetry), there's no definition for design. Every client, every job is different. There are, however, some guidelines you should consider:

The estimate. As elementary as this is, it is the source of most problems. Estimated time must be compared to actual time on every single job, and

the former should not be regularly above the latter. If so, you may be trying to gild the lily. If your analysis shows consistent underestimating, eschew your perfectionist tendencies or raise future estimates.

What really matters. There is a point in every job when those involved have to decide, "This is good enough." As a general rule, forgo further refinements whenever they become ineffective in raising job effectiveness, unnecessary in speeding up production, or invisible to the client. This takes discipline and practice when you are actually doing the work; it takes good management skills when you are supervising others.

The 90 percent rule. However individuals define it, our experience is that they can only expect to achieve about 90 percent of perfection and still be commercially successful. Beyond this point, trying to achieve it becomes increasingly costly and elusive. It often takes as much effort to go from 90 to 95 percent of perfection, as from 0 to 90 percent.

SUMMARY: Dedicate your business to excellence, never to perfection—that is, unless your clients are willing to pay for it.

❧ The Entrepreneurial Disease ❧

The Entrepreneurial Disease is a business malady characterized by an owner's excessive involvement in every activity of his or her company. In its most benign form it takes the form of a principal being swallowed up by the business, surrendering most of his or her personal life. In its most virulent form it strangles companies by funneling all decision making through a single choke point—the owner. In all cases it weakens enthusiasm and morale, a critical flaw in organizations requiring a high degree of creativity.

Most companies started by an individual experience this. The larger the company grows under the direction of its founder, the more likely it is to be damagingly present. If you've ever thought of your company as your "baby," chances are you've already been infected. So, what do you do? How can you keep an understandable desire to control your company from turning into a self-defeating obsession? Here's what to watch out for and how to treat the symptoms.

WHAT IS NORMAL. As with any diagnosis, it is usually tougher to define normal than abnormal. Not only is every individual, firm, and environment different, but we are all driven by different goals and aspirations. Nonetheless, there are some things that are common to all self-employed designers.

Hard work. In counting only time spent actually on the job (i.e., discounting thinking at other times), Creative Business surveys indicate that near-

ly all self-employed designers work harder for themselves than they ever did for anyone else. Hardest working of all are principals of firms with three to six employees who average a little over sixty hours a week. Principals of shops with two employees average between fifty and fifty-five hours weekly, as do principals of shops with six to a dozen employees. Freelancers and principals of shops with more than a dozen employees average around forty-five hours.

Good pay. Principals of successfully established firms typically pay themselves as much or more than they could receive as a salary from someone else. Their paycheck is also comparable to what companies in other service industries pay for similar levels of experience and responsibility. Unlike principals of most entrepreneurial businesses, however, most designers do not build equity in their businesses. What they take out in salary is usually their only financial reward.

Enjoyment. This is the offsetting factor for the typical self-employed situation—working harder for about the same salary and no long-term equity. Most creative entrepreneurs enjoy the process of founding a business based on their unique style and approach, the satisfaction of seeing it succeed and grow, controlling their own future, helping clients, and mentoring employees. Indeed, for many this is not so much a career choice as something that seems preordained.

Guideline. If you're working much harder, making much less, or not enjoying the life you've chosen, you almost certainly have a touch of the malady.

WHAT IS NOT NORMAL. In addition to the above general indications, there are several specific Entrepreneurial Disease symptoms. Be concerned if you have more than one, especially for an extended period of time.

Putting in excessive hours. This is probably the most visible indication, although not necessarily the most accurate one. One individual's definition of excessive may be another's definition of normal. But while there is no right number of hours to work, everyone should know his or her own comfort level. In other words, be able to differentiate between a working schedule that is personally satisfying and one that is required to keep the business afloat—the difference between a stimulating schedule and one that's a killer. Guideline: How much you must work should always be less than how much you want to work.

Not taking enough time off. This usually goes hand-in-hand with putting in too many hours. Here, too, it is important to contrast what is required with what you may find personally satisfying. In addition, however, keep in mind that most people operate much more effectively after taking a few days off. In fact, the productivity-enhancing benefits that come from

recharging one's batteries are so well accepted in the corporate world that many large companies require their executives to observe weekends, holidays, and annual vacations. It is a policy you should adopt as well. Guideline: Time off is not a luxury. You need it to provide productivity-enhancing rest, relaxation, and lifestyle balance.

Being perpetually snowed under. It is the nature of a service business that work often comes in feast-or-famine cycles, that even the most organized individuals occasionally feel overwhelmed. But it shouldn't be the norm. This situation may be a very rational response to having too much work; or, equally likely, it may be the result of a lack of organizational skills, or from having the wrong type of clients. Whatever the reasons, it is a condition that increases the likelihood of mistakes, reduces the time available for decision making, and results in critical functions slipping behind. The stress involved can also be damaging to your mental health (see below). Guideline: You should feel that you are getting ahead in your business, not falling behind.

Losing your perspective. This is a major symptom and one of the more difficult to recognize. It is a tendency to view business decisions in the same way as personal ones. Business decisions should be rational, nonemotional, and based on whatever increases profitability; personal decisions are usually subjective, emotional, and based on whatever increases personal pleasure. They are the apples and oranges of the decision-making world. Perhaps the most telling example of how Entrepreneurial Disease can cloud judgment is in spending money. In nearly all personal situations the less money spent, the better—expenditures reduce your net worth. But in many business situations (albeit not all!) spending money is actually advantageous—wise expenditures, investments, are necessary for the business to prosper and grow. Guideline: Understanding the difference between personal and business decision making is crucial to long-term business health.

Making all the decisions. This is not something the principal of a two-person firm needs to think about, but it certainly is an issue with larger firms. Starting at about three or four employees, alternative decision-making procedures must be instituted, then constantly reviewed and broadened as the size and other procedures of the shop change. If this doesn't happen, problems arise because the principal becomes either too overworked to attend to crucial details or isn't always available to make decisions. The most common problems are: lower billable efficiency due to inadequate direction and wasted time; cash-flow crunches caused by billing falling behind; low morale and higher turnover because employees feel less important; client disaffection because they can't always get immediate answers; and the loss of any potential for building long-term equity.

Guideline: Making all the decisions yourself is a waste of your time and your company's resources. It leads ultimately to a company that chokes on its own success.

Trying to clone yourself. As comforting as it may be to hire others who share similar backgrounds, talents and styles, it is the wrong way to increase the viability of your business. Your name on the door should not mean that your stamp needs to appear on everything. From a new business standpoint, a staff with mostly similar creative approaches and working experiences is unable to offer your clients creative variety. From a management standpoint, such a staff is unable to offer your company fresh ideas and new directions. An owner's creative ego overruling business practicality is a sure indication of the Entrepreneurial Disease. Guideline: Hire people with different skills and experiences, especially individuals who are more talented than you.

Damaging your health. This is the bottom line: Your health is the most valuable personal and business attribute you have. It also happens to be easy to take for granted, perhaps because it is difficult to assess health risks until it is too late. Entrepreneurial Disease usually exhibits itself as a feeling of omnipotence: it could never happen to me. This attitude can result in ignoring the need for disability insurance, underfunding health insurance, putting off taking an occasional physical, and getting too little exercise. It also minimizes the need to find ways to compensate for the mental stress of being in a subjective business that requires pleasing clients for a living. Guideline: Whatever your practices are today, you should ask yourself if you can sustain this pace long into the future. If not, plan to change before it is too late.

HOW TO INOCULATE YOURSELF. Recognizing the problem is the first step. The second is immediate treatment—changing your everyday behavior. The third step is modifying deeply routed procedures—inoculating yourself for the future. Here are some steps that may help.

Assess what your talents are, and aren't. This is the place to start because you should learn to concentrate on what you do well and farm out, delegate, or turn down what you don't. Trying to be all things to all people all the time—clients or staff—is at best a recipe for diminished efficiency, at worst, one for ultimate failure.

Listen mostly to your head, not your heart. This is business, not romance. Yes, it is important to maintain a balance—some analysis, some gut feel—but most decisions should be based on reasoning, not personal whims. Be especially attentive to the following: facilities and equipment—do you have fancy digs and state-of-the-art stuff because they are cool, or because they benefit business?; promotion—are your efforts based mostly on creative self-indulgence, or what will bring the greatest return on invest-

ment?; clients and assignments—is who you work with and what you do based on what's most enjoyable, or what has the most profit potential?; staff and vendors—are you getting your money's worth, or do personal relationships sometimes stand in the way of efficiency?

Hire the very best talent you can afford. The better they are, the easier life will be for you, and the more your company will prosper. In particular, don't let your ego keep you from hiring those more talented than you or who have skills you lack. Yes, they may leave after you've taught them everything you know, perhaps even to work for a competitor. But you'll still be ahead, especially if all employees are required to sign noncompete agreements. (See chapter 4.)

Delegate everything you can. The smarter, more talented, and diverse your staff is, the easier it will be to delegate. Of course, how much is practical for you depends on your organization's size. But most shop principals delegate far less than they should. At some point nearly all marketing and client contact, creative and executional tasks, and project and office management can be turned over to others. The only things that should normally be reserved for principals are overall creative, financial, and strategic direction. Don't stab yourself in your wallet by underestimating the potential of your staff. If your lack of delegation is caused by not having thought about it, an enlarged creative ego, or a desire to retain control—work on your problem. If it is caused by staff incompetence—work on training or replacing them.

Build a solid organization. Most of us start our self-employment careers eschewing traditional business structures. Our company is going to be different—a relaxed, collegial atmosphere where everyone does great work and has fun. None of those bureaucratic rules, regulations, policies, and procedures in our business! Then, as the business grows, we discover that unstructured usually turns out to be chaotic. Lack of clear procedures confuses clients, frustrates vendors, and leaves employees wondering what they should be doing. The larger the organization becomes, the harder we end up working, the more the quality of our company's work diminishes, and the less happy everyone turns out. Any organization with more than two individuals needs clearly defined policies and procedures. The longer you wait, the more damage will be done to your business, and the more difficult changes will be to implement later. Also keep in mind that the way the boss acts in a small organization usually has as much impact as written policies. Like it or not, you are the role model who sets the standards for general office behavior. If, for example, you set a frenetic pace, it will become the accepted norm. If you are relaxed about promptness and working hours, your employees will be, too.

Wean dependent clients. Finally, as your business matures and grows, so must your client relationships. If you run a small firm, let go of clients who

you've outgrown and who take up too much of your time (see chapter 13). If you run a large firm, gradually turn over the responsibilities of handling long-term clients to staff members. The clients will actually be better served, staff morale will certainly improve, and you'll have time to get to many of the issues that now seem to elude you. Think of it this way: once you were the business; now you're much more, you're its chief honcho. If you still have only one or two big clients, work hard at diversifying. You're no doubt already aware that this situation makes you financially vulnerable. But equally important, it almost ensures that your need to keep these clients happy all the time will enmesh you in the minutia of every project you do for them.

❦ Avoiding Burnout ❦

Burnout is one of the workplace issues of the new millennium. The pace of everyday life often seems to outstrip our abilities to keep up with it. The result: worry, stress, fatigue—and ultimately the inability to cope without giving up much of what we value.

Burnout may have suddenly become a pop concern, but for designers it is already something of an old-hat issue. We've always endured stress of a big-league nature. There's the constant possibly of having our concepts rejected, our creativity demeaned, our talent growing stale. Added to this are the pressures of running a small, vulnerable business: finding clients, pricing and estimating correctly, ensuring cash flow, paying bills. Clients have become much more sophisticated and demanding recently. Competition has increased as well.

FACING THE PROBLEM. How big a problem is burnout among designers? Think: how many senior, gray-haired ones do you actually know? Probably fewer than one in a hundred. How many do you know who continue to do cutting-edge work, decade after decade? How many of your designer friends and classmates are still in the business? How many have dropped out to do other things?

Now think about yourself and your life and work style. Can you sustain your present pace for the next five years? Ten years? Thirty? If the answer is "No way," you'd better start taking burnout very seriously. You are setting yourself up for later failure, perhaps at a stage of your life when you will have very few employment options left.

If you answer, "I'm not sure," think a little more. Though most of us complain about it from time to time ("I feel so burned out lately"), we tend to visualize burnout candidates only as harried, harassed individuals. While this description certainly fits one profile, it is little more than a

stereotype. The fact is, there are busy designers who lead frantic lives, yet thrive on all the action. Then there are others who appear relaxed and in control, yet ultimately cave in under years of accumulated pressure.

A BURNOUT TEST. So, what type are you? Are you a sprinter, someone running pell-mell toward burnout? Or are you a marathoner, paced to finish at the retirement time you select? To give yourself a better idea, spend a few moments with the following brief, self-scoring assessment quiz.

Rate yourself on each of the quiz's statements. If it strongly and consistently describes you, give yourself a rating of 4. If the statement frequently describes you, give yourself a 3. If the statement only sometimes describes you, mark yourself with a 2. If the statement very rarely describes you, give yourself a 1. When finished total your score—from a low of 20, to a high of 80.

1. My business is reactive (client's determine direction); not proactive (I set direction).

<p align="right">4 3 2 1</p>

2. Most of my firm's projects come from small organizations or nonprofit institutions.

<p align="right">4 3 2 1</p>

3. The client personnel I deal with often don't have decision-making authority.

<p align="right">4 3 2 1</p>

4. My job involves nonstop interaction with clients or employees.

<p align="right">4 3 2 1</p>

5. My firm works primarily with the same clients.

<p align="right">4 3 2 1</p>

6. My firm works primarily on the same types of assignments.

<p align="right">4 3 2 1</p>

7. Most projects are deadline oriented.

<p align="right">4 3 2 1</p>

8. I face few new creative or management challenges.

<p align="right">4 3 2 1</p>

9. I don't create much anymore.

<p align="right">4 3 2 1</p>

10. I average more than fifty work hours a week and don't feel I can take many vacations.

 4 3 2 1

11. Whether creative or management problems, the buck always stops with me.

 4 3 2 1

12. There's no "significant other" sharing my life.

 4 3 2 1

13. I don't have a wide circle of close friends.

 4 3 2 1

14. It isn't possible to have others handle some of my workload. Only I can do what I do.

 4 3 2 1

15. Although I keep busy working, I feel bored and unchallenged.

 4 3 2 1

16. Some of my personal goals conflict with each other (e.g., do my own thing/make more money).

 4 3 2 1

17. I'm not very well organized. I have no formal working procedures.

 4 3 2 1

18. I usually take shortcuts when the client won't know the difference anyway.

 4 3 2 1

19. At the end of each day, I feel emotionally drained and totally exhausted.

 4 3 2 1

20. I have forty or more work years left (score 4); thirty (score 3); twenty (score 2); ten or less (score 1).

 4 3 2 1

Score: _____

If your score is 65 or more, you're a prime candidate for burnout—better take action to change your work style before it's too late. A score of 50 to 64

means you're in the danger zone—think now about changing some of your working procedures. If you score between 30 and 49—you're probably not at risk, but stay vigilant. If your score is below 30—relax, take the rest of the day off. (But then, you were probably going to do that anyway.)

TREATING THE CAUSES. Although this burnout test will usually provide a good indication of personal risk, burnout is a complex condition whose symptoms are not always readily apparent. Most significantly, burnout isn't always the result of long hours and difficult assignments. It can also arise out of boredom, long-term dissatisfaction, a perceived lack of control, and a general sense of desperation. Whatever the cause, when left untreated burnout can result in declining creativity, a loss of career interest, and physical and mental malaise. Serious stuff.

While you can't control all the circumstances that lead to burnout, you can control many with common-sense considerations and changes.

Assess your basic compatibility. If you aren't cut out for a life of self-employment—and not everyone is—chances are you'll develop burnout symptoms through constant frustration. Thus, if you scored high, the first thing to consider is your personal lifestyle preference. Do you really want to run a design business with all its resulting pressures?

Address your weaknesses. Look again at the burnout test questions you scored highest on. They clearly show what conditions and procedures you need to change to lower your risk. Change may not be possible in all cases, but it will be in some. For example, if your business is mostly reactive (question 1), you should get serious about a marketing effort to gain better clients and assignments, likewise if most of your work comes from small companies or nonprofits (question 2). If you have goal conflicts (question 16), sort them out. If you've identified risky personal procedures (questions 17 and 18), try to change them. As for question 10, as a rule you should keep regular business hours—nine to five, five days a week. Those who find it necessary to constantly burn the midnight oil are either mismanaging their firm's time or taking on bad clients. When considering the former, keep in mind one of the Peter Principles: Work will always expand to fill the time available to do it. As for the latter, unrealistic and unnecessary demands may be as simple as client education, or as complex as finding new ones. Either way, it must be done if your business (and you) are to remain healthy.

Keep busy. It's a fact of business life that projects tend to come in spurts, and sometimes there's a wait between spurts. Yet inactivity can not only be destructive to our own self-esteem, but it can also negatively affect the morale of employees. Keeping busy is important whether or not there is revenue-producing work. The best way to fill nonproject working hours is with more business planning and marketing activity. This includes, but is not limited to: analyzing your business and its potential, preparing mail-

ers and promotional materials, setting up appointments, taking old clients to lunch, and showing your firm's portfolio.

Sweat a lot. Not the project-induced kind, the physically-induced kind. Hard physical activity reduces mental stress through the body's production of natural tranquilizers (endorphins). If you haven't done so already, build some rigorous physical activity into your daily routine. A two-mile run, an hour of aerobics, or a hard game of tennis will do as much as anything else to reduce the tension that leads to burnout. In the long term, exercising is every bit as important to your future success as your creative or management skills.

Valuing the Business

How much your business is worth (its value) is always of interest, if for no other reason than curiosity. There are, however, times when value must be determined. For example: selling to an outside buyer; sharing ownership; merging with another firm; getting a divorce; establishing an employee stock ownership plan (ESOP); preparing a buy/sell agreement; funding a buy/sell with life insurance; dissolving a firm and distributing its assets. The more that's at stake, the more important it is to have a realistic valuation—one that's based on clearly supported data.

FIRST, A REALITY CHECK. Unlike other types of companies, design firms seldom invest in facilities, have no product inventory, and have relatively few hard assets. Products are also intangible—ephemeral ideas. Income is often directly related to the talent of the principal(s), a situation that can be exacerbated by their involvement in all the firm's activities. For all these reasons, the value of most design firms is usually less than firms of comparable size in other industries. Indeed, in many cases, and especially with shops with fewer than five employees, there is little value aside from the hard assets and the paycheck that the principal takes from the firm each week. We mention this here not only to avoid unrealistic expectations, but also to set the stage for why the process of valuing a design firm is somewhat different from that of other companies.

VALUATION BASICS. There are two major elements to any business valuation. Net asset value (NAV), the business's liquidation value, is determined first. Then return on investment (ROI), the value of a future income stream, is calculated.

Net asset value (NAV). This is the business's equity, how much money would be received if everything was sold off or cashed in. It is determined by adding up cash on hand, accounts receivable, savings, and the market

value of items like computers, peripherals, desks, etc. Subtracted from this figure are accounts payable, long-term debt, lease obligations, and any other financial commitments. Net asset value is the foundation of a business valuation because the market value of a company can never be lower than this figure. It is the only value that many design firms have, including nearly all freelancers and small firms.

A management consultant's valuation form.
Courtesy of ReCourses, Inc.

Return on investment (ROI). This is sometimes referred to as the business's "goodwill." ROI can be determined in several ways, but the only way that usually makes sense for closely-held small businesses is looking at the amount of demonstrable, predictable profit (or cash flow) that has been generated in the past several years. After examining the basis for a firm's profit, the valuator arbitrarily assigns a number (multiple) that is used to determine the ROI component of the valuation. Multiples for small businesses having sales of less than $1 million are typically from 3.0 to 4.0; larger firms a higher number. (The multiple is based on the valuator's experience, and several standard accounting procedures.)

What does this mean? A multiple of 5.0, which assigns a higher value to the business, means that the valuator believes that a potential investor would be comfortable with only a 20 percent annual return on investment (ROI). A multiple of 4.0, which assigns a lower value to the business, means that the valuator believes that there is higher risk involved, and that an investor would demand a return of 25 percent.

HOW THE VALUATION OF A DESIGN FIRM IS DIFFERENT. Although assigning a multiple is crucial to any valuation, the way it is normally derived does not address many of the specific issues facing a design company. This tends to lower the valuation multiple used. Because of the unique nature of design companies, management consultants working with design firms find it is usually better to standardize on a single "average" multiple (4.0), then apply a number of industry-specific adjustments (factors) to it. (See the "Sample Valuation Worksheet" on page 349.)

"Hard" ROI adjustments. These are the objective adjustments used to factor the multiple. For example: adding previously expensed items back to the balance sheet; accounting for work-in-progress; allowing for income tax for current year profit in an S corporation, or corporate taxes with a regular C corporation; and properly allocating salaries as cost of goods sold (COGS) or overhead, regardless of W-2 or 1099 status.

"Soft" ROI adjustments. These are the subjective adjustments used to factor the multiple. They are applied after the formula has yielded an initial valuation number. They take into account such things as the end-purpose of the valuation (selling to an outside buyer, divorce settlement, sharing ownership, etc.), the way the firm is structured, and where the business comes from. As an example, suppose the valuation is requested to help set the value of ownership shares. The initial valuation figure is $500,000. Although the whole firm may be worth this much, one-quarter of it is not worth $125,000 to a noncontrolling stockholder. This is because of his or her inability to control dividends, set salaries, and affect the destiny of the business. In such cases, a "minority discount" factor deducts from the valuation of their share. (A "control premium" factor may also add to the share of controlling stockholders.) Other examples would be a "risk" factor if a large portion of the business came from a single client, or a "nonattractiveness" factor if the business had a number of difficult clients. Conversely, another factor might increase the value if the business was well diversified or specialized in a growing and lucrative field.

FACTORS WITHIN YOUR CONTROL. The key to a design firm with high market value is not talent. Because talent is ephemeral and tied to specific individuals, it creates little in the way of long-term (transferable) value. Rather, the key is good management. It is having hired exceptional talent and supporting it with the systems, procedures, and marketing that have led to consistent profitability. In turn, this has led to a business whose name and recognition (brand) can be transferred to others with minimal negative impact.

In fact, the ownership of most design firms is never transferred. The reason is simply that they haven't been managed well enough to create trans-

ferable value. Or, put another way, the business is still personal, it has not been institutionalized.

Size and stability. Except in unusual situations, design firms of fewer than five individuals seldom have any value greater than fair market value of their hard assets. If you run a firm of this size or smaller, chances are you will have to grow if you wish to acquire transferable value. Firms larger than five must be able to demonstrate stable profitability or show profitable growth.

Principal(s) replaceability. This is the acid test because unless a new owner can fill the shoes of the old owner without excessive client concern the business has little value, regardless of its past success. Firms where principals are directly involved in client service and creative direction are the riskiest to new owners; those where the principals function largely in managing the business are the safest.

Percentage of income represented by the largest clients. This is a crucial consideration. Anything more than 25 percent downgrades the firm's value. Value diminishes rapidly as the percentage represented by the largest clients increases.

Number of principals. A single principal often indicates a firm too dependent on one person. Two or three principals usually result in a firm with enough delegation of responsibilities to give it staying power. More than three principals often results in ponderous decision making.

Work habits. The more time off principals can take, the stronger the indication that the business can run on its own. On the other hand, when principals have to work excessively long hours to keep the business profitable, it indicates that profitability is being subsidized.

Accounts receivable average. Average age shouldn't exceed sixty days. A higher average usually indicates that accounts receivable are not being well managed.

Debt-to-asset ratio. It should be from .20 to .60 (to determine this, divide assets by long-term debt). A ratio above the target range indicates a greater likelihood of defaulting on debt payments, which are inflexible. In other words, it indicates more debt than can be easily serviced if business takes a downturn. Moreover, if the ratio has been climbing, it may indicate that borrowing is making up for losses that should have been addressed by other means.

Cash reserve. It should average three months of operating expenses (overhead) in cash not receivables.

Billable time. It should normally be in the 50 to 75 percent range. If one client represents more than a third of the workload it should be at the high end of the range or even higher.

FACTORS BEYOND YOUR IMMEDIATE CONTROL. There are some things you can't do anything about. Sometimes this works to your advantage, sometimes not.

Reputation. It can be changed in the long run by staffing and working procedures, but in the short term, it is what it is. A strong reputation affects how much clients will want to work with the firm in the future.

The economy. The stronger the economy, the more business opportunity that exists, the more money potential purchasers have.

Geographic location. What is the local business climate for design firms? It may not be the same as the general business climate. And what about competition? Is there little? Lots?

Are there potential buyers? This is the bottom line if the purpose of the valuation is cashing out. Although a stable, profitable company helps create its own demand, no business has sale value beyond that of its assets unless there is someone who will at least consider purchasing it. So if the purpose is a sale, the valuation and the sale price will not necessarily be the same. (Note: A business may still have value for other purposes—e.g., the ongoing income stream important in divorce settlements, or valuing shares for employee stock ownership.)

ARRANGING FOR A PROFESSIONAL VALUATION. Talk to a management consulting firm with design firm clients, or your accountant. Don't take seriously valuations provided by those selling other services—e.g., insurance or personal financial planning. Not only do you get what you pay for, but an unrealistic valuation can lead to dangerously false conclusions. Also be wary of those who provide a valuation by merely plugging numbers into a predetermined formula. In industries with extensive data histories it is sometimes possible to provide a reasonably accurate one this way. But the only way to get an accurate valuation of a design firm is through a combination of numbers, research, and industry knowledge.

Allow a month or more, start to finish. It will take a week or two to get all the materials together that the valuator needs. After that, he or she will probably take another two weeks to produce a preliminary number. Then another week or two is normally spent in fine-tuning. Valuations can be produced in less time, but the cost will go up, or the accuracy down. The end result should be a hard number ($ value), all the supporting financial data, and a thorough explanation. The formulas used should be apparent, too. This permits doing updated valuations later by plugging in new numbers without going through the whole process.

As a rule, a thorough, professional valuation for a design firm typically runs from $3,000 to $5,000. Later updates by the same valuator typically average $1,000. Updates every one or two years are recommended, especially for a firm with more than one principal.

Lastly, here are two other ways design firms are different from most other types of businesses: 1) many are never sold because, as covered above, they have little or no transferable value; and 2) those sold are usually sold to a partner, to one or more employees, or to another creative firm wishing to expend their market or capabilities. Design firms are seldom sold to traditional investors looking for business opportunities.

SELLING TO A PARTNER. Transferring ownership through the sale of your share of the company to a partner is simple and straightforward assuming he or she is willing, there is a predetermined valuation formula, and there are procedures for selling shares to other owners. It also helps if a mechanism for funding a buyout has previously been established. If none of this exists, at best there will be difficult negotiations; at worst a potentially devastating standoff.

When there is a disagreement over the business's value and, therefore, the selling owner's share, two separate valuations should be conducted, ideally each done by a firm selected by one of the principals. The sale value is then mandated to be the figure derived by the average of the two.

If a partner's lack of cash turns out to be the problem, you have four alternatives: agree to a payment spread over time (see below), settle for a lower payment, force the dissolution of the business and the distribution of its assets if you own 50 percent or more of the company, or attempt to find another buyer for your share.

SELLING TO AN EMPLOYEE. Lacking a partner, this is probably your best option. It provides continuity because an employee already knows the business. There will be fewer changes, which means there is less risk of client defections. The major downside is that few employees have the required capital and may have limited borrowing capacity. For this reason you may have to help finance the sale. The norm is a five- to ten-year note for up to 80 percent of the sale price, financed at a point below bank rates. This arrangement (often referred to as "taking back paper") may provide you with tax advantages (spreading out the income), and if the buyer should default on payments you get the business back. For the buyer there are no bank applications, borrowing is cheaper, and he or she gets to finance the purchase out of future profits.

If you wish to prepare a selected employee to eventually buy you out and he or she indicates interest, you should offer a "right of first refusal." Such an agreement is no guarantee of a future sale, but it does have benefits. For you it increases your chances of a future sale to the employee and it helps succession planning. For the employee it is an immediate morale booster and provides an opportunity for future job security.

SELLING TO MORE THAN ONE EMPLOYEE. It is the same procedure as above with the addition of deciding what percentage of ownership each employee will receive. (See "Ownership Sharing?" in chapter 1.)

SELLING TO ANOTHER CREATIVE FIRM. This is the other practical option. For agencies looking to expand into the design market, adding capability by buying a turnkey operation can be faster and more attractive then growing it internally. Likewise, it can be the fastest route for a growing interactive or direct marketing organization to add design expertise. In most cases what the buyer will be looking for is a stable, profitable, and highly regarded operation. Your clients are important, but probably not as much as you'd like to believe, because any smart buyer realizes that they may decamp after the organization changes hands. To ease the transition and keep as many clients and employees as possible, buyers often insist that the previous owner sign an employment contract for a year or more.

USING A BUSINESS BROKER. It is worth a try because business brokers get paid on commission. No sale, no pay. The commission rate is normally in the 6-to-8 percent range with a minimum fee, but is negotiable. Note, however, that brokers' contracts always stipulate that any sale happening during the contract period (typically six months), even if not initiated by them, earns them the commission. For this reason be sure to write into the contract the names of any firms or individuals who will be excluded. For best results it is wise to use a business broker who has experience in marketing creative or media-type organizations.

SIGNING A NONCOMPETE AGREEMENT. Much of the nonasset value of an ongoing design business rests upon its clients. The value is diminished by clients who depart with a departing owner. For this reason, departing principals are expected to sign noncompete agreements. Typically, such agreements restrict you from accepting assignments for the next six months from any recent client.

HOW MUCH PAYMENT IN CASH, HOW MUCH IN STOCK? Sales to other firms, especially larger publicly traded ones, are often funded at least partially by shares of their stock. For obvious reasons, a high stock percentage can be risky. Generally, the more cash the better.

SECTION FIVE

Appendices

APPENDIX I
Twenty-Five Management Standards

BECAUSE OF THE YOUNG AGE of the design industry, something we've lacked that other types of business rely on are standards—accepted norms against which we can measure how well we are doing. To remedy this situation, Creative Business has been developing industry standards for several years. The following are divided into three categories—marketing, operations, and finances.

❋ Marketing Standards ❋

COSTS AND TIME—20 PERCENT OF WORK HOURS AND AGI. To ensure consistent work flow over the long run, approximately one in every five work hours should be spent on marketing. This means eight hours per week per creative employee, principals included. One in five creative employees should be devoted to marketing. We recommend that most sales reps be paid by commission—15 percent of new creative billings; 5 to 10 percent on "house account" billings and markups. Total marketing costs, including rep expenses, should be about 20 percent of AGI.

SUCCESS—50 TO 75 PERCENT OF COMPETITIVE OPPORTUNITIES IS A REALISTIC GOAL. Being asked to bid on a job requires a strong reputation and good marketing. Being selected usually requires a convincing presentation, good client chemistry, and the right price, not to mention weaker competition. While we all hope to get every job we bid on, this is unreal-

istic and we should budget our marketing efforts accordingly. Creative Business surveys find that most firms average getting about 50 percent of the competitive (multibid) assignments they receive from new clients. The success rate of competitive assignments coming from existing clients averages about 75 percent. Larger firms in very competitive situations often average as low as 25 percent (1 in 4). Success should be measured by long-term (more than six month) averages, never any single project or client.

CONTACTS TO GET PROJECTS–2 TO 3 FOR MOST NEW ONES; 3 TO 5 BEFORE A CLIENT WILL SWITCH BUSINESS. Persistence is the key to success. Good, stable clients seldom come easy. The better the client, the longer it usually takes to convince them to try someone new or to make a switch. Being persistent without being irritating requires you to believe, absolutely, that it would be in the client's interest to give you a try. Then, after the initial contact, make each follow up as unobtrusive as possible—regular mailings, an occasional phone call, etc.

WORKLOAD COMMITMENT–UP TO 50 PERCENT MORE THAN WHAT CAN BE HANDLED DURING REGULAR HOURS. One of the most challenging tasks of any business is balancing customer demand with product supply. The challenge is even greater for a service business because demand is highly unpredictable and supply can't be inventoried. Weeks can go by without a new opportunity, then several projects will come in one day. Resulting proposals may all produce jobs, or none at all. Because of the likelihood that not all proposals will be accepted, and the possibility of project delays, most firms bid on more work than they can handle. This should not be a problem as long as it is for less than sixty weekly work hours per creative employee in small and mid-sized firm, or fifty or more in larger firms. If all jobs should come through on time, the extra need can be met by working overtime, or hiring temps. Committing beyond fifty to sixty work hours per employee, however, is risky. It is unlikely that this much extra work load could be handled without compromising quality, missing delivery, or both.

REPEAT TO NEW CLIENTS–2 TO 1 IS A GOOD RATIO. New jobs from current or former clients are an important component of any business mix. The smaller the company, the more important they are. (Smaller firms get fewer jobs based on reputation, and they usually can't afford as much selling effort.) Jobs from current or former clients, where sales and learning expenses are lower, often produce profit that can be 20 percent higher or more. On the other hand, working with new clients is also important. These jobs provide new creative stimulation, plus business diversity and security. Thus, a good mix of existing to new client work is about 2 to 1 (66 percent) for small and mid-sized firms (up to twelve individuals). The larger the

firm, the lower the ratio that's usually acceptable; larger firms often operate comfortably on a repeat-to-new-client ratio as low as 1 to 2 (33 percent).

ESTIMATING AND PROPOSAL WRITING—1 TO 2 PERCENT OF TOTAL LABOR HOURS, AND 1 TO 2 PERCENT OF THE ESTIMATED BILLING OF ANY SINGLE JOB. Because of the variability of jobs and potential, estimating is a tough function to quantify. But based on Creative Business surveys, successful, multiclient firms average about 20 percent of total labor hours on marketing, and estimating and proposal writing averages between 10 and 20 percent of marketing time. Thus, estimating and proposal writing averages between 1and 2 percent of total labor hours. Many successful firms also believe that estimating and proposal writing should cost (the $ value of figuring and writing time only, not of making the sales call) between 1 and 2 percent of the job's estimated billing. Depending on the circumstances (how much the assignment is desired) many firms consider it acceptable to expand this up to 8 percent of estimated job billing, but seldom more. At 10 percent and beyond, one is essentially working on speculation, an unhealthy business practice.

TERMS AND CONDITIONS—ONE-THIRD OF ESTIMATE WHEN BEGINNING, ONE-THIRD AFTER FIRST CREATIVE SUBMISSION, ONE-THIRD AT COMPLETION; ALL INVOICES "NET 30." Progress payments are the standard for billing design work. Payments in thirds are the generally accepted norm. They avoid the risk of granting unlimited credit to the client while also avoiding a client's risk of writing you a large blank check. Payment due in thirty days from date of invoice ("net 30") is the accepted business standard.

⊕ Operating Standards ⊕

WORKWEEK—FORTY HOURS. Work flow and profitability should be planned around the standard business week. (Typically 8:30 to 5:30, or 9 to 6, with an hour for lunch.) Although variability of demand may occasionally require longer hours, they should be the exception, not the rule. If demand persists, procedures should be changed, or more help hired. When principals or employees routinely put in long hours, the creative emphasis eventually shifts from quality to quantity (getting it done), details slip through the cracks, errors in judgment become common, and burnout becomes a concern.

HIRING STAFF—USE THE "60/6 RULE." You or affected employees should be working around sixty hours a week for around six months before additional staff is considered. This will reduce the common mistake of hiring

too soon. When hiring, look for complementary, never similar, talents and skills. A variety of staff experience, expertise, and styles is key to attracting a variety of clients, and in growing any business whose product is creative problem solving.

STAFF SPACE–TWO HUNDRED SQUARE FEET PER EMPLOYEE IS A GOOD STARTING POINT. Personal style preferences, type of work, office layout (open space or cubicles), access to equipment (scanners, printers, copiers), and building layout (windows, noise, traffic flow) all affect the workplace requirements of creative individuals. These considerations, plus the need to plan for future growth, makes planning office/studio space specific to every firm. Most individuals feel comfortable when their zone is about 10 x 12 or 120 square feet; additional space requirements are for common areas—reception space, hallways, storage, toilet facilities, etc.

BOOKKEEPING TIME–TWO HOURS A WEEK PER EMPLOYEE ON AVERAGE. Firms of up to five individuals typically employ a part-time bookkeeper who spends up to one day a week keeping the books. A full-time book-keeper, who combines this activity with other office functions (e. g., receptionist), is usually necessary for firms with six to a dozen employees. The person should be hired for bookkeeping skill first, other functions second. A dedicated, full-time bookkeeper is usually necessary in firms with more than a dozen individuals. In these firms, bookkeepers usually also handle "comptroller" functions—projecting cash flow, evaluating profitability, seeking discounts, and setting payment schedules.

PROJECT BACKLOG–TWO TO FOUR WEEKS WORK. The more work you can count on, the greater your cushion against future business downturns and variable cash flow. However, having commitments that will carry you far into the future is not necessarily beneficial. It may indicate a dangerous dependence upon a few assignments or clients. The right amount of work backlog is determined by your firm's past history, client stability, type and length of most assignments, and fixed overhead costs. Because the larger the firm the higher the fixed costs (especially labor), the need for work backlog usually expands somewhat with growth. Whereas a two-person firm can be comfortable with as few as two weeks of backlog (eighty hours), larger ones may need four or more weeks of labor hours for safety. It is unusual for even the largest design firms to have work commitments for more than six weeks worth of labor hours.

BUSINESS RECORDS–KEEP FOR AT LEAST SIX YEARS. The Internal Revenue Service (and most state equivalents) does routine audits within three years from the date a yearly return is filed. Since records are sometimes inter-

connected, accountants recommend keeping most for at least twice as long. Certain other corporate records must be kept indefinitely—check with your accountant. It is also a good policy to keep old client records. Historical data helps when estimating new work and in tracking business performance. After about six years, however, conditions have usually changed enough to make the information irrelevant.

☙ Financial Standards ☙

BILLABLE EFFICIENCY—50 TO 75 PERCENT ON AVERAGE. Average billable hours—actual billed hours divided by total payroll hours (all billable and nonbillable staff, principals included)—is the productivity basis upon which labor rates should be calculated and is the best overall indicator of a design firm's health. It is tough to make a profit if the average is less than 50 percent for more than six months. If so, there's a marketing or staffing problem; find new business or cut staff. On the other end of the scale, it is difficult getting average billable hours above 75 percent because of nonbillable activity—vacations, sick days, dead time, administrative personnel, chores, etc. Thus, your billable efficiency should be between 50 and 75 percent.

QUICK RATIO—1.25 TO 2.0. A business's quick ratio is often considered the best short-term (quick) indicator of financial health. It is determined by dividing short-term assets (mostly receivables) by short-term liabilities (mostly payables).

MARKUPS—25 PERCENT ON MOST OUTSIDE SERVICES. Separating outside expenses identifies them as items over which you have no control. Marking them up helps cover the cost of paperwork and handling, and recognizes that you usually have to pay before being paid by the client. While the standard for most expenses is 25 percent, larger ones are often marked up more or less—e.g., printing markups are typically 25 percent for jobs of $1,000 to $5,000, more on smaller jobs, less on larger ones. (When printing is paid directly by the client—i.e., there is no markup—press supervision time should be charged.)

ACCOUNTS RECEIVABLE—FOUR TO SIX WEEKS OF INCOME. Management of accounts receivable is among the first things bankers look at when assessing a firm's credit worthiness. The traditional indicator is the average number of days until a firm's invoices are paid. Over sixty usually indicates collection problems. Another is relating receivables to income. By this measure, if the monthly average is too high, too much money is being tied up unproductively, indicating a work-flow, billing, or collection prob-

lem. If too low, it might indicate too little cushion and a cash-flow problem, especially in the absence of liquid assets. The ideal range for most design firms is less than six weeks, but more than four.

INVOICE COLLECTION—SIXTY DAYS OR LESS ON AVERAGE. How long it takes to get payment after an invoice is sent is an indicator of client quality, and how close your invoices match your estimates. Assuming invoices are "net 30," average collection of sixty days or less is okay, no need for concern (less than forty-five days is ideal); if seventy to ninety days, there's a problem needing attention; if ninety days or more, there's a serious problem needing immediate attention. Invoices over a hundred and twenty days old are often uncollectible.

MONTHLY DAYS SALES OUTSTANDING (DSO)—FORTY-FIVE OR UNDER. This is another standard accounting measure of how long it takes to collect bills. To calculate it, tally your accounts receivable at the end of the month and divide by that month's billings. This will produce a factor that is then multiplied by thirty days to produce the DSO. For example, if your accounts receivable were $200,000 and that month's billing was $100,000, the factor would be 2, which when multiplied by thirty days produces a DSO of 60. If billings rose to $200,000 with the same receivables the DSO would be 30; if they dropped to $50,000 the DSO would be 120. Obviously, the DSO will fluctuate from month to month. Aim to keep it at forty-five days or under.

UNCOLLECTED BILLINGS—1.5 PERCENT OF AGI OVER SEVERAL YEARS. Avoiding problem-prone clients and getting progress payments will reduce the occurrence of uncollected billings, but they can never be totally eliminated. Uncollected billings are a combination of unpaid invoices (bad debts) and client-negotiated invoice reductions. They typically run around 1.5% of AGI when averaged over several years. Averaging is crucial because uncollectables come in cycles; a few in one year, then none for several years. To reduce what could be a devastating impact, consider setting aside 1.5% of AGI in an interest-bearing account.

LIQUIDITY—5 TO 15 PERCENT OF YEARLY INCOME. Because of work flow and payment variability, a design firm's income is seldom in synch with its expenses. Most also have an occasional need to cover an "emergency" outlay, such as replacing a computer or hiring a temp. It is a rare business that doesn't get stuck by an occasional dead-beat client. Thus, every business needs a certain amount of liquidity—readily available cash. It can take the form of working capital (money in the bank) or a line of credit (immediate borrowing privileges). For businesses with low overhead, many steady clients and one or two employees, as little as 5 percent of yearly income may be sufficient. Businesses with a high overhead, a few clients, and a

large payroll are most at risk and should have up to 15 percent of yearly income available. For the average design firm, 10 percent of yearly income is usually sufficient.

VULNERABILITY TO CLIENT LOSS—NO MORE THAN 25 PERCENT OF INCOME FROM ONE CLIENT, OR 50 PERCENT FROM TWO. Sudden loss of a dominant client is one of the major causes of design firm failure. The best insurance against it is for no one or two clients (including all subsidiaries and divisions) to be responsible for a high percentage of your business. Otherwise, the firm should have sufficient liquidity (money in the bank) to cover a business recovery period. If 25 percent of your firm's income comes from just one client, funds should be available to cover two months of future expenses; if 50 percent, enough to cover three months; if 75 percent, enough to cover four months; if 100 percent, enough to cover five months, the maximum time it should take to get replacement business.

INCOME PER EMPLOYEE—$8,500 PER MONTH OR BETTER. The higher the figure, usually the more profitable the operation. To determine it for your firm, divide your monthly AGI by the total number of employees—creative and noncreative, including yourself. For example, a monthly AGI of $50,000 for a six-person firm gives a figure of $8,333 per person. (For part-time employees use appropriate fractions.) This figure gives a good indication of overall productivity because it takes into account both income-producing (creative) and non–income-producing (sales and administrative) staff. To achieve the goal of $8,500 or higher, billable employees' time must be billed at three or four times their salary—e.g., a billable employee making $3,000 a month should average billable time of $9,000 to $12,000.

INCOME DISTRIBUTION—PAY/BENEFITS 45 PERCENT; SALES (INCLUDING SALARIES AND COMMISSIONS) 20 PERCENT; GENERAL OVERHEAD 15 PERCENT; PROFIT/CAPITALIZATION 14 PERCENT; FACILITIES 6 PERCENT. Although there is some variation among firms (e.g., firms with senior staff will probably have higher pay/benefits, lower sales costs), the above are guidelines to shoot for. Pay/benefits includes all salaries, exclusive of sales personnel but including that of principals, and all benefit expenses—health insurance, staff parties, 401k administration, etc. Sales includes sales rep salaries/commissions, benefits and expenses (or those of principals that have been apportioned), plus all other costs associated with marketing—mailers, ads, web sites, etc. (When sales salaries/commissions are included in pay and benefits, this percentage is about 70 percent and marketing about 5 percent.) General overhead includes all miscellaneous expenses—equipment payments, supplies, etc. Profit/capitalization is money which is set aside to capitalize new equipment, or for expansion or equity buildup. Facilities includes space rent/mortgage, utilities, cleaning, etc.

CHECK SIGNATURES—AT LEAST ONE PRINCIPAL'S ON ALL; TWO FOR MORE THAN .5 PERCENT OF AGI IN MULTI-OWNER FIRMS. In all but the largest design firms*, at least one principal should sign or countersign all checks and financial commitments. A bookkeeper's signature alone is not sufficient for fiscal security. For amounts greater than roughly .5 percent of AGI two principals should be required to sign the check or commitment. This guards against one principal unilaterally obligating the firm. In firms larger than several dozen employees a professional comptroller, generally accepted accounting practices (GAAP), and routine audits are usually sufficient to protect the interests of investors.

Six Management Case Studies

APPENDIX II

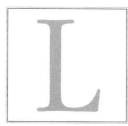

OOKING AT THE PROBLEMS and opportunities faced by other firms—the case study method widely used by the world's top business schools—can often provide a good indication of what you are doing right and wrong in your business. The six case studies presented here describe real-life situations and recommendations as reported by the management consultant David C. Baker. (Re-Courses, Inc., 6101 Stillmeadow Drive, Nashville, TN 37211. 615-831-2277. www.recourses.com.) The names, locations, and many of the details have been changed so as not to violate anyone's trust.

⊕ Case Study 1: Self-destructive Management ⊕

We'll call this firm Swift Design. Swift's speciality is the entertainment industry, specifically J-cards for CDs and cassettes, point-of-purchase (POP) displays, and promo posters. They have worked with the biggest names in the industry on both concepts and complete projects, but they purchase no printing.

THE SITUATION. The company, an S corporation, was formed twelve years ago by Sharon Swift, who is the heart of the organization even though she hasn't done design for years. In fact, she knows little about the computers that produce all their work today. Sharon functions as the salesperson, creative director, and art director on most celebrity photo shoots. Excluding

Sharon, Swift Design has eight full-time employees—one senior designer, four designers, two designers/production people, a receptionist/clerk, and a business manager/bookkeeper.

In a recent year, Swift Design billed about $687,000 in service fees. This was down from $720,000 the year before. Two years previously, Swift billed slightly under $1 million. The firm was rapidly losing business to others who were marketing more aggressively, whose designs were more cutting edge, and who seemed to be more adaptive to client requests, even though they often charged more.

Swift Design's billings for the most recent year worked out to a little over $76,000 per employee, a figure considerably below the industry benchmark of at least $100,000 per employee.

Other than less work, one reason for the relatively low billings was an average hourly rate of $100. This rate had not been adjusted for several years; the firm was underpriced in a field where average rates for their quality of work run around $150. Even more important was that the firm actually billed only 6,875 hours, or 36 percent of its available work hours. Industry averages are from 50 to 75 percent. Assuming a midpoint of 60 percent, Swift should have been billing around 10,400 hours. (The math: 9 employees x 48 weeks [4 weeks are not billable because of vacations and sick days] x 40 hours x .60= 10,400.) In short, they had too little work for too much staff.

A QUANTITATIVE ANALYSIS. Three traditional business evaluation ratios told a similar story.

	Swift	Normal
Quick	1.27	1.25–2.00
Debt-to-Asset	0.54	0.30–0.60
Return on Equity	0.10	0.15–0.35

While the Quick Ratio (short-term assets ÷ short-term liabilities) was in the middle of the normal range, it should have been higher for a business in Swift's condition. It indicates they had insufficient cash to address a major crisis—e.g., job gone bad, key employee walking away with accounts, a client disputing a large bill, major equipment purchase, etc.

The Debt-to-Asset ratio (what's owed ÷ by what's owned) was barely within the normal range. It indicates fixed overhead that severely limits options; there was little room to make expense cuts from anywhere other than payroll.

The Return on Equity Ratio was dangerously low, and it would have been even lower if Sharon had not been taking out considerably less than she was really worth in salary. (She was only paying herself $58,000.) It measures both the value of the business as an investment, and the extent

to which funds are available to sustain growth. It is calculated by dividing shareholder equity—assets minus debts—by net profit, or what remains after all overhead and salaries, including the principal's, are paid. (This calculation assumes that the corporation's principal(s) receive fair-market salaries, which in a firm of Swift's income should be from $70,000 to $90,000.)

A QUALITATIVE ANALYSIS. Sharon Swift possessed a brilliant conceptual mind sought out by many clients. She also was a stylish, persuasive person who fit comfortably into the ego-saturated entertainment world. But back at the firm Sharon was different, often arbitrary and unpredictable when dealing with employees. (Inconsistency is the cardinal sin of management.) She could be friendly or belittling to a staff member depending on her moods and whether things were being done her way. The more pressure she felt, the more intense and difficult she was to work with. And, because there was no hierarchy (everyone reported directly to Sharon), important decision making often waited on her availability.

Staff turnover had been nearly 20 percent during the previous decade (1 out of 5 yearly when averaged over several years). This gave Swift Design the reputation of being the training ground for the industry. Talented individuals stayed just long enough to get experience and "build their book" before going on and often becoming competitors. Turnover had recently declined, but this was partly due to the fact that Swift Design had gradually become a home for employees who were just hanging in there, insecure about their own abilities.

Perhaps because of her intense creative focus, Sharon was in denial about the seriousness of her problems, despite the obvious drop in business. She viewed the situation as a temporary matter needing only a minor fix. An objective, outsider look revealed a much more discouraging picture. If the present trend continued, the company would probably fail within a year. The combination of Sharon's management style and her firm's dwindling cash flow called for immediate and drastic changes, summarized by two broad recommendations.

RECOMMENDATION ONE: Pare staff and redefine responsibilities. Swift Design could only barely support a staff of six (five plus Sharon) for the amount of business they could count on in the future. Three positions needed to be immediately eliminated. In addition, the five remaining positions needed to be redefined to ensure that the company operated efficiently. In addition to Sharon, the staffing recommendations were: one creative director, two mid-level designers, one low-level production person/designer, and one office manager/bookkeeper/receptionist. The most important of these recommendations was to define and appoint a separate creative director. This person would become the only one Sharon worked

with on matters regarding the company's product. The creative director would schedule all work and supervise everyone but the office manager. Swift Design's most senior employee, we'll call him Charlie, should have been a logical candidate for the new creative director position. Unfortunately, he was slow and only moderately talented. He was filling the role as the person who could best interpret Sharon's thoughts and ideas. Because he couldn't fit in the new organization, Charlie would have to be one of the employees let go.

Another change was to define and appoint a person to the position of office manger/bookkeeper/receptionist. He or she would also report to Sharon and be responsible for all noncreative management responsibilities. In addition to routine functions and keeping the books, this would include tracking key business indices (e.g., percent of billable time for each employee) and reporting any potential financial concerns to Sharon. The current bookkeeper/office manager could be appointed to this position. The current receptionist/office manager would have to be let go.

The other positions—two mid-level designers and a low-level production person/designer—were redefined in terms of computer literacy, the possession of a sought-after style in today's entertainment field (somewhat "alternative"), a sensitivity to what works at retail, and knowledge of prepress procedures and processes. Two of the present employees who were qualified could stay on, the other two would have to be let go. Finally, all employees would be required to sign noncompete agreements. They would curtail Swift being a training ground for employees with larger ambitions.

RECOMMENDATION TWO: Market Swift's uniqueness. Sharon needed to reclaim and rebuild her unique reputation in the entertainment design field. This was her firm's marketing USP (Unique Selling Proposition) and it had been badly eroded by being spread too thin and becoming out-of-touch with her client's needs. By restructuring Swift Design, Sharon would be set free to concentrate on developing even closer client and celebrity contacts. This activity, combined with an occasional "informational" mailing, should be all her firm would need to ensure a steady flow of job inquiries. Backing up this increased visibility would be a staff capable of producing the look many of her clients were seeking. Her company also would be run more cost-efficiently.

Finally, the combination of her contacts and experience, coupled with more contemporary design, would permit a small-risk increase in hourly rates: $125 immediately, to be increased to $150 or higher in two years if all continued to go well.

IMPLEMENTATION CONCERNS. Sharon had to embrace the need for change. More importantly, to implement it. The redefining of positions is easy.

Laying off staff to accomplish it, especially a long-time employee like Charlie, is not. Nor is learning to avoid micromanagement, cutting yourself out of the loop of creative decision making, or turning over management responsibilities. Sharon also had to face up to an even tougher fact: the design world constantly evolves and she hadn't. Although her talent and experience were still unique, there were others of equal potential who saw things differently than she did. She had to learn how to ally with them before it was too late.

● Case Study 2: ●
Dealing with the "Gorilla Client"

Ernie Suffern is now the principal of a three-person marketing communications firm located in upstate New York. He's been in business for ten years, the first half dozen with a partner who eventually lost interest and went off to study in Europe.

THE SITUATION. At the time the partnership dissolved, Ernie was just getting involved with one of their larger clients. He and the client got along famously. So much so he suddenly had little or no time left for other clients. He eventually dropped most of them. Ernie's versatility soon made him a virtual subsidiary of the client company. Before starting any new venture, Ernie was called in for advice, to develop start-up sales materials, handle ads, do executive speeches, organize employee meetings, etc. Ernie stopped being just a supplier; in essence, his three-person firm had become a marketing partner.

THE PAYOFF. Ernie's loyalty and hard work paid off. Handsomely. His firm charged $150 an hour, and had never had an invoice challenged by this client. In a recent year his sales were $425,000. Costs were just $249,000, leaving a profit (before his salary) of $176,000.

At the time of the business audit his current business assets (cash and receivables) were $130,000. With $30,000 in equipment (fair market value), he had $160,000 in total assets. Payables were just $96,000. Thus, the net worth of his business was $64,000 ($160,000 less $96,000).

With a personal income of $176,000, his personal life wasn't suffering either. He drove a luxury sports car, owned an expensive condominium with a reasonable mortgage, and lived the life of the eligible bachelor. Although he hadn't had time for a real vacation, he did attend all his client's meetings at first-class resorts.

A PROBLEM? Whenever more than 25 to 30 percent of a firm's income comes from one source it raises a red flag. In Ernie's case, more than 83

percent of his firm's income (and even more of its profit) came from what he referred to as "my gorilla client."

But given the profitability of work from this client, was it practical to suggest that he try and cut it back? Doing so wouldn't be easy; it's always hard to say no to someone who loves you. The work also was creatively challenging, too. Giving up gobs of immediate money for some long-term stability would be difficult, to say the very least.

THE RECOMMENDATION. So what is practical? We recommended that Ernie continue to work with the client at the same level. But also recognizing, to use his analogy, that the care and feeding of gorillas is always risky. Sooner or later they will turn on you. When this happens, adequate protection is necessary for survival.

This recommendation was based on two conditions. First, the net worth of Suffern Marketing was relatively high, and Ernie had been socking money away in his personal savings account. He had the financial resources necessary to buy some time when (not if) the gorilla tosses him out.

Second, Ernie also had a plan to immediately resume marketing when necessary. This is important because as crucial as having cash is in the short term, it can be quickly exhausted. Marketing—replacing the business—is not only the long-term solution, but also the one that takes a while to become effective. (Rule of thumb: The better the business you're going after, the longer it takes.)

FIVE CONSIDERATIONS FOR YOU. Here are five ways you can protect yourself if you have a similar "gorilla client." First and most important, don't kid yourself—it is very unlikely that you can keep a client more than a few years in today's volatile business world. If you do, consider it a gift. Furthermore, don't think that you are insulated just because you work for several different divisions of the same company. Even the biggest can have a company-wide freeze on all outside vendors, or "not-approved" outside vendors.

Second, as time passes make sure you raise your fees in keeping with higher business costs and increased expertise. Otherwise, you'll probably find yourself with up-to-date overhead costs and a years-out-of-date rate structure, or working for a "good" client for much less than for "not-so-good" clients. Although it is always hard to charge more, it should actually be easier from clients who already know and trust your abilities. Chances are you will agonize more over any increases than they will. Do you like the client so much you're willing to subsidize their profitability?

Third, make sure your billable efficiency (total work hours ÷ by billable hours) is at least 60 percent, ideally 70 percent. This will probably be necessary for you to sock away enough money to protect yourself.

Fourth, set up a self-insurance fund by siphoning off about 10 percent of your profit every month into a separate money market fund. Arrange to have it swept from your checking account automatically. Having adequate cash immediately available is the only sure protection against a sudden loss of business.

Fifth, have a marketing campaign ready to go. Cash will tide you over, but you still have to rebuild your business after a big client departs. The sooner you do it, the faster you'll recover and the smaller the financial hit you'll take. Ideally, this campaign will be a sudden increase in ongoing marketing activity. For example, a mailing campaign already developed to which you can make last-minute modifications and send to press. Remember, when long-term relationships go bad, it often happens with just a couple weeks notice.

◉ Case Study 3: Fast-Growth Danger Signals ◉

Ferguson & Jacobs (F&J) is a nine-person advertising agency in a mid-sized city in a predominantly rural state. They are the regional specialists in retail advertising and promotion. The agency was started five years ago by the two principals who had extensive retail experience, but no hands-on advertising background or training. They knew what worked and what didn't in retail and simply hired others to accomplish it, freelancers at first, then staff. In such situations, systems often evolve from trial and error, what's learned from employees, and by rubbing shoulders with other peers at social gatherings. This is not always the best way to acquire crucial business knowledge.

THE SITUATION. The growth curve at F&J had been steep. The firm's AGI rose nearly 60 percent in two years. The last year's sales totalled $1,164,000. Pass-through costs (media & printing) were $579,000 leaving an AGI of $585,000. The two principals each took out $89,000 in salaries, and a net profit of $76,000 was invested in the company's name.

THE IMPENDING PROBLEM. Although the situation at F&J looked great at first glance, all was not what it seemed. The steep growth curve was actually overdue for a dive. This was immediately apparent by looking at their billable efficiency, always the quickest way to measure the pulse of a creative firm. It was only 41 percent, below the 50 to 75 percent range desired.

F&J worked on a fee (versus commission) basis, billing $85 per hour on average. At this rate (too low even for the cost-sensitive retail industry and their location), the difference between 41 and 60 percent billable efficiency

was about $280,000 yearly! That's a bunch of money to give away. (If their rates went up, they would, of course, make more, but they would also lose more unless their billable efficiency improved.) Low billable efficiency always points to one of two things: not enough work for the number of employees or inefficient work-flow systems. Often it is a combination of both because they are closely related.

THE NOT-ENOUGH-WORK PROBLEM. This is easy to see and the cure is equally self-evident: more marketing activity (preferable) or reducing staff. The concern is not so much discovering the problem, but having the willpower to quickly address it. In any event, this was not the immediate problem at F&J. They had built a solid reputation in their market niche and had plenty of work.

THE INEFFICIENT-WORK-FLOW PROBLEM. There were four areas that could have been responsible. Each was looked into at F&J:

1. Were projects mostly "deadline driven" or "budget driven?" The hours any employee puts into a project should be dictated by the time budgeted for it in the estimate. When projects start to routinely become deadline driven—i.e., extra, nonbudgeted time is required to get them done on time—look for internal work-flow bottlenecks or overly optimistic estimating.

2. Was the labor accounting (time tracking) accurate? Often, a significant amount of work time isn't tracked or billed. This can be because employees forget, or because they want to reduce the amount of time they report spending on a job. Sometimes, too, hours recorded end up not being billed because the job ran over the estimate as a result of poor planning or inadequate client communications. Whatever the reason, all time should be recorded, and billed.

3. Was there a traffic hub? A traffic hub to a creative firm operates much like the control tower at an airport—it reduces accidents. Without it, mid-sized and larger firms often resemble a bunch of freelancers working under one roof. Think of a traffic hub as a way of connecting all the spokes of an organization together so they function efficiently. The employee holding this position (production/traffic coordinator) must be in the office full-time, but in firms with fewer than six employees can also have other tasks. He or she tracks budgets and schedules, manages capacity, and balances competing demands. This includes keeping work flowing by anticipating bottlenecks and communicating changes and problems to those involved. The production/traffic coordinator also does most of the interfacing with vendors and keeps the principals or financial person apprised of significant expenditures that may be in the offing. The best

hires come from printers ("print scheduler"), service bureaus ("production manager"), or ad agencies ("production/traffic manager").

4. Were employees' equipment and facilities adequate? The final potential cause of inefficient work flow is employees working with outmoded systems or facilities. In other words, they have plenty of work, but they can't get it done fast enough because of slow hardware, outdated software, etc. Actually, this is seldom a problem, although you'd never know it by listening to some employees.

THE SOLUTIONS FOR F&J. Now let's look again at the situation at Ferguson & Jacobs. Their staff of nine consisted of the two principals (one managed the business, the other functioned as creative director); one office manager/receptionist/bookkeeper; one senior designer; one designer; one interactive designer/production artist; one copywriter; and two account executives. Work flow was managed by the account people. This didn't work well for two reasons. First, while they were out servicing clients, there was no single person managing things back at the shop. Second, the creative staff resented being micromanaged by individuals more closely aligned with the client's interests. F&J's lack of a traffic hub was the primary problem, although there were minor problems in work often being deadline-driven and in time tracking. Equipment and facilities were more than adequate.

Our recommendation was that F&J hire a production/traffic coordinator and install a number of procedures to provide better job tracking, including the purchase of an integrated software package. The effect would be projects done more efficiently, but which would also cost clients more (because less subsidization would take place). For this reason we also recommended an aggressive marketing campaign to go after new clients, who would be less resistant to higher fees. Of course, all this would cost, but fortunately F&J could afford it. Their quick ratio (2.34) and debt-to-asset ratio (0.48) showed that they had the flexibility to take on the additional overhead.

With some serious effort, we calculated that they would see improvements in billable efficiency within two months, and close the efficiency gap (move from 41 to 60 percent) within nine months.

⚙ Case Study 4: Not Making Tough Decisions ⚙

This firm was an eight-person shop in a large southeastern city, doing mostly design, but some ad work. They'd been in business twenty-four years, focusing mostly on retail packaging for the last ten. Originally three principals, the firm had been headed by two for the last five years.

THE SITUATION. From a high of twenty-eight employees and $2.3 million in sales a decade earlier, the trend had been steadily downward: $1 million three years prior; $840,000 two years prior; $800,000 the year before. Three clients accounted for 68 percent of sales (40 percent + 15 percent + 13 percent). Principals were having difficulty paying themselves their $70,000 base salaries; cash flow deficits were being taken out of cash reserves, which were nearly exhausted.

THE PROBLEMS. The departed principal had been the businessperson. In the five years since he left, neither of the two remaining principals had faced up to the need for reorganization or the reality of shrinking size. Sales were one third of what they had been, but the same 7,200 square feet of space was still occupied. Other overhead expenses were similarly bloated. When the third principal departed, he had pillaged the firm, taking business and key staff with him. This left vacancies that were filled with less-than-qualified individuals. The two remaining principals had a paralyzing loyalty to employees who were only marginally qualified but had been with the firm an average of ten years.

THE SOLUTIONS. We recommended that the principals terminate the two least effective employees as soon as possible. They were dragging down staff productivity and were resistant to change. (This was obvious from billable time reports and interviews.) Further, put three employees on notice that improvement was necessary or they would also be replaced. Hire two new, talented designers. Have one of the principals assume daily operating responsibility and co-creative direction. Focus on reducing general overhead expenses to less than 15 percent of income, increasing billable time to 60 percent. Have the other principal assume full-time sales responsibility and co-creative direction. Put together a marketing plan aimed at both increasing sales in the lucrative packaging area and reducing dependence on three clients.

THE RESULTS. The firm took the advice, but it was too late. They were forced to close. All creditors were satisfied. The employees and one principal found work elsewhere. The other principal founded a new firm with stronger financial controls and a more suitable staff. His new company is small, but healthy.

THE LESSONS. Get rid of unproductive staff as soon as you see the writing on the wall. Trust your instincts—the danger of being wrong is much less severe than the danger of not acting aggressively. Staffing decisions must be made for the good of the group, not individuals. That's your job, and no one else can ever do it. If you've only got three oxygen masks in a plane with five people, the only thing worse than choosing who gets to

breathe is not choosing at all—leaving all the masks unused. You can buy flexibility in making tough staff decisions as follows: Don't hire until there is an overwhelming need (those affected have been working sixty or more hours for several months with no foreseeable let-up) have a financial cushion for lean times (at least 10 percent of your gross income set aside in liquid assets—when you dip into it you know something is up); control your activity with proactive marketing; and consider letting employees go when sales are less than three times payroll for more than three months.

⊛ Case Study 5: Relying on Referrals ⊛

Located in a west-coast city within driving distance of an almost limitless market, at first glance this design firm seemed to be doing everything right. Income was about $450,000 three and two years ago, then jumped to about $600,000 last year and was projected to jump again in the current year.

THE SITUATION. With a staff of six, including one principal, financial indices were in line and bills were being paid on time. $30,000 was kept aside for the inevitable rainy day (although at 5 percent of income this was a little low). A $50,000 credit line (an appropriate 8 percent of income) was seldom used, and always paid back within two months of when it was tapped.

SO, WHAT WAS THE CONCERN? Work load. Most assignments were handled at a frenetic pace usually initiated by a telephone call from a client with an immediate need. This had earned them an enviable reputation as a can-do operation in just five short years, but the operation had also turned into something of a creative factory. Clients dictated what they wanted, and there were few high-margin, creatively exciting projects. Running a tight ship with this type of work required modest salaries—between $30,000 and $40,000. Employees were under pressure and constantly grumbling about how hard they worked for so little money. The principal, who took out only $50,000 plus a $6,000 bonus, had come to wonder why she was putting up with the risks of ownership while making less than she did when working for someone else. It was not a happy or creatively stimulating working environment.

THE PROBLEMS. The firm had fallen victim to its own success. It was trapped under the weight of clients who had come to expect minimal creativity with fast turnaround at modest prices. (They were charging $80 an

hour.) New clients expected the same service because they came from the referrals of existing clients. The underlying problem was apparent: there was no marketing. No one was devoted to generating new, better business. Although referrals are always flattering because they indicate satisfied clients, from a marketing standpoint they usually only produce more of the same. They don't change the type of business; they result in reactive, not proactive activity. A consistent marketing effort is the only predictable way to shape a business's future, even out work flow, and expand into desired areas. It is also the surest way to shape the perception that others have of a firm.

THE SOLUTIONS. Our recommendations were that the firm immediately raise its billing rate to $100 an hour. Although this would result in the loss of some business, the net result was projected to be incremental income of approximately $2,000 a week. With this funding, a full-time sales representative could be hired and a marketing effort—direct mail and telephone calls targeted at getting more significant assignments— could be launched without cutting into existing business. (The sales rep was paid on commission, but her expenses and draw required funding.) New work generated by this activity would be handled mostly by the principal, the most talented person available. Although this required the principal to work even harder, she agreed it was necessary for the short term. As soon as business warranted, a high-level creative talent would be hired.

THE RESULTS. At this writing, it's still a little early to tell. Marketing efforts often take months or years to pay off. The bigger the targeted firms and assignments, the longer it takes. Nonetheless the results have been encouraging—the direct mail and phone calls have resulted in an average of three sales presentations a week. Several more challenging assignments have already been bid on, and two seem a real possibility. Interestingly, too, less business was lost by the price increase than anticipated.

THE LESSONS. Design firms often think of marketing only as a way of getting new business, not as a way of changing the type of business they have. Thus, when business is good, they ignore or cut back on marketing efforts. Most design businesses—freelance or multiperson firm—should devote about 20 percent of labor hours to marketing—week-in, week-out. If conducted properly this will not only ensure a consistently steady flow of assignments, it will produce better ones. If the effort should result in too much business, that's okay: drop the older, less attractive clients in favor of the newer, more attractive ones. The way to grow a firm that is both profitable and constantly renewing itself through new creative challenges is to keep getting better clients.

Case Study 6:
Failing to Institutionalize the Company

Harris Weber is a very talented designer with a distinctive style who started freelancing ten years ago in a large midwest market. As his reputation has grown, so has his business—currently five employees and $700,000 in income.

THE SITUATION. Things were starting to fall apart. He wanted to continue growing but didn't see how it was possible. "There aren't enough hours in the day. How do others do it without compromising the quality of their work?"

THE PROBLEMS. Harris was trying to operate a larger business like a freelance operation. This was apparent from his involvement in all aspects of all assignments; paperwork getting bottlenecked on his desk; office routines disintegrating when he took a (rare) day off; employees who didn't seem to care about the future of his business.

THE SOLUTIONS. We recommended that Harris make Weber Design into a true company, not an individual's avocation—to institutionalize it. This first required assigning job titles, rank, and specific responsibilities to each employee, then delegating real authority. For example, one employee was given authority for office management, another for creative direction. Every assignment became the responsibility of a project manager. Harris stopped insisting that everything be done his way, style and creativity included, and came to realize that even an occasional mistake was a small price to pay for increased motivation and productivity. He agreed that future hires should be based on adding portfolio variety, not similarity. All employees were required to have occasional client contact. Regular meetings ("gripe sessions") and a profit-sharing plan were instituted to provide employees with a sense of participating in the future of the firm.

THE RESULTS. Dramatic. Harris is working less hard and the business has not fallen apart. Employee morale is way up. A few older clients miss Harris's personal involvement, but not the new ones. Most significantly, a system is in place that will allow continued growth without negatively affecting Harris's enthusiasm and health.

THE LESSONS. The opportunities of an organization are theoretically infinite, an individual's physical and mental capacity is always finite. Excessive involvement by a firm's founder, the Entrepreneurial Disease, is a common problem that worsens with size. The problem commonly shows

up in three forms: a principal trying to clone himself when hiring employees, attempting to micromanage employees, and refusing to delegate responsibilities. The effect is to reduce the variety of the shop's product (its creativity), destroy employee morale, and make both the operation more susceptible to errors and the principal to creative and managerial burnout.

APPENDIX III

A Designer's Short Course in Marketing

C HANCES ARE most of what you do for your clients is a part of their marketing efforts. The better the client, the more they look to you not only for creative talent, but also to apply it in ways that enhance their goals. Or, they look to you for recommendations on new initiatives. Perhaps you're not as fluent in the language of marketing as you should be. For most design firms understanding the marketing process is already essential, and rapidly becoming more so. This appendix provides a "Cliff's Notes" or "Dummies' Guide" approach to the subject—enough marketing knowledge to let you pass the credibility test with all but the most sophisticated clients.

⊛ A Marketing Orientation? ⊛

You probably already realize the role a marketing orientation plays in your firm's future. In fact, it is likely you emphasize it when pitching clients. It is, after all, what they want to hear. This approach—promoting creatively-oriented marketing strategies—is a good one for design firms of all types and sizes. At the same time, however, it raises a concern: just how much substance is supporting the claims? Our experience is, sometimes not much. Many designers we've talked with over the years exhibit an embar-

rassingly limited understanding of the subject. Others can talk the talk, but can't walk the walk.

Ethics aside, there is probably no harm in promoting marketing knowledge when there is little to back it up as long as clients are unsophisticated. To them organization, decoration, and exposition are probably synonymous with marketing anyway. Even so, a little real marketing knowledge will make you a more valuable resource.

More importantly, however, is the increasing number of sophisticated clients. To them, marketing is not just creative polish. It is also strategies, positioning, pricing, and distribution, to name but a few of the more basic activities. Working with these clients doesn't necessarily require you to have a marketing M.B.A., but it does require an ability to understand what they're talking about and enough knowledge to make meaningful contributions.

❀ What It Is and Isn't ❀

Because marketing is a young discipline that's part art and part science, it suffers from more than its share of misconceptions.

MARKETING IS MORE THAN JUST AN INDIVIDUAL'S TALENT OR EXPERIENCE. Exaggerating the importance of successful selling or personal intuition is a common mistake. A client's decades of experience dealing with customers seldom provides the expertise needed to address significant new opportunities. Indeed, it often provides a misguided sense of optimism. And while it is true that creatives have lots of communication expertise, and it is an essential element of marketing, it is usually only a small part of a marketing mix.

MARKETING AND SELLING ARE NOT SYNONYMOUS. Confusing the two is another common mistake. In smaller organizations the two activities may be handled by one individual, but even so, they are often separate functions. Marketing is the overall process of taking a product from manufacturing through to customer satisfaction; sales is the specific process of taking orders. Another way of looking at the distinction between the two is that even though all persons in marketing must be customer focused, usually only salespeople have regular customer contact.

In some organizations—e.g., not-for-profits—there's lots of marketing activity with little or no sales activity. In others—e.g., retailing—there's much more sales activity than marketing activity. For most organizations, however, marketing consists of several important and well-balanced activities, of which sales is but one.

MARKETING HAS SEVERAL COMPONENTS. Although every marketing organization is different, traditionally they are responsible for at least the following six functions: marketing research—determining what customers want; product planning—recommending what the company should produce; advertising and promotion—telling customers about the product; distribution—providing the means to get the product to where the customer can purchase it; sales—taking orders; and customer service—ensuring that customers are satisfied.

MARKETING IS USUALLY ONE OF SEVERAL COMPANY DIVISIONS. Again, every organization is different, but most cluster activities into several major divisions. The divisions for a typical company might be: research and development—providing products for the future; manufacturing—making today's products; marketing—finding customers for today's and tomorrow's products; finance—ensuring that the company makes money; and human resources—finding, training, and administering personnel.

MARKETING CONTINUES TO GROW IN IMPORTANCE. In theory, client organizations are structured so that each major division is of equal importance. In truth, however, some are more equal than others. Marketing is the most important function in many organizations and is almost always so among those that rely on selling consumer goods.

We live in an environment that presents us with an ever-increasing number of choices. At the same time, the increasing complexity of the products we are offered makes it more difficult for us to choose among them. Helping customers come to a decision—marketing—has increased in importance. The more commodity-like (undistinguished by significant differences) products become, the more important this will be.

⊛ Marketing Focus Versus Customer Focus ⊛

Many businesses today misapply the rhetoric of marketing. To be a marketing-focused company is often equated with being a customer-focused one. Actually, the two are not the same.

MARKETING FOCUS. The true definition of a marketing-focused company is one that embraces what is often called the "marketing concept": creating a satisfied customer (a market) takes putting him or her first and foremost at every stage of a product's life—conception to service. This is also sometimes referred to as the "outside-in approach" because ideas on what to make and do come from outside, not internally.

Now, if this seems self-evident, consider that it is not the way many firms work. Rather, many operate on the "selling concept," or the "inside-out approach." A product is first created around the firm's capabilities, then they try to find a market for it using whatever means currently exist. In some cases this is unfortunate, but not in all.

CUSTOMER FOCUS. Why shouldn't every company be totally focused on the wishes of its customers? Well, if all were, many inventions and technological breakthroughs (copy machines, personal computers, Web browsers, etc.) would never have been introduced because customers didn't know they wanted or needed them. Put another way, true marketing-focused companies often miss new markets and development opportunities. Furthermore, companies working on government contracts or in regulated industries, such as health care and financial services, are often restricted in how much marketing they can do, yet, they are no less customer focused.

HOW MUCH LEADING VERSUS HOW MUCH FOLLOWING? At minimum, of course, all companies should be responsive to the needs of their potential customers, but how much of a true marketing focus they have should depend on their goals. Companies wishing to improve an existing widget or gain market share should probably orient their marketing efforts around closely following the lead of their customers.

On the other hand, those companies wishing to develop new products or markets must be careful not to follow the wishes of existing customers so closely that they are blinded to new opportunities that customers are unable to articulate.

For most organizations a balanced marketing effort—sometimes following the leads of customers, other times leading them—is appropriate.

☙ Marketing Structures ☙

The best way to structure the several aspects of marketing efforts is the subject of an old debate. Most clients use one of the two fundamentally different approaches—by function, or by product.

THE TRADITIONAL FUNCTIONAL APPROACH. In this structure, the various activities required to market a product are handled by functional departments—e.g., advertising—that are separately budgeted and report independently to the individual charged with overall marketing responsibility (e.g., the Vice President of Marketing). He or she sets priorities and allocates responsibilities and budgets.

This approach is the more common one because it follows the traditional hierarchical management system familiar to all business people. It is utilized by industrial organizations, business-to-business (B2B) marketers, or where a company's name is more widely known than that of its individual products or brands. (Example: The name General Electric has far more marketing value than any of the company's thousands of brand names.)

Within this approach the way an organization actually breaks down the marketing function varies greatly, based on its size and products. A small company selling to businesses may lump all marketing functions together under the umbrella of sales. Another with a large sales force may make sales a separate function equal to marketing. Finally, a large, broad-based company may organize its marketing around half a dozen functions.

THE BRAND OR PRODUCT MANAGER APPROACH. This structure does away with separate, independent departments, such as advertising. Instead, all the functional specialties required to market a specific product or brand are brought together. The brand becomes a profit center with its own budget. It is headed by a manager who usually reports directly to the individual charged with overall responsibility for the company's marketing.

This approach was pioneered by Proctor & Gamble in the 1920s. It is most commonly used today by consumer product manufacturers, those selling generic or commodity products, and companies whose brand names have more impact than their own. (Example: The brand "Pampers" has more marketplace impact and value than the manufacturer's name, Proctor & Gamble.)

❂ The Four *P*s of Marketing ❂

Most clients plan strategies and set budgets around what are often referred to as the Four *P*s of Marketing—product, price, promotion, and place. The marketing version of the weak-link theory is that no effort can be better than the weakest of the four.

PRODUCT. It is often said that even the worst product can be successfully marketed—but only once. Too often, marketing is given scant attention at the product design level (the back end). In contrast, products that are designed with marketing in mind have features designed to make them more desirable to customers, are better suited for the uses cus-

tomers put them to, and are packaged in a manner that makes them more appealing. When all this happens, the later functions of marketing are much more successful. Marketers often refer to their properties in one of three ways when discussing both new and exciting products.

Core attributes: As the name implies, it encompasses the essentials—what customers buy the product to achieve and what it would fail without. For example, if the product is a bar of soap, the core attribute would be its ability to produce clean hands.

Expected attributes: These are the things that customers come to expect, often because they are available in competitors' products. In our bar of soap example, they would probably be a smooth texture and a pleasant scent.

Augmented attributes: These increase the appeal of the product, but wouldn't necessarily be missed if customers hadn't been introduced to them. They are what often provides a product's competitive advantage. Again, in our bar of soap example, they could be the addition of a moisturizer, or a larger, or smaller size.

One other major consideration of the product aspect of marketing is the life-cycle concept. It says that a product is constantly maturing and will ultimately die unless it is occasionally reinvented. Much of the product focus of marketing is on keeping it young and fresh.

PRICE. Marketing's role in pricing is to interpret the size of the market (volume affects costs) and what customers are willing to pay. Then to keep the variable costs of a product's promotion and distribution in the proper relationship to the mostly fixed costs of its manufacturing.

Marketers may use one of several pricing strategies to meet their profit goals. The most common are: Cost-plus pricing, which adds a straight percentage to the product's unit cost; target pricing, which is based on achieving a certain volume; experience-curve pricing, which assumes there will be an increase in manufacturing and distribution efficiency over time; value-based pricing, which focuses not on the product's cost, but its perceived value; and competition-based pricing, which matches the competition, often at a loss to gain market share.

One other key pricing concept is that costs should fall over a product's life span as development costs are amortized and customer awareness rises. This provides the opportunity for either greater profit, or to adjust prices to meet competitive threats.

PROMOTION. This is the area of marketing activity that most directly affects most designers. Along with selling it encompasses what most people think marketing consists of.

Although definitions of promotional media are constantly shifting, the most common are: advertising—group audience contact through print, broadcast, outdoor, and interactive media; direct marketing—individual customer contact through letters, catalogs, and brochures; sales promotion—providing customer and dealer incentives, sales literature, displays, package design, etc.; and public relations—creating favorable market environments for companies and individual products.

By far the most significant thing happening in promotion is a continuing explosion of choices. New technologies and specialized media have reduced the cost and increased the efficiency of targeting messages to the interests of specific types of customers. The role of promotion is increasingly viewed in the context of supporting one-on-one (versus mass) marketing efforts.

PLACE. If customers can't find the product they can't purchase it, and all other aspects of marketing come to naught.

The backside, or company end of this function, is usually called distribution. It involves the logistics of product warehousing, scheduling, and shipping. On the front side, or customer end, it is usually called channeling, selecting the locations—distributors, dealers, or retailers—that allow customers to procure the product.

Companies traditionally look at three factors. Coverage—how can they make it easy for customers to find the product?; control—how much control will they have over the way the product is priced and displayed?; and costs—how much must be added to the unit cost to cover expenses?

In deliberating where and how their products will be sold, companies also have to keep antitrust laws in mind. (In the United States, primarily the Clayton and Sherman Acts.) Generally, the factor that determines whether an activity is illegal is whether there is intent to restrain trade or create a monopoly. The following four situations are all problematical, although they are legal in many situations: exclusive franchises—not allowing dealers to sell brands that are competitive; restricting territory—not allowing dealers to sell outside a specified area; limiting distribution—not allowing otherwise qualified dealers to carry a product; and tying agreements—requiring the dealer to carry a company's full line, not just one product.

⊛ Strategy and the Marketing Mix ⊛

Whether done formally or informally, the marketing process for all organizations begins with a strategy from which a target market (a group

of similar customers) is derived. It will be addressed by a mix of marketing activities.

The essence of the marketing mix is that effectiveness usually requires a combination of functions, and that they need to be in the right proportion to each other. An effective mix for cereal, for example, would be different from that for milk, and different still from that for fruit, even though all are used by the same customer for the same purpose at the same time. Typical marketing mix functions affecting creative development are summarized below.

RESEARCH. It is used throughout a product's life. First in preproduct planning, later in monitoring market activity, and later still in defining problems and opportunities. The findings strongly affect the creative approaches clients will accept.

Some of the more common techniques used are: trend analysis—determining industry change; situation or market-share analysis—comparing sales to those of competitors; test marketing—introducing a product to a controlled market to gauge reaction; focus groups—getting subjective opinions from a select group of individuals; and statistical sampling— quantifying as many sales variables as possible.

PRODUCT PLANNING. This is where marketplace ideals meet manufacturing reality. The result is usually a compromise: a product with enough features to be salable at the target price, but not so many as to make it unprofitable. This process is important from any creative firm's standpoint in that it determines the features and benefits they must work with. Participation in product planning is increasingly common among large design firms and agencies, but is rare among smaller design firms.

PROMOTION. This is the battleground for customers' minds, where the input of a creative firm affects the rest of the marketing mix, not the other way around. What media to use and what creative approach to take determines promotional effectiveness. Efforts can be designed to increase awareness, to pull a product through a retailer, or to help a sales force or retailer push a product to customers.

The amount spent varies widely from industry to industry. It ranges from a low of under 1 percent of sales for some heavy industrial goods to 20 percent or more for some consumer products. As a percentage of marketing dollars, the range is even greater—from a low of zero to a high of 100 percent. The only correct way to set the promotional component of a marketing budget is to first determine promotional objectives, then cost out what it would take to meet them.

SALES. This is the part of the marketing mix concerned with supporting a sales force. It affects the work of creative firms in two significant ways, especially in industrial and business-to-business organizations.

The first effect is that sales and promotional dollars are often considered interchangeable. That is, an increase in the sales portion of the marketing budget will often come at the expense of the promotional portion, and sometimes vice versa.

The second effect is that much promotional activity is directly in support of a client's sales force. Brochures, lead-generating ads and mailings, point-of-purchase (POP) displays, and trade show exhibits are all ways to help salespeople contact customers, or close a sale by explaining a product's benefits.

CUSTOMER SERVICE. The role of marketing seldom ends with the sale. For many industrial and business-to-business products especially, follow-up customer service can be a significant portion of the mix. This is crucial in ensuring happy customers and repeat business. Creative firms typically support customer service activity by producing owner's manuals and customer response media.

❧ Marketing Plans ❧

Marketing plans are the way to orchestrate the marketing mix. Several individual plans typically make up the marketing program for a company, which is but one chapter in its business plan.

COMMON ELEMENTS. All marketing plans have three things in common: 1) they detail the marketing mix, the what, when, and where of the various activities; 2) they indicate what resources are required and what the cost of them will be; and 3) they project what results can be expected and when. The staffs of a product manager in larger companies, or the vice president or director of marketing in smaller ones, typically prepare marketing plans. In larger companies the vice president or director of marketing is responsible for the firm's overall marketing program.

YOUR OPPORTUNITY. When receiving a significant assignment from a client, ask to see the product's marketing plan, or at least the relevant sections of it. Some firms may not want to share this confidential information with you. Even so, asking is nearly always beneficial. It identifies your firm as one focused on marketing, not just creativity, and it shows that you care about getting important marketing details correct.

Then, too, particularly among smaller companies, the response may be, "Plan? Our plan is in my head." In these cases, it may also be appropriate to ask whether they need help in preparing one. Again, even if the client declines, you have clearly indicated where your priorities are, and have almost certainly differentiated your firm from your competition.

Finally, companies that would normally only share or ask for marketing plan assistance from large agencies or marketing consultants often do need presentation, writing, and editing help, all potentially lucrative assignments.

❂ Marketing Plan Formats ❂

Although there is tremendous variety among marketing plans, most are divided into several sections, each containing one or more pages as appropriate. The five sections outlined below would normally be considered minimum.

INTRODUCTION AND STRATEGY. This section, sometimes called an "executive summary," typically is a single page of three or four short paragraphs that summarize what the company seeks to achieve, the product, its markets, and the focus of the marketing efforts.

DESCRIPTION. This section details the item and where, by whom, and why it is needed. In addition, each of the principal user benefits is briefly described (e.g., "Built to last"), as are the specific features that back up the benefits (e.g., "Constructed entirely of Lexan® and Type 310 stainless steel").

EXTERNAL CONSIDERATIONS. Factors that are outside the control of the company that could affect marketing are provided in this section. These typically fall into three broad categories: 1) general assumptions—economic, political, environmental, social, and technological factors; 2) market characteristics—history, size, type, typical customers, buying patterns, etc.; and 3) competitive products—their characteristics, strong and weak points, pricing, distribution, market share, and possible response.

OBJECTIVES. This section details as specifically as possible the goals of the marketing effort within a certain time frame. For example, to book sales of 10,000 units during the year, to get distribution of a new product in 60 percent of available outlets by next Christmas, or increase awareness among twenty-five-to-forty-year-olds by 10 percent.

TACTICS. This is typically the most detailed section of the plan. It sets forth a timetable and specific instructions for the marketing actions that are to be taken. For example, a pre-announcement press conference to be held on April 1; sales calls to start mid-April, full-page trade ads in three industry journals to begin running in May, product shipment to dealers June 1, dropping a 10,000-piece direct mailing in mid-June, or printing 15,000 brochures to answer customer inquiries in mid-June.

COSTS AND ROI. Here the financial resources required to make it all happen are covered—how much money will it take, and where and when will the dollars be allocated—and what the payoff should be—a projection (guesstimate) of return on investment (ROI).

❦ Marketing Plan Style ❦

There are no hard and fast rules about the writing and design of marketing plans. There is only a consensus that they should always be easy to read, conservative, and business like.

DESIGN AND WRITING. Strategy and planning documents shouldn't appear promotional or fancy, but they should be attractive and professional. The goal is fast and easy communication. This usually means a design oriented around readability, not style. Likewise, it means copy that is concise and easy-to-read with lots of bullets, subheads, and reader aids.

WHAT TO CHARGE. The design and writing of strategy and planning documents is more strategically than creatively challenging. Not only can it provide good additional income, but it also can position your firm at a higher level in customer minds. That, in turn, usually leads to more sophisticated and challenging creative assignments. Keep in mind when pricing that marketing plans are among a company's most essential documents. They articulate strategies and tactics to an audience of its important employees. The pay range for this type of activity should never be less than that for high-level design work, typically $150 an hour and up.

WHAT ABOUT SOFTWARE ALTERNATIVES? There are several inexpensive programs that make it easy for clients to put together basic marketing plans. You may want to recommend that clients facing marketing planning investigate these programs, or you may want to use one yourself to offer insights and speed up the basic formatting if you get a request to help out a client.

Keep in mind, however, that despite being excellent outliners and providing easy formatting, no program can substitute for custom marketing-plan preparation and styling. This process is, and will remain for the foreseeable future, the norm for most sophisticated firms.

Samples and Forms

❧ Formal Business/Financial Plan ❧

(Full-size copies of the sample forms shown throughout this book can be down-loaded for personal use at **www.creativebusiness.com/guidebook.html.**)

*A Plan For
The Growth Of
Dedicated Associates*

Dedicated Associates, Inc.
1784 Big Sky Blvd.
Big Sky, Montana 00000
(000) 000-0000
January 15, 2002

Summary

Dedicated Associates, Inc. provides graphic design and marketing communications services.

The firm has three full-time employees in addition to the full-time participation of its two principals.

Gross income in 2001 was $000,000.

The Company is a subchapter S Montana corporation chartered in October, 1995 and operating without interruption since. Fifty-one percent of the Company's outstanding stock is held by Sally J. Dedicated; forty-nine percent by Joseph H. Dedicated.

This plan outlines the business activities, projections and opportunities for Dedicated Associates, and details the need for additional capital in 2002 to finance growth.

Principals

Dedicated Associates was founded by Mr. and Ms Dedicated shortly after their marriage in 1995. Their objective was to utilize the skills they had developed in New York City to found a stable business offering Montana companies and organizations the same high level design and marketing communication services usually associated only with larger metropolitan areas.

Prior to founding Dedicated Associates, Ms Dedicated was a senior account executive and group vice president at Dernbach, Dones and Dale advertising, where she worked primarily on the advertising campaigns of Freedom Equity Fund, Big Pit Copper Products and Machismo Trucks. She began her career as a writer in the Chicago advertising agencies of Hand, Triangle and Gelding. In her ten years at that firm she worked on a variety of client communications problems. She is a graduate of Oxford University.

Mr. Dedicated had been a senior designer and vice president of Imperious Design where he had worked with such clients as National Accounting Machines, Regional Airlines, Analog Computers, and Gamble and Doctor. Before joining Imperious Design he had worked for nearly ten years in various design capacities for several well-known New York graphic design firms. He is a graduate of the Montana Academy of Design.

Facilities & Staff

Dedicated Associates occupies 2,000 square feet of office space in the Cattleman's Bank Building. The space is leased through March 2005, and is adequate for the growth projected.

The firm owns miscellaneous office furniture and equipment valued at approximately $0,000, one Macintosh Computer server and peripheral devices with current market value of over $00,000. Two other Macintosh computers and attendant peripherals are leased, as is a high-resolution scanner and a large format high-resolution printer. All equipment is appropriate for the growth projected, but will need to be supplemented.

Dedicated's staff consists of five individuals with a variety of appropriate talents, experiences and functions. No additional staffing is projected in the short term.

Free lance talent—writers, illustrators and photographers—is also contracted for as business volume requires.

Services Provided

Dedicated Associate's business is offering graphic design and marketing communications services. We conceive, design and produce corporate identity programs, internet sites, trade show exhibits, packages, signs, booklets, annual reports, and print advertising.

We are among the top five firms in Montana providing these services, and have clients through the region, including the State of Montana. We are the recipients of many state and national awards for excellence. We also enjoy a reputation as being an innovation leader, and have received national recognition for some of our operating procedures.

Several of the services we offer to our clients—primarily typesetting and expensive pre-press color work—are purchased by us from specialty suppliers.

The Market

The traditional market for graphic design and marketing communications has been expanding for decades as more organizations appreciate the bottom-line benefits of quality services. This expansion has been considerably accelerated in the past decade by the introduction of new, computer-driven technologies.

The overall growth of the market, and particularly the growth made possible by computer-driven technologies, has enabled our firm to prosper in Montana. The "New York" quality we can bring to our clients at Montana prices simply would not have been possible a decade ago.

Now the continued development of technology makes it possible for us to enter a new, dynamic and profitable market segment.

Opportunity

Our new opportunity is adding color pre-press services to those we already provide.

By adding color pre-press capabilities we will not only be able to lower our overall costs of color printing to our clients, but will also be able to provide better, faster service while maintaining tighter quality control. In addition, we will be able to market this service to other smaller and less experienced firms in our business.

Our projections indicate that we can handle this expansion with no increase in facilities or staff, and only a moderate and manageable increase in equipment.

As the financial projections indicate, we believe this opportunity will be a highly profitable market extension. We also believe it is a natural and timely one. We are unique in having a combination of staff, equipment, experience and clients that will allow us to establish a primary position in a developing technology before there is serious competition in our market area.

Financial Need

To add color pre-press capabilities it will be necessary to obtain new computer software, additional memory for our existing computers, an image setter, and a high-performance flatbed color scanner. The total outlay is approximately $00,000 as outlined below.

Software		
(type and description here)	$	000
Computer memory		
(amount and description here)		0,000
High-performance flatbed color scanner		
(model number and description here)		00,000
Image Setter		
(model number and description here)		00,000
	Total	$ 00,000

We wish to financed the purchase of this equipment with a five-year loan.

Summary Profit Projection

Detail on the financial position of Dedicated Associates can be obtained from the Company's Corporate Tax Returns and the Annual Statement of Financial Condition prepared by Barney & Smith, CPAs. Both are attached. This page summarizes the specific financial projections upon which the loan request is made.

Monthly income

Present (12-month, 2001 average)	$00,000
Additional typesetting*	0,000
Additional color pre-press**	0,000
Projected income	$00,000

Monthly expenses

Present labor (December 2001)	$ 0,000
Present overhead (12-month, 2000 average)	0,000
Loan payment and interest***	000
Projected costs	$00,000
Additional profit	$ 000
Profit as a percent of additional sales	00 percent

*Assumes an average of xx pages @ $00 per page. In 2001, Dedicated contracted for xx pages @ $00.
**Assumes an average of xx color pre-press jobs @ $000 each. In 2001, Dedicated contracted for xx color pre-press jobs @ $000.
***Assumes a five-year note for $00,000 @ x.x percent interest.

Estimating Worksheet

Date: _____ Revision #: _____
Client: _____
Project: _____
Job #: _____ Client PO #: _____
Proposal required by: _____
Projected start date: _____
Projected finish date: _____

Job specifications

Dimensions/format/size/scope _____
Number of pages/images/items _____
Quantity _____
Colors _____
Paper/fold/presentation _____
Number of photos/illustrations _____
Number of words _____
Number of charts/graphs/graphics _____
Special considerations _____

Input time

	Hours		$ Rate		Total
Initial meeting(s)	_____	x	_____	= $	_____
Additional meetings	_____	x	_____	= $	_____
_____ Client interviews	_____	x	_____	= $	_____
Background research	_____	x	_____	= $	_____
Travel time	_____	x	_____	= $	_____

Conceptual time

	Hours		$ Rate		Total
_____ In-house meetings	_____	x	_____	= $	_____
Creative research	_____	x	_____	= $	_____
Strategizing/evaluating	_____	x	_____	= $	_____
Concept/development	_____	x	_____	= $	_____
Design/writing/sketching	_____	x	_____	= $	_____

Execution time

	Hours		$ Rate		Total
_____ Client meetings	_____	x	_____	= $	_____
Full layout/draft/sketch	_____	x	_____	= $	_____
Formatting	_____	x	_____	= $	_____
First revision	_____	x	_____	= $	_____
Second revision	_____	x	_____	= $	_____
Author's alterations	_____	x	_____	= $	_____
Travel time	_____	x	_____	= $	_____

Sub-contracted services

	Hours	$ Rate		Total
Interviewing suppliers	_____	x _____	=	_____

	Estimate	Markup		Total
Copywriting	_____	+ _____	= $	_____
Design/layout/execution	_____	+ _____	= $	_____
Illustration	_____	+ _____	= $	_____
Original photography	_____	+ _____	= $	_____
Stock photography	_____	+ _____	= $	_____
Mfg/production/printing	_____	+ _____	= $	_____

Production time

	Hours	$ Rate		Total
Project management	_____	x _____	= $	_____
Art direction	_____	x _____	= $	_____
Typesetting/graphics	_____	x _____	= $	_____
Preproduction	_____	x _____	= $	_____
Production supervision	_____	x _____	= $	_____
Postproduction	_____	x _____	= $	_____

General expenses

	Estimate	Markup		Total
New type fonts	_____	+ _____	= $	_____
Special supplies/software	_____	+ _____	= $	_____
Copies & stats	_____	+ _____	= $	_____
Delivery services	_____	+ _____	= $	_____
Cabs/tickets/mileage	_____	None	= $	_____
Meals/hotels	_____	None	= $	_____
LD telephone/fax	_____	+ _____	= $	_____
Service bureau charges	_____	+ _____	= $	_____

Miscellaneous

_____	$ _____
_____	$ _____
_____	$ _____
_____	$ _____
_____	$ _____
_____	$ _____
_____	$ _____
_____	$ _____
_____	$ _____

Additional usage rights: _____

		$ _____
Administrative expense (small jobs)	+5% to 10%	$ _____
"Optimism factor" compensation	+10% to 20%	$ _____
Job/client difficulty factor	+ _____ %	$ _____
Competitive factor	− _____ %	$ _____

Estimated total

$ _____

(letterhead)

June 1, 2001

Mr. William Prospect
Vice President, Sales
Breakthrough Medical Products
198 Swansea Drive
Dayton, OH 45427

Dear Bill:

This letter will constitute an agreement for Squeamish Graphics to develop a single-page magazine advertisement and a Web page announcing the introduction of the CleanSlice Ligament Cutter. Placement of the ad in appropriate magazines and implementation of the web page on Breakthrough's web site will be handled by Breakthrough.

Schedule: The project will include the following on approximately the dates indicated:

July 1—Fact gathering meeting with your staff and appropriate personnel from the product development group.

July 10—Presentation of our ideas and conceptual approaches for review and input.

July 18—Presentation of final ad and Web page layouts.

July 19/August 1—Photography, artwork preparation, copywriting, electronic file development, and coding.

August 1/8—Approval routing at Breakthrough.

August 8/15—Final modifications and changes by Breakthrough.

August 15—Electronic files sent to Breakthrough's multimedia department for Web implementation.

more . . .

SQUEAMISH TO PROSPECT—2

September 1—Ad films sent to appropriate magazines by Squeamish from a list supplied by Breakthrough.

Fees: The following is an estimate of our fees for this project based on the information you've provided. Please note that if conditions or the schedule changes, the actual price may be higher or lower. We will, however, keep you informed of any change which exceeds 10 percent of the estimate.

Phase I—Research and concept development	$1,750
Phase II—Photography, copywriting, and artwork	$3,250
Phase III—Art direction, typography, and layouts	$2,500
Phase IV—Electronic file and films	$1,600

Expenses: Out-of-pocket expenses will be billed at a 25 percent mark up, which covers our handling costs. Such items normally include deliveries, service bureau charges, and long-distance phone calls.

We estimate total expenses for this project will be:$ _250_

Estimated project cost: $9,350

Ownership. All original photographic film, including transparencies and negatives, remain the property of the photographer selected. All preparation materials, including original artwork and electronic files and printing films, remain the property of Squeamish Graphics. All ideas and concepts not used remain the property of Squeamish Graphics and may be used in the future as they deem appropriate.

Terms: Approximately one third of this estimate ($3,000) to be billed upon acceptance; approximately one third ($3,000) upon acceptance of final layouts; the balance upon completion of the project. If any phase of the project is delayed for longer than sixty days, we will bill for work completed.

All invoices are net, payable within 30 days of receipt. Interest of 1.5 percent per month may be charged on past-due accounts.

As I have previously indicated, I believe my firm's experience handling similar projects provides Squeamish Graphics with the expertise necessary to do an outstanding job for Breakthrough.

more . . .

SQUEAMISH TO PROSPECT—3

If this proposal meets with your approval, please indicate by signing and returning one copy to me. A purchase order should be initiated as soon as possible.

If you have any questions, please call.

Thanks for the opportunity to submit this proposal. I'm looking forward to working with you.

Sincerely,

I. M. Squeamish
Principal

✦ Detailed Proposal ✦

(letterhead)

A PROPOSAL
TO PRODUCE A
CAPABILITY BROCHURE
FOR SECURITY FINANCIAL SERVICES

Prepared for
Sally D. Client
Director of Marketing Support
September 1, 2001

CONTENTS

Assignment Background page 3

Assignment Objectives page 4

Savant Associates' Experience page 5

Savant Associates' Approach page 6

Estimate of Savant Associates' Cost page 9

Estimate of Other Costs page 10

Working Agreement ... page 11

Approval ... page 12

Examples of Savant Financial Experience pages 13/14

2

ASSIGNMENT BACKGROUND

Security Financial Services, a division of Security National Bank, provides personal investment counseling and special banking services for individuals whose net worth exceeds one million dollars. The division was founded in 1993 to provide both a broader range of custom products and services and more personal attention to high-deposit customers. Security was the first bank in South Florida to provide this service. Since that time, all banks in Security's market area have offered similar programs and most have promoted them aggressively.

To date, the three-hundred-plus customers of the division have been acquired solely through referrals by officers of the bank's fifteen retail outlets. There has been no advertising and there is no literature to explain the division's products and services, or how they differ from that offered by other, competitive banks.

3

ASSIGNMENT OBJECTIVES

1) To broadly support a marketing campaign that will seek to double Security Financial Service's customer base within the next twelve months.

2) To fulfill the estimated 3,000 literature requests that will result from Security's "Talk to a Specialist" advertising campaign due to begin in December 2001 and run through April 2002. The material produced must key off the ad that will be producing the requests.

3) To provide literature that introduces the full range of the division's many services to its existing customers who may know of only one Security service.

4) To help educate and motivate all bank personnel about the "state of the art" nature of the products and services provided by Security Financial Services.

PRODUCTION AND SCHEDULING REQUIREMENTS

To design, write, and oversee production of a brochure that explains the immediate and long-term benefits of using Security Financial Services to handle a wealthy individual's financial and estate planning.

The brochure produced can be up to 20 pages (16 text plus cover) and utilize full color. Quantity will be 25,000. There are no restrictions on style, but it is desired that the brochure focus on the higher quality personal service provided by Security.

Due to the lack of any literature at present, and the formal announcement of the division's marketing campaign at a sales meeting starting on November 12, the brochure must be delivered by November 10, 2001.

4

SAVANT ASSOCIATES' EXPERIENCE

Savant Associates is a Miami firm specializing in communications and graphic design services for businesses throughout the southeast. Our firm was founded in 1989 by John J. Creative and Sarah S. Smart who combined over twenty years of corporate communications experience. Previously Mr. Creative was Vice President and Creative Director for Outstanding Advertising of Fort Lauderdale; Ms Smart was Vice President of Marketing and Strategic Planning for Swamp Land Development Corporation of Hialeah.

Since its founding in 1989, Savant Associates has built an impressive reputation for producing materials and programs that are strongly market-focused, yet are also tasteful and contemporary.

We have worked for small firms and large, startups and those well established. Some of our more prominent clients have been: Cuba Libre Airlines... Belle Glade Jai Alai Fronton... Delectable Ugly Fruit... Barely An Island Bahamas Spa & Resort... and HelpingHand Medical Centers. Projects have include advertisements, brochures, sales literature, package design, store displays web page design, and corporate identity programs.

Our extensive financial services experience includes working with South Florida Savings & Loan, Coral Gables Municipal Savings Bank, and Retirement Funds Investments. (See pages 13 and 14 for examples.) Assignments for these and other institutions have included the production of annual reports, product sales literature, and identity and signage programs. We are not currently working for any other financial services institution.

Savant Associates currently has a staff of ten who encompass a wide range of design and marketing skills. If we are granted this assignment, strategic planning and account service will be handled by company principal Sarah S. Smart; creative development and project management will be handled by company principal John J. Creative.

5

SAVANT ASSOCIATES' APPROACH

Phase I — Information Gathering

First Meeting

The Savant Associates account team of Sarah S. Smart and John J. Creative will meet with Security Financial Services to clarify objectives, identify subjective preferences, discuss possible thematic approaches, and uncover potential marketing problems.

In addition to Sally Client, we suggest this meeting include Laurie Jameson, Vice President of Marketing; Craig Heritage, Group Vice President; Vicki Montenegro, Account Supervisor, Florida; and any other bank personnel who can contribute to the overview of opportunities, concerns and potential problems.

In addition, we suggest that representatives of Bamboozle & Bamboozle provide a briefing of their "Talk to a Specialist" advertising campaign strategy, creative approach, and fulfillment requirements.

We also suggest that any previously developed materials or information on the division and its competition be made available to us.

Second Meeting

Based upon the overview obtained in the first meeting, John J. Creative will interview Sally Client and Craig Heritage to gather the specific detail and information needed to write and art direct the brochure.

Schedule

To assure meeting your deadline of having brochures for the sales meeting on November 12, we suggest that the first meeting be scheduled the week of September 7. The second meeting should happen a week or so later, ideally during the week of September 14.

6

Phase II — Idea Development

Concepts

Based on the input from the two meetings with your staff, Savant Associates will develop up to three conceptual, or rough, approaches to the brochure. A cover treatment and one spread from one of these approaches, our recommendation, will be rendered in full size, in color, along with a quarter-size dummy (mock up) of the entire brochure. Also developed will be an outline of the copy.

Third meeting

At this meeting we will present our approaches to Sally Client and Craig Heritage. Input from this meeting will be used to set the final direction for the brochure.

Schedule

We anticipate that the third meeting (conceptual presentation) will take place approximately two weeks after the second (detailed input), ideally the week of September 28.

Phase III — Development and Approval

Photography

We will select the photographer and supervise the taking of photographs. We will ask Security to help us in making arrangements and providing technical supervision during each photographic session.

Writing

We will develop copy in keeping with the direction provided at the third meeting and submit drafts to Sally Client for approval.

Design

We will execute the design approved at the third meeting and will coordinate and integrate the copy when it is approved. We will set type and prepare electronic (printing) artwork for the approval of Sally Client.

Schedule

We anticipate that first copy draft will be completed approximately one week after the third meeting, ideally the week of October 5. Final draft will be completed approximately one week later, ideally the week of October 12.

We anticipate photography to be done during the week of October 12.

We anticipate that mechanicals will be available for review three weeks after the third meeting, ideally the week of October 19. Final approval of all mechanicals will be necessary by October 27.

Phase IV — Printing and Delivery

Printer selection

Savant Associates will ask for bids from three printers and recommend one of the

7

three based on a combination of cost and quality factors. Selection will be made by Security Financial Services.

Print Supervision

Savant Associates will oversee printing of the brochure, giving instructions to the printer, supervising color separations and corrections, and checking proofs. However, Security Financial Services will have ultimate responsibility for the accuracy of the brochure as indicated by a signed approval of the final blue line (salt print) proof.

Schedule

Printing and binding of 25,000 four-color, 20 page brochures will take approximately two weeks from the time final, approved mechanicals are turned over to the printer. Assuming that mechanicals are approved by October 27, delivery by November 9 is feasible.

Project Timing

Note: the delivery of this brochure by the required date requires close adherence to the schedule outline above. Delivery cannot be guaranteed unless critical dates are met.

8

ESTIMATE OF SAVANT ASSOCIATES' COST

Phases I & II — Information and Idea Development
For three meetings, up to three conceptual approaches, one quarter size dummy of complete brochure, full-size rendering of cover and one spread, copy outline, typography sample.

$ 5,600

Phase III — Development & Approval

Copywriting	$ 4,000
Photo supervision and editing	2,800
Design	3,000
Electronic art	3,800
Typography	3,200
Photostats and photo copies	400
	$17,200

Phase IV — Printing & Delivery
Instructions to printer, checking separations, on-press supervision.

$ 2,400

Miscellaneous expenses—our costs +25percent markup
Deliveries $ 200

Total of Savant Associates' estimated costs
(Estimated costs do not include taxes.) $ 26,200

9

ESTIMATE OF OTHER COSTS

Photography

4 days @ $1,000 day	$ 4,000
Expenses and supplies	750
	$ 4,750

Printing
25,000, 8.5x11," 16-pages plus cover, 4-color process plus spot varnish on cover, 12 color separations, saddlewire bind. $19,000

Total of other costs $25,750

Note: this is an estimate for planning purposes only based on our past experience. Actual photography and printing prices will be determined from competitive bids.

All photography and printing will be billed by the vendordirectly to Security Financial Services.

Estimates do not include shipping or taxes.

10

WORKING AGREEMENT

Estimates
The costs and expenses cited in this proposal are our best estimates given the information provided. If additional information is forthcoming, the project specifications change, or the scheduling changes, cost and expense estimates may change.
 Cost and expense estimates are appropriate for 30 days from the date of this proposal. Taxes are not included in cost and expense estimates.

Revisions & Alterations
Work not described in this proposal, including but not limited to revisions (AAs), corrections, alterations and additional proofs, will be billed as an additional cost at the hourly labor rate of $125 per hour, or at our cost plus 25% markup.

Terms
Approximately one third of the total estimated costs in advance; approximately one third upon acceptance of the design concept; the balance upon delivery.
 If any phase of the assignment is delayed longer than sixty days, we will bill for work completed to date.

Responsibility
Savant Associates will make every reasonable effort to assure the accuracy of the material produced, but are not responsible for the correctness of copy, illustrations, photographs, trademarks, nor for obtaining clearances or approvals.
 We will take normal measures to safeguard any materials entrusted to us. However, we are not responsible for the loss, damage or unauthorized use of such materials, nor are we responsible for the actions of the vendors and suppliers we utilize.

11

Ownership
All materials used in the production of this assignment—including original artwork and computer generated artwork, formats, and code—remains the property of Savant Associates.
 Unless otherwise agreed upon, all original photographic film (transparencies and negatives) will remain the property of the photographer selected.
 Unless otherwise agreed upon, all printing materials (primarily films, plates, and electronic files) remain the property of the printer selected.
 Ideas which are not accepted remain the property of Savant Associates and may be used in the future in the course of other assignments.

Purchase Order
If this proposal is acceptable, a Security purchase order in the amount of $27,000 should be initiated. All invoices submitted against the purchase order will be net, payable within 30 days of receipt. Interest may be charged on past due invoices.
 We shall be pleased to begin work upon receipt of your purchase order.

Submitted by:

Sarah S. Smart
Principal
Savant Associates

Approved by:

Sally Client
Director of Markeing Support
Security Financial Services

12

EXAMPLE OF SAVANT FINANCIAL EXPERIENCE

(Illustration here)

The symbol of South Florida Savings and Loan is one of the most recognizable in the state. Because it is so strongly identified with the organization, any change is risky. Yet an organization's visual identity must also be strong and contemporary, or its market position can suffer.

Updating South Florida's symbol while also protecting it and building upon its equity was the challenge faced by Savant Associates.

The result of our efforts is a symbol with a much friendlier, more contemporary feeling. Equally important, along with it we developed a comprehensive corporate identity manual. It informs employees about the invaluable asset the symbol represents, and provides guidelines for its use on media ranging from calling cards, to ads, to company vehicles, to signage.

13

EXAMPLE OF SAVANT FINANCIAL EXPERIENCE

(Illustration here)

For Retirement Funds Investments we were asked to audit their communications programs to employees, shareholders and customers. What we found were sporadic efforts that were expensive in terms of confusion, redundancies and missed marketing opportunities.

Our challenge was to create an economical, effective and coordinated program.

The result is a redesigned "RIF Weekly," the newsletter for employees, quarterly and annual reports that further reinforce the company's market positioning, and a new quarterly house organ, "The Sentinel," sent to all customers.

14

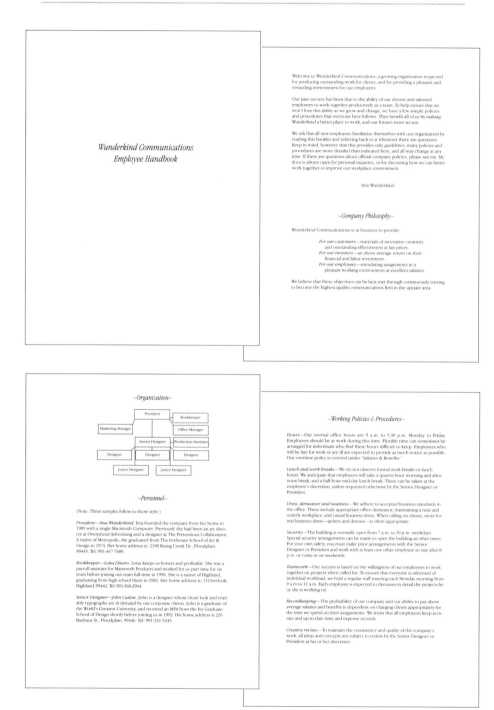

Wunderkind Communications
Employee Handbook

Welcome to Wunderkind Communications, a growing organization respected for producing outstanding work for clients, and for providing a pleasant and rewarding environment for our employees.

Our past success has been due to the ability of our diverse and talented employees to work together productively as a team. To help ensure that we won't lose this ability as we grow and change, we have a few simple policies and procedures that everyone here follows. They benefit all of us by making Wunderkind a better place to work, and our futures more secure.

We ask that all new employees familiarize themselves with our organization by reading this booklet and referring back to it whenever there are questions. Keep in mind, however, that this provides only guidelines; many policies and procedures are more detailed than indicated here, and all may change at any time. If there are questions about official company policies, please see me. My door is always open for personal inquiries, or for discussing how we can better work together to improve our workplace environment.

Ima Wunderkind

—Company Philosophy—

Wunderkind Communications is in business to provide:

For our customers—materials of innovative creativity
and outstanding effectiveness at fair prices.
For our investors—an above average return on their
financial and labor investment.
For our employees—stimulating assignments in a
pleasant working environment at excellent salaries.

We believe that these objectives can be best met through continuously striving to become the highest quality communications firm in the upstate area.

—Organization—

```
                    President          Bookkeeper
  Marketing Manager                    Office Manager
                 Senior Designer    Production Assistant
    Designer        Designer           Designer
       Junior Designer    Junior Designer
```

—Personnel—

(Note: Three samples follow to show style.)

President—Ima Wunderkind. Ima founded the company from her home in 1985 with a single Macintosh Computer. Previously she had been an art director at Overpriced Advertising and a designer at The Pretentious Collaborative. A native of Metropolis, she graduated from The Irrelevant School of Art & Design in 1974. Her home address is: 2198 Rising Creek Dr., Floodplain, 99445. Tel: 991-447-7689.

Bookkeeper—Lotta Dinero. Lotta keeps us honest and profitable. She was a payroll assistant for Mammoth Products and worked for us part time for six years before joining our team full-time in 1996. She is a native of Highland, graduating from high school there in 1982. Her home address is: 13 Overlook, Highland, 99442. Tel: 991-568-2964.

Senior Designer—John Caslon. John is a designer whose clean look and readable typography are in demand by our corporate clients. John is a graduate of the World's Greatest University, and received an MFA from the Ivy Graduate School of Design shortly before joining us in 1992. His home address is 226 Bauhaus St., Floodplain, 99446. Tel: 991-331-5245.

—Working Policies & Procedures—

Hours—Our normal office hours are 9 a.m. to 5:30 p.m. Monday to Friday. Employees should be at work during this time. Flexible time can sometimes be arranged for individuals who find these hours difficult to keep. Employees who will be late for work or are ill are expected to provide as much notice as possible. Our overtime policy is covered under "Salaries & Benefits."

Lunch and work breaks—We do not observe formal work breaks or lunch hours. We anticipate that employees will take a quarter-hour morning and afternoon break, and a half-hour mid-day lunch break. These can be taken at the employee's discretion, unless requested otherwise by the Senior Designer or President.

Dress, demeanor and neatness—We adhere to accepted business standards in the office. These include appropriate office demeanor, maintaining a neat and orderly workplace, and casual business dress. When calling on clients, more formal business dress—jackets and dresses—is often appropriate.

Security—The building is normally open from 7 a.m. to 10 p.m. weekdays. Special security arrangements can be made to open the building at other times. For your own safety, you must make prior arrangements with the Senior Designer or President and work with at least one other employee to stay after 8 p.m. or come in on weekends.

Teamwork—Our success is based on the willingness of our employees to work together on projects when called for. To ensure that everyone is informed of individual workload, we hold a regular staff meeting each Monday morning from 9 a.m to 11 a.m. Each employee is expected to discusses in detail the projects he or she is working on.

Recordkeeping—The profitability of our company and our ability to pay above average salaries and benefits is dependent on charging clients appropriately for the time we spend on their assignments. We insist that all employees keep accurate and up-to-date time and expense records.

Creative review—To maintain the consistency and quality of the company's work, all ideas and concepts are subject to review by the Senior Designer or President at his or her discretion.

–Working Policies & Procedures–

Ownership—All ideas and work performed at Wunderkind Communications, or for Wunderkind clients while in the firm's employ, are the property of Wunderkind. Where appropriate, employees are provided with up to 6 samples for their own files.

Personal work style—We attempt to be as flexible as possible, consistent with the demands of jobs and overall office productivity. Generally, we allow radios/stereos, bringing children and pets to work, and decorating your workspace with personal items and artwork. We do not allow any personal items or behavior that other employees or supervisors object to.

Sexual and other forms of harassment—We do not tolerate sexual or other harassment. If you feel these conditions exists, contact the President immediately. If you do not feel comfortable doing this, we encourage you to contact: (name, address and telephone number of of state agency responsible).

Nondisclosure/noncompete/software use policy—Projects and client information are not to be discussed or taken outside the company. All employees are required to sign a noncompete agreement prohibiting them from working independently on assignments for current or potential clients for a period of six months after leaving the company. No company software may be copied, or new software employed, without the President's permission.

Miscellaneous—We do not allow use of company computer equipment for personal use, except occasional e-mail messages and authorized freelancing. (See "Dealing With The Outside.") Occasional use of the telephone for personal calls is allowed, but for local calls only. Occasional personal use of copy machines is also permitted. Smoking is not allowed at any time.

–Dealing With The Outside–

Vendors and purchase orders—To maintain quality, we use only a few proven vendors approved by the Senior Designer or President. All expenditures of more than $50 must be authorized by a purchase order; lesser amounts can be authorized by the Office Manager from petty cash.

Demeanor—We expect each employee to conduct him or herself appropriately and professionally whenever dealing with individuals outside the company. The actions of an individual employee reflect on the company and all other employees.

Telephone—All employees should answer the telephone in the way determined by the Office Administrator or President, and maintain a courteous and professional manner at all times.

Correspondence—All written communication with outside vendors and clients should be in the formats determined by the Office Administrator or President.

Freelancing—We allow freelancing after hours providing it does not interfere with the employee's performance during work, and there is no conflict of interest with present or potential clients. Company equipment or time can not be used for freelancing without the permission of the Senior Designer or President.

Professional recognition—We budget for a limited number of submissions each year to award competitions. Choices are made by the Senior Designer.

Presentation to clients—To assure consistency, all ideas, concepts and materials shown to a client should be prepared and formatted in the manner determined by the Senior Designer or President.

–Salaries & Benefits–

Pay—Paydays are semi-monthly on the 15th and last day of the month. When the payday falls on a weekend or holiday, checks will be distributed on the closest regular workday.

Performance reviews—Employee performance is reviewed after 6 months, thereafter yearly on his or her anniversary date. Any salary adjustments resulting from that review take effect on the first of the next month.

Overtime—Based on job requirements as stated in the job description, employees are either "exempt" or "non-exempt" from federal and state labor laws. Non-exempt employees are entitled to overtime pay after working more than 8 hours in any day, or 40 hours in any week. Exempt employees are entitled to overtime compensation after working more than 10 hours in a day, or 50 hours in a week. Non-exempt employees will be compensated at 1.5 times their normal pay. Exempt employees may choose 1.5 compensatory hours, or pay at 1.5 times their normal pay.

Personal and vacation time—Personal and vacation time is awarded at the rate of 1 day for every month worked on the last calendar day of the month. (12 days yearly.) Up to 24 days may be accrued. Employees leaving the company will be compensated for any earned and unused time.

Sick time—In addition to 12 personal and vacation days, all employees earn 1 sick day every 4 months (3 yearly). *Sick days are not available to supplement personal and vacation days.* Up to 6 sick days may be accrued. Personal and vacation days may be combined with sick days when required to cover extended illnesses.

Holidays—The company observes the following 9 holidays: New Year's Day, President's Day, Memorial Day, 4th of July, Labor Day, Thanksgiving and Christmas, plus 2 other floating holidays determined by the President at the beginning of each year.

–Salaries & Benefits–

Health insurance—We offer group medical and dental insurance through (name). 50% of premiums are paid by the company. Full details of coverage and terms are available from the Office Administrator, including the possibility of benefit continuation at group rates if you should leave the company.

Leaves of absence—We will hold an employee's job, or a similar job, open for a period not to exceed six months for maternity leave, extended illnesses or unusual situations approved by the President. In these situations, health insurance will be provided until the end of the month in which the leave begins. Other benefits are not provided during leaves of absence.

Expenses—We reimburse employees for reasonable expenses incurred in the conduct of business, providing prior approval has been obtained from the Senior Designer or President.

Retirement plan—A 401(k) Plan administered by (name) is available for employees who wish to save for retirement in a tax-advantaged manner. Details of the plan are available from the Office Administrator.

Profit sharing bonuses—All individuals employed at year end are eligible for profit-sharing bonuses. Profits are defined as an excess of funds after all expenses have been funded. Profit sharing funds are distributed proportional to employee's salaries, normally on the first payday in January. At the employee's option, a bonus may be received as cash, or directly deposited in the employee's 401(k) plan. We attempt to provide an indication of bonus probability by December 1st of each year.

---*Marketing Manager Job Description*---

The Marketing Manager is our company's primary source of new business. He or she works with the President to determine our marketing plan, then implements it.

Education: BA degree preferred.

Experience: 1-2 years selling creative services required, preferably for a graphic design company, printing firm, or advertising agency.

Important attributes: Understanding of graphic design, the creative process and print production. Pleasant personality. Optimistic. Determined. Helpful. Attentive to details. Easy to work with.

Primary responsibilities: Helps determine company marketing strategy. Contacts potential clients. Obtains appointments. Shows the company's portfolio. Estimates project costs with creative staff. Prepares and presents proposals to clients. Evaluates marketing plan efforts.

Secondary responsibilities: Keeps informed of the progress of jobs in production, and provides contact and service as necessary for good, continuing client relations.

Promotion path: Does not normally lead to other positions.

Salary grades: Commission basis—15% of creative billings and products and services markups. Draw equal to the monthly salary of a grade 6 employee.

Labor status: This is a sales position and is exempt from most federal and state labor laws.

Supervisory responsibilities: None

Reports to: President

---*Senior Designer/Art Director Job Description*---

A Senior Designer/Art Director occupies a high-level creative position in our company. He or she is expected to be able to take full creative, fiscal and production responsibility for any project.

Education: BA degree in graphic design preferred. Graduate work in graphic design or fine art helpful.

Experience: 6+ years working experience as an art director or graphic designer, and proficiency with QuarkXPress, Illustrator and Photoshop required. Proficiency with Dreamweaver and Flash helpful, as is supervisory responsibility.

Important attributes: Outstanding creativity. Ability to help clients define and solve the most complex communications problems. Strong business understanding and financial skills.

Primary responsibilities: Meets with clients. Defines project parameters. Estimates project costs with the Marketing Representative. Develops innovative ideas and concepts. Presents and helps "sell" work to clients. Supervises print production.

Secondary responsibilities: Selects and monitors outside vendors. Helps train Designers and Junior Designers. Evaluates and recommends new procedures and equipment.

Promotion path: Does not normally lead to other positions.

Salary grades: 6 & 7

Labor status: This is a professional position and is exempt from most federal and state labor laws.

Supervisory responsibilities: Designers and Junior Designer(s) as designated.

Reports to: President.

---*Designer Job Description*---

A Designer occupies the mid-level creative position in our company. He or she is expected to take full creative, fiscal, and production responsibility for most projects.

Education: BA degree in graphic design preferred.

Experience: Macintosh literacy, 3-5 years working experience as an art director or graphic designer, and proficiency with QuarkXPress, Illustrator, and Photoshop required. Proficiency with Dreamweaver and Flash helpful.

Important attributes: Strong creative ability. Ability to work productively with clients. Recognition of project creativity/profitability tradeoffs. Some business understanding and financial skills.

Primary responsibilities: Meets with clients. Defines project parameters. Estimates costs with the Senior Marketing Representative. Develops innovative ideas and concepts. Presents and helps "sell" work to clients. Supervises print production.

Secondary responsibilities: Selects and monitors outside vendors as appropriate. Helps train Junior Designers.

Promotion path: Eligibility for promotion to Senior Designer expected within 4 years. Possibility for promotion to Creative Director or Senior Marketing Representative.

Salary grades: 4 & 5

Labor status: This is a professional position and is exempt from most federal and state labor laws.

Supervisory responsibilities: Junior Designer(s) as designated.

Reports to: Senior Designer or President as designated.

---*Junior Designer Job Description*---

A Junior Designer occupies the entry-level creative position in our company. This position typically involves project research, idea generation and execution of concepts. He or she is also expected to take responsibility for some smaller projects under the direction of his or her supervisor.

Education: BA degree in graphic design preferred.

Experience: Macintosh literacy required. 1–2 years in agency or design studio and proficiency with QuarkXPress, Illustrator, Photoshop, Dreamweaver, and Flash helpful.

Important attributes: Promising creative ability. Attention to detail. Willingness to experiment, learn, and grow creatively. Ability to recognize and adapt to changing conditions, including redefining his or her responsibilities as appropriate.

Primary responsibilities: Develops and executes design concepts efficiently. Occasionally supervises print production.

Secondary responsibilities: Maintains and upgrades computers, software, and peripherals.

Promotion path: Eligibility for promotion to Designer expected within 4 years; for promotion to Senior Designer expected within 8 years, depending upon experience and performance.

Salary grades: 2 & 3

Labor status: This is a professional position and is exempt from most federal and state labor laws.

Supervisory responsibilities: None

Reports to: Designer, Senior Designer or President as is designated.

—Production Assistant/Coordinator Job Description—

A Production Assistant/Coordinator monitors production schedules and acts as a liaison between creative staff and outside vendors. Is the point of contact for all production-related questions, whether internal or external.

Education: Some college preferred.

Experience: None required, but previous production experience and creative talent helpful.

Important attributes: Ability to learn rapidly. Detailed. Organized. Tough. Must work well under pressure. Personable and easy to get along with.

Primary responsibilities: Monitors and updates schedules set by President or Senior Designer. Informs appropriate staff of upcoming events. Releases and tracks all materials provided to vendors and clients.

Secondary responsibilities: Monitors outside vendors and reports to President or Senior Designer on their performance. Evaluates and recommends new production procedures.

Promotion path: Promotion from Assistantant to Coordinator (grade 4) expected within 4 years. Or possibility for lateral move to Junior Designer if creatively talented.

Salary grades: 2, 3 & 4

Labor status: This is a professional position and is exempt from most federal and state labor laws.

Supervisory responsibilities: None.

Reports to: Senior Designer or President as designated.

—Office Manager Job Description—

The Office Manager administers all office activities, and is the public face of our company. The execution of his or her responsibilities is highly visible and greatly affects the efficiency and productivity of our other employees. His or her personality and demeanor also has a major impact on our clients and vendors.

Education: Business training or some college preferred.

Experience: Word processing and typing skills required. Bookkeeping experience preferred. Previous experience in a similar type company helpful.

Important attributes: Organizational ability and attention to detail. Friendliness and personality. Good telephone manners. Flexibility in adapting to different individuals and changing conditions.

Primary responsibilities: All company clerical activities, including correspondence, filing and record keeping. Answers the telephone and relays messages. Greets visitors.

Secondary responsibilities: Occasional bookkeeping. Maintains appearance of reception area and conference room. Evaluates and recommends office procedures and equipment. Assists company staff as may be considered appropriate by supervisor.

Promotion path: Does not normally lead to other positions within the company.

Salary grades: 1 & 2

Labor status: The hours and working conditions for this position are subject to federal and state labor laws.

Supervisory responsibilities: None

Reports to: President

❧ Agent Agreement ❧

(letterhead)

September 1, 2001

Mr. A. Longshoreman
Vice President, Marketing
Lakefront Shipping Corporation
485 North Fairfax
Buffalo, NY 14702

Dear Mr. Longshoreman:

This letter, when signed by you, appoints us as (an) (your) exclusive) agent for the advertising of (all your) (insert specific) products. As used herein, "advertising" pertains to the purchase of all promotional media and the production of all materials to be used therein. This includes, but is not limited to, newspaper and magazine space, and radio and television broadcasting time. For the purposes of this agreement it shall specifically exclude [list media—e.g., billboards].

As an independent contractor, we agree to devote our best efforts to producing the most cost-effective advertising for your company. We further agree not to act as advertising agent for any products or services directly competitive with yours without your consent for the period of this agreement.

In return, you agree to make available to us the information we need pertaining to your markets, products and plans, and to cooperate with us in every reasonable way.

Services
We shall provide services customarily performed by advertising agencies. However, no services shall be performed unless and until we have received your prior authorization. A non-inclusive list of some of the services that will be provided on request include:

Analysis. We will analyze your marketplace activities, effectiveness, and opportunities.

Plan. We will prepare advertising programs for your approval based upon our analysis and your objectives and budget.

Production. We will conceive and produce materials appropriate to the approved advertising program.

Media. We will negotiate with the appropriate media and arrange for space and time as needed to carry out the agreed-upon advertising program.

Service. We will perform all necessary and related services to properly carry out your advertising program.

more...

Content to Longshoreman—2

Compensation
Our compensation will be derived from fees charged for providing the services outlined above, or such other services as you may authorize. Our service fees are as follows:

Senior talent—principally planning and creative concepts:
$175 per hour.

Mid-level talent—principally creative executions, media and account service: $120 per hour.

Junior talent—principally alterations and changes: $100 per hour.

Clerical and administrative services: $45 per hour.

Outside purchases—photography, illustrations, talent, color separations, etc.—will be billed (at cost) (at cost plus 25 percent markup).

Expenses incurred in travel will be billed at cost.

Our service and expense fees will be billed monthly. Our payment terms are net 30.

Media billing
Subject to your approval, we will place advertisements in the media agreed upon. Billing from the media will be directly to (company). You agree that (agency) is not responsible for any charges for media placed with your approval. Any commissions that may be earned by (agency) from media placed for you will be credited against our service fees.

Indemnification
We agree to indemnify and hold (company) harmless against any and all claims, liabilities or damages which arise 1) from dealings between us and third parties, and 2) the preparation and presentation of advertising. This indemnification shall include the costs of litigation and counsel fees.

You agree that we shall not be liable to (company) as the result of any default of suppliers of materials and services, or owners of media or other persons who are not our employees or agents.

Personal nature
This contract is between (company) and (agency) and neither party can delegate or assign any of its rights or duties to anyone else without the written consent of the other party.

Arbitration of disputes
(Company) and (agency) agree that any controversy or claim arising out of or relating to this contract, or the breach thereof, shall be settled by arbitration

more...

Content to Longshoreman—3

in accordance with the rules of the American Arbitration Association. Judgment upon the award rendered by the arbitrator may be entered in any court having jurisdiction thereof.

Termination
Either party may terminate this contract by giving the other party written notice at least 90 days before the effective date of termination.

No work in progress shall be completed unless requested by you. All contractual obligations in accordance with this contract shall remain in effect with respect to the winding down of all contractual relations. We will attempt to assign all of our contracts with third parties on your behalf.

We will deliver to you all papers and other materials related to the work performed in accordance with this contact. You agree to pay all reasonable costs of storage or transport of such items.

Period
(This agreement shall continue thereafter until terminated by either party.)
(This agreement is for a one year period beginning on [date] and concluding on [date].)

Sincerely,

Mal Content
Executive Vice President
Supervisor of Shipping Accounts
Overlooked Advertising

Accepted:

Mr. A. Longshoreman
Vice President, Marketing
Lakefront Shipping Corporation

Work-for-Hire Agreement

This is an agreement between __(name of contractor)__, normally doing business at
_____, and __(name of creative firm)__, normally doing
business at_____.

This Agreement covers the preparation and submission of ideas and materials for
_____(describe project)_____, further described in Purchase Order #_____, for a
total fee of $____ upon satisfactory completion. This work is considered work-for-
hire under the copyright law taking effect January 1, 1978. All concepts, ideas, copy,
sketches, artwork, electronic files and other materials related to it will become the
property of __(name of creative firm)__.

__(Name of creative firm)__ may use any and all materials generated as it sees fit with-
out any additional compensation; however, __(name of creative firm)__ is not under
any obligation to use such materials.

To the extent that any of the materials may not, by operation of law, be a work made
for hire in accordance with the terms of this Agreement, __(name of contractor)__
hereby assigns to __(name of creative firm)__ all right, title and interest in and to any
copyright, and __(name of creative firm)__ shall have the right to obtain and hold in its
own name any copyrights, registrations and other proprietary rights which may be
available.

__(Name of contractor)__ represents and warrants to __(name of creative firm)__ that to
the best of his/her knowledge the concepts, ideas, copy sketches, artwork, electronic
files and other materials produced do not infringe on any copyright or personal or
proprietorial rights of others, and that he/she has the unencumbered right to enter
into this Agreement. __(Name of contractor)__ will indemnify __(name of creative firm)__
from any damage or loss, including attorney's fees, rising out of any breach of this
warranty.

Any proprietary information, trade secrets and working relationships between (name
of contractor)__ and __(name of creative firm)__ and its clients must be considered
strictly confidential, and may not be disclosed to any third party, either directly or
indirectly.

Please indicate acceptance of the terms set forth above by counter-signing a copy of
this Agreement. It is necessary for us to have a copy signed by you before we can
authorize you to proceed on this project.

Contracted by: _____(signature)_____ Agreed to by: _____(signature)_____
Name: _____ Name: _____
Title: _____
(name of creative firm)

On this _____ day of _____ 20___.

Emergency Planning Form

Last Updated: _____

Immediate Attention:

Action	Responsible*
1.	
2.	
3.	
4.	

Notifications:

Client	Telephone	Contact	Responsible*
Law firm	Telephone	Contact	Responsible*
Accounting firm	Telephone	Contact	Responsible*
Local telephone	Telephone	Account #	Responsible*
Long distance telephone	Telephone	Account #	Responsible*

Review and update semi-annually. File copies offsite with principals and senior staff. *Assign two individuals—primary and backup.

—1—

Insurance company	Telephone	Policy #	Responsible*
Computer service	Telephone	Contact	Responsible*
Internet service	Telephone	Account #	Responsible*
Electric service	Telephone	Account #	Responsible*
Gas service	Telephone	Account #	Responsible*
Water service	Telephone	Account #	Responsible*
Landlord	Telephone	Contact	Responsible*
Banks	Telephone	Account #	Responsible*
Other			Responsible*

Backups:

Electronic files	Address	Telephone	Responsible*
Safety deposit boxes	Bank	Telephone	Responsible*
Other			Responsible*

—2—

Major Equipment Inventory:

Item	Brand	Model	Serial #	Purchase date	Cost

Rental Services:

Temporary help	Address	Contact	Telephone
Short-term office space	Address	Contact	Telephone
Short-term electronics	Address	Contact	Telephone
Other	Address	Contact	Telephone

Staff Addresses:

Employee	Address	Telephone	Next of kin telephone

—3—

Index

A

accounting services, 52–53
 purpose, 51–52, 53–54
 selecting, 52–53
AdMan software, 297–98
Advertising Age magazine, 238
advertising budgets, 238
advertising for design firms, 173–74
agency work
 award competitions, 186
 billing systems, 215–16
 compensation systems, 162–63
 conflict of interest issues, 162
 legal context, 161
 media commissions, 162–63
 staffing mix, 99
 vs. project work, 160, 161–62
age of principals, 285
American Arbitration Services, 71
arbitration, 70–73
asset appreciation/depreciation, 301–2
associate business model, 40–44
automobile insurance, 65–66
awards and honors, 185–88

B

Bailee's insurance, 64
balance sheet accounting, 317–18
banks/banking
 as funding source, 303–4
 personal relationship, 56–57
 selecting, 55–56
bartering for services, 221–22
billing
 accuracy of, 230
 collections problems, 72
 commission basis, 162–63, 220–21
 efficiency in, 288, 297, 312–17
 fee basis, 163
 hourly charges, 214–16
 profitability and, 311

projects exceeding estimate, 270–71
 retainer basis, 163
 working on retainer, 223, 224
bonuses and profit-sharing, 121–22, 128
bookkeeping services, 54–55
brainstorming sessions, 137–38
brokering, 278–79
burnout, 284, 344–48
business plan
 credibility of, 321–22
 description of business structure, 31–32
 financial section, 33
 formalization of process, 29–30
 format, 31
 goal setting, 30
 good qualities in, 29–30
 importance of, 27–28
 objectivity in, 321
 ongoing use of, 33–34, 321–22
 preparations for writing, 30–31
 rationale, 28–29
 sample, 34
 statement of purpose, 31
 trend tracking and, 320–22

C

capital
 accumulation, 333–34
 need for funding, 299–302
 ownership sharing to obtain, 21–22
 sources of funding, 302–6
career development, 120, 122–23
cash flow
 in associate business model, 43
 bartering for services, 221–22
 financing needs, 300
 goals, 283
 growth prerequisites, 289
 preparing for disruptions in, 333–34
 retainer arrangements and, 223–24
C corporations, 20–21, 307–8
Certified Public Accountant, 52

civic organizations, 180
client perception
determinants of, 242–45
 downsizing actions, 146–47
 evaluation of sales presentations, 209–10
 importance of, 177
 marketing goals, 155
 ownership sharing rationale, 22
 of professional awards, 185–86
 quantitative outlook, 200
 reputation building, 176
 in retainer arrangements, 225–26
 role of salesperson in communicating, 197
 of size of firm, 276–77
 of specialist firms, 158
 value, 208–9
client relations, 116, 168–69
 assessing customer satisfaction, 267–70
 client wants and needs, 241–45
 conflict of interest in, 251–55
 determining client budget, 236–37
 diversity of client base, 288
 dropping clients, 270–72
 with former employees in competing firms, 326–27
 getting client's respect, 253
 in-house creative review before presentation, 133–34
 joint-venture partnerships, 219
 leadership role, 252
 in maturing businesses, 343–44
 negotiating, 198
 number of clients, 289
 problem clients, 245–51
 in project work, 279–80
 qualifying clients, 197–99, 236–37
 raising prices, 230, 233–35
 receiving repeat work, 292–93
 recognizing potential problem situations, 262–67
 retainer arrangements, 224–25
 significance of, 241
 in Stage Three companies, 284
 start of design process, 132–33
 turning down business, 296
 volume discounts and, 227–28
Clients & Profits software, 298
commission, 220–21
 in agency work, 162–63
 sales staff compensation, 195
competition

design awards, 185–88
 from former employees, 326–27
 market trends, 156
 specialization of services and, 158
computer files, 259–62
computers
insurance, 64
 organizational needs, 44–45
 confidence, 18
confidentiality, to avoid conflicts of interest, 251–55
conflicts of interest, 251–55
 in agency work, 162
consultants, hiring, 73–74
 public relations professionals, 178–79
copyright issues, 260, 329–30
corporations, 20
 subchapter C, 20–21, 307–8
 subchapter S, 20
creative associates, 42
creative organizations, generally
 business planning in, 28
 direction in, 131–32
 formal policy development in, 80
 management style, 39–40
 predictability in, 36
 specialization in, 159
 stimulating creativity in, 136–38
 teamwork in, 137
 time management in, 312–13
credit cards, 305–6
credit rating, 302, 305

D

death of partner, 328–29
debt-to-asset ratio, 351
debt-to-equity ratio, 301
design process
 in agency work, 161
 client involvement, 132–33, 264–65
 designer autonomy in, 134–36
 in-house creative review before presentation, 133–34, 140–42
 ownership of preparatory materials, 259–62
 recognizing potential problem situations, 262–67
 salesperson role, 191
 stimulating creativity in, 136–38
 use of prototypes and intermediary

work, 255–58, 264
DesignSoft software, 298
direct-mail advertising, 175–76
disability insurance, 59–61, 63, 112–13, 323
discounted prices
 client requests for, 263
 for not-for-profit organizations, 228–30
 profitability and, 311
 for volume, 226–28
dismissing employees
 documentation, 151
 downsizing considerations, 143–47
 legal issues, 90, 150–51, 325–26
 notice of, 145–46
 problem employees, 147–49
 procedure, 151–52
 rationale, 150
 role of job descriptions in, 90
 severance, 146, 151–52
dropping clients, 270–72

ego, 18
e-mail, 174
emergency planning, 327–28
employee compensation and benefits
 benefits package, 112–13
 bonuses and profit-sharing, 121–22, 128
 company growth and, 289–90
 corporate policy statements, 86–87
 employee concerns, 82
 employee motivation and, 120–21
 equitable application, 93–94, 120, 129
 giving raises, 128–30
 insurance coverage, 62–63
 interns, 103
 job descriptions, 90, 91
 local standards, 111
 offers to new employees, 111–13
 overtime, 113
 ownership sharing, 123
 as percentage of firm expenses, 77
 as percentage of firm income, 310
 pricing of services, 216, 231
 sales staff, 193, 195–96
 severance pay, 146, 151–52
 shop rates and, 163
 sick leave, 113
 staff affordability calculations, 96–98, 145
 tax withholding, 330–31

vacations and holidays, 113
employees
 in associate business model, 42–43
 career development opportunities, 120
 freelance workers, 63
 handbook of policies and procedures,
 84–89, 149
 information sharing with, 119, 145–46
 job descriptions, 87, 89–92
 job satisfaction, 116
 legal action by, 72–73
 management relations, 36, 85, 118–19
 motivation, 115–24
 noncompete agreements, 27, 92–93
 number of, 95–98
 performance evaluations, 90, 124–28, 151
 preferred working conditions, 36, 44, 82
 promotions, 122–23
 sales, 205–6
 selling firm to, 353–54
 work schedules, 124
 see also dismissing employees; employee
 compensation and benefits; hiring
employment agencies, 105
entrepreneurial disease, 339–44
equity funding, 22
errors and omissions insurance, 64
estimates and proposals
 in associate business model, 42
 large projects, 262
 ownership of preparatory materials,
 259–60
 ownership of prototypes and intermediary work, 256–57
 problems of perfectionism, 338–39
 productivity analysis, 314
 profitability and, 311
ethical practice, conflicts of interest, 251–55

fee-for-service, 163
 financial management
 advertising budgets, 238
 asset appreciation/depreciation, 301–2
 associate business model, 42, 43
 award budgeting, 188
 balance sheet accounting, 317–18
 bartering for services, 221–22
 benchmarking trends, 318–22
 business plan, 33

buying office space, 49–50
capital accumulation, 333–34
company growth, 290, 291–92, 300
debt-to-equity ratio, 301
electronic tools for, 297
fraud/corruption in, 323–24
funding needs, 299–302
funding sources, 302–6
impediments to profitability, 230–31
income statements, 317, 318
indications for downsizing, 145
large firms, 276
lease negotiations, 46–49
legal fees, 67–69
mid-sized firms, 275, 276
outside accounting services, 51–57
resource allocation for marketing, 190
return on advertising investment, 173
return on investment calculations, 301
sale of firm, 353–54
small firms, 275
spending on office space and facilities,
 45–46
staff size, 95–98, 145
valuation of business, 328–29, 348–52
see also billing; employee compensation
 and benefits; pricing of services
firing. see dismissing employees
flextime scheduling, 124
fraud
 bookkeeping, 55
 corrupt employee, 323–24
 insurance against, 65
 pension plan administration, 65
freelance workers, 274
 insurance considerations, 63
 potential problems of, 100–101
 tax issues, 99, 101, 330–31
 use of, 100
 vs. hiring, 99–100

general partnership, 19, 25
Graphic Artists Guild, 231, 238
growth
 cash flow and, 289
 controlling, 291
 financing for, 300, 333–34
 goals, 287
 indications for hiring, 98, 289
 insurance issues, 289–90
 maintaining work flow, 294–96
 management challenges in, 290–91
 managing, 90, 277–78, 286–92
 marketing considerations, 290
 national economy as factor in, 287
 need for, 273
 number of clients, 289
 potential problems, 290–91, 291–92
 prerequisites, 288–89
 pricing and, 288–89, 291
 productivity and, 288
 space considerations, 290
 stages of corporate development, 281–86
 types of, 287–88
 see also size of firm

health care insurance, 58–61, 62–63, 112
health maintenance organizations, 58
heating, ventilation, and air conditioning,
 47
high-end projects, 204–7
hiring, 144, 148
 discrimination, 103–4
 evaluation of applicant, 107–10
 finding qualified applicants, 103–5
 of freelancers, 100–101
 of friends and family, 106
 indications for, 98, 289, 294–95
 informing applicant of decision, 113–14
 of interns, 102–3
 job application form, 107
 mistakes in, 89
 portfolio review, 106, 109–10
 résumé review, 107
 role of job descriptions in, 89
 safe growth guidelines, 289
 sales staff, 191, 192–95
 talent mix considerations, 98–99
 of temporary workers, 101–2
 trial employment, 148–49
 use of tests, 110
 vs. outside contracting, 99–100
hourly fees, 213–16, 233, 288–89

income and profitability
 billable efficiency, 96
 billing systems, 162–63

company growth, 287–88, 290, 291–92
compensation for principals, 97–98,
 307–10
compensation in client equity, 222–23
determinants of, 230–31, 310–12
discounts for not-for-profit organizations
 and, 229
employee bonuses and profit-sharing,
 121–22
employee compensation and, 310
goals, 299, 302–3
as indicator of company performance,
 306–7
management strategies to increase prof-
 itability, 312–17
markup/commissions, 96–97
in mature companies, 283, 284
method for calculating, 307–10
outside financing and, 302–3
per employee, 291–92
pricing of services, 214, 216, 217, 219,
 331–32
pro bono work and, 180
profit-sharing, 41–44
raising prices, 170
rationale for hiring temporary workers,
 100
ratio of old-to-new clients and, 310
repeat clients, 223, 292–93
sales effort, 190
size of firm and, 275, 276, 312
staff affordability calculations,
 95–98
staff size and, 95, 290
trend tracking, 318–22
volume discounts, 227–28
income statements, 317, 318
incorporations, 20–21
insurance
 agent selection, 57–58
 automobile, 65–66
 bonds against fraud, 65
 business interruption, 64
 business owner's policy, 63–64
 commercial general liability, 64
 company growth and, 289–90
 disability, 59–61, 63, 112–13
 electronic equipment, 64
 as employee benefit, 62–63
 employer liability, 65
 errors and omissions, 64
 health care coverage, 58–61, 62–63,
 112

incapacitation of principal(s), 323
key individual, 27, 62, 323
lease provisions, 49
life, 61–62, 63, 112
lost/damaged/stolen materials,
 64–65
natural disaster, 65, 327–28
needs evaluation, 58
transit coverage, 65
umbrella liability, 64
worker's compensation, 63
interns, 102–3

J

job descriptions, 87, 89–92, 94, 120
 legal significance, 325–26
 performance evaluations and, 125
Job Order software, 298
joint ventures, 20

K

key-person insurance, 27, 62, 323

L

leases, 304–5
 building services, 47
 escalation clause, 47
 improvements and renovations,
 47–48
 insurance provisions, 49
 move-in date, 48
 recognition clause, 49
 renewal terms, 48
 sublet provisions, 48–49
 unexpected cancellation, 327
legal issues
 acting as agent for client, 161
 considerations in job descriptions, 92
 corrupt employee, 323–24
 discrimination, 103–4
 dismissing or punishing employees, 90,
 150–51
 downsizing considerations, 146
 employee benefit packages, 112
 employee handbook, 85
 exemption from labor laws, 92
 failure to collect proper tax, 324–25

lawsuit from dismissed employee, 325–26
nondisclosure agreements, 255
ownership of preparatory materials, 259–62
protection of spec work, 203–4
theft of ideas, 329–30
use of prototypes and intermediary work, 256–57
verbal commitments, 265
legal services
alternative dispute resolution, 70–73
fees, 67–69
legal audit, 69
selecting, 66–67
working relationship, 66, 67–68
legal structure of firms, 18–21
life insurance, 61–62, 63, 112
limited liability company, 21
limited liability partnership, 19–20
liquidity index, 291, 301
loans
affordability, 300–301
need for, 299–300, 301–2
sources, 302–6
vs. leases, 304–5

M

management
assessment of, 77–79
associate business model, 40–44
burnout, 344–48
business growth and, 290–91
chain-of-command model, 37–39
coaching model, 39–40
corporate culture, 37
in creative organizations, 131–32
delegation, 37, 117–18, 134–37, 343
electronic tools for, 296–98
employee motivation and, 117–19
employee relations, 36, 85, 118–19
entrepreneurial disease, 339–44
as factor in valuation of firm, 350–51
fault-tolerant, 148
formal employment policies and, 94
giving constructive criticism, 118, 138–40
improving employee work habits, 149–50
in mature companies, 283

ownership sharing and, 22
problems of perfectionism, 335–39
role of business plan, 28
stimulating creativity, 136–38
strategies to increase profitability, 312–17
sudden risk situations, 322–34
see also dismissing employees; financial management; hiring
marketing
agency work, 160
company growth and, 290
components, 171
experience of firm as selling point, 168, 169–70
getting publicity, 176–79
to increase profits, 310, 332
language of, 206
to maintain work flow, 295, 313
market trends, 155–57
reputation building, 176
research activities, 203
resource allocation for, 190
role of salesperson in, 197
specialization of services, 157–60
value-added, 219
see also promotional activity; sales activities
markups, 220, 279
Martindale-Hubbell Lawyer Locator, 67
media commission, 162–63, 220–21
mediation, 70–73
meeting management, 313
minimum charge, 231
minority-owned business, 56
mission statement, 31, 85
application, 166–67
good qualities in, 164–65
purpose, 163–64
selection of, 165–66
morale, 313
mortgage loans, 50
motivation
attitude and, 117
client relations and, 116
intangible motivators, 116–19
management role in, 117–19
role of mission statement, 164
significance of, 115
during slow periods, 313
tangible motivators, 119–24
teamwork and, 115–16

N

naming of firm, 22, 205, 242–43, 280
 specialization and, 160
National Arbitration and Mediation, 71
natural disaster, 327–28
net asset value, 348–49
networking, 179–80
noncompete agreements, 27, 92–93, 196, 354
 rationale, 326–27
nondisclosure agreements, 204, 255
not-for-profit clients, 228–30

O

optimism, 321
organizational structure and functioning,
 35–36
 adaptability, 37
 assessment, 77–79
 associate business model, 40–44
 chain-of-command model, 37–39
 chart of, 82–84
 coaching model, 39–40
 corporate culture, 37, 285
 decision-making structure, 37
 description in business plan, 31–32
 employee concerns, 82
 employee handbook, 84–89
 job descriptions, 87, 89–92
 legal structure of firms, 18–21
 need for policies and procedures, 343
 predictability, 36–37
 problems in, 77
 size of firm, 22, 37
 stages of corporate development, 281–86
outside services
 accounting, 51–54
 banking, 55–57
 bookkeeping, 54–55
 brokering, 278–79
 consulting, 73–74
 corporate policy statements, 86
 employment agencies, 105
 insurance, 57–66
 legal, 66–73
 markup, 162–63, 220
 range of, 51
 for sale of firm, 354
 sales commission, 42
 valuation of business, 352

vs. hiring, 99–100
 see also freelancers; temporary workers
overtime, 98, 289, 295–96
 compensation, 113
owner equity, 43
ownership sharing
 death of partner, 328–29
 employee participation, 123
 with general partners, 25
 legal protections, 27, 328–29
 majority ownership, 26–27
 potential problems in, 24–25, 328–29
 rationale, 21–23
 selection of business associates, 23–24
 as source of financing, 305
 stock buy-back agreements, 27, 328–29
 by stock distribution, 25–26
 valuation of associate's contribution,
 24
 valuation of business, 328–29, 348–52

P

parental leave benefits, 112
partnerships, 19
perfectionism, 335–39
personal finances
 compensation for owners, 97–98, 307–10
 owning office space, 50
 in sole proprietorships, 18–19
personal qualities
 age of principals, 285
 client relationship, 168
 for coaching model of business manage-
 ment, 39
 corporate culture and, 37, 285
 employee–management relations, 36
 entrepreneurial disease, 339–44
 for freelance work, 274
 law firm relations, 66
 for managing large firm, 276
 for managing mid-sized firm, 275
 for managing small firm, 275
 perfectionism, 335–39
 performance evaluation, 127
 risk of burnout, 344–48
 selecting accounting services, 52
 selecting business associates, 23–24
 self assessment, 77–79
 of successful executives, 17–18
Peter, Laurence J., 246

Peter Principle, 246
physical environment
 buying office space, 49–50
 company growth, 290
 employee motivation and, 123–24
 lease negotiations, 46–49
 for sales department, 193
 space requirements, 44
 spending on, 45–46
 three Cs, 44
 unexpected cancellation of lease, 327
 work space calculations, 47
positioning, 155, 160, 205, 242–43, 280
 adapting to change, 167–70
pragmatism, 18
preferred provider organizations, 58
preparatory materials, 259–62
press releases, 177–78
pricing of services
 additional concepts, 258
 client budget and, 235–40
 client perception, 208–9
 to control growth, 277, 291
 cost considerations, 331–32
 dispute resolution, 72, 270–71
 employee compensation and, 216, 231
 estimating procedures, 219
 growth prerequisites, 288–89
 industry averages, 214, 231
 long-term projects, 261–62
 markup of outside services, 220
 in mature companies, 283
 minimum charge, 231
 noncash compensation, 221–23
 not-for-profit clients, 228–30
 profitability and, 310
 raising prices, 230–35
 retainer arrangements, 223–24, 225–26
 sales incentives, 206, 218, 219–20
 time-based, 213–16, 288–89
 by value to client, 216–20
 volume discounts, 226–28
 see also billing
printing
 brokering, 278–79
 markup, 220
problem employees, 147–49
pro bono work, 229
 appropriate levels, 180–81
 company readiness for, 180
 credit for, 184
 declining, 184–85

management, 183–84
 project selection, 181–83
 tax benefits, 181
productivity, 81
 growth planning, 288
 organizational structure and, 36
 pricing of services, 216
 role of job descriptions in, 89–90
 during slow periods, 313
 tracking, 314–17
 volume discounts and, 227
profit. see income and profitability
promotional activity, 243
 advertising, 173–74
 direct mail, 175–76
 e-mail bulletins, 174
 frequency, 172–73
 long-term orientation, 172
 professional networking, 179–80
 rationale, 171–72
 Web site, 174
 see also marketing; sales activities
publicity, 176–79, 184, 187

Q

quick ratio, 291, 301

R

receptionist, 55
record keeping
 employee performance evaluations, 128,
 151
 productivity tracking, 314–17
 in support of decision to dismiss
 employee, 151, 325–26
Resolute Systems, 71
retainer arrangements, 163
 advantages, 224
 client perspective, 225–26
 disadvantages, 224–25
 indications for, 226
 pricing, 225–26
 rationale, 223–24
retirement
 employee plans, 113
 of firm principal(s), 50
 pension plan insurance, 65
return on investment, 348, 349

S

sale of firm, 353–54
 sales activities
 adjusting work flow, 294–96
 approved vendor lists, 207
 assessing customer satisfaction, 267–70
 in associate business model, 41, 42, 43
 business mix, 278–81
 categories of design projects, 200
 client values, 209–10
 compensation for sales staff, 193, 195, 196
 conflict of interest in, 251
 development of new salesperson, 196–97
 dropping clients, 270–72
 expense reimbursement, 195–96
 goal setting, 192–93
 high-end projects, 204–7
 hiring, 192–95
 importance of, 189
 information gathering for, 202–3
 maintenance of effort, 190
 moderate-visibility projects, 207–10
 with new clients, 206, 236–37
 noncompete agreements, 92–93, 196
 number of clients, 289
 office space and equipment for, 193
 part-time employees, 191–92
 price incentives, 206, 218, 219–20
 professionalism in, 243–44
 prospecting, 191
 qualifying clients, 197–99, 236–37, 247–48, 332–33
 ratio of old-to-new clients, 292, 310
 receiving repeat work, 292–93
 recognizing potential problem situations, 262–67
 referrals, 192
 with regular clients, 207
 resource allocation, 190
 revenue-crucial projects, 200–204
 role of firm principal in, 191
 salesperson responsibilities, 197
 staffing for, 190, 191
 successful bidding rate, 295
 team presentations, 205
 value comparisons, 208–9
 vocabulary, 201–2
 volume discounts, 227
 Web advertising and, 189–90
 see also pricing of services

scheduling, 295–96
 time management, 314
severance pay, 146, 151–52
sexual discrimination, 325–26
sick leave, 113
size of firm, 22
 adaptability, 37
 billing systems, 215
 business management model, 40
 business mix, 278–81
 client perception, 276–77
 diversity of client base, 288
 effects of incapacitation of principals, 323
 employee handbook, 84–85
 growth management, 90, 277–78
 industry trends, 273–74
 large shops, 276
 legal proceedings and, 72
 mid-sized firms, 275–76
 need for growth, 273
 need for written policies, 80
 options, 274–76
 organizational chart, 83
 profitability and, 312
 ratio of old-to-new clients and, 292
 significance of, 95
 small shop, 274–75
 stages of development and, 281–82
 Stage Three companies, 285
 as valuation factor, 351
 working alone, 274
Small Business Administration, 303–4
sole proprietorships, 18–19
specialization, 157–60, 312
spec work, 162, 203–4
statement of purpose. see mission statement
stock distribution
 majority ownership, 26–27
 for ownership sharing, 25–26
StudioManager software, 298
surveys of customer satisfaction, 267–70

T

taxes
 accounting services, 53
 bartering for services, 221
 discounts for not-for-profit organizations, 229
 employee withholding, 330–31

failure to collect, 324–25
freelance workers, 99, 101
health insurance deductions, 59
life insurance deductions, 62
pro bono work and, 181
profitability and, 303, 307
technology, 156–57, 242
cost of tools of production, 300
implementation, 157
management software, 296–98
need for investment, 285, 299–300
telecommuting, 124
telephones, 45
temporary workers, 99–100
best use of, 101–2
hiring for full-time employment, 104–5
time sheet, 314–16
top-down management, 37–39
Traffic Office Manager software, 298

U.S. Arbitration and Mediation, 71

V

vacations and holidays, 113
valuation of business, 328–29, 348–52
vice presidents, 92
visual audit, 203
volunteering. see pro bono work

W

Web site, 174, 189–90
women-owned business, 56
worker's compensation insurance, 63
Wurman, Richard Saul, 243